The Big Book of NEW Design Ideas David E. Carter

THE BIG BOOK OF NEW DESIGN IDEAS Copyright © 2005 by COLLINS DESIGN and DAVID E. CARTER

All rights reserved. No part of this book may be used or reproduced in any manner whatsoever without written permission except in the case of brief quotations embodied in critical articles and reviews. For information, address Collins Design, 10 East 53rd Street, New York, NY 10022.

HarperCollins books may be purchased for educational, business, or sales promotional use. For information, please write: Special Markets Department, HarperCollins Publishers Inc., 10 East 53rd Street, New York, NY 10022.

First Edition

First hardcover edition published in 2003 by: Harper Design International, *An Imprint* of HarperCollins*Publishers*

First paperback edition published in 2005 by: Collins Design An Imprint of HarperCollinsPublishers 10 East 53rd Street New York, NY 10022 Tel: (212) 207-7000 Fax: (212) 207-7654 collinsdesign@harpercollins.com www.harpercollins.com

Distributed throughout the world by: HarperCollins International 10 East 53rd Street New York, NY 10022 Fax: (212) 207-7654

Book design by Designs on You! Suzanna and Anthony Stephens

Library of Congress Control Number: 2005924198

ISBN: 0-06-083309-2

All images in this book have been reproduced with the knowledge and prior consent of the individuals concerned. No responsibility is accepted by producer, publisher, or printer for any infringement of copyright or otherwise arising from the contents of this publication. Every effort has been made to ensure that credits accurately comply with information supplied.

Printed in China by Everbest Printing Company through Four Colour Imports, Louisville, Kentucky.

First Paperback Printing, 2005

Advertising	5
Annual Reports	23
Book Jackets	32
Calendars	51
Catalogs & Brochures	
Corporate ID/logos	96
Editorial Design	163
Environmental/Signage	
Exhibits & Trade Shows	199
Illustration	203
Labels & Tags	222
Letterhead Sets	224
Menus	261
Music CDs	263
Outdoor	265
Packaging	275
Posters	302
Promotions	332
Retail Graphics	366
Shopping Bags	371
T-Shirts	373
Web Pages	376

The original **Big Book of Design Ideas** has become one of the bestselling graphics books of all time. As one example, the book made amazon.com's *Top 1000* books and stayed there for a good while. That territory is usually reserved for novels, cook books, diet books, biographies, and other "general audience" books. Few books with a narrow audience reach those type of sales numbers.

So, when my publisher asked for a **Big Book of NEW Design Ideas**, he said, "Do a book just like the first one, only make it even better."

A "Similar Book, But Better." I think this book accomplishes that goal.

How? For some categories such as brochures, annual reports, and promotions, only a single page or image was shown in the first book.

This time, most brochures and annual reports show the cover as well as a two-page spread. That way, the viewer can see how the inside design relates to the cover.

For promotions, many have been given a full page and several photos. For the designer who uses this book as a springboard for ideas, the value is in the details.

One thing has not changed from the previous book: every piece in this book was selected for its ability to inspire designers and to trigger new ideas that may not even be related to the original piece shown in this book.

So, that pretty well describes what you will find in this book. For all of you designers who use books like this for what I call "solitary brainstorming," I hope this book will be as valuable to you as the first one was.

Danz

ADVERTISING

Creative tirm GAUGER + SANTY San Francisco, California client STUDIO 360°

PHOTOGRAPHIC RESOLUTION

Bring your explusions focus. Tashibu's new 4-8TUE0033 and/dimension explore offers the highest resolution in its class—an alternature 2400x000 dpt. If's also equipped with printing and security factories as and its ordinary factor. The scient Barteman factories are also forecast, the most epsequenting features in the price. To view sur complete line of cosple

TOSHIBA

creative firm **DGWB**

Santa Ana, California creative people JON GOTHOLD, EDUARDO CORTES, ENZO CESARIO, DAVE SWARTZ, MING LAI, DAVE HERMANES, NEAL BROWN, KARA LAROSA client TOSHIBA COPIERS

> creative firm **THE UNGAR GROUP** Chicago, Illinois creative people TOM UNGAR, MARK INGRAHAM, DOUG BENING client AMERICAN HARDWARE MANUFACTURERS ASSN.

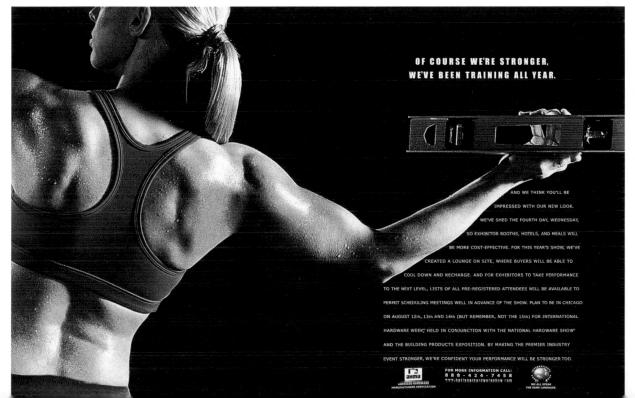

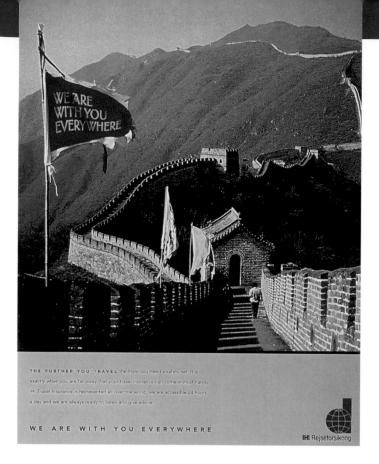

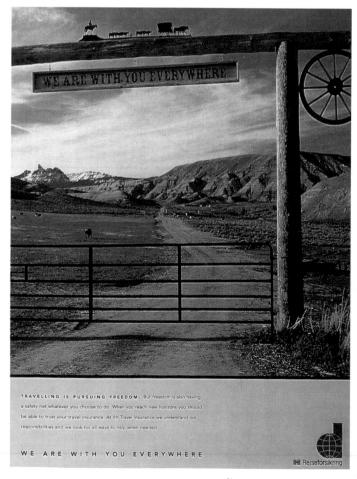

creative firm HEIMBURGER Denmark Creative people ERIN CHAPMAN, HEINRY RASMUSSEN client IHI TRAVEL INSURANCE

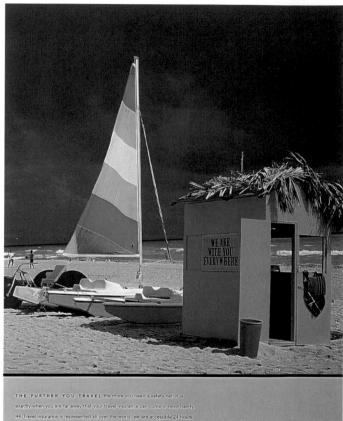

IHI Reisefo

(H) Travel insurance is represented all over the world, we are accessible 24 hours a day and we are always ready to listen and give advice.

WE ARE WITH YOU EVERYWHERE

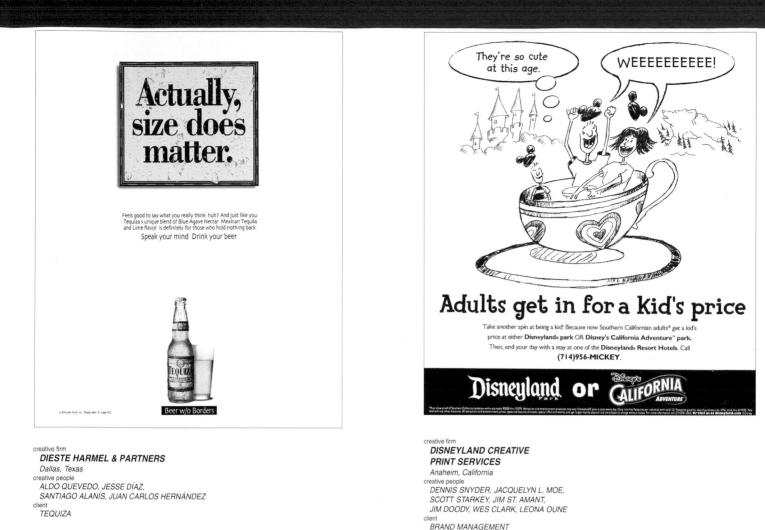

MCCLAIN FINLON ADVERTISING Denver, Colorado creative people TOM LEYDON, MATT LOCKETT, ANA BOWIE, BILL SIEVERTSEN client

MUTUAL UFO NETWORK & MUSEUM



creative firm **LEO BURNETT COMPANY LTD.** Toronto, Canada creative people JUDY JOHN, KELLY ZETTEL, JOSH RACHLIS, SEAN DAVISON, ANNE PECK client WOODBINE ENTERTAINMENT GROUP

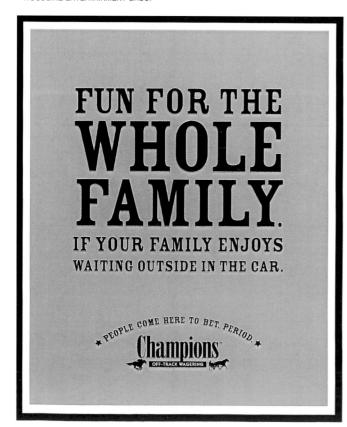

ALL MEDIA PROJECTS LIMITED (AMPLE) Port of Spain, Trinidad & Tobago creative people ASTRA DA COSTA, AUSTIN AGHO, CATHLEEN JONES, GAIL MATTHEW, GAIL HUGGINS-FULLER, MARIANELA INGLEFIELD

BP TRINIDAD AND TOBAGO LLC (BPTT)

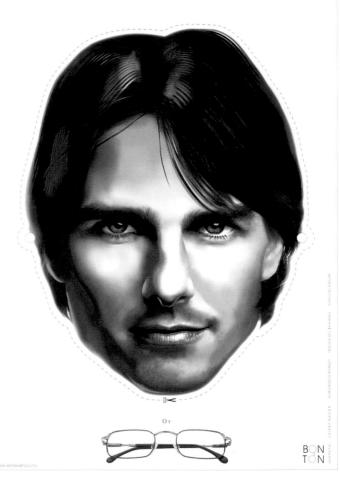

creative firm **TBWA-ANTHEM (INDIA)** New Delhi, India creative people PROBIR DUTT, ARNAB CHATTERJEE, SANJAY SAHAI client BON-TON OPTICALS Round of finety chapped Atberta beef, broiled and presented with lettuce, ripe tomato and sweet onion on a sesame-herb bun, accompanied by beans with park, deep browned in a rich tomato sauce.

creative firm LEO BURNETT COMPANY LTD. Toronto, Canada creative people JUDY JOHN, TONY LEE, KELLY ZETTEL, ANNE PECK client H.J. HEINZ CO. OF CANADA

LAWRENCE & PONDER IDEAWORKS Newport Beach, California creative people LYNDA LAWRENCE, SIMONE BEAUDOIN, MATT MCNELIS client PICK UP STIX

creative firm

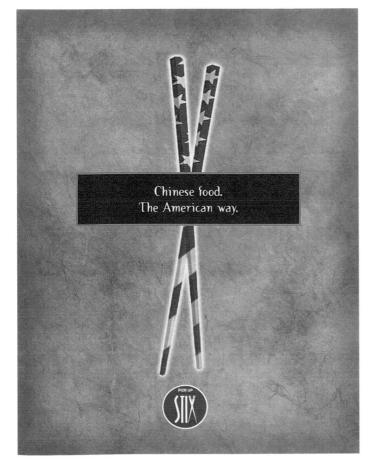

reative firm LAWRENCE & PONDER IDEAWORKS Newport Beach, California reative people LYNDA LAWRENCE, MATT MCNELIS, EVA FINN, GARY FREDERICKSON lient

And you thought they were just beans

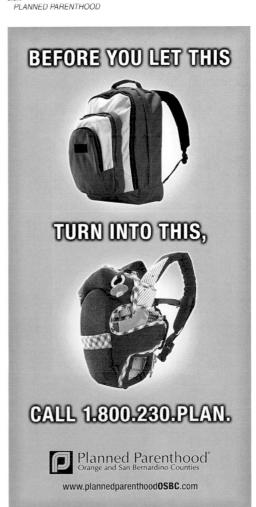

DGWB Santa Ana, California

JON GOTHOLD, DAVE SWARTZ, ENZO CESARIO, DAVE HERMANAS, ELLIOTT ALLEN, ADRIEN RIVERA. MYKE HALL

THE GYPSY DEN

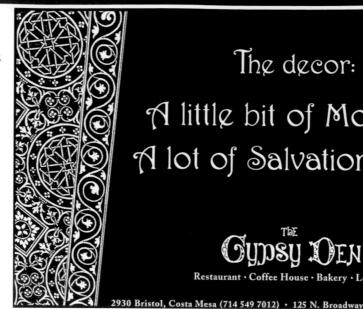

The decor:

A little bit of Morocco. A lot of Salvation Army.

Santa Ana (714 835 88

'Kelloaa's Nutri-Grain Cereal Bars is part of your complete breakfast

creative firm LEO BURNETT COMPANY LTD. Ontario, Canada creative people JUDY JOHN, MONIQUE KELLEY, MARCUS SAGAR, KIM BURCHIEL client KELLOGG CANADA

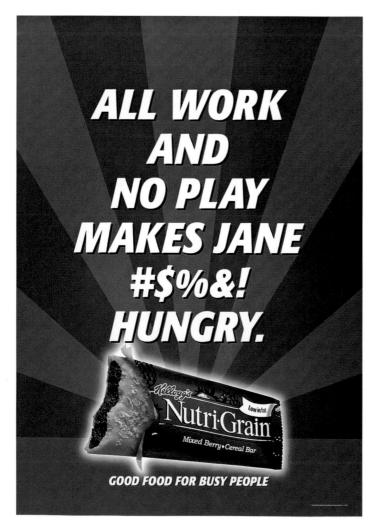

NOW YOU CAN HAVE BREAKFAST AND DRY HAIR.

GOOD FOOD FOR BUSY PEOPLE

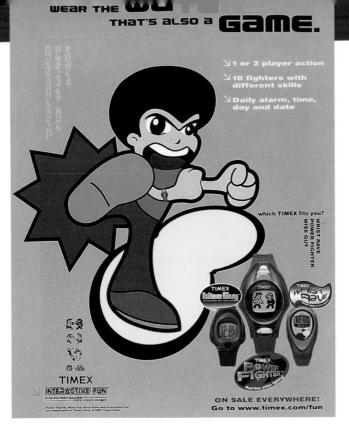

creative firm

THE SLOAN GROUP New York, New York creative people SEAN MOSHER-SMITH, RODDY TASAKA client TIMEX

The Business Book & Author Luncheon With Bob Woodward. Monday, October 16, Noon.

Bob Woodward would like to get being connected with the best-reling mather of books like All The President Man and Wood. The Short Life and Fat Times of So-All 5. For indexs call 336-2020 or with some Bob Woodward who is and Whod. The Short Life and Fat Times of Maneever you device to do. don't miss mather of books like All The President Man and So a

Presenting Sponsor: BUSINESSJOURNAL

Table Sponsors: ATC-T, Chich-fil-A, Royal & SurvAlliamer, Clarintt, NaSa, Specialized Media Marhering and Powartions Pepti-Cola Boating, Company of Chevlotte, TIAA-CREE WFAE 90.7 fm, Centura Bank, Forondator For The Carolinas, WCCB-Fax 18, U.S. Trost of North Carolina, The BoolMark, Phillp Morris USA

TBWA-ANTHEM (INDIA)

New Delhi, India creative people PROBIR DUTT, ARNAB CHATTERJEE, SANJAY SAHAI

BON-TON OPTICALS

creative firm

WRAY WARD LASETER ADVERTISING Charlotte, North Carolina creative people

JENNIFER APPLEBY, TOM COCKE,

DAVE DICKERSON, ELAINE BOSWELL

client NOVELLO FESTIVAL OF READING

DO YOU SPEAK CHERRY CREEK?

BOSS HUGO BOSS J. CREW DIESEL BERNINI,

Strong? Yes: But silent? Never. Not when you talk this talk. Your very own language of fashion. So many stores, both expressive and exclusive. Spotern nowhere less in the Rocky Mountain West.

Neiman Marcus, Saks Fifth Avenue, Lord & Taylor and Foley's. Valet Parking. 303-388-3900 Click on www.shopcherrycreek.com

> creative firm **ELLEN BRUSS DESIGN** Deriver, Colorado creative people ELLEN BRUSS, CHARLES CARPENTER client

CHERRY CREEK

client CHERRY CREEK SHOPPING CENTER

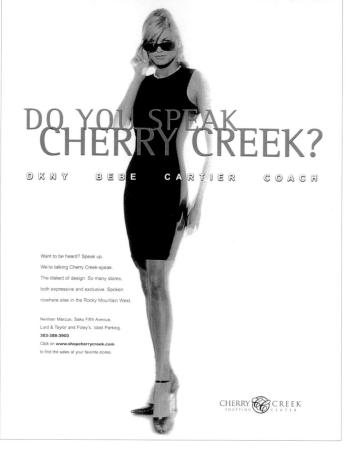

DO YOU SPEAK CHERRY CREEK?

POLO/RALPH LAUREN BURBERRY CUTTER & BUCK SCARPALETTO

Your words carry weight. What you say, goes. And you go to Cherry Creek. So many stores, both expressive and exclusive. Spoken nowhen else in the Rocky Mountain West.

Nelman Marcus, Soka Fifth Avenue, Lord & Taylor and Foley's, Valet Parking, 303-365-3900 Citck on www.shopchenycreek.com to find the sales at your favorite stores.

CHERRY CREEK

You can be sure that tickets for this rare public appearance by Tom Clancy will go faster than rats off a sinking ship. So reserve your seats now for a presentation, with a question and answer session, from one of the best-selling authors of all time. It's sure to be a high point in this year's Novello Festival of Reading. Don't miss the boat.

Friday, October 27 at 7:30pm Ovens Auditorium Tickets: Orchestra - \$15 Balcony and Mezzanine - \$10 To order, call Tichetmaster at 522-6500 For more information, visit vowenovellofestival net.

Tata 🕡

creative firm WRAY WARD LASETER ADVERTISING Charlotte, North Carolina

creative people JENNIFER APPLEBY, TOM COCKE, DAVE DICKERSON, ELAINE BOSWELL client

NOVELLO FESTIVAL OF READING

"Yov're shit, and you know you are..."

creative firm SCANAD Denmark creative people KIM MICHAEL, PHILLIP HELBO, HENRY RASMUSSEN client KULTURSELSKABET STILLING

creative firm **DELRIVERO MESSIANU DDB** *Coral Gables, Florida* client

VOLKSWAGEN

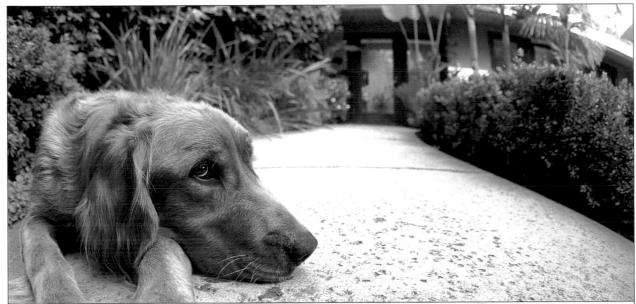

No a todos les gustará que tengas un Volkswagen

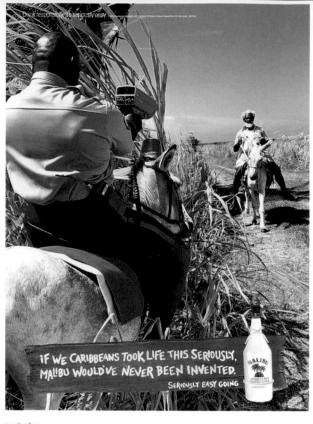

creative firm J. WALTER THOMPSON New York, New York creative people MIKE CAMPBELL client MALIBU

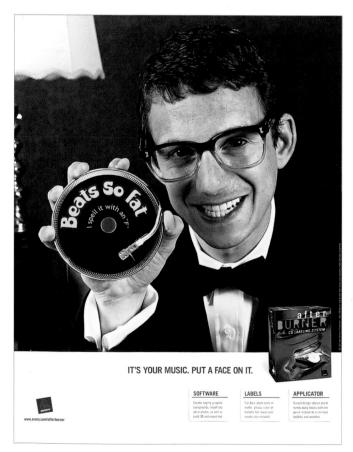

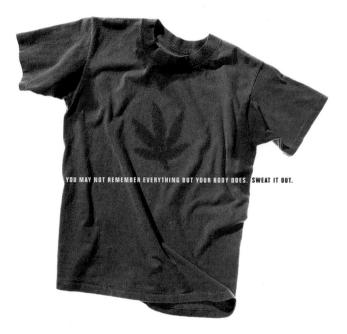

GoodLife

creative firm **LEO BURNETT COMPANY LTD.** Ontario, Canada creative people JUDY JOHN, KELLY ZETTEL, TONY LEE, KIM BURCHIEL client GOODLIFE FITNESS CLUBS

creative firm **DGWB**

Santa Ana, California creative people JON GOTHOLD, DAVE SWARTZ, ENZO CESARIO, ANDRE GOMEZ, ELLIOTT ALLEN, DAVID ALBANESE, MYKE HALL, DAYLE REIMER client

client AVERY AFTERBURNER

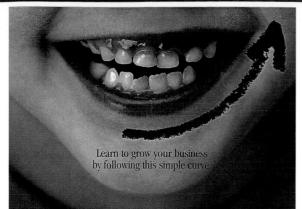

To sharpen your business skills, there's no better place than IAAPA Orlando 2002. With educational seminars and workshops covering everything from fundamental skills to the latest trends and best practices—plus visionary keynote speakers—IAAPA Orlando 2002 will put you at the topof the learning curve. Visit www.iaapaorlando.com today.

For more show information, to register or to exhibit, contact LAAPA: ON_LINE: www.iaapaorlando.com (USA) 703.836.4800 (USA) 703.836.4700 (USA) 102.000 (USA) 102.000

Learn Buy Network Satisfy

creative firm KIRCHER, INC.

Washington, D.C. creative people BRUCE E. MOHGAN, HICH GILROY, TINA WILLIAMS

client INTERNATIONAL ASSOCIATION OF AMUSEMENT PARKS AND ATTRACTIONS

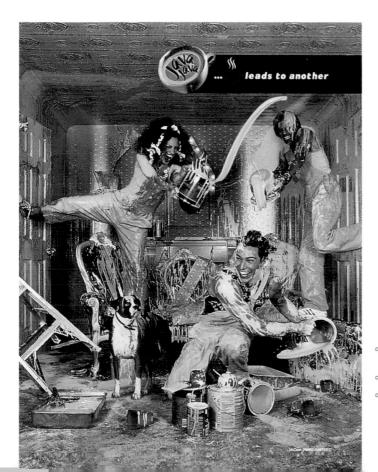

MCCANN-ERICKSON SYDNEY Sydney, Australia reative people JELLY LAND lient NESTLE

"Man will never reach the moon, regardless of all future scientific advances."

– Lee De Forest, Radio Trailblazer, 1957

They thought you couldn't reach a reservoir 25,000 feet down in 7,000 feet of water either.

We made it possi

When Erwonture Global Technology developed Solid Espandable Tubular (SET**) Technology, amaing possibilites opened up for deenwater wells that before were too costly, or simply out of reach. SET Technology allows you to reach TD with cosing large enough to produce the well effectively, but with a wellboar small enough to minimize rig size. It's an ideal tabance that results in less equipment and ultimately hundricks of millions of dollars in savings. Applying SET Technology to your terefit is the only thing we focus on at Erwenture. So call 281-492-5000 and aik us for the moon on your next project. Well how you how to you til live.

SAVAGE DESIGN GROUP Houston, Texas

creative fire

creative people PAULA SAVAGE, ROBIN TOOMS, BO BOTHE, SCOTT REDEPENNING

client ENVENTURE GLOBAL TECHNOLOGY

creative firm GBK, HEYE Bavaria, Germany creative people ALEXANDER BARTEL, MARTIN KIESSLING, CORINNA FALUSI, THORSTEN MEIER, KATRIN BUSSON, JAN WILLEM SCHOLTEN client ELLE

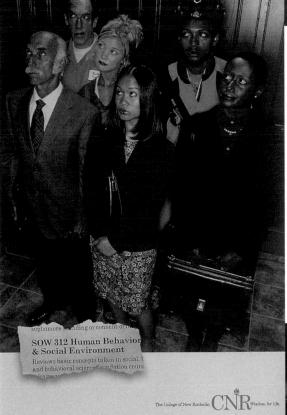

creative firm McCANN-ERICKSON New York, New York creative people TOM JAKAB, GEORGE DEWEY client THE COLLEGE OF NEW ROCHELLE

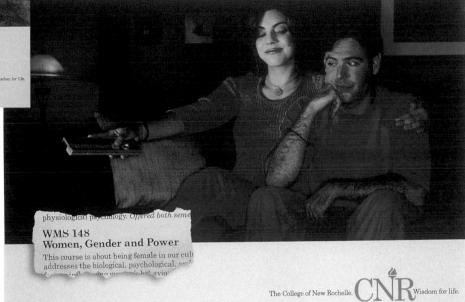

The College of New Rochelle.

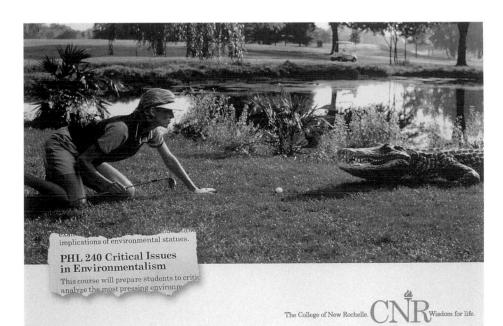

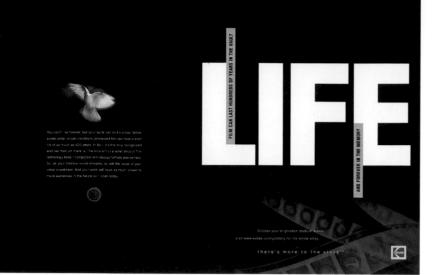

creative firm **BUCK & PULLEYN** Pittsford, New York creative people KATE SONNICK, ANNE ESSE, GEORGE KAMPER client KODAK

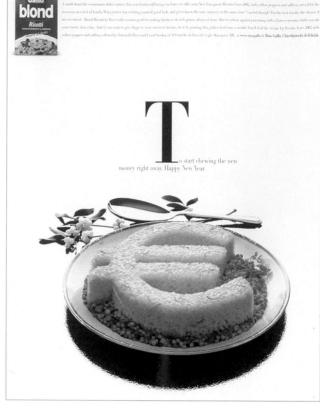

creative firm **SCANAD** Denmark creative people LARS HOLMELUND, HENRY RASMUSSEN

I have ironed his underwear for 20 years. Met him in Copenhagen when he was supposed to be on business in Bangkok. Served oysters in champagne sauce every night at bedtime. Yesterday he ran off. With a man... And now You tell me that I've got an asthma! Simple asthma treatment in a complicated world

Buventol Easyhaler' (salbutamol) New simple pouvder inhalator

end factoria substanti. Dapovengi internativari substanti. Dapovengi internativari substanti di alla di internativari substanti di alla di internativari substanti di alla di alla di alla di alla di internativari substanti di internativari di alla di internativa di alla di internativa di alla di internativa di internativa di alla di internativa internativa di internativa in

Cerecopharm

Easyhaler

creative firm **VERBA SRL** Milano, Italy creative people GIANFRANCO MARABELLI, SILVIA ERZEGOVESI, LORENZA PELLEGRI, BRUNO DEWE DONNE client F&P-RISO GALLO

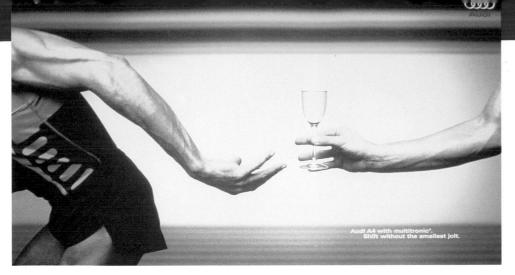

creative firm VERBA SRL Milano, Italy

creative people STEFANO LONGONI, JOSEPH MENDA, FRANCESCO FALLISI, PIERPAOLO FERRARI client AUTOGERMA-AUDI DIVISION creative firm **CHANDLER EHRLICH** Memphis, Tennessee creative people MIKE LEON, MARINA DUFRENE client CHURCH HEALTH CENTER

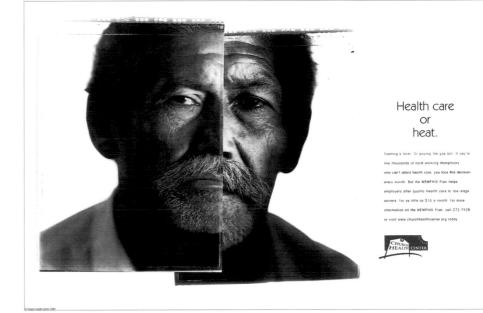

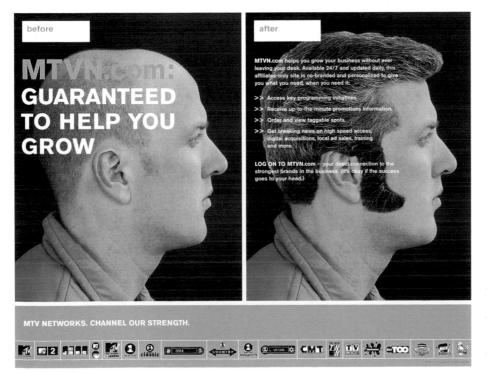

creative firm **MTV NETWORKS CREATIVE SERVICES** New York, New York creative people NAOMI MIZUSAKI, JOHN FARRAR, PATRICK O'SULLIVAN, KEN SAJI, CHERYL FAMILY client MTV NETWORKS

18000 annual cardiac procedures 2,500 open heart surgeries I name 3 FLORIDA HOSPITAL

creative firm **FRY HAMMOND BARR** Orlando, Florida creative people TIM FISHER, SEAN BRUNSON, SHANNON HALLARE client FLORIDA HOSPITAL

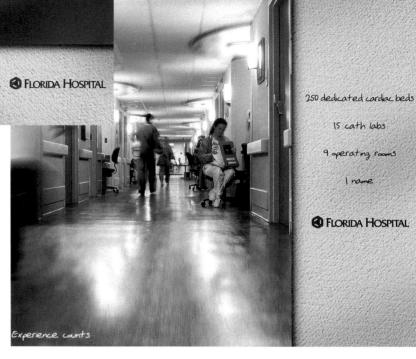

creative firm VERBA SRL Milano, Italy

rvilario, Italy creative people STEFANO LONGONI, GIULIO BRIENZA, FRANCESCO VIGORELLI, FULVIO BONAVIA

client AUTOGERMA-AUDI DIVISION

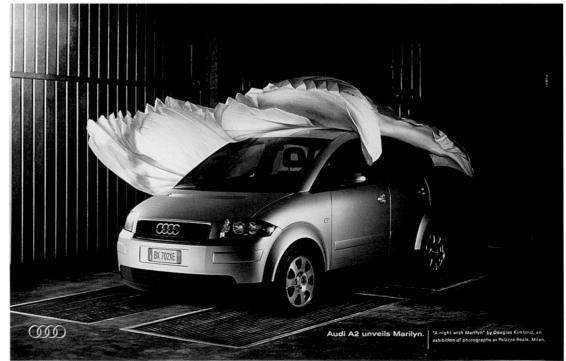

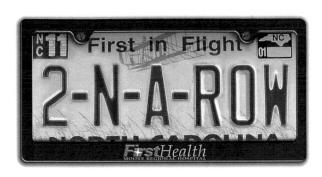

For the second consecutive year, FirstHealth Moore Regional was named a 10 Top Cardiovascular Hospital. We are honored to be the only hospital in the state to receive this award for a second time. Hospital ist constantly outperform their peers, with mortality and complication rates as much as 27 prevent lower than other hospitals. So if you need any type of cardiovascular procedure, we invite you to check us out. Because when you you you head, we don't

think you'll let anyone else work on your heart. <u>THE HEARTHERST CENTER</u> www.firsthealth.org. 800-213-3284

FirstHealth Moore Regional: Named A Top 100 Cardiovascular Hospital Two Years In A Row.

creative firm **STERRETT DYMOND STEWART ADVERTISING** Charlotte, North Carolina creative people RUSS DYMOND, LEE STEWART, ADAM LINGLE

client FIRST HEALTH OF THE CAROLINAS

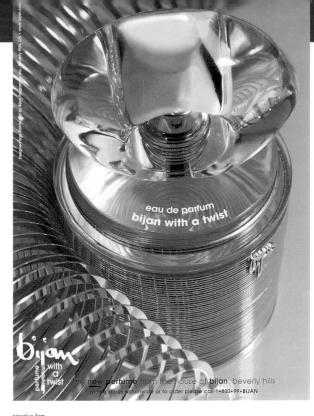

Creative limit BJJAN ADVERTISING Beverly Hills, California creative people MR. BIJAN, CYNTHIA MILLER, ANDREA BESSEY client BIJAN FRAGRANCES

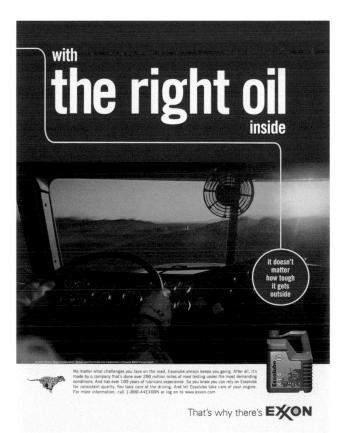

creative firm MCCANN-ERICKSON New York, New York creative people VANESSA LEVIN, JAN REHDER, JERRY CONFINO, SAL DESTEFANO client EXXON MOBIL creative firm HEIMBURGER Denmark creative people ERIN CHAPMAN. HENRY RASMUSSEN client DECATHLON

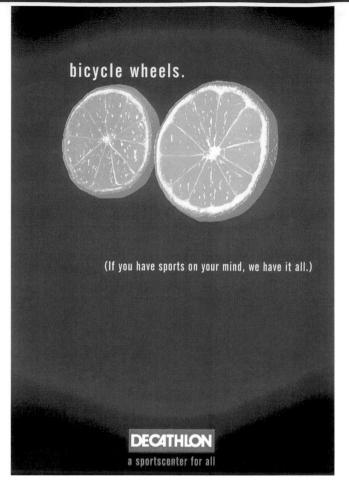

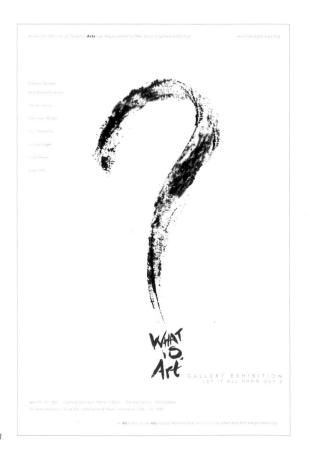

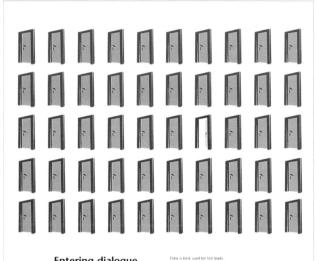

Entering dialogue

But most sales resources are swallowed by contacts without results, Eliminate them and save a lot. And use your powers were they matter. your powers were they matter 15 the and or called to the bone Remoundy meetane information. This is called stromation and that in what Heldenge produces. By glown and laternative information factional, efficiency of the strong the dom and poolene response. This is the foundations for protubility of the strong the strong the strong the protubility of the strong the strong the strong the protubility of the strong the strong the strong the protubility of the strong the strong the strong the protubility of the strong the strong the strong the protubility of the strong th start by calling +45 8730 7744.

creative firm SCANAD Denmark creative people LARS HOLMELUND, HENRY RASMUSSEN

> M3AD.COM Las Vegas, Nevada creative people DAN MCELHATTAN III client AIGA LAS VEGAS CHAPTER

creative firm

ANNUAL REPORTS

Delivering Relevant Media

Astral Media **Uth** anniversary Se

o n target audiences

The past year's performance of the Astral Media Television Group was unprecedented, with our pay, pay-per-view and specialty services achieving higher than ever viewer satisfaction and advertising revenues.

Our focus on creating a full entertainment experience - providing content relevant to our target audiences, creating strong brands, and build-ing long-term relationships with our consumers - is proving to be a winning formula. With our pay-TV networks at the forefront of growth in digital and our specialty channels attracting strong niche markets, we have solidified our position as a broadcasting leader in both the English and French-language markets.

creative firm BELANGER RHEAULT COMMUNICATIONS DESIGN LTD Montreal, Ganada creative people JEAN LAUZON, ANNIE BOISSONNEAULT ASTRAL MEDIA

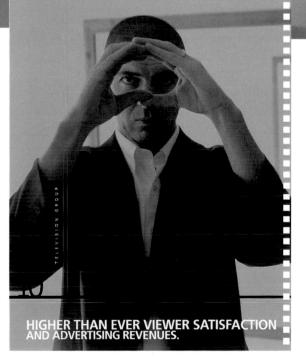

GRAFIK Alexandria, Virginia

creative people JONATHAN AMER, JUDY KIRPICH. LYNN UMEMOTO, MELBA BLACK client ACTERNA

Our strengths lie in our actions.

- We are streamlining operations and refocusing our resources.
- We are maintaining our presence in the world's largest communications markets.
- We are broadening our already diversified product and service portfolio.
- We are connecting to our customers with an industry-leading sales and support force.
- We are continuing our aggressive commitment to research and development.

Refocusing on our core business allows us to reduce costs and increase efficiency.

Certainly, no one could have expected the extent of the industry's prolonged downturn but, in response, we are accelerating our plans to streamline our infrastructure and reduce costs, increase efficiency and introduce new products to the marketplace.

ethiosing and introduce new products to the manepapace. A Acterna, we believe that a storog company is a focused company. That's why we have committed convolves to focusing on our core business. We are the world's largest provider of test and management solutions for optical transport, access, and cabe werevorks, and the second largest company overall in communica-tions test. Our mission is to advance global communications with innovative test and management solutions intended to drive our customers' business performance to new levels. We realize that, or start competitive, we must evaluate and taxinualize our opera-tions, our product sets, and our world/ore.

We will continue to consolidate our order fulfillment and manufacturing facilities. Last yout, we consolidated seven North American plants into two plants, a consolidation that accounted for about 20 percent of our workforce reduction. We are turning our attention this year to realizing new synergies in our Buropean operations. By concludating manufacturing and order fulfillment into fewer sites, we reduce costs and improve our responsiveness to coantores. to customers.

Our recent decisions to sell Airshow and our wireless handset te business are in concert with our strategy to refocus on our core

Perhaps the most difficult of our cost-cutting initiatives has been the streamlining of our infrarenceme. In fiscal 2002, we elimina-ed 1.580 positions or 17 percent of our workforce. These actions — coupled with aggressive cost management — have reduced our infrastructures costs by approximately 1810 million on an annulated basis. We announced the elimination of an additional 400 positions that with be realized in the first half of fiscal 2003, producing an additional \$100 million in annulated sevings.

2. Our presence in diverse global markets is a tra global markets is a true strategic advantage.

We have an established global presence serving customers in more than 80 countries worldwide. When one market experiences turbulence, our presence in other markets helps balance us. We have seen relative stability in Asia as we encounter challenges in the North American market and in Europe.

the North American market and in Burope. In order to thrive in an increasingly global marketplace, our contonners more carently the global marketplace, our contonners more carently the global prostners. In order to maintain their competitive advantage in a turbulent economic environment, partner with a substantial global prostners and more the world's top 50 communications services providers and explosite and providers and the global prostners are among the world's top 50 communications services providers and explosite and the global prostners are among the world's top 50 communications services providers and explosite manufacturers, including 47k7, 15K, Version, Sprint, Deneche Teledom, China Telecom, Chex and Siemens. With extensive global proteins and cable, these contoners meed a partner that can provide full targe of complementary rates and masagement products and services and cable, these contoners meed a partner that can provide full targe of complementary rates and masagement products and services and cable, these contoners meed a partner that can provide on the service services set, we believe we are positioned and provide contoined support and solutions to our customers between they are.

creative firm KIKU OBATA + COMPANY St. Louis, Missouri creative people AMY KNOPF, CAROLE JEROME client ANHEUSER BUSCH EMPLOYEES' CREDIT UNION

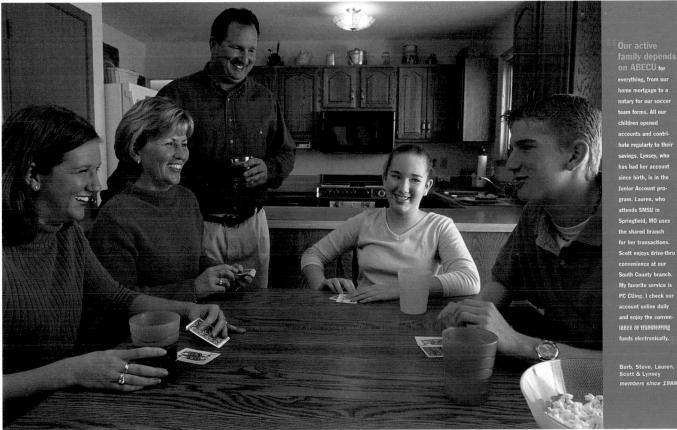

. from ou gularly to the . Lynsey, who has had her account since birth, is in the Springfield, MO uses the shared branch Scott enjoys drive-thr convenience at our South County branch My favorite service is PC CUing. I check our account online daily and enjoy the conven lence or transferring funds electronically.

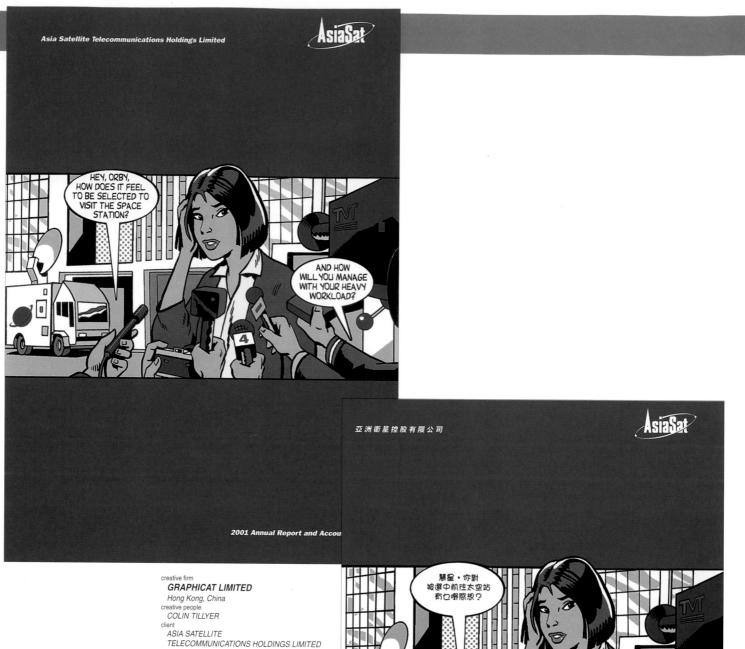

 Rg
 Rg

 Rg
 Rg

 Rg
 Rg

二零零一年年報及賬目

Vantage Point

HO BEE INVESTMENT LTD Annual Report 2001

creative firm UKULELE DESIGN CONSULTANTS PTE LTD Singapore creative people DAPHNE CHAN client HO BEE INVESTMENTS LIMITED

> Like the intricate structure of a leaf, Ho Bee's properties are of lasting beauty and value. Through these assets, Ho Bee creates value for her stakeholders, shareholders and investors.

the start C

annual 2001 Report

10110110

JATIONAL FISH WILDLIFE

DEVER DESIGNS Laurel, Maryland creative people BYRON HOLLY, JEFFREY L. DEVER client NATIONAL FISH AND WILDLIFE FOUNDATION

ANHEUSER-BUSCH

STRATEGIC PARTNERSHIPS

A salongtime partner of the National Fish and tradition of high standards in protecting the environment. The company's leadership in conserving and enhancing matural resources for future generations corregizes the many programs that compiles our partnership. Anheuser-Busch has delivered more than \$3.7 million to more than \$30 outdoor enhancement projects in 14 states.

Datch in destructed more tank 5.7. innova tank 50 outdoor enhancement projects in 4.8 states. "Anheuser-Buach's commitment to conserving natural resources has been a priority for the Buach family for generations," aid Dan Hoffmann, itercor of Budweiser marketing. Anheuser-Buach, Inc. "We're prood to be associated with our "Bodweiser Outdoor' partner organizations ilide the National Fish and Wildlife Foundation, and together, we are ensuring people will be able to enjoy downer warder one inde forum?"

The National Fish and Wildlife Foundation, and together, we are ensuring people will be able to enjoy the great outdoors in the future." One highlight from 2001 was the establishment of the Budweiser a Scholarship Program. Scholarship awards avaires studies that respond to significant

erabilihanent of the Budweiser Conservation Scholandip Porgam. Scholandip avards upport innovative studiet har respont to significant challenges in fish, wildlike, and plant conservation in the United States. Through the program, which drew over 200 applications from more than 90 institutions of higher education in e11 states last year, Anbeues-Busch fosters a new generation of leaders in fish and wildlife conservation. In 2001, scholarships of 510,000 each were awarded to: Toidd Aschenbach University of Kansas, Patricia Bright, VA-MD Regional College of Veterinary Medicine: Eric Teasy, Easter Illnois University of California at Smitz University of California at Smitz University of California at Smitz

12

State University; Susan Parks, Massachusetts Institute of Technology; Jennifer Sevin, North Carolina State University; and Richard Shefferson, University of California at Berkeley.

California at Berkeley. Additional programs in Anheuser-Busch's conservation portfolio include the "Help Budweiser Help the Outdoors" sales promotion and the "Budweiser Outdoorsman of the Year" Award.

Outdoormain or the Yara Awaid. Over the past three years, the Budweiser Outdoors fall promotion has raised more than \$1 million for conservation. In the fall, more than 300 participating Anheuser-Busch wholesalers donate a percentage of proceeds from all bortles and cans of Budweiser sold during a select period. The money is divided among several conservation organizations and goes directly to the organization' on-the ground conservation projects. Brace Lewis, of Natcher, MS, was honored on

Bruce Lewis, of Narcher, MS, was honored on January 13, 2001, as the sixth annual "Budweiser Outdoorsman of the Year" Award recipient. One of Mr. Lewis' opportunities is to distribute a \$50,000 grant from Bodweiser and the Narional Fish and Wildlife Foundation to the wildlife and natural resource conservation groups of his choice.

From "the tiger in your rank" to the tiger in in wild Asian habitat, ExosMobil and the tiger's future come together with the Foundation in the Save The Tiger Fund (STF). Ed Ahnert, president of the Exoon-Mobil Foundation, reflexts on his experience with the partnership: "NFWF offers a forum where business, government, and nonprofits work harmoniously on conservation. By acknowledging that human activity and environmental preservation must coexist, we can

and unrounning prevation must construct we can operate with abare of an astrong middle ground." In 1995, when STF began, Asia's wild tigers were in severe decline throughout their range. Human population growth and loss of habitat dreve tigers from their homes, while overharvesting of prey species suared the cat, and poaching took its toll. A century before, an estimated 100,000 tigers roamed the continent, by 1995,

only five to seven thousand remained. By DSJs only five to seven thousand remained. Reponding to the crisis, EconMobil and the Foundation recovered to a weight digers. STF forged partnenhips, put conservation dollars on the ground in tiger range, and encouraged collaboration among conservationitis and communities around the world. Positioning ineff to be an intelligent investor, STF recognized the need to support local people who share their

"Jonne ange" with wild igen. In 2001, the Foundation evaluated the accomplibments of STF's first sizes. The such appendix ments of STF's first sizes. The such appendix abilitize key tiger populations. "The Fund, through its Council of tiger experts—guided by chairman John Seidenticker—has built leadership, and near unity, in the world of tiger conservation," notes John Robinson, vice preident for international conservation at the Wildlife Conservation. Such

vice president for international conservation at the Wildliff Conservation Society. STF has invested more than \$9.2 million in 158 projects in 12 of the 14 tiger-range countries since 1995. It has drawn unprecedented public participation of more than 19,000 individual donations totaling more than

\$1.4 million to date. STF's impact has been significant, awarding more than 28 percent of total tiger conservation funds from 1998 to 2001.

The key to STF's success is its willingness to focus on the human side of tiger conservation. Early tiger conservvation measures rited to keep people and tigen spare. In today's crowded world, efforts to save tigers must help people if they are to succeed. STF has grasped and acted on this simple truth: saving wild digers requires engaging the millious of people who live near them. Kathryn Fuller, President of the World Wildlife Fund, notes that, because STF focuses on locally driven conservation, "An Asiabased leadership has emerged—opeaking the languages, knowing the customs of stakeholders, in a position to mobilize political will."

In 1995, extinction was predicted for wird tigers. Today, against the odds, rigers still prove the terzi grasaland take edge India and Negal, the wild bot derlands of Cambodia and Viernam, and the var bores foress of the Russian Fer Jax. The Sizer For Fund has played a critical role in helping conservationists and local communities anded for conservation to benefit tigers and people for generations to come.

WE STAND OUT

DAVIDOFF ASSOCIATES New York, New York creative people PATRINA MARINO, ROGER DAVIDOFF

creative firm

client THE PEPSI BOTTLING GROUP INC.

WE SELL SODA

Financial Highlights	
\$ in millions, except per share data	2001(1)
Net Revenues	\$ 8.443

Net Revenues	\$	8,443	\$ 7,982	\$ 7,505
Operating Income ²²	s	676	\$ 590	\$ 396
EBITDA®	s	1,190	\$ 1,061	\$ 901
EPS(2)(3)(4)(6)	s	1.03	\$ 0 77	\$ 0.35
Operating Free Cash Flow®	s	295	\$ 273	\$ 161

2000(1)

1999(1)

1

(1) Fiscal
 (2) Exclusion
 (3) Fiscal

999 notation (4 2) was shift fatta yao 2000 nonva e y 2 sun. International inquitation of all shaft having and reliable with provid procession. In the second state of the second state of the second state of the second state of the induced state of the second state of the second state of the second state of the second state is a defined as or and provided by generation factor state and generatives. It cannot be as designed the first first of the second state of the second state and the second state of ontitam (4) Fintel 3. (5) Operation

Stock Price Performance

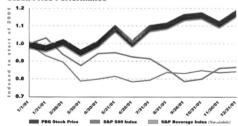

Diluted Earnings Per Shar

Return on Invested Capital

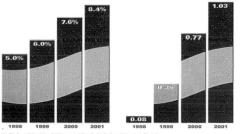

consisted of 53 weeks. ted of 52 weeks while f

impter of paramate importances and ether therapy and credits. (1999) and 1999 miles are initial adultic offering of 1000 million shows of common cited dening the easim parada possible in offers are 2001 three parameters and dening the easim parada possible and parameters are adjusted and 2000, 1999 and 1998 here have adjusted in offers are 2001 three parameters and plit. 2000 initialized Consola task law change herefits of \$0.08 per show. on stock on March 31, 1999 as if the shares (4) Fis (5) Fis

TTLING GROUP

PORT 2001

ANNUAL REPORT 2001

tive fin crea SIGNI DESIGN Mexico City, Mexico creative people DANIEL CASTELAO, FELIPE SALAS AMERICA MOVIL

Consolidated Revenues and EBITDA

RELEVANT FINANCIAL DATA

(millions of Mexican pesos)	2001	2000(2)	Chg%
Total Revenues	41,364	30,095	37%
EBITDA	12,491	5,995	108%
EBITDA Margin ⁽¹⁾	30.2%	19.9%	N.A.
Operating Profit ^{®®}	8,014	2,906	176%
Net Income ^m	2,281	905	152%
EPS (Mexican pesos) ⁽¹⁾	0.17	0.06	168%
EPADR (US dollars)()	0.38	0.14	168%
Total Assets	96,271	92,928	4%
Net Debt	9,263	-16,888	155%
Shareholders' Equity	58,684	69,229	-15%

(millions of Mexican pesos) (millions) Revenues
 EBITDA 41.4 30.1

2000

2001

2000

2001

Subscribers

26.6

30-

10-

2000

(1) Before exceptional ite (2) Proforma figures ms

EBITDA MARGIN INCREASED FROM 20% to 30% IN 2001

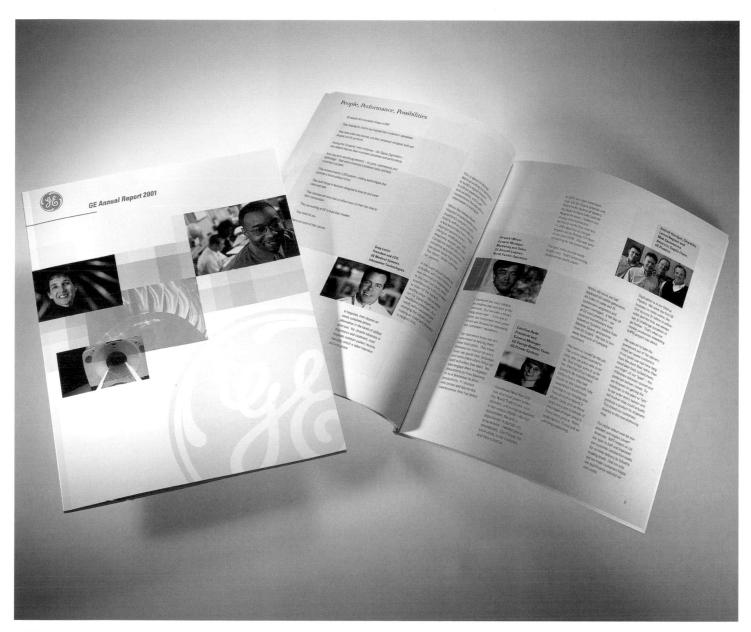

creative firm FUTUREBRAND creative people SVEN SEGER client GENERAL ELECTRIC

BOOK JACKETS

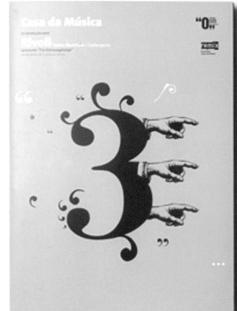

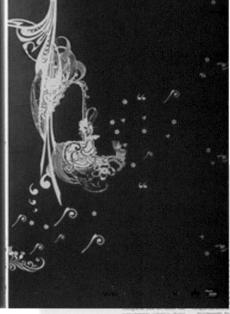

creative firm LIZÁ RAMALHO creative people LIZÁ RAMALHO client CASA DA MÚSICA

Remix - Ensemble Casa da Música

Dates is based as a fine to the a detail of types a finite at the second field of the second seco

The design of the second secon



List - Human Reconstruction Provide Administration Economication Reconstruction contract Provide Instantional Reconstruction Contract Interface Instantional Contract Interface

行發

Linners: Chen y angle delte sengueries erit sonne angenes. Partis Marie I angenes dermannen er erit sonne erit angenes dermannen er er erit angenes dermannen er er erit angenes der erit sonne erit angenes angenes erit angenes erit sonne erit erit sonne erit sonne erit erit sonne erit sonne erit erit sonne erit sonne erit angenes erit sonne erit erit sonne erit sonne erit sonne erit sonne erit erit sonne erit sonne erit sonne erit sonne erit erit sonne erit sonne erit sonne erit sonne erit sonne erit sonne erit erit sonne erit The second secon

32

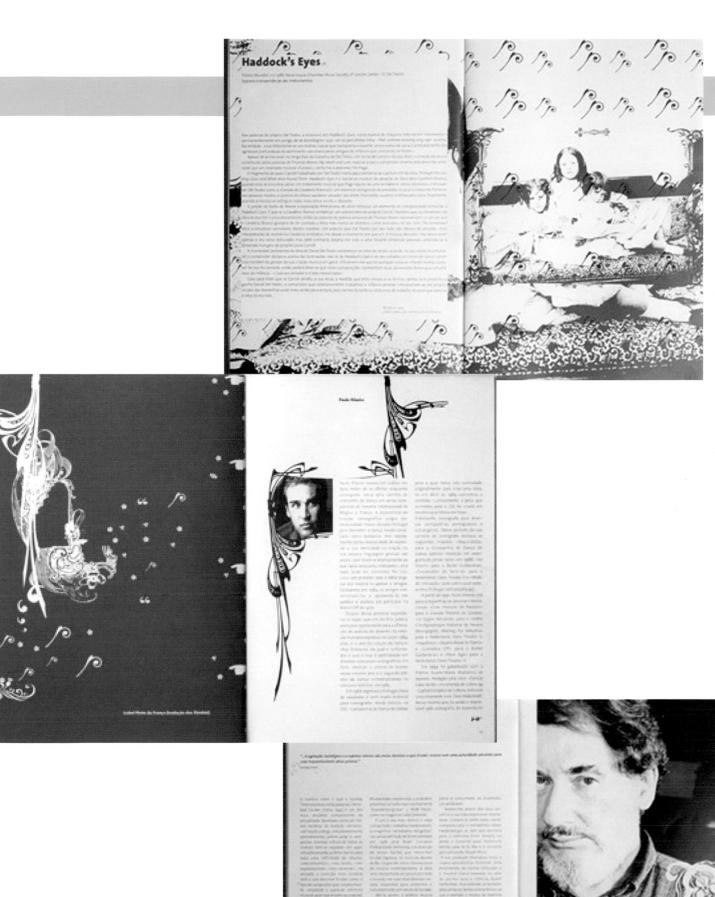

creative firm LIZÁ RAMALHO creative people LIZÁ RAMALHO, PEDRO MAGALHAES client CASA DA MÚSICA/PORTO 2001

L'AMORE, 2ª VEZ

2. So can't exceed to any environmental segments in the second second

and the analysis and an and the state of a state of a state of a state of the state

to the second of second to the property of the base of

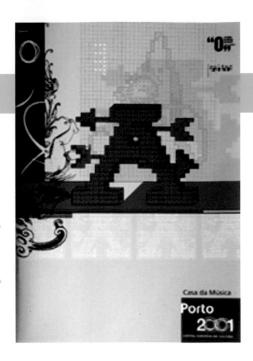

LINER DE MUTIONE : PUTIONE DE SPERIE DE PORTE ETP 15 PROVINSE DONC EXVEL: TURNES NUMERIPAS

L'AMORE INDUSTRIOSO

attent erk folger gereigt som de sakeren er ertenen annagert for an annage Notenen Sachte i

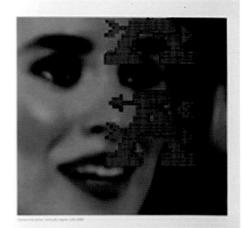

••;

IN BOCCA AL LUPO

A sprakaj si sang tanàné sa kaong ka

We get, when links are even to use a transmission of a status of a point links are even to the status of the stat

(d) Al Status in Quere in Their card and Australia Queri (Lind). Status in the result is a structure of a factor for a structure of a structure for a structure of a structure of a structure for a structure of a st

.

"O rotundo sucesso do Remis Ensemble"; "O que ouvimos tos música viva, com capacidade para diser algo a qualquer público." "(...) vimos uma sala cheia aplaudir entusiasticamente um concerto de música contemporánea."

"Vejam como soa bem esta música.", "Inúmeras intervenções solisticas de primeiro plano, aliadas a um sólido entrosamento do conjunto, impõem o Remix como um agrupamento com grande futuro na interpretação destes exigentes programas."

"O Remix tem mostrado as suas qualidades desde o final do ano passado. (...) o ensemble acabóu por aparecer (esta será uma entre muitas outras cosas boas que o Porto 2001 deixa. para o futurol."

10 Remix-Ensemble demonstrou contar com solisitas comumados, capazes de construir em conjunto uma sonoridade caleidoscópica mas coesa " ...

"A realização musical pelo Remix-Ensemble Casa da Mouca foi

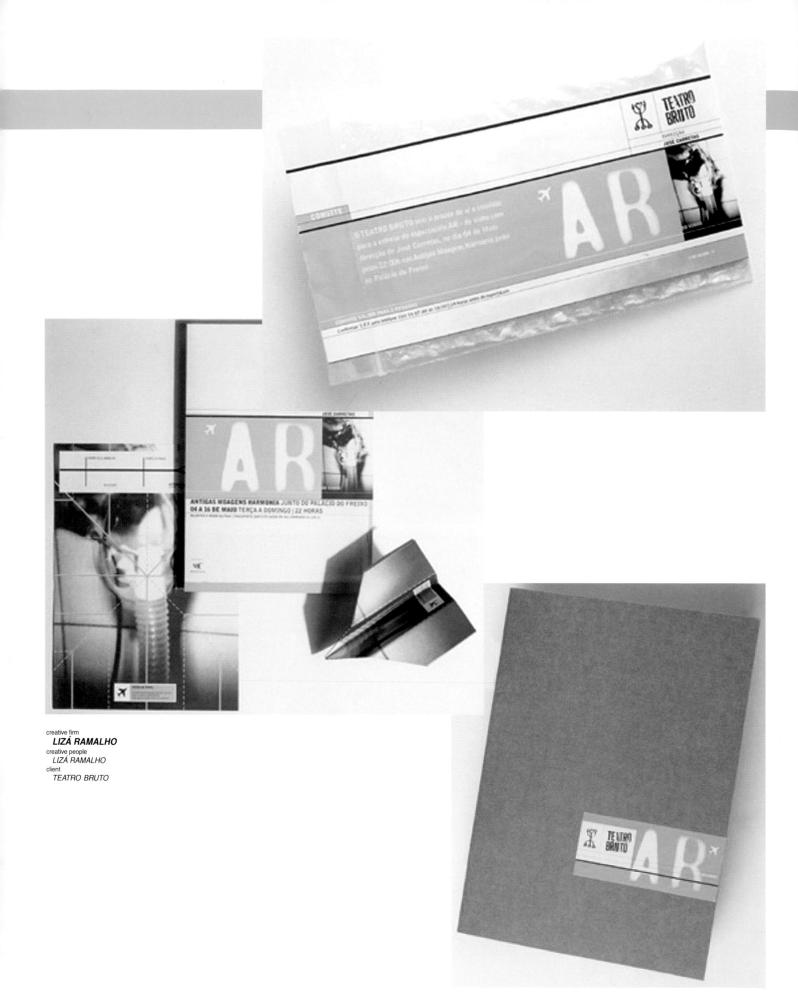

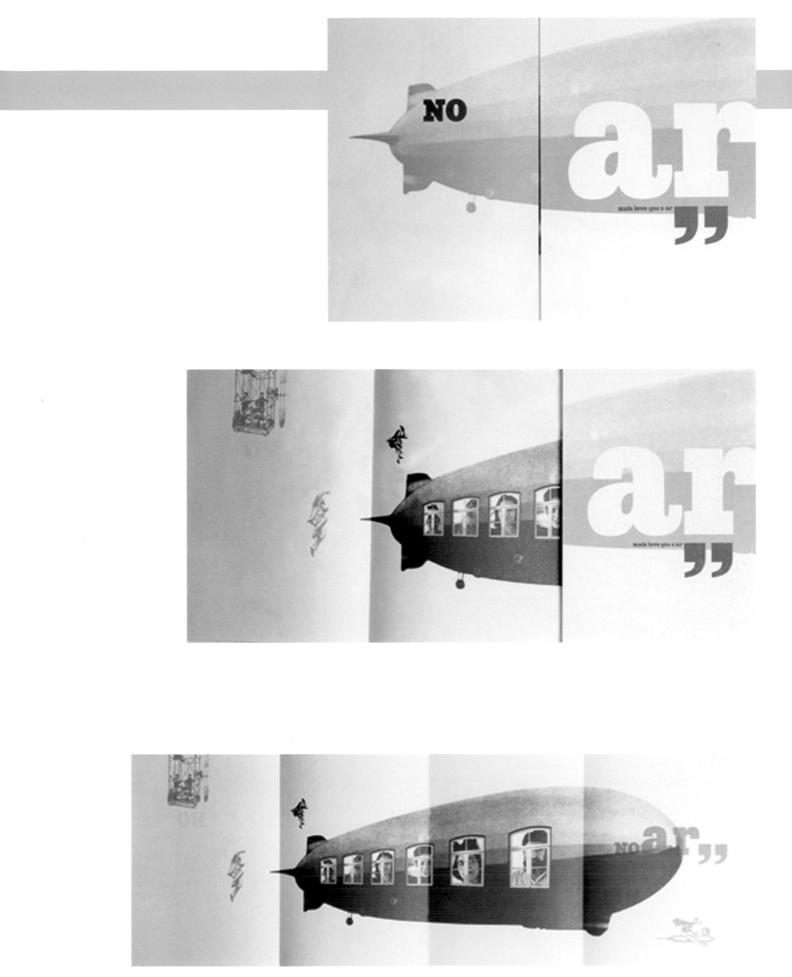

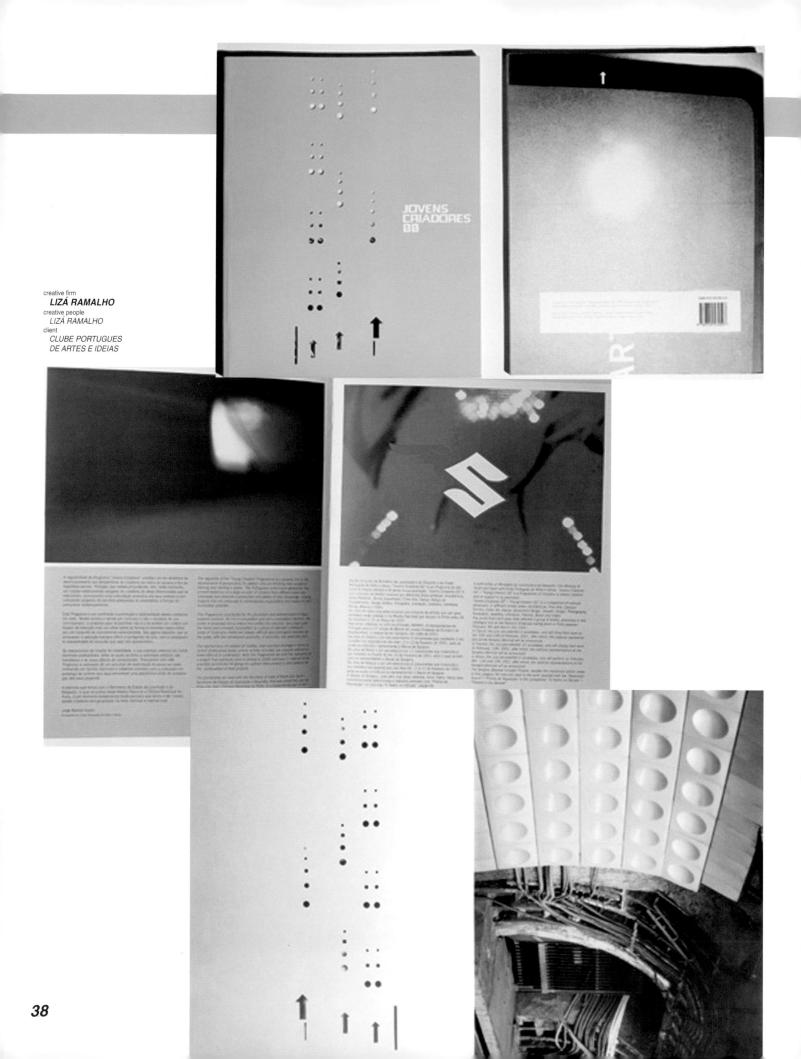

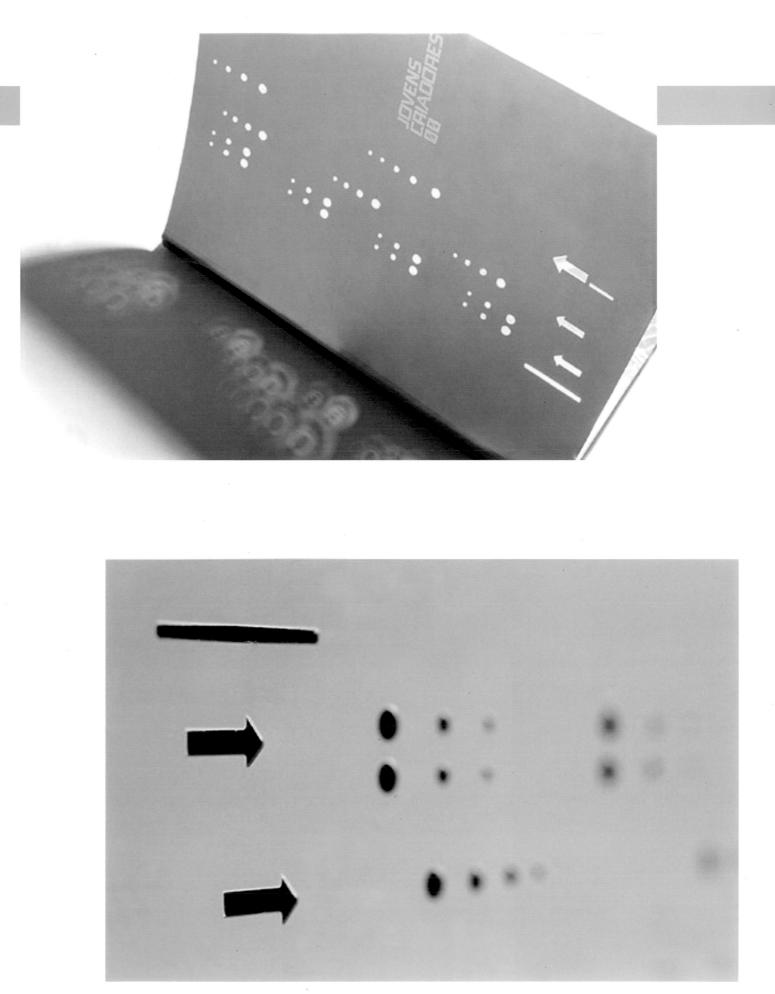

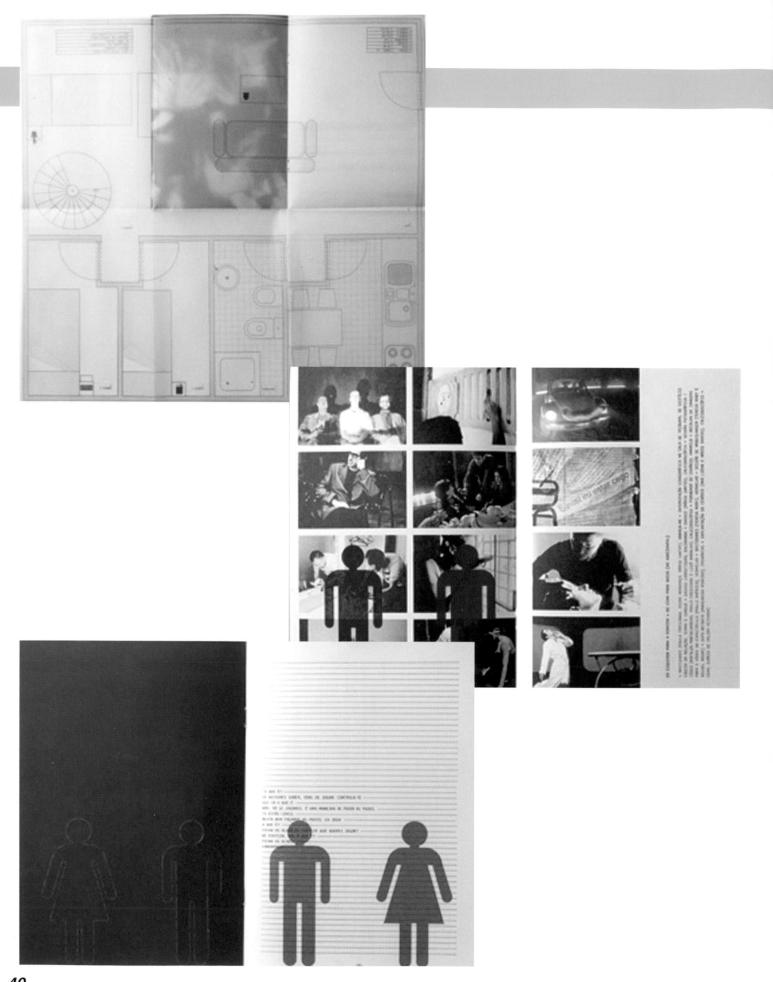

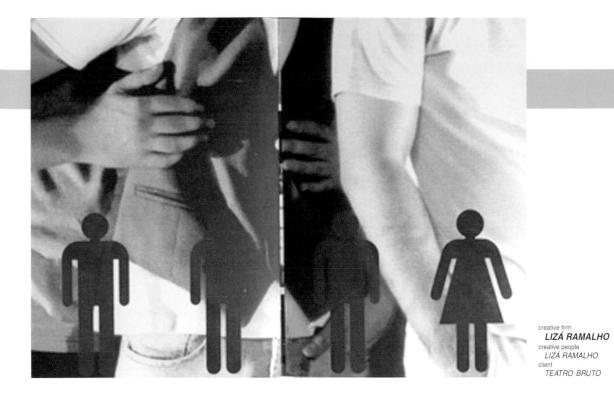

creative firm **LIZÁ RAMALHO** creative people *LIZÁ RAMALHO* client *CASSIOPEIA*

PENA MARQUESA I DERIGA 1979, 19865-05 ERVIA LONALA EFERTA INCL. INTERNATION REPORTA THE MARQUEST FOR COMPACT LOCAL AND ADDRESS

Publicitions 6 all Applicitions in derivations and manifestions down and and a second and a seco

I princi appropriate la forma de la forma de la forma de la principa de la companya de la companya de la principa de la forma de la principa de la companya de la companya

In Particular Gen Super Aurilla (Service Del Service) and a finite descelle and placement is a super role on long from the state sales advantation structures and a structure state base base and an approximate in superinstagical descentarios programment fragment descentarios and the structure of the structure structure of the structure of t

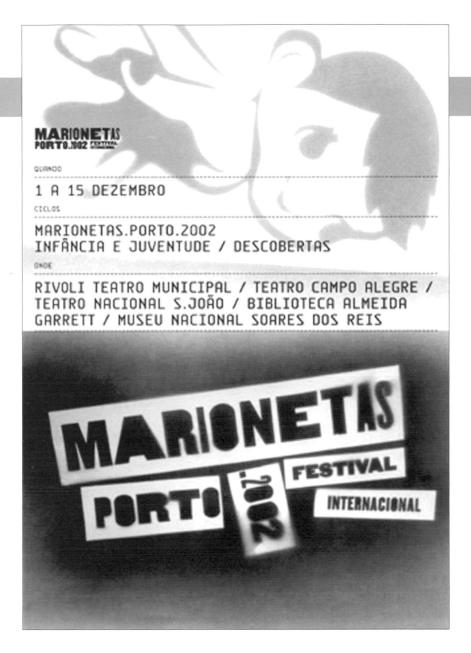

creative firm LIZÁ RAMALHO creative people LIZÁ RAMALHO client AS BOAS RAPARIGAS Ma queste en colorada de Ju destinition de Officiente de Ju de que a successe fait du accompanderse todo a una 38.00 ater de Molty, live au delte que, so brigane, "respirite and speed

Assess Prop · Ultra 100

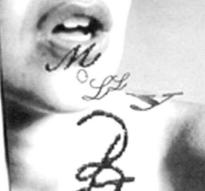

Classes de Jamos Popro, maio pate Soil de Nora, a mucher boda a sua vida. De que le e Mucity, a lacrones, a carmel aba 303 an aganti i d Mail Multin B -

An other sector of the sector Des environnesses and die Standford weige officialise auf die Standford under der die die sollie die Standford under distandford under die Standford under die Stan increased the systematic and they in function from and the systematic field of the systematic field of

tene un territo Residence dans acceleto compo-ticageno compo-las compositivas la compositiva da compositiva d

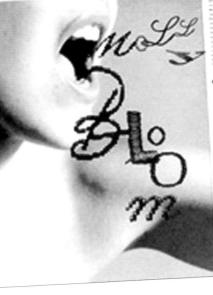

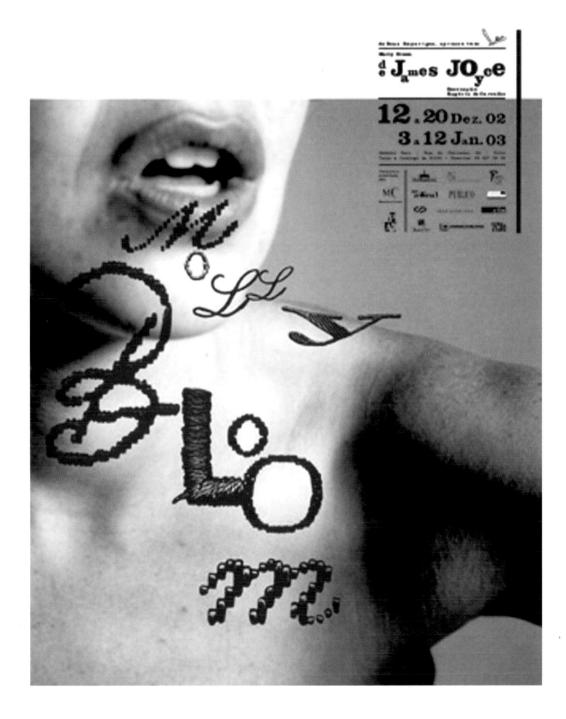

creative firm LIZÁ RAMALHO creative people LIZÁ RAMALHO client CASA DA MUSICA/PORTO 2001

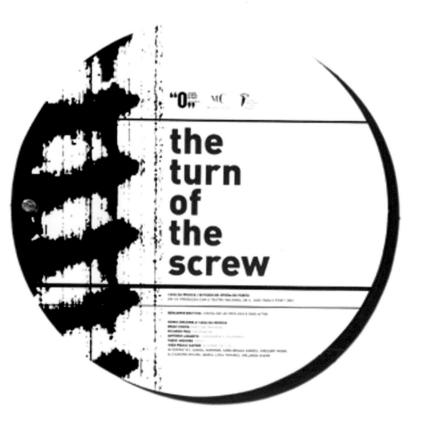

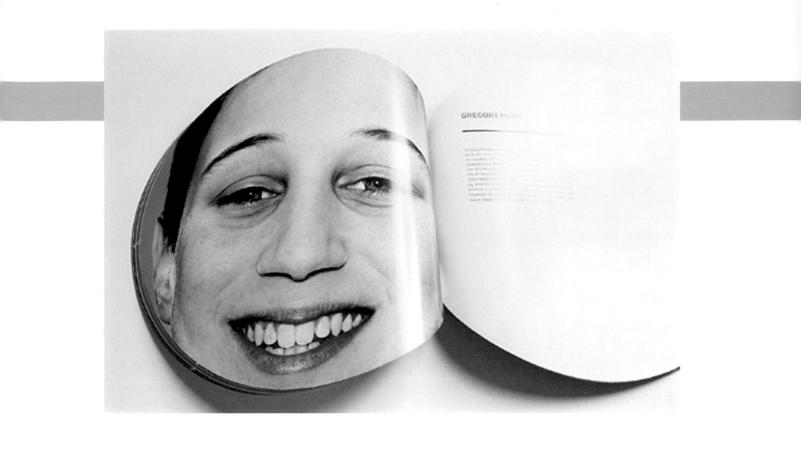

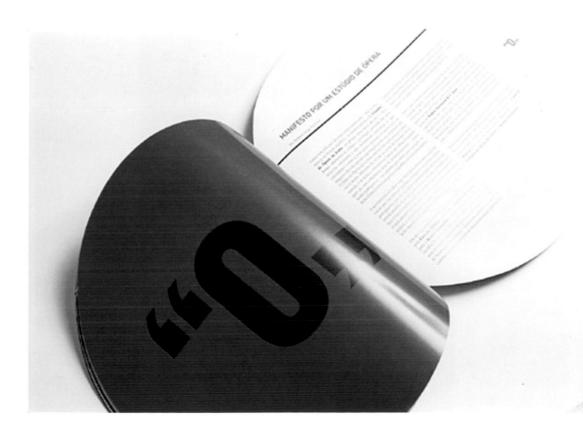

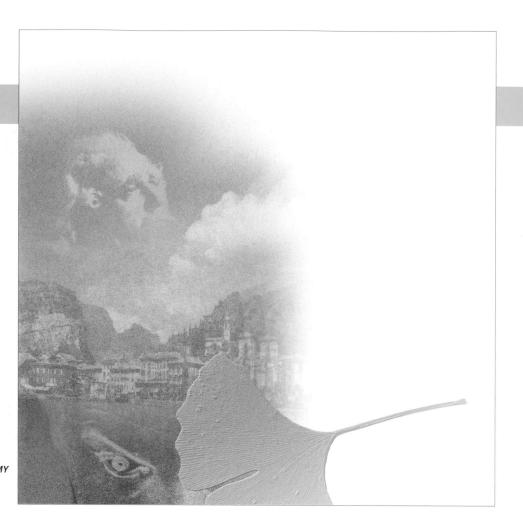

creative firm VILNIUS ART ACADEMY creative people AUSRA LISAUSKIENE client KNYGU NAUJIENOS

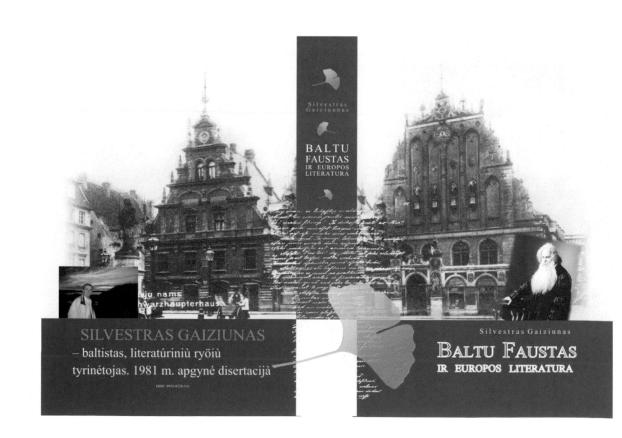

ZENTA MAURIŅĀ KNYGA apie ŽMONES DAIKTUS

creative firm VILNIUS ART ACADEMY creative people AUSRA LISAUSKIENE

		 						1
							CAL	
h							END	
Ľ.							20	
							N	
						and the owner of the		
	/	No.1	-				5 6	OAL ENDADO
	the family and		3				6	CALENDARS
							7	OALENDANO
						-		
		Charles and the second			Via			
							Ő	
			DOMTAR INC.				=	
						and the second sec	12 13	
6							ž	
L							3	
			MAGNUM PHOTOS				16 17	
			1	110		1 The second	őe	
	State of Concession, Name			por 1	1	-	5	
				No. of Concession, Name			0	
							21 2	
L			State of the		Ser.		3	
			No.	-11	A. 17	5	24	
							25	
							26 2	
							17 28	
							Ŋ	
L							30	
Ľ							31	

creative firm **EMERSON, WAJDOWICZ STUDIOS** New York, New York creative people JUREK WAJDOWICZ, LISA LAROCHELLE, 60 MAGNUM PHOTOGRAPHERS client DOMTAR

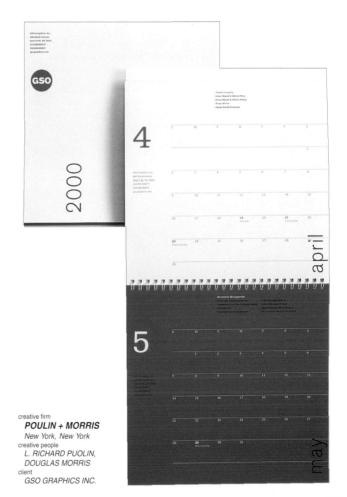

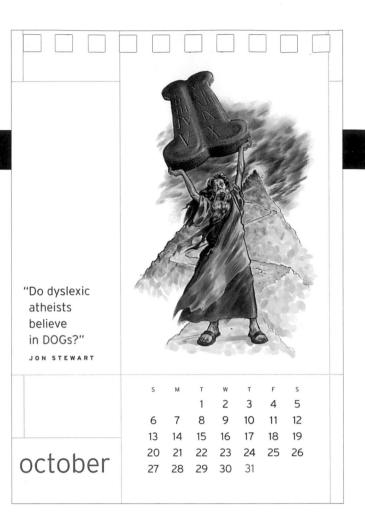

creative firm BAKER DESIGNED COMMUNICATIONS Santa Monica, California Santa Monica, california creative people GARY BAKER, MATT COLLINS, BRIAN KEENAN, BOB BAILEY, MICHELLE WOLINS, AARON KING client BAKER DESIGNED COMMUNICATIONS

	S M	т	w	т	F	s	
	1	2	3	4	5	6	
	78	9	10	11	12	13	
1	4 15	5 16	17	18	19	20	
2	21 22	2 23	24	25	26	27	
2	8 29	9 30	31				
	1	1 7 8 14 15 21 22	1 2 7 8 9 14 15 16 21 22 23	1 2 3 7 8 9 10 14 15 16 17	1 2 3 4 7 8 9 10 11 14 15 16 17 18 21 22 23 24 25	1 2 3 4 5 7 8 9 10 11 12 14 15 16 17 18 19 21 22 23 24 25 26	1 2 3 4 5 6 7 8 9 10 11 12 13 14 15 16 17 18 19 20 21 22 23 24 25 26 27

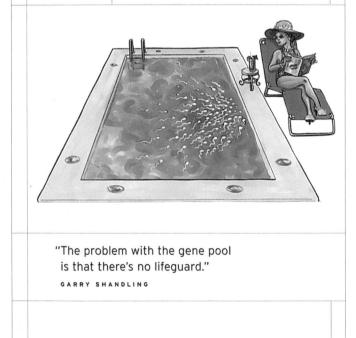

s	м	т	w	т	F	s
					1	2
3	4	5	6	7	8	9
10	11	12	13	14	15	16
17	18	19	20	21	22	23
24	25	26	27	28	29	30

november

"Karaoke bars combine two of the nation's greatest evils: people who shouldn't drink with people who shouldn't sing."

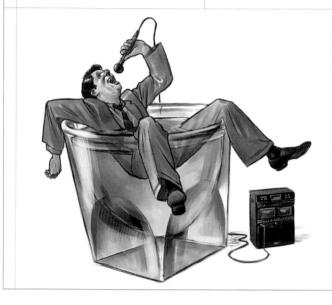

	Se	эp	te	ml	be	r	
'If life was fair,	S	м	т	w	т	F	S
Elvis would be	1	2	3	4	5	6	7
alive and all the	8	9	10	11	12	13	14
impersonators	15	16	17	18	19	20	21
would be dead."	22	23	24	25	26	27	28
JOHNNY CARSON	29	30					

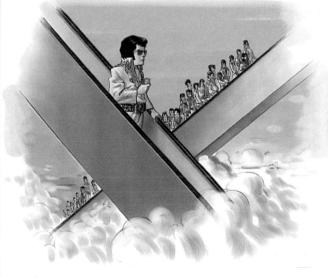

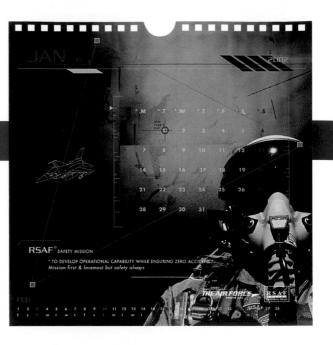

creative firm UKULELE DESIGN CONSULTANTS PTE LTD Singapore creative people DAPHNE CHAN

client REPUBLIC OF SINGAPORE AIR FORCE

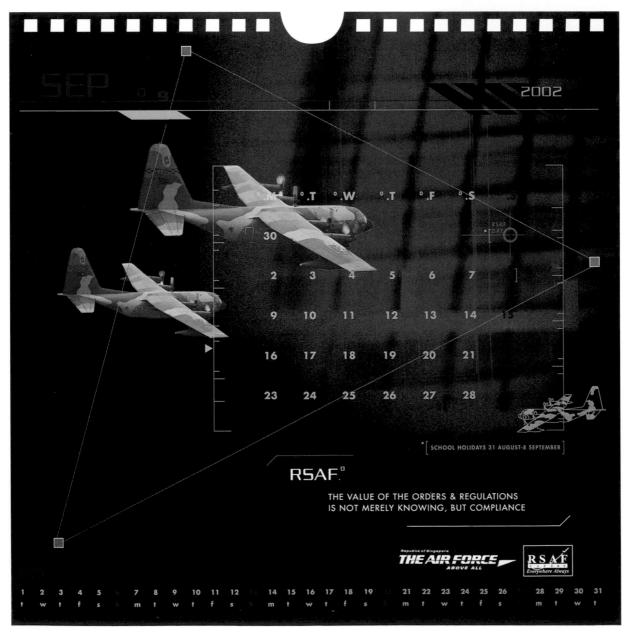

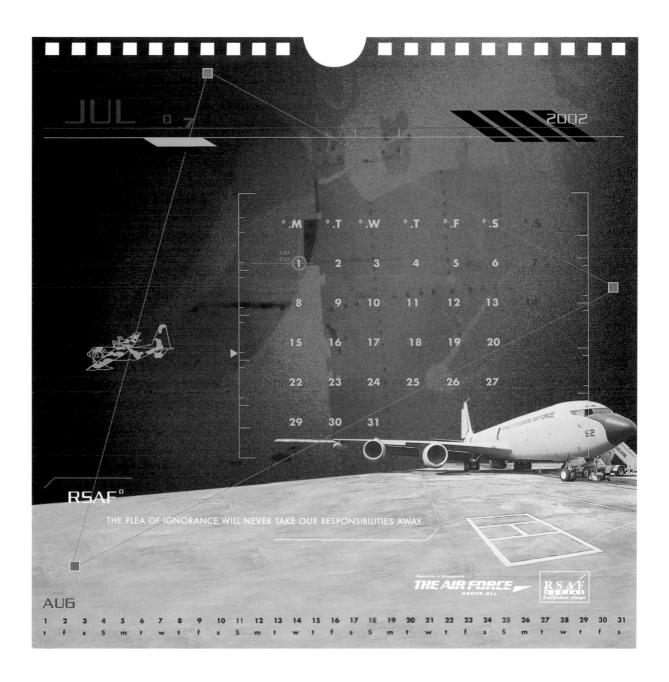

creative firm MN DESIGN GROUP Rockville, Maryland creative people MITCHELL NYDISH client MN DESIGN GROUP

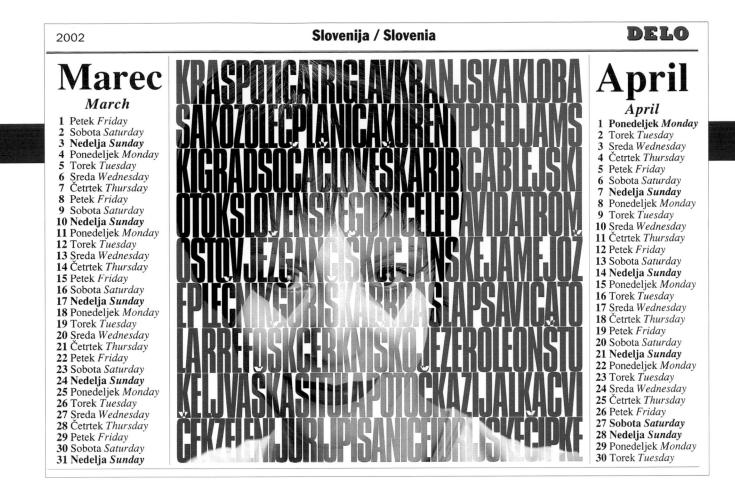

creative firm **FUTURA DDB D.O.O.** *Ljubljana, Slovenia* creative people ZARE KERIN client DELO DAILY NEWSPAPER

sunday	monday	tuesday	wednesday	thursday	friday	saturday
					1	2
3	4	5	6	7	8	9
10	11	12	13	14	15	16
17	18	19	20	21	22	23
Saint Patrick's Day	25	26	27	28	29	30
31 taster Sunday	20	20	21	28 Passaver Hory Thursday	29 Good Friday	30
larne Rizika + Journeyman Pr	ess • Arnisano Design • Finch Fe	ę	00		february 2002 5 M T W W F 5 1 2 3 F 5 F 7 8 W W 11 U W M 5 M W 11 U W M 5 M W 12 2 2 2 3 M 5 2 W 27 65	april 2002 5 M f H H H F 5 1 2 3 4 5 4 7 8 9 10 17 19 19 2 21 22 13 41 55 22 22 73 80

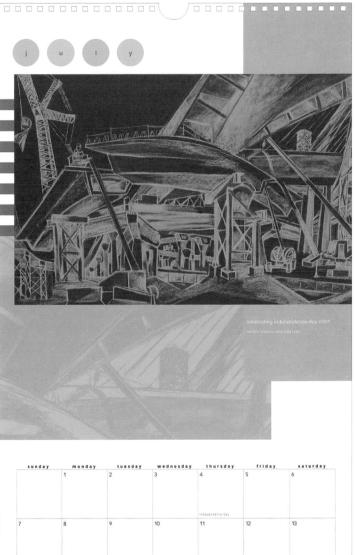

august 2002 5 M T W 7H F june 2002 5 M T W TH F 5

CATALOGS & BROCHURES

creative firm **GEE + CHUNG DESIGN** San Francisco, California creative people EARL GEE, FANI CHUNG, KEVIN NG client APPLIED MATERIALS

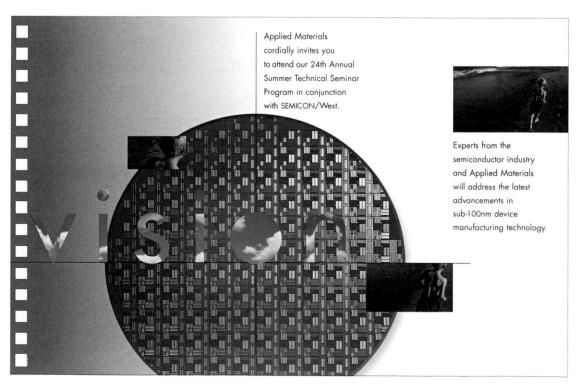

creative firm **CHEN DESIGN ASSOCIATES** San Francisco, California creative people MAX SPECTOR client WESTED

creative firm **DESIGN RESOURCE CENTER** Naperville, Illinois creative people JOHN NORMAN, DANA CALLAWAY client CP2 DISTRIBUTION, LLC

Research,

XYLIFLOSS® Pocket Dental Flosser

WestEd

Service

The Xylifloss Pocket Dental Flosser will change the way you floss - forever.

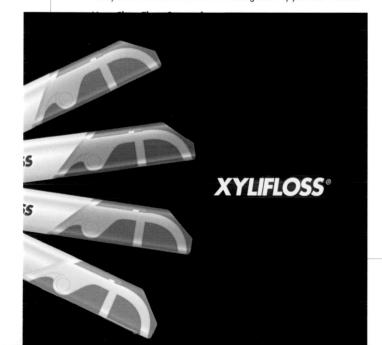

DESIGN • Developed with oral care specialists • Unique design allows easy accessibility to hard-to-reach back teeth • Superior flossing coverage

FLOSSER • Over 250 uses – economical and portable • Mint flavored, shredresistant, waxed floss • The only flosser featuring Xylitol-coated floss.

FLOSS STORAGE • When pulling out new floss

there are no impurities – therefore, it's extremely hygienic

Handle with floss storage keeps minty fresh taste on floss
Features travel cap for portable use.

MECHANISM • Floss tension is automatically adjusted • Locking mechanism retains proper tension during use • Built-in cutter trims off used floss in a snap

LEVINE & ASSOCIATES Washington, D.C. eative people MAGGIE SOUOHNO, JENNIE JARIEL client THE SERVICE GROUP

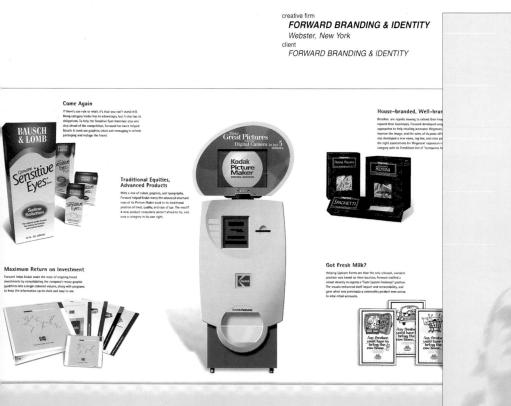

it takes more than a logo

Forward does not have their own "style". They do not create fanciful lease the eye or themselves. In their world, through a proven process that turns brand equity theories nable objectives. Those are met through a tion of visual and associative elements.

"Once we know what makes your brand special, we've got to make it tangible to your audiences. It's got to have impact and meaning, people need to remember it, and you've got to be able to design walks in lock step with strategy. They do this arrows a protect it. That's naking a lot of a logo," explains Jim Forward, abrowsh a proven process that turns brand equity theories:

"Instead, you should leverage all the tools at your disposal: colors, typefaces, image styles, graphics, symbols, tag lines, even packaging structures. Unfortunately, many organiz discipline and mechanisms to take full advantage of their Too often, companies manage a stable of logos and call w problem? New logo! Soon they're holding a handful

New problem? New logo! Soon they're noturn a summer of pebbles, instead of the boulder they need to smash through the competitive clutter. So they alter designs, introduce new symbols, new names and sub-brands, never focusing on the real so of the problem. Never finding a solution.

identity. Make them work together to more effe 00 communicate what makes your brand different and why that difference is important. Turn them into a great ny, with meaning, power and longevity. Don't create a logo Create a brand identity that's impactful, memorable and relevant.

ROCHESTER, NY: Their volleyball team is firms and are seasoned enough to look past the nicknamed the Brand Bastards. When probed for puffery to find real value. They may have been meaning, Duke Stofer, Senior Designer at disappointed in studies missing the mark, in the level of service they receive, or in the fees we're first generation. We didn't come into clients they're expected to pay. They're looking for something better. For passion without pretense For discipline and consistency. For them, we're a breath of fresh air."

Forward, explains. "We have no brandfathers -

by joining a successful concern. We didn't inherit

a reputation. We create it ourselves, every day."

The volleyball team, which regularly pits some

of Forward's "elders" against kids half their age,

doesn't win much. But on the branding court it's

another story. Win they do, on a regular basis,

For the past 12 years, Forward has been winning

clients, winning awards and winning competitive

contracts with some of the world's greatest brands. How does this small consultancy keep billion dollar brands happy and healthy? "Simple. We

solve problems," says Carlo Jannotti, VP and

often-irreverent Senior Brander at Forward. "Most of our relationships begin with referrals from satisfied clients. Many of these referrals have experienced the ways of the big city branding They are not an ad agency, a promo ions firm, or a design studio. They are unlike any marketing communications company you've ever dealt with. They are Forward, and they know how to grow brand equity.

branding and identity

TradeFactory's flexibility allows for levels of customization not available in competing systems. Three primary user interfaces are currently in use: Portfoliofrader, IndexTrader, and SpreadTrader. For many clients, IndexTrader, and SpreadTrader. Key trading and theore in the proving particular theory of the take advantage of TradeFactory's adaptability, addressing unique callenges, such as integrating writh existing, in-house systems using our standard API or via FIXCTL

Streamlined Order Management

TradeFactory offers complete control over the execution priores: It privides user-defined views of all trading activity by position and P&L, sector and industry group, trading list, basket or portfolio, and a variety of other criteria. A realtime view of message flow provides details on open, executed, and cancelled orders including terms, secution price, contra information, market center, status messages, and more.

Flexibility

Broker-Neutral Routing Tradéfactory gives you access to the liquidity you need. A completely broker-neutral platform, Tradefactory provides access to every major exchange; ECN, market maker, and broker-dealer. In addition to fast, reliable connections to these market centers, the system provides for flexible youling usualibuturus. Tradefactory also offers fully-integrated brokeroge services through an NYSE-member broker-dealer. This essential component of the trading solution is simply not available from competing system providers.

complete control over the execution process.

creative firm CULLINANE New York, New York creative people CARMEN LI client GOLDMAN SACHS

Capacity

The success of your business depends on the speed and reliability of your trading solution. To ensure the highest level of performance, TradeFactory delivers exceptional throughput and incorporates the most robust order management system available totay. On peak days, total executed shares have exceeded 20% of the NYSE volume. Additionally, the core infrastructure of TradeFactory has been in use for newr 10 years, far longer than any competing product. In that Line, its efficiency and reliability have been proven in all market conditions.

Support

The TradeFactory system and user support group is in a class by itself. This unmatched level of service is the result of teaming experienced trading professionals with expert technologists.

The TradeFactory support group routinely responds to trading/market center inquiries, index and basket definition changes, user interface questions, and other issues as they arise.

The development and support groups operate from their own facilities, independent of Goldman Sach's II and trading areas. This affords TradeFactory staff complete control over systems and software, and guarantees the confidentiality and propriety that trading professionals expect.

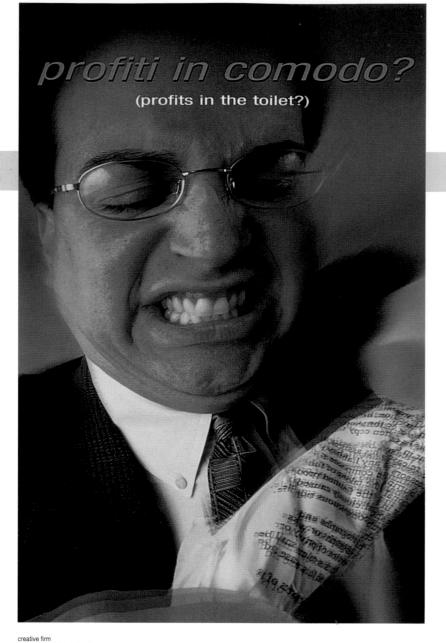

Creative Irim MUELLER & WISTER, INC. Plymouth Meeting, Pennsylvania creative people JOE QUINN, ED STEVENS, BOB EMMOTT client MUELLER & WISTER, INC.

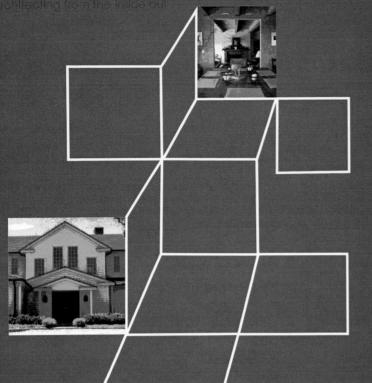

DON BLAUWEISS ADVERTISING & DESIGN Bronxville, New York DON BLAUWEISS

creative firm

client CHOURA-FORBES ARCHITECTURE & DESIGN

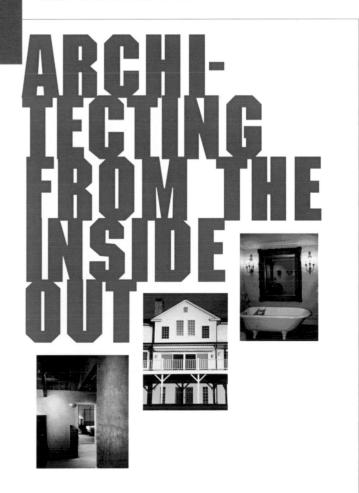

hat is special about Choura-Forbes architec-ture? A Choura-Forbes house or renovation

is an example of an architectural idea that originates with the space within, and flows seamlessly to the outside.

On approach, a Choura-Forbes home is seen sitting comfortably and gracefully among its neighbors and within its surroundings.

The distinctive classicallyaccented style, with its generosity of space and fluidity of line, imparts a warm and welcoming spirit.

Inside, that look and feel remain constant.

HERE AND ABROAD.

Founder and lead architect, Bana Choura has an Bana Choura has an international architectural presence. She has accomplished noted work from Monte Carlo to Larchmont, Tunisia to Rhinebeck, the Middle East to Soho.

Choura-Forbes homes and renovations are designs for living, achieved through patient and insightful dialogue between Bana Choura and the client family. The result is a warm and welcoming exterior set harmoniously on the site and within its environment. environment. Inside, each room has its own personality and sense own personainy and sense of purpose, yet all are unified in spirit, and in the sense of ease and accom-modation one feels moving from room to room.

FEELING AT HOME, AT HOME.

U[®]LADMFA

som December 12, 1975, Oxford, Alabama DESREE BFA, Photography/Sculpture, 1999 University of Alaska

GIRL (left) and LAMP (right)

oil on panel

p.11

creative firm FAUST ASSOCIATES, CHICAGO Chicago, Illinois creative people BOB FAUST client UNIVERSITY OF ILLINOIS AT URBANA/CHAMPAIGN

ULADMFA

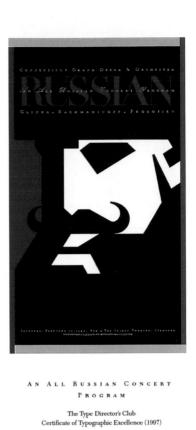

The Type Director's Club Typography 18' (1997) North Light Books 'The Basics of Visual Communication' (2000) Connecticut Art Director's 20th Annual Awards Show (1995) Excellence Award - Public Service Excellence Award - Posters Print's 1995 Regional Design Annual Craphis Poster '96 AICA/Boston The 1995 BoNE Show (The Best of New England) Graphic Design: USA's Awards Annual (1995)

creative firm **TOM FOWLER, INC.** Norwalk, Connacticut creative people THOMAS G. FOWLER, ELIZABETH P. BALL client TOM FOWLER, INC.

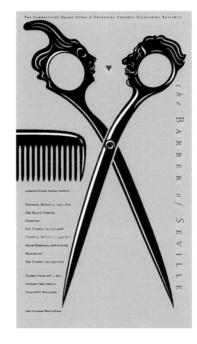

THE BARBER OF SEVILLE

22nd Annual Connecticut Art Director's Club Awards Show (1997) Gold Award The Library of Congress Permanent Design Archives

1999 American Graphic Design Awards - Poster/Pro-Bono Creativity 27

Print's Sports & Entertainment Show

North Light Books 'The Basics of Visual Communication'

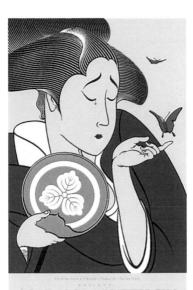

MADAMA * BUTTERFLY

MADAMA BUTTERFLY

Rockport Publishers 'Designer Posters' Frint's 1995 Regional Design Annual

Creativity '95

Connecticut Art Director's 20th Annual Awards Show (1995) Silver Award - Posters

Graphic Design: USA's Awards Annual (1995)

United Way. The Way America Cares. Community by Community.

THE NFL AND UNITED WAY ... partners in building

creative firm ROTTMAN CREATIVE GROUP LaPlata, Maryland creative people GARY ROTTMAN

THE NFL AND UNITED WAY

NFL & UNITED WAY HOMETOWN HUDDLE

On any given Tuesday, NFL players are out in the community—encouraging kids to stay in school, serving meals to the elderly, helping to build homes for low-income families. But once a year, NFL teams join forces with United Way on a single day for the annual Hometown Huddle.

During this national day of community service. NFL heroes from each of the 31 NFL teams put down their shoulder

pads and pick up a paintbrush, box of clothes, or spatula to help lend aide and assistance to members of their communities. Over 300 players, team representatives, and their families interact with an estimated 3,000 United Way agency recipients during the 31 Hometown Huddle events held coast-to-coast.

Hometown Huddle gives the public an opportunity to see how NFL players consistently volunteer their time to improve the communities where they live and play. They are not only impact players on the field, but off the field as well.

THANKSGIVING DAY

HALFTIME SHOW NFL football on Thanksgiving Day is one of the most treasured traditions of the holiday season and United Way's halftime show with the NFL is fast becoming a welcomed addition

The Thanksgiving Day halftime show celebrates the United Way's longtime partnership with the NFL and serves as a thank you to the millions of donors and volunteers who help United Way make a visible impact on communities. Graciously hosted by the Detroit Lions, the halftime show is presented to 80,000 football fans in the Pontiac Silverdome and broadcast live to more than 30 million television viewers nationwide.

stronger

communities

The past two years have featured live performances by one of the country's hottest bands, Third Eye Blind and the Grammy Award winning group, Boyz II Men. It takes more than 700 people from throughout southeastern Michigan volunteering

their time and talents to produce the 9-minute show. In the true spirit of the Thanksgiving season, this joint effort demonstrates the power of working together as a team

creative firm **ALBERT BOGNER DESIGN COMMUNICATIONS** Lancaster, Pennsylvania creative people KELLY ALBERT, PATRICK CASEY client

client SAGEWORTH

creative firm

EVADING IT TODAY.

Abraham Lincoln

The Estate And Single Vineyard Wines

GALLO I SONOMA Winery

From left to right: Greg Kovacevich, Mark Greenspan, Jon Winstead, Matt Gallo, Jeff Lyon

23 60

"For a winemaker, it doesn't get much better than this. In addition to the best grapes from some of Sonoma's finest vineyards and a state-of-theart winery, I also get to work with some terrific people."

Gina Gallo

ed wines e of the noma e North-Estate uvignon rn ardonnay, rroduc-Ily styled in select years from the "Best of the Best" of our

Sonoma family vineyards. Since the

these wines have continued to receive

tion and acclaim.

first release in 1993,

international recogni-

From left to right: Carmeton Frey, Scot Covington, Eric Cinnamon, Gina Gallo, Ted Coleman, Marcello Monticelli, Ralf Holdenried Single Vineyard series of wines are sitespecific reference wines which showcase a "New World" style. These wines are full

of character and expressive fruit, driven by the unique flavors grown in the specific micro-climate and soil conditions found in that vineyard. Like the Estate program these wines are made in select vintage years and in quantities determined by the harvest conditions of the vineyard.

Single Vineyard wines

The Gallo of Sonoma

creative firm MARCIA HERRMANN DESIGN Modesto, California creative people MARCIA HERRMANN client GALLO OF SONOMA

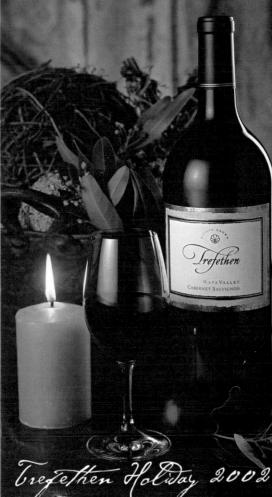

creative firm DESIGN SOLUTIONS Napa, California creative people DEBORAH MITCHELL, RICHARD MITCHELL client TREFETHEN VINEYARDS

The Award Winning Wines of

- The Award Winning Wines of Interfeten Vineyards a la Carte (201, 2001 Base by Ricellar, 2014)

 2001 Jaste Dy Ricellar, 2014

 2001 Jaste Dy Ricellar, 2014

 2001 Jaste Charlonary, 822

 2017 Jaste Charlonary, 823

 2019 Jaste Charlonary, 824

 2019 Jaste Charlonary, 810

 <td

The Vino Linear Optimization The account of the second sec

To order call: 1-800-556-4847

We are proud to release our of HaLo Cal d for the fut of winemakers, Hailey and Loren Trefethen. This limited release 100% Cabernet Sa generatio mas of the land; berries, mint and bay are alive in this our Hillside Vineyard is the best of the best. Aro Elegant, rich, dark cherries and sultry oak on the palate lead to a long, lingering finish...(W1) \$125.

71

KROG Jlubjlana, Slovenia creative people EDI BERK, JANEZ PUKSIC, INES DRAME

creative firr

GIVO. LJUBLJANA

Živimo, kot si želimo – prostore si pr

Vidovo povezujejo s centrom Ljubljane redne avtobusne proge, do vseh ljubljan je bližna brniškega letališča. Dostop do avtoceste prihrani čas popotnikom h g kaj dragocenih minut krajša. Izlet na Gorenjsko je lahko lepši, ker je odločite

Je obrita otniskoga retansca, ja retansca, ja tekstova je lahko lepši, ker je odločite poldne na Sorškem polju ali ob brzicah Save v Tacnu je le streljaj daleč. Potep na Smarno goro spremeni trajanje dneva. Na obisk Toškega Cela vabi sonce, ki na Vidovo zaradi usmerjenosti na jugozahod zagotovo posije ... • Življenje v Šentvidu ima mnogo prednosti tako za tistega, ki uživa v zavetju doma, prilagojenega njegovim željam, kot za tistega, ki prisega na raziskovanje sveta. Življenje v Vidovem je prijazno družinam z otroki, ki potrebujejo dovolj prostora za igro, mladim ljubiteljem družabnosti in popotnikom, ki potrebujejo vsak dan nove izzive, starejšim, ki jih mika posedanje v senci dreves, ljudem s posebnimi potrebami, ki potrebujejo širša vrata v svet. • Vidovo smo zasnovali tako, da je vsakomur prijazno na voljo prav tisto, kar sam razume s kakovostjo življenja.

Oglejmo si Vidovo

S svojo zunanjostjo zbuja zaujanje. Opečna kniha in strešce mansande mu dajejo visi domskrosti, terase obcuke prostornosti. Hrbitalamo se mu mimo šelavnovaja struji dodoposni srljuvistove cista: (kolik kolovega so postrike a getića, tjerel koli po dutiško tgriđe, Celoviško cesto zakriva devoredi. Kot gostje partniramo na partiritiču ob dovomi cesti, kot itanovalici se prek pokrte uvozni-osubre kalinčne odpavamo do parkirišć v desh kletnih etadah Z daljinskim pravljačem odperno automatiska vrsta. Prija ja lakiho spavamo v kletni stravnih. Po desh notenjih stopričića ka z dvajadom se do-

pravimo do svojega doma v enem od treh nadstropij ali v mansardi. Če smo pršli peš, lahko vstopimo skozi enega od dveh vhodov, ki ga varujejo

na vhodna vrata. Če smo prsti s kolesom, namesto partiniča uporabimo kolesamico ob vhodu. Če smo prišt z imalidsim vostičkom, smo avtonobil parkirali na posebnem parkimem mistru, v hišo pa vstopimo skozi dovolj širola vrata, ne da bi na pri tem ovrale kaktrskela

stopnice. Skozi dodatna varovalna vrata v hodnik in skozi protivlomna vrata v stano nje smo prispeli domov – v osončeno bivališče z razgledom na zeleno okolje.

Izberimo svoj prostor in ga prilagodimo svojim željam

Ce dičemo dom, lahko zbramo med stanovanji v velikosti od 30 do 130 m². Večna stanovanji je opremljena z zaslekljeno lobo ali balkorom, nekatera pa imajo tudi razkosno strebno teraso. Vsa stanovanja, tudi mansardna, so dostopna z dvjalom in po enem od iveh notranjih stopnič.

Ce iščemo prostor za mirno poslomo dejavnost, ga najdemo v pritičju Vidovega, z mrano pisaniško dejavnosto pa se lahko naselimo tudi v prve naidstroge. Vsi poslovni prostori imajo vse potrebne priključke na napeljeve, lasten vhod in moznost dodalnega vloda za dostavo.

Vidovo je zasnovano tako, da se lahko prilagaja raznovrstnim potrebam. Vsi nepre mični in nespremenljivi elementi (konstrukcijske steme in instalacije) so na obodu stano vanj, notranje stene pa so montažne in porrujajo pri notranji razporeditvi domala neo

mejene možnosti. Prostore v vsakem sta novanju lahko prilegodimo vašim željam Zasnova Vidovega daje nove rasje žnosti uzdi poslovnim prostorom. Nobe konstrukcijski element ne moži notranj areditve – vsi so na obodu prostora; tam so tudi instalicijski jitiki.

GIVO

Poglejmo pod površino

95,31 m² 34,22 m² 44,61 m² 36,56 m² 31,51 m² 29,50 m² 55,83 m² 55,83 m² 55,58 m² 54,45 m² Vidovo je zgrajeno tako, da ustreža vsem zahtevam predpisanih standardov, pravilnikov, predpisov in zakonov glede konstrukcijske trdnosti, požarne varnosti, toplotnih izgub in zvočne zaščite.

Osnowi nosilni konstrukcijski elementi so iz armiranega betona, ločine stene på so z opečnih votakov. Medetažne pložće so iz masinnega, 24-centimetrskega armiranega betona, kar zagotavlja izgemno zvočno izoliranost. Strešna konstrukcija je lesena, kritina pa je opečna.

Stanovanja in poslovne prostore v objektu Vidovo ogrevajo radiatorji, priključeni na estno toplovodno ormezje. Vsako stanovanje in vsak poslovni prostor ima lasten šte-

vec porabe energije. Tudi ogrevanje sanitarne vode je urejeno s povezavo na toplovod. Vlaka enota ima priključek na vodovodno, električno in telefonsko omrežje ter možnost kabelskega priključka. Objekti ma urejeno meteorno in felalno kanalizacijo.

Zaupajmo kakovosti

Pri načrtovanju Vidovega smo s posebno pozornostjo izbrali materiale in načine obdelave. Pri zasteklitvah in vratih smo misili na varnost, pri tlakih na trajnost, pri celotni obdelavi na funkcionalnost, kakovost in privlačen videz.

Vse zasteklitve v prstičju so dvojno toplotnoizolativne in izvedene v aluminjastih okvinjih. Ostale zasteklitve so izvedene v PVC okvinjih in so toplotnoizolativne. Okna so opremljena z žaluzijami.

Vhodna vrata v stanovanja so lesena in v jeklenih vratnih podbojih. Vrata so protipožarna, protihrupna in protrkomna. Notranja vrata so lesena. Oba vhoda v Vidovo sta opremljena z domotoru in zaprali. Vrata v kletno parkirtiče so mrežna kovinska in se samodejno odprago.

V santanjah, kuhinjah in poslovnih prostorih so tla obložena s keramičnimi ploščicami. Sanitarni prostori so do stropa oblečeni v keramiko, v kuhinjah pa je keramika položena na stene nad kuhinjskima nizoma. V spalničah in dnevnih sobah je po tleh kako-

vozten parket. Notranje stene v stanovanjih so iz Jahkih muvčno-kartonskih pložč na konstrukciji iz pocinkanih kovinskih profilov. Obodne stene so ometane ozroma glajene in popleskane z belo poldisperzijsko barvo.

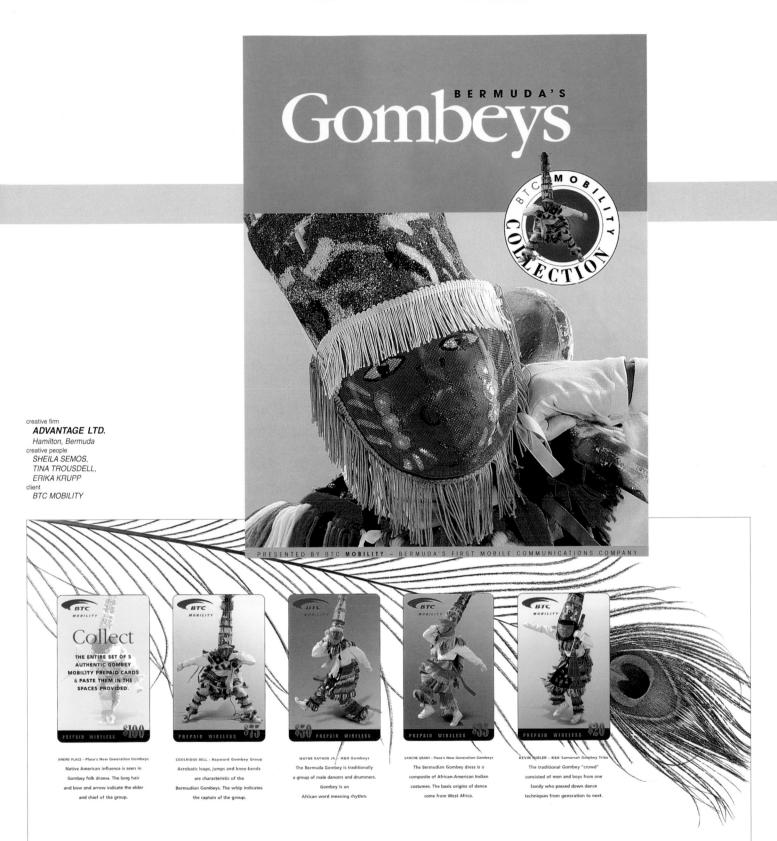

'If you see a group of people dancing down a Bermuda street to the sound of drums and whistles and if those dancers are wearing... colourful costumes, then you may well be witnessing... The Gombeys". ""

Wett influe trate the G to dar No.

The Military influence is seen in the use of the kettle drum and snare drums as well as the fife and triangle.

ne original Bermuda ombej in St. David's oppeared only after niset. They wore no suture except an uminated paper hat di dapped out a sythm on an provised drum.

73

creative firm **GOUTHIER DESIGN** Fort Lauderdale, Florida creative people JONATHAN GOUTHIER, JO HALLMARK, APPI client THE ANCHOR CLUB

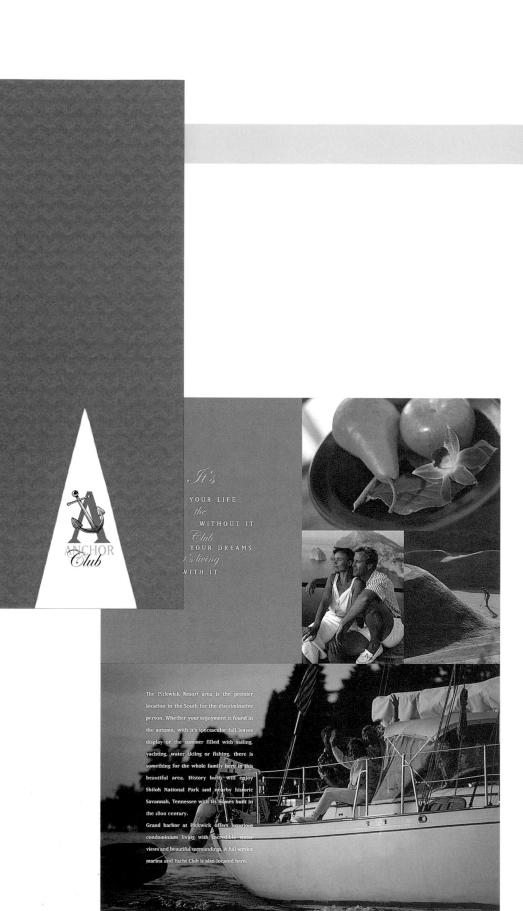

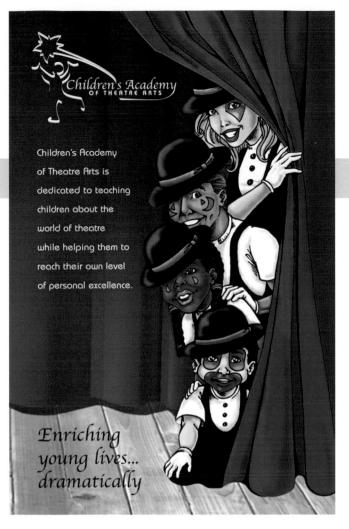

creative firm GRAPHIC PERSPECTIVES Alexandria, Virginia creative people SAUNDRA HUTCHISON, JOSEPH ADDAMS client CHILDREN'S ACADEMY OF THEATRE ARTS

creative firm X DESIGN COMPANY

Denver, Colorado creative people ALEX VALDERRAMA, ANDY SHERMAN client FRX SOFTWARE CORPORATION

Time Right. Every American Century...

wouldn't it be refreshing ...

Piper Rudnick

Dalla

Edi

creative firm **GREENFIELD/BELSER LTD** Washington, D.C. creative people BURKEY BELSER, LISE ANNE SCHWARTZ client PIPER RUDNICK LLP

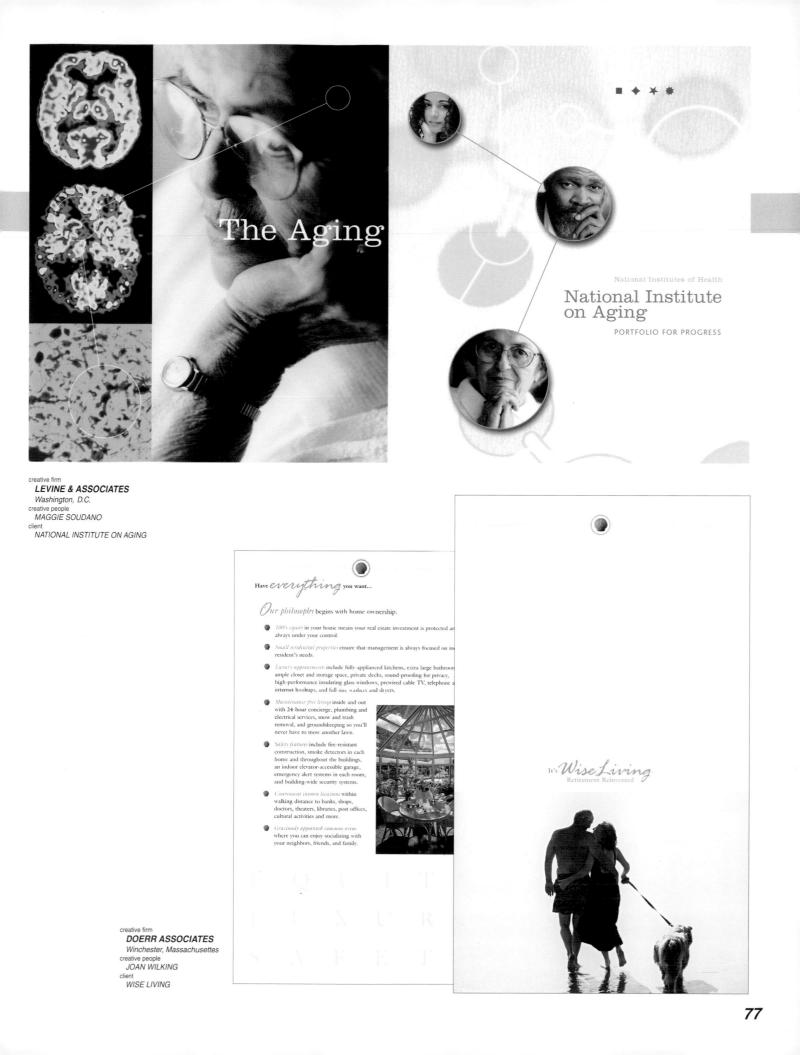

creative firm **LEKAS MILLER DESIGN** Walnut Creek, California creative people LANA IP client STEINHORN CONSULTING

STEINHORN

When you outsource to

Steinhorn Consulting,

you reduce the expense

maintaining an in-house

retirement plan depart-

ment. Instead you will

have our team of highly

working on every aspect

credentialed experts

of your plan.

and complexity of

distill it all into a formal plan design that will merge your goals with the regulatory and statutory requirements of qualified retirement

plans. Whether you want to establish a new plan or you have an existing plan with administrative or compliance problems, we are the experts you can count on.

The Plan Administration System

When you outsource to Steinhorn Consulting, you and your Human Resources staff are freed from the daily burdens of adminis-

tering and running a qualified retirement plan.

We take care of everything. We interact directly with your payroll system eliminating ongoing data collection. We process all deposits, handle withdrawals, take care of government reporting and form filing, handle all recordkeeping, maintain the voice and Internet access systems and keep the plan in proper compliance.

Leading edge technology is the backbone of The Plan Administration System, facilitating everything from our precision recordkeeping to the most sophisticated back-up and disaster recovery system in the industry.

The Participant Education Program

The availability of effective plan and investment education results in a better understanding of the plan and its investments. And a better understanding of the plan translates into more employees deciding to contribute to the plan, higher contribution rates and more appropriate investment allocation.

Employee meetings, detailed enrollment kits, assistance with asset allocation, ongoing communications, Internet access and printed account statements are all part of The Participant Education Program, a critical component of a successful plan.

The Investment Selection and Review Program

We offer you access to a diversified range of investment options from multiple money managers. Investment options are provided for all major asset classes, covering a broad risk spectrum and representing a wide range of investment styles to meet the individual needs of each participant.

From this universe of investments a suitable menu

can be offered to participants and these selections are reviewed annually to ensure they continue to meet the guidelines established by the plan's Investment Policy Statement. Employees receive first class service and easy access to accurate information about their retirement plan. Employers receive professional, reliable and cost-effective systems that free Human Resources staff to concentrate on larger issues.

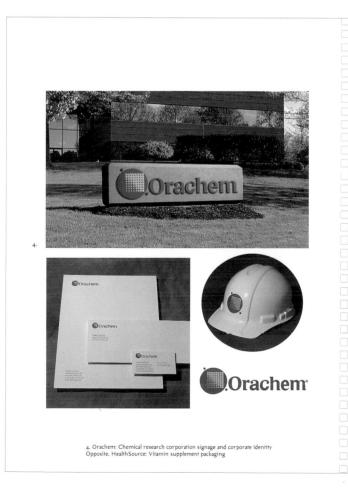

creative firm **OUT OF THE BOX** Fairfield, Connecticut creative people RICK SCHNEIDER client OUT OF THE BOX

Out of the Box. Out of the Ordinary. Out There

We've created a consumer package design company with graphics that are out of the common mold. Yet based on 25 years of strategic, award-winning design, brand identity plus advertising experience for products ranging from personal care to foods, healthcare to computers, and beverages to jeans.

As you view the samples inside, notice the unusual choice of type, texture, color and contour. They come from marketing-sawy art direction, a feel for consumer appeal, and an understanding of how to blend fresh design within necessary marketing and cost parameters.

In order for consumers to take your product out of the box, they must first be drawn to it. That's Out of the Box.

Allow us to show you our package.

YOU WORK HARD.

COLORFUL PROFILES

WHO'S WORKING HARD FOR YOU?

creative firm **DESIGN RESOURCE CENTER** Naperville, Illinois creative people JOHN NORMAN, DANA CALLAWAY client ACE HARDWARE CORPORATION

celebrate ARCHITECTURE 2002		
creative firm IDB STUDIO/RTKL Dallas, Texas creative people DAMON BAKUN client AMERICAN INSTITUTE OF ARCHITECTURE	Northeast Perspective Projects	RTKL Associates inc.
		Jarons felt that this project begin with the metaphor of a piece of paper. When devel- oped it is usalini that original idea without becoming difuted it then extends beyond that container to utilize and benefit from its context on the kinker. The originational system is extremely clear and easy for a user to interpret. The structure balances a sophisticated form with a clear way to occupy the building.

GREENFIELD/BELSER

Washington, D.C. creative people BURKEY BELSER, CHARLYNE FABI, LIZA CORBETT client

PILLSBURY WINTHROP LLP

What project are you most proud of?

Why you ask: You'll not only learn more about the nature of the work associates do, but you'll also learn about the person you're talking to—and create a positive association he or she will remember after you leave.

Whom you ask: Associates.

Follow up:

What was your most challenging or difficult case? How did you resolve the difficulty? The answer may be, "same as above," but if it's not, you'll learn how the firm handles problems and

How effectively does the firm use technology?

Why you ask: Effective technology will make your job easier; out-of-date or poorly supported technology will make it harder. The firm's interest and investment in technology are also clues to its short-term priorities, long-term strategy and personality (vibrant early adapter or slow-moving follower) Whom you ask:

Associates-usually the firm's most tech-savvy lawyers.

Follow up:

Long hours and rigorous workloads demand technology you can depend on in the office, at home and on the road. Ask if user support is available remotely 24/7.

How much client contact will I have?

Why you ask: Client contact and relationships are key to building a successful practice and making partner. Not to mention that seeing the faces and knowing the players makes the work more fun. Whom you ask:

Follow up: Ask how the firm helps associates build practices. Teaching networking strategies, introducing you to clients and supporting business development activities are tangible ways the firm can support you Good decisions

are the lifeblood of

your organization.

At Idea Sciences we

offer practical tools

and services that deliver

informed, coordinated

and decisive action.

Our ongoing research

provides clients with the

most effective creative

decision making and problem

solving solutions.

creative firm **GRAPHIC PERSPECTIVES** Alexandria, Virginia creative people SAUNDRA HUTCHISON, JOSEPH ADDAMS client IDEA SCIENCES

Tools for smarter decisions Ideasciences

creative firm **BRIDGE CREATIVE** Kennebunk, Maine creative people ALEXANDER BRIDGE, AMANDA HANNAN client RAM MANAGEMENT CO., INC.

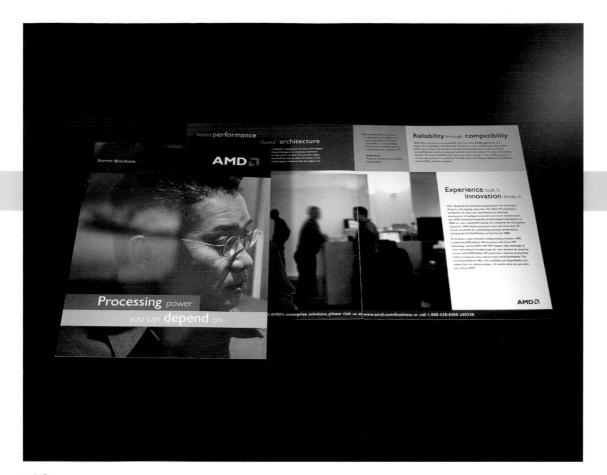

creative firm **FUTUREBRAND** New York, New York client AMD

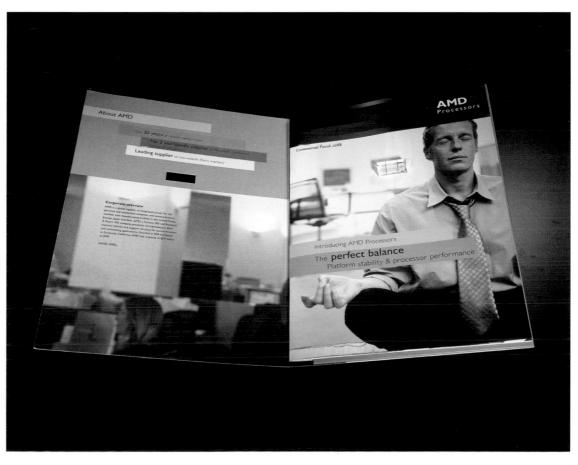

creative firm **PREMIER COMMUNICATIONS GROUP**Royal Oak, Michigan royal Cas, wichnyan creative people RANDY FOSSANO, PETE PULTZ, KATE PULTZ GMC ENVOY

creative firm **ROTTMAN CREATIVE GROUP, LLC** La Plata, Maryland creative people GARY ROTTMAN client DENISON LANDSCAPING

creative firm HANSEN DESIGN COMPANY Seattle, Washington creative people PAT HANSEN, JACQUELINE SMITH client THE MATTEI COMPANIES

creative firm **DEVER DESIGNS** Laurel, Maryland creative people JEFFREY L. DEVER, CHHIS LEDFORD client LIBRARY OF CONGRESS



Achievement in Radio Awards

0 0

creative firm FUTUREBRAND New York, New York creative people MARCO ACEVEDO client CARE

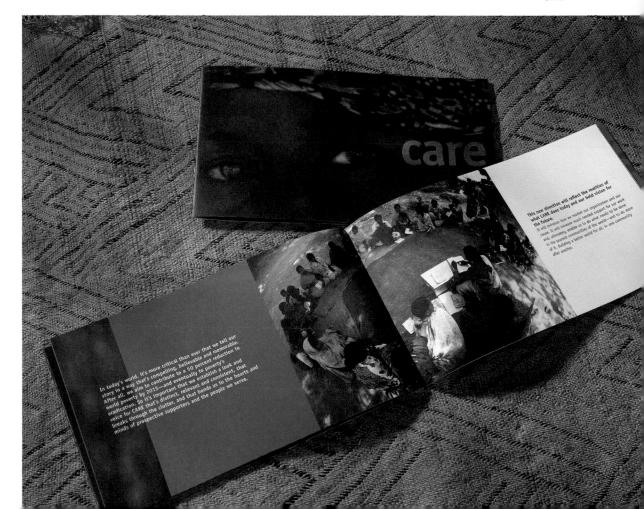

creative firm LEVINE & ASSOCIATES Washington, D.C. creative people MAGGIE SOUDANO client NATIONAL CENTER ON EDUCATION AND THE ECONOMY

NATIONAL CENTER ON Education AND THE Economy

و چ

America's Choice®

Wherever there are schools using the America's Choice School Design, we carefully track the progress of our students against the state's standards, using their state tests. And students in America's Choice schools are performing very well on them. Results are why the America's Choice School Design is one of the fastest growing comprehensive school design programs in the country.

Inside our design is one of the most highly aligned and most powerful instructional systems anywhere. This potent system is designed to zero in on the key topics in the curriculum, so every student can thoroughly master what is most important, in the least amount of time.

The America's Choice curriculum materials are not only matched to the standards, but they are designed to get students to world class standards no matter how far behind they are when they start. Students who begin the program behind, or start to fall behind when they are in it, are identified quickly and given the extra help they need to get back up to speed. A five-layer safety net system is there to catch anyone who stumbles, from students whose understanding of basic math concepts going into middle school is a bit shaky, to students entering high school whose lack of ability to comprehend what they are reading makes it almost certain that they will drop out of school.

America's Choice has been carefully designed to meet the needs of children

from high poverty inner city and rural schools, but it is not set to low standards. To the contrary, there are primary grade students in inner city America's Choice schools writing essays with storag narrative lines that would bear comparison with any suburban school in the United States. Likewise, our math curriculum is designed to get all students ready for high school calculus.

What these words cannot capture is what happens when you visit an America's Choice school and sit down to look at the work of the students. It is work that routinely atonishes their parents and teachers, and becomes the source of pride and confidence in their ability that empowers them to ever greater accomplishments. That is the heart of what it means to be an America's Choice school. creative firm JONES DESIGN GROUP Atlanta, Georgia creative people VICKY JONES, CAROLINE MCALPINE client GEOGRAPHICS

show how you match

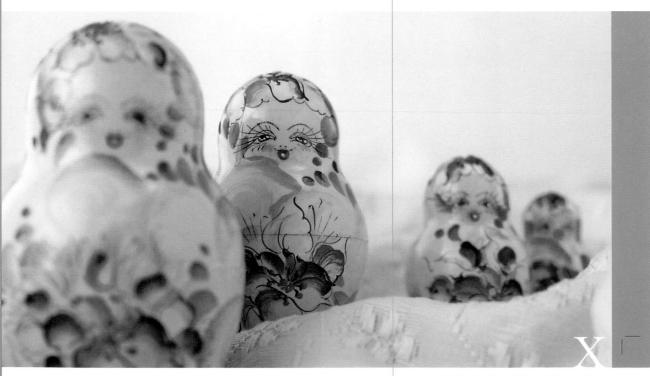

NERS-GEOSPECTANES - PAS 7/8 12 - PAS 507 - PAS 2/8 - 4/2 12 - PAS 507 - 4/2 12 - 4/2 12 - 4/2 12 - 4/2 12 - 4/2 12 - 4/2 12 - 4/2 12 - 4/2 12 - 4/

Same color both sides of sheet. Every sheet.

NEW 10-COLOR PRESS

show your true colors

0

1. 1. H

because isn't the first page as important as the last?

For students talented in math and science... The best way to enter the world of engineering

> Johns Hopkins University Whiting School of Engineering

Summer Introductory Engineering College Credit Courses and Internship Opportunities

JILL TANENBAUM **GRAPHIC DESIGN & ADVERTISING** Bethesda, Maryland creative people JILL TANENBAUM, SUE SPRINKLE

creative firm

JOHNS HOPKINS UNIVERSITY/PTE

Providing **entry** to the next generation **of engineers**

HeadsUP

Johns Hopkins University Engineering Summer Program for leading high school and early college students

HEADSUP is attracting and building tomorrow's top

engineers. By partnering with the program, you can connect with these talented students, build your company's image, and energize its operations.

- Offer summer internships to HEADSUP students
- Exhibit at the annual HEADSUP What Is Engineering? Fair to reach area students and their families. Sponsor HEADSUP scholarships

For details on HEADSUP corporate opportunities, enter...

Johns Hopkins Unversity Whiting School of Engineering

KEYS TO THE CITY

WASHINGTON INSIDERS understand the interplay of law and politics that is essential to solving problems with the federal government. Dyer Ellis includes professionals skilled at combining legislative and regulatory strategies to achieve results. Their access to movers and shakers on Capitol Hill can ensure your interests get a fair hearing. And their first-hand knowledge of executive agencies enables us to provide insightful and effective assistance.

DYER Ellisø

JOSEPH

DOING BUSINESS WITH GOVERNMENT doesn't come naturally. The rules and procedures are labyrinth-like, counter-intuitive, novice-unfriendly. Dyer Ellis lawyers represent both new and experienced contractors. We level the playing field by insisting that agencies define terms and conditions so that our clients can compete fairly at every stage of the bid process

of the U.S

DYER ELLIS &

JOSEPH

........

creative firm GREENFIELD/BELSER Washington, D.C. creative people BURKEY BELSER, TOM CAMERON, GEORGE KELL client DYER, ELLIS & JOSEPH

SOLUTIONS THAT FIT

creative firm **BETH SINGER DESIGN** Washington, D.C. creative people CHRIS HOCH client

client B'NAI B'RITH YOUTH ORGANIZATION

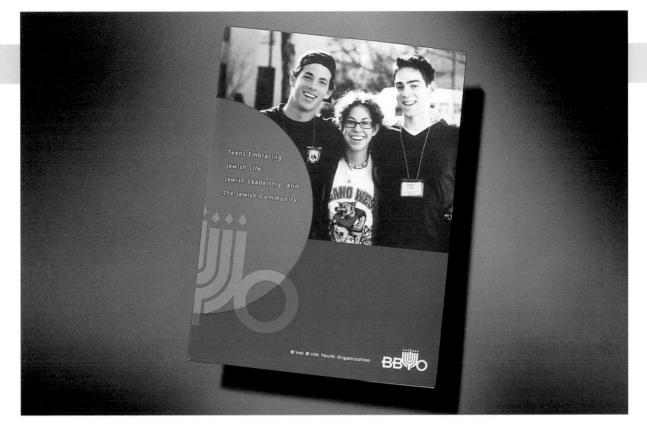

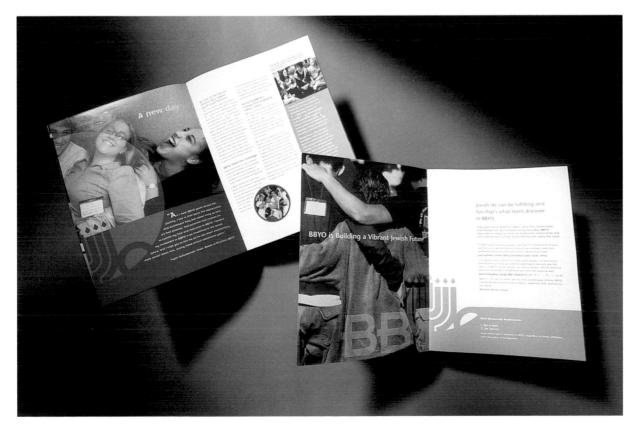

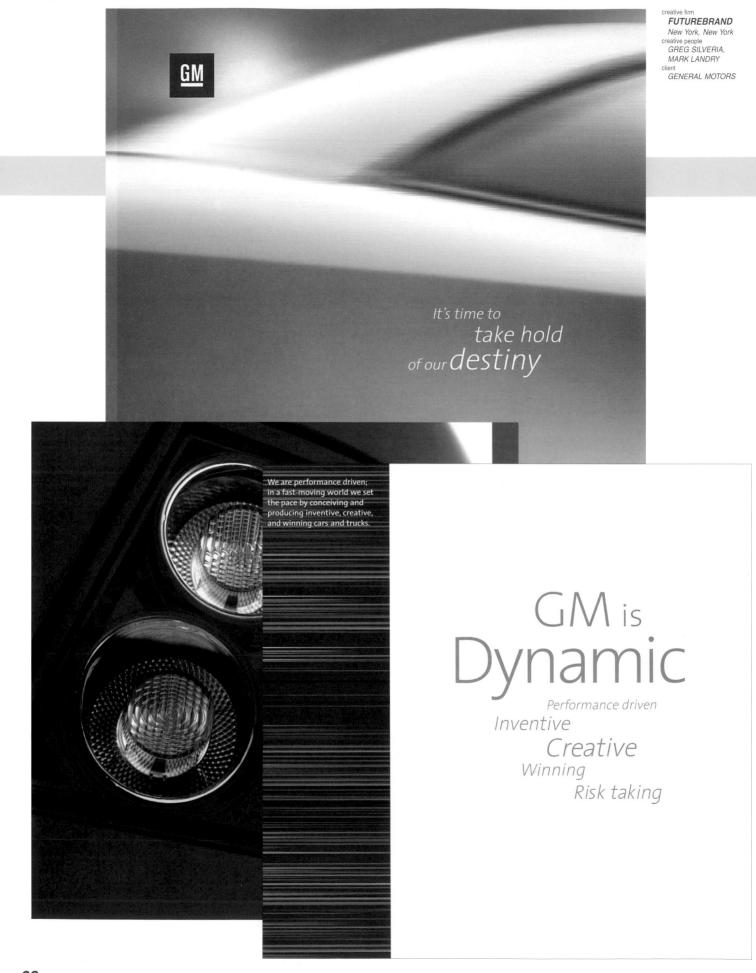

Every day, careers are found

{ Every hour, every day, all year long }

THE CHRONICLE OF HIGHER EDUCATION'S

careernetwork.com

creative firm GREENFIELD/BELSER Washington, D.C. creative people BURKEY BELSER, TOM CAMERON. GEORGE KELL DYER, ELLIS & JOSEPH

Every week, career seekers get

1,500,000 page

unique Visitors

75employer

profiles

Exponential impact. Our employer profiles let you spotlight your organization and stand out in a crowded market.

e-mail job alerts

You've got mail.

Top volume. 2 million career seekers every month.

careernetwork.com

careernetwork.com

FORSYTH SCHOOL "At Forsyth, you have to work hard. But what you get in return is much more than the amount of hard work you give. Forsyth shapes its students into smart, caring, just GREAT people. Forsyth is one of the greatest gifts your parents

Class of 2002 alum

could ever give you."

BERKELEY DESIGN LLC St. Louis, Missouri creative people LARRY TORNO client FORSYTH SCHOOL/PHOEBE RUESS

creative firm

Spanning a city block, Forsyth's houses face onto both Forsyth and Wydown Boulevards with the backyards forming a secure campus "commons" rea that is hidden from street view. Life unfolds here on the playgrounds and playing fields. Older and younger children mingle at lunchtime, recess and after school. Teachers come to know children of all ages in this intimate space. Adults gather in this area to collaborate or simply to chat. In warm weather, you'll find children and adults eating lunch outside. Forsyth's backyards are the neighborhood for the School community. "The campus provides a 'neighborhood' setting that so many kids don't get to enjoy nowadays," reflected a parent. "It instills a sense of ownership in the children

The children are grouped two grades per house, except for the sixth graders, who share their house with the library. Students — except for the youngest ones in Pre-Kindergarten and Junior-Kindergarten — travel across campus for music, art, physical education, drama, science, library and lunch. Many times a day, they are out in the open, travelling across the "backyard". The physical experience for a Forsyth student is very different than traditional institutional settings provide. In open outdoor space, children can be children. They can move, run, be aware of the environment many times during the day — not just at recess or during physical education. The joy and energy that abounds at Forsyth is due in part to the campus layout. Forsyth feels like something out of a children's book.

The houses themselves were built during the period from 1924 to 1928, and each has its own architectural genre. Although the houses have been remodeled to accommodate their new "families" and a gymnasium and science building have been integrated into the campus, care has been taken to preserve the residential demeanor that defines both the neighborhood and the School. A child in Senior-Kindergarten, for example, might be based in what was formerly a spacious, paneled living room with a baronial stone fireplace mantel and leaded glass windows. The following year, that child would move up the sweeping circular staircase to one of the Grade 1 classrooms --- large spacious rooms, with bay windows, smaller breakout rooms and "real" bathrooms.

"The **best** thing about Forsyth is that it **isn't** an **ordinary** school. The houses make it like a **village** or **neighborhood** where everyone knows each other."

- Class of 2002 alum

creative fir GREENFIELD/BELSER Washington, D.C.

creative people BURKEY BELSER, CHARLYNE FABI,

LISE ANNE SCHWARTZ

lient LEVICK STRATEGIC COMMUNICATIONS

is dead. Η

Drill down and tunnel over.

Traditional PR relies on "umbrella" communications -broad messages targeting general-interest media. lines to those who control the decision to hire you.

the "go to

y publications, in-h

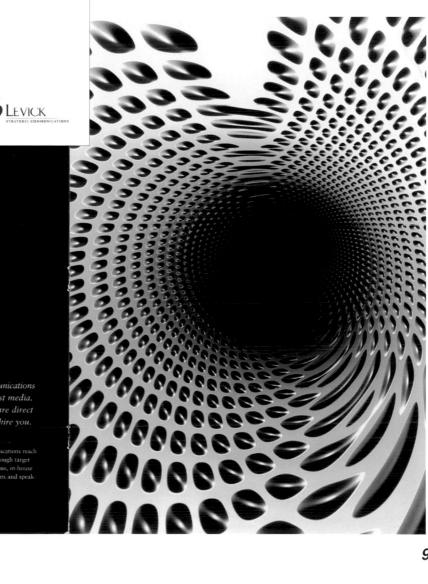

CORPORATE ID PROGRAMS

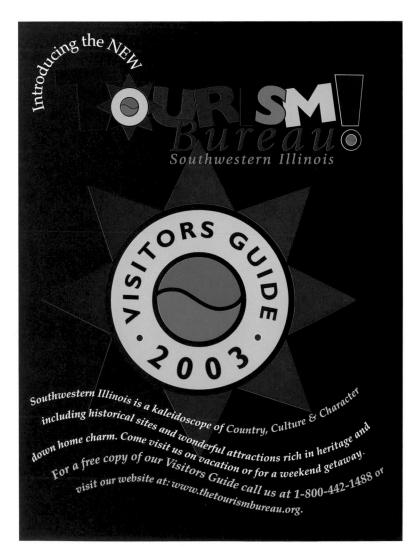

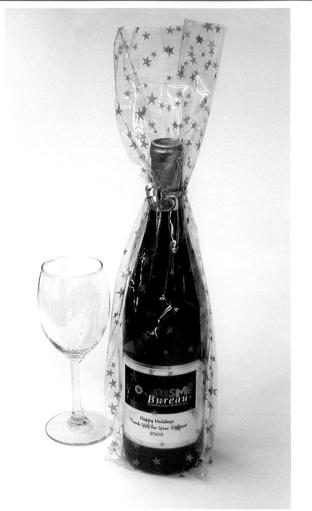

creative firm AKA DESIGN, INC. St. Louis, Missouri creative people CRAIG SIMON, J.R. GAIN client THE TOURISM BUREAU SOUTHWESTERN ILLINOIS



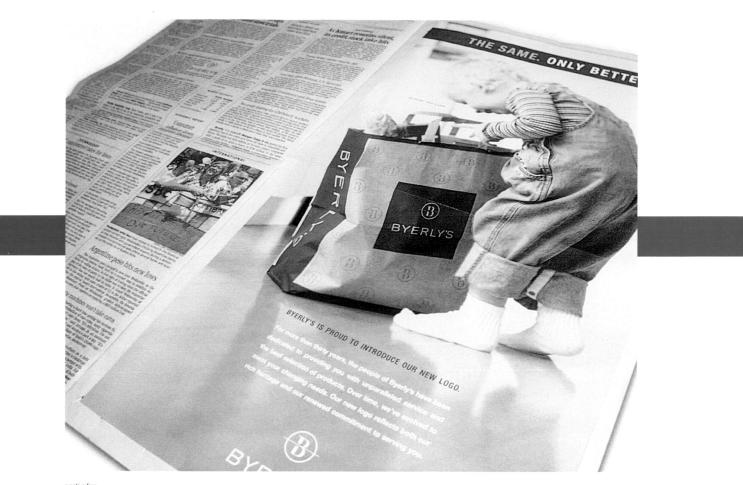

creative firm **CAPSULE** Minneapolis, Minnesota client LUND FOOD HOLDINGS

creative firm **AKA DESIGN, INC.** St. Louis, Missouri creative people CRAIG SIMON, STACY LANIER client SPLASH CITY FAMILY WATERPARK

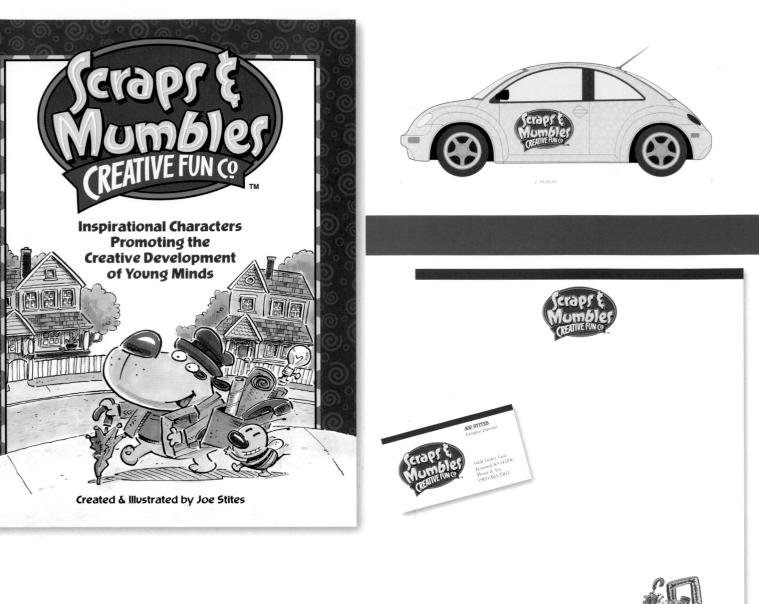

creative firm **THE LEYO GROUP, INC.** Chicago, Illinois creative people JOE STITES, JAYCE SCHMIDT, BILL LEYO client SCRAPS & MUMBLES CREATIVE FUN CO., LLC

Constant of the second second

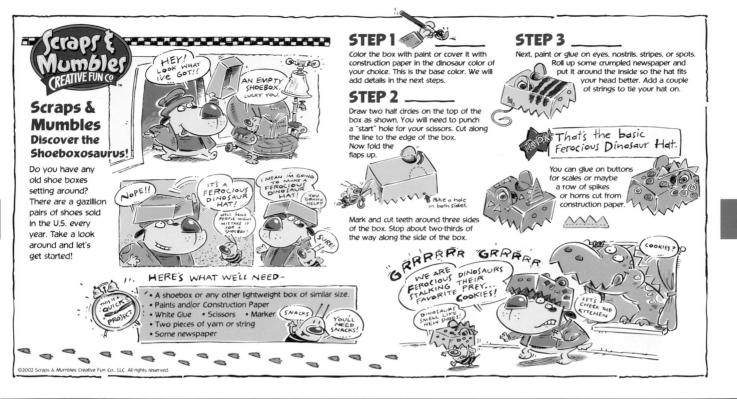

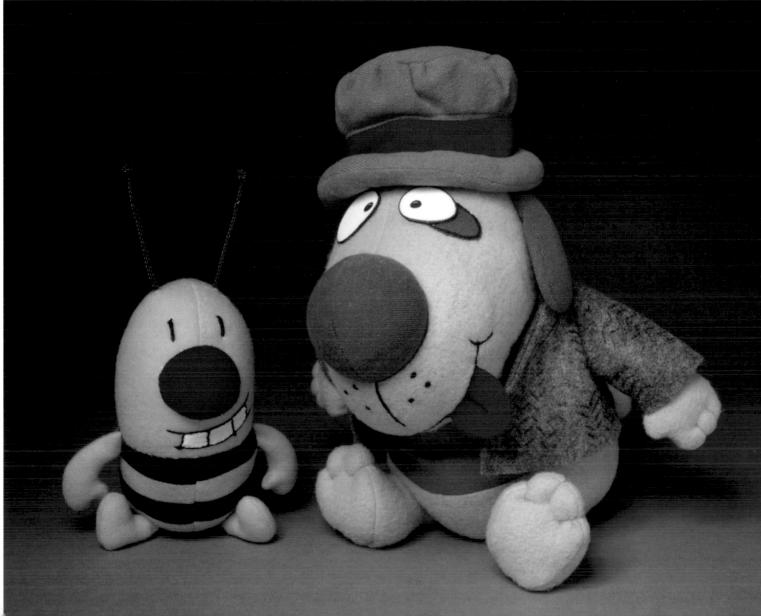

Z

Ľ

U

m

MARKETING | DESIGN

Copenhagen Black

Challenge

Leveraging a 178-year-old brand to introduce a new flavor that would attract a contemporary consumer segment

4-color process metal lid; Berni's

Marketing

Solution

unique brand image communicated an urban, bourbon flavor offering **R e s u l t** Trade has embraced and endorsed product; shelf presence

A design system including a

commanding; consumer sales phenomenal **Q u o t e** "Berni is a real proactive partner." Rich Fasanelli, Vice President,

A SAUSACE

www.bernidesign.com

creative firm

BERNI MARKETING & DESIGN Greenwich, Connecticut creative people STUART M. BERNI, PELOR ANTIPAS client U.S. SMOKELESS TOBACCO

(Berni Marketing uses 8-1/2" x 11" flyers to showcase their work in branding. Since the entire promotional piece is appropriate for this book, several different examples of their work are shown in this format.)

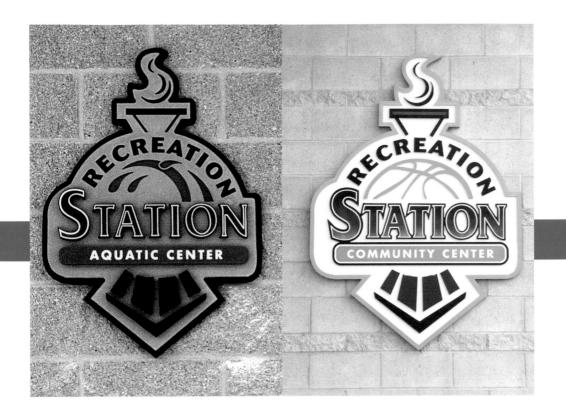

creative firm **AKA DESIGN, INC.** St. Louis, Missouri creative people *CRAIG SIMON*, STACY LANIER client RECREATION STATION

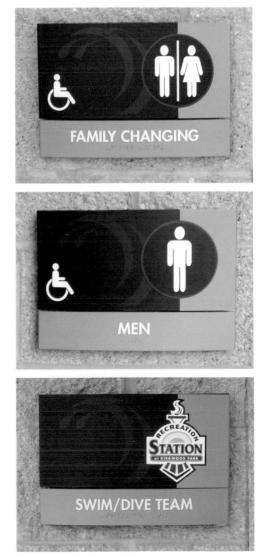

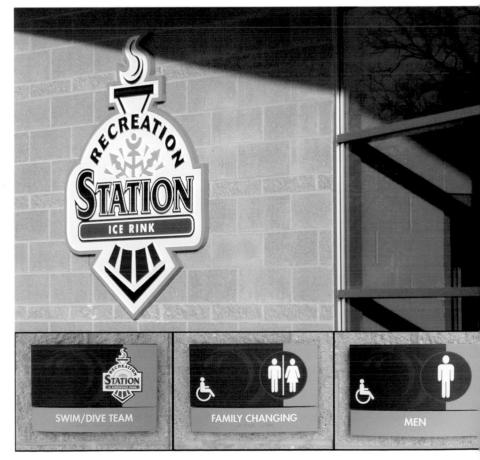

creative firm **AKA DESIGN, INC.** St. Louis, Missouri creative people JOHN AHEARN, STACY LANIER client COPERNICUS FINE JEWELRY

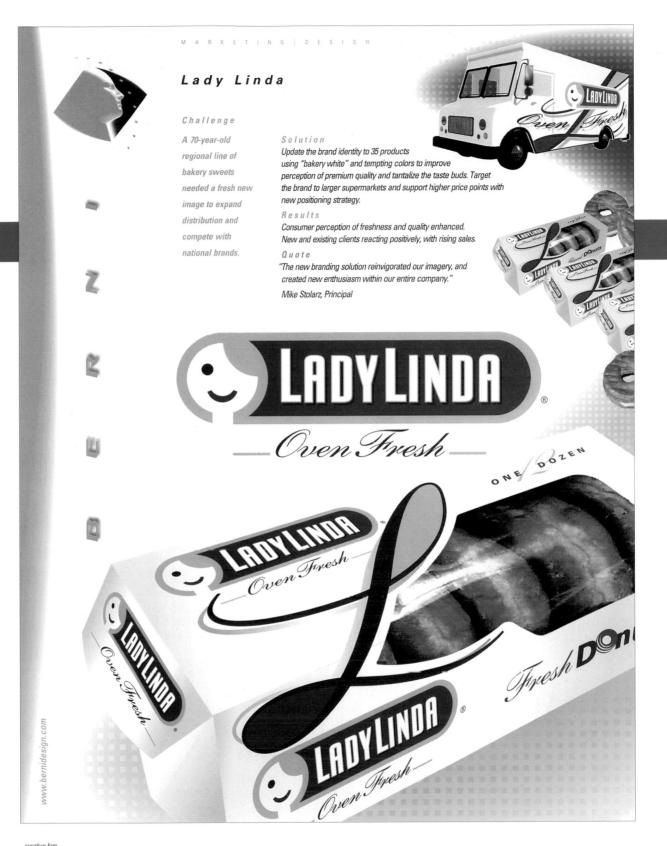

creative firm **BERNI MARKETING & DESIGN** Greenwich, Connecticut creative people CARLOS SEMINAVIC, STUART M. BERNI client LADY LINDA

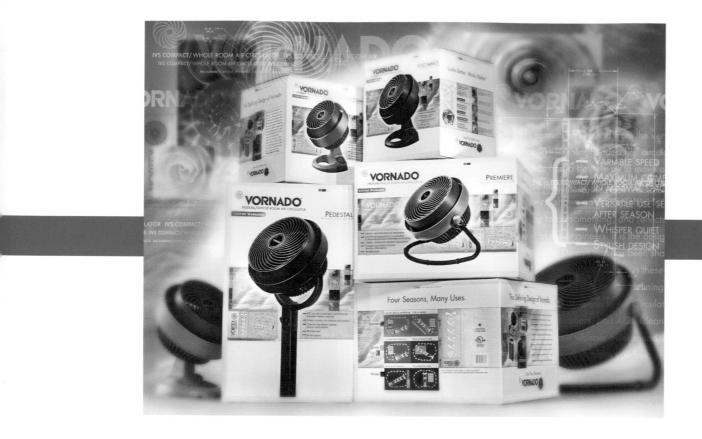

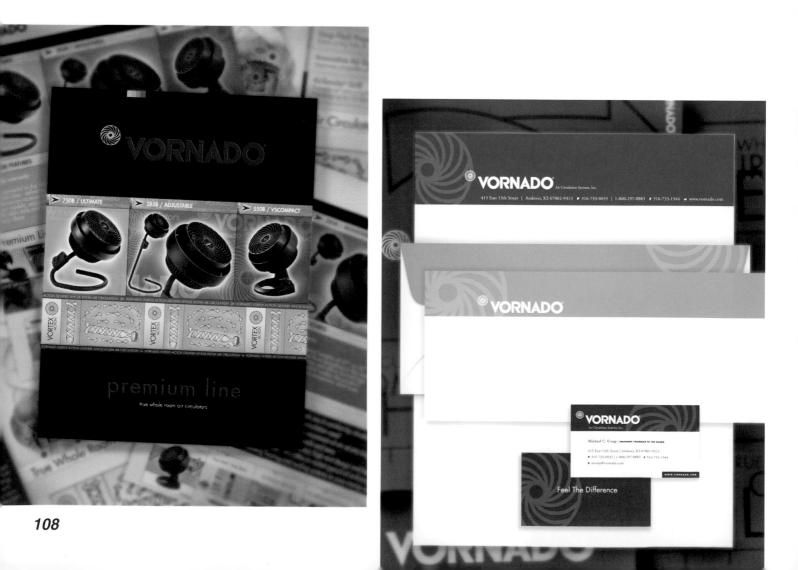

VORNADO®

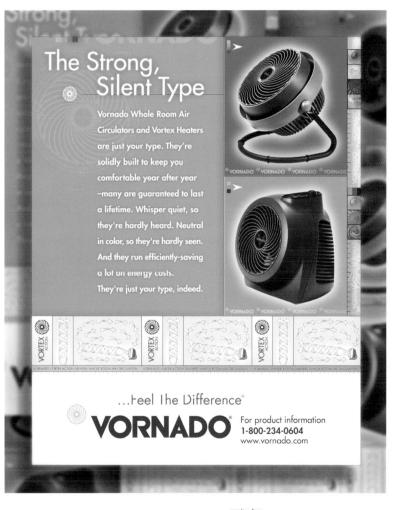

creative Imm INSIGHT DESIGN COMMUNICATIONS Wichita, Kansas creative people TRACY HOLDEMAN, LEA CAHMICHAEL

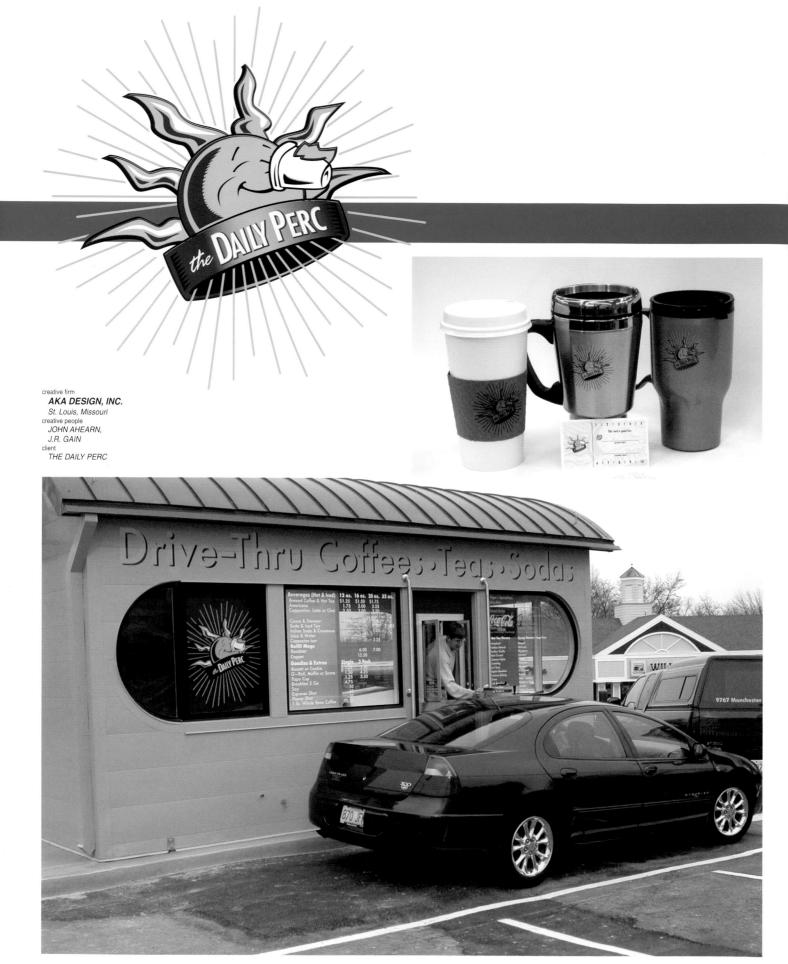

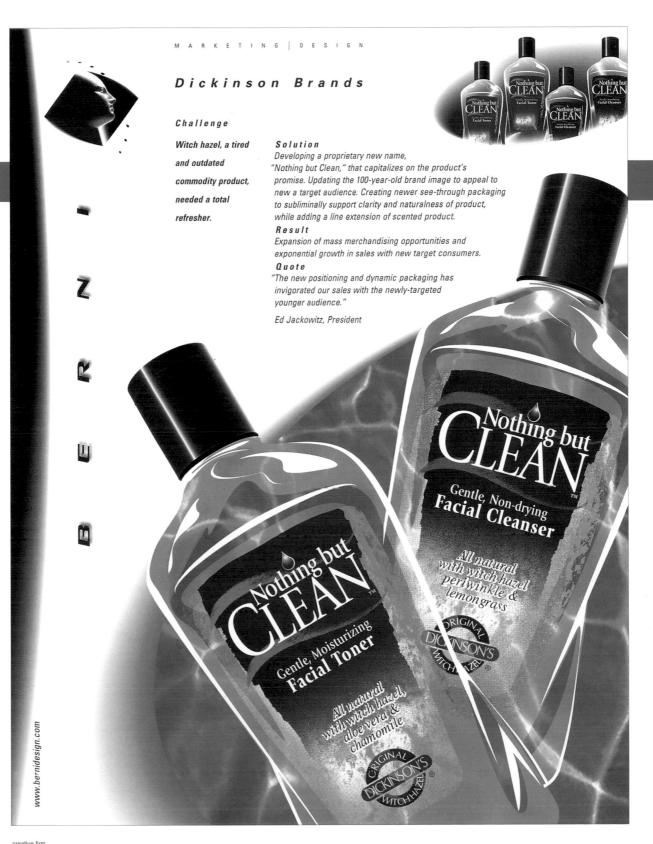

creative firm **BERNI MARKETING & DESIGN** Greenwich, Connecticut creative people STUART M. BERNI. CHRISTINE DIKOWSKI client DICKINSON BRANDS

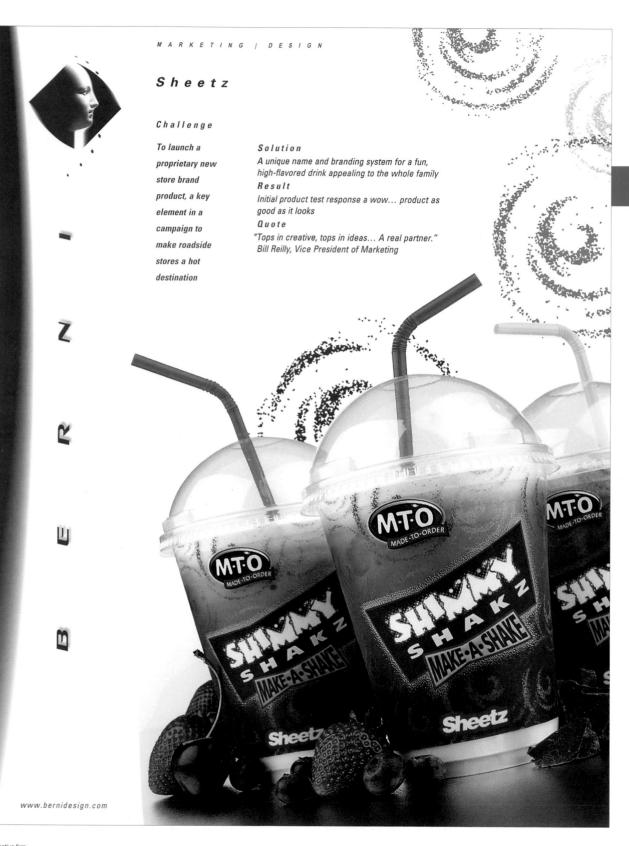

creative firm **BERNI MARKETING & DESIGN** Greenwich, Connecticut creative people STUART M. BERNI, MARK PINTO

client SHEETZ

7

2

Ш

M A R K E T I N G I D E S I G N

Revel

Challenge

Create a new brand name, positioning strategy and packaging for a new smokeless product to capture crossover tobacco market S o l u t i o n A product identity that appeals to smokers' needs when they cannot light up. Creation of innovative branding program and positioning that moves away from traditional smokeless tins and invokes traditional cigarette imagery.

Result

Successful test marketing shows consumer is enthusiastic: 45% of smokers surveyed looking for an acceptable alternative to cigarettes are willing to try product. Q u o t e

"UST has a hit product. The image makeover starts with the packaging." Gordon Fairclough, Wall Street Journal

anytime, anywhere...

creative firm **BERNI MARKETING & DESIGN** Greenwich, Connecticut creative people PETER ANTIPAS client U.S.S.T.

www.bernidesign.com

CKS

MILD

20 COU

PUSH

creative firm **AKA DESIGN, INC.** St. Louis, Missouri creative people JOHN AHEARN, RICHIE MURPHY client AKA DESIGN, INC.

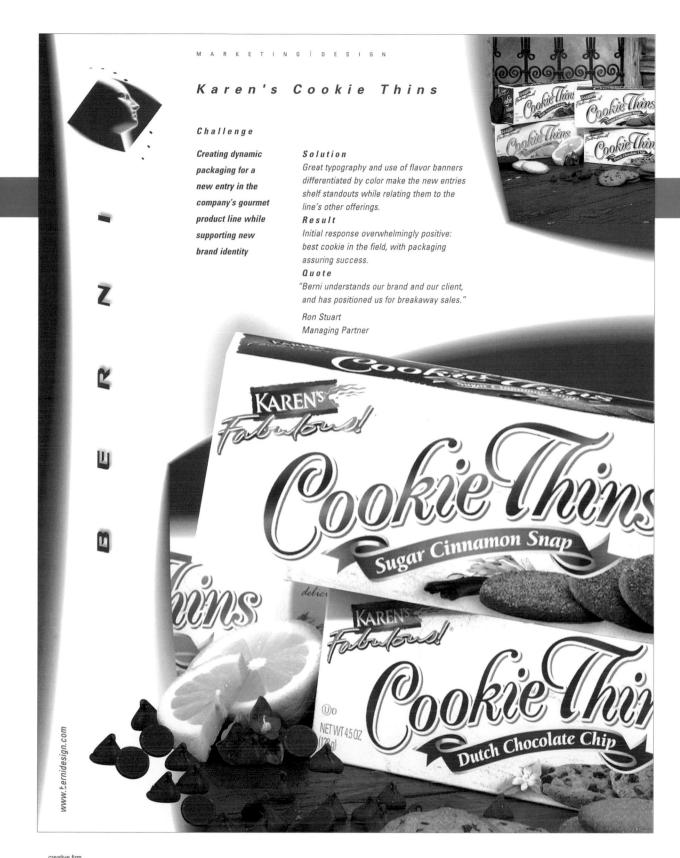

creative firm **BERNI MARKETING & DESIGN** Greenwich, Connecticut creative people STUART M. BERNI, PETER ANTIPAS client BISCOTTI & CO., INC.

creative firm **CUBE ADVERTISING & DESIGN** St. Louis, Missouri creative people DAVID CHIOW client SAINT LOUIS ZOO

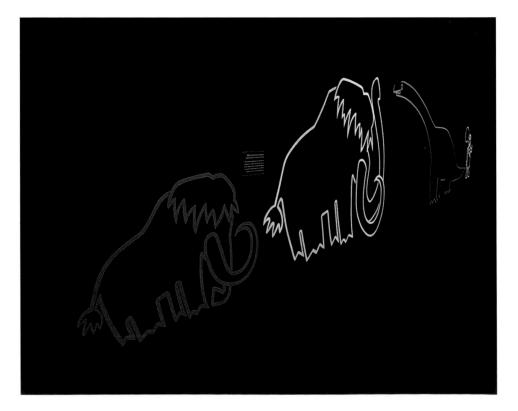

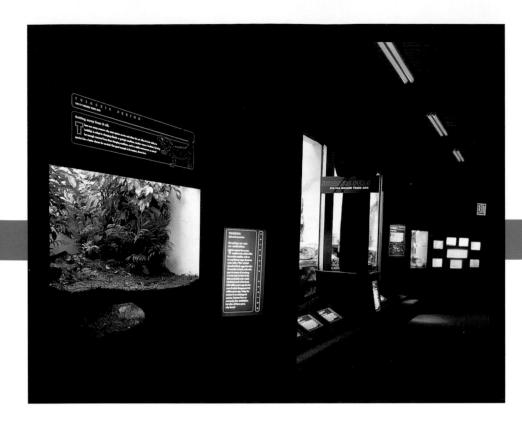

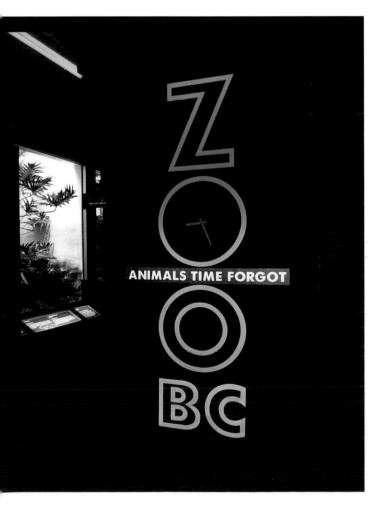

creative firm **FUTUREBRAND** New York, New York creative people MICHAEL THIBODEAU, PAUL GARDNER client MICROSOFT

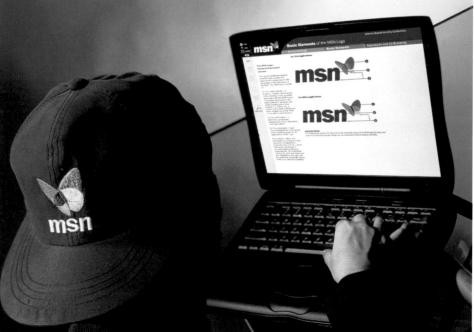

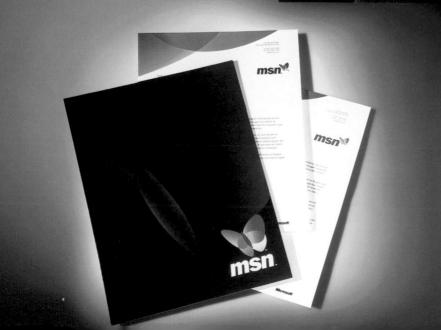

creative firm **DUNN AND RICE DESIGN, INC.** Rochester, New York creative people JOHN DUNN, DARLENE KOCHER client HASBRO, INC.

LOGOS

Blue Streak

creative firm **DESBROW** Pittsburgh, Pennsylvania creative people BRIAN LEE CAMPBELL client VOCOLLECT

creative firm **DESIGN FORUM** Dayton, Ohio creative people AMY DROLL client PARIS BAGUETTE

LOUISIANA STATE UNIVERSITY

Centennial Celebration 1902-2002 American Urological Association, Inc.

Orlando Annual Meeting • May 25-30 2002

creative firm **PHOENIX DESIGN WORKS** New York, New York

creative people JAMES M. SKILES, ROD OLLERENSHAW, CRAIG MILLER, RICHARD TSAI

LOUISIANA STATE UNIVERSITY

creative firm LEVINE & ASSOCIATES Washington, D.C. creative people RANDI WRIGHT, JOHN VANCE client AMERICAN URILOGICAL ASSOCIATION

creative firm FIXGO ADVERTISING (M) SDN BHD Selangor, Malaysia creative people FGA CREATIVE TEAM client TRISILCO MOTOR GROUP

KARACTERS DESIGN GROUP Vancouver, Canada creative people MARIA KENNEDY, NANCY WU client FOR SOMEONE SPECIAL

> creative firm **PAT TAYLOR INC.** Washington, D.C. creative people PAT TAYLOR, GRAPHICS BY GALLO client PALIS GENERAL CONTRACTING

creative firm FIIDA HOLMFRIDUR VALDIMARSDOTTIR Reykavik, Iceland creative people FRIDA HOLMFRIDUR VALDIMARSDOTTIR client THE ICELANDIC ASSOCIATION OF INTERNAL MEDICINE

creative firm KARL KROMER DESIGN San Jose, California creative people KARL KROMER client FIRESTARTER

Medical Systems Inc.

creative firm IRIDIUM, A DESIGN AGENCY Ottawa, Canada creative people MARIO L'ECUYER client VMI MEDICAL SYSTEMS

creative KARACTERS DESIGN GROUP Vancouver, Canada creative poople MARIA KENNEDY, ROY WHITE. JEFF HARRISON client RECRUITEX

ativo fir PHOENIX DESIGN WORKS New York, New York creative people JAMES M. SKILES. ROD OLLERENSHAW NASCAR

creative firm TOOLBOX STUDIOS, INC. San Antonio, Texas creative people PAUL SOUPISET

KOEN SUIDGEEST

MAD

D

creative firm **CONCRETE DESIGN COMMUNICATIONS** Toronto, Canada creative people JOHN PYLYPCZAK client COMPANY DNA

creative firm HAMBLY & WOOLLEY INC. Toronto, Canada creative people PHIL MONDOR client PLURIMUS

CHAMBER OF COMMERCE

creative firm **ZGRAPHICS, LTD.** East Dundee, Illinois creative people NATE BARON, JOE ZELLER client

NORTHERN KANE COUNTY CHAMBER OF COMMERCE

Cornerstone

creative firm **PORTFOLIO CENTER** Atlanta, Georgia creative people ANNA CAZARUS client CORNERSTONE CHURCH

> creative firm **PHOENIX DESIGN WORKS** New York, New York creative people JAMES M. SKILES, ROD OLLERENSHAW, CRAIG MILLER, RICHARD TSAI client MLBP INTERNATIONAL

BAUERNIKEHOCKEY

creative firm **NOLIN BRANDING & DESIGN INC.** Montreal, Canada creative people GILLES LEGAULT client BAUER NIKE HOCKEY

creative firm LOGOS IDENTITY BY DESIGN LIMITED Toronto, Canada creative people RENA WELDON, BRIAN SMITH client FUNDY CABLE

creative firm **PETE SMITH DESIGN** TORONTO, CANADA creative people PETE SMITH client ICC TOOLS

creative firm TRAPEZE COMMUNICATIONS Victoria, Canada creative people MARK BAWDEN client PROTOCOL OFFICE, PROV. OF BC

creative firm PHOENIX DESIGN WORKS New York, New York creative people JAMES M. SKILES client MLBP

creative firm MARCIA HERRMANN DESIGN Modesto, California creative people MARCIA HERRMANN client ROCKY MOUNTAIN FOODS

KINGSBOROUGH

creative firm MAGICAL MONKEY New York, New York creative people ROSWITHA RODRIGUES, RICHARD WILDE client

KINGSBOROUGH COMMUNITY COLLEGE

at hon A M E R I C A®

creative firm LISKA + ASSOCIATES, INC. Chicago, Illinois creative people LISKA + ASSOCIATES, INC. client AT HOME AMERICA

creative people PAUL SCHERFLING, AMY KNOPF, TERESA NORTON—YOUNG client MARITZ

"Here for Good"

Community Foundation for Monterey County

creative firm **THE WECKER GROUP** Monterey, California creative people ROBERT WECKER

COMMUNITY FOUNDATION FOR MONTEREY COUNTY

NET PERFORMANCE

creative firm EVENSON DESIGN GROUP

Culver City, Calitornia creative people MARK SOJKA, STAN EVENSON client OVERTURE.COM

creative firm KIRCHER, INC. Washington, D.G. creative people BRUCE E. MORGAN client IAFIS

> creative firm BARBARA BROWN MARKETING & DESIGN Ventura, California creative people BARBARA BROWN, JON A. LESLIE client MAVERICKS GYM

creative firm X DESIGN COMPANY Denver, Colorado creative people ALEX VALDERRAMA client X DESIGN COMPANY

SIMTREX

THE SKILLS TO SUCCEED, GUARANTEED.

creative firm WHISTLE Atlanta, Georgia creative people RYAN GLISSON, RORY CARLTON client SIMTREX CORP.

creative firm HERIP ASSOCIATES Peninsula, Ohio creative people WALTER M. HERIP, JOHN R. MENTER client

CUYAHOGA VALLEY NATIONAL PARK

creative firm **CONFLUX DESIGN** Rockford, Illinois creative people GREG FEDOREY client ATWOOD MOBILE PRODUCTS

Schulman, Ronca & Bucuvalas, Inc.

creative firm SCHNIDER & YOSHINA LTD. New York, New York creative people LESLEY KUNIKIS client SRB/

IMS | SYSTEMS

creative firm **PHOENIX CREATIVE GROUP** Herndon, Virginia creative people KATHY BYERS, RANDY POPE client IMS SYSTEMS

creative firm **KEEN BRANDING** Charlotte, North Carolina creative people MIKE RAVENEY client DeMICHO

nice erchar an creative firm

Creative limit ZGRAPHICS, LTD. East Dundee, Illinois creative people KRIS MARTINEZ FARRELL, JOE ZELLER Client THE SPICE MERCHANT AND TEA ROOM

creative firm **OUSLEY CREATIVE** Santa Ana, California creative people MIKE OUSLEY client CNA TRUST

PlanStat

WILMINGTON CHILDREN'S MUSEUM

creative firm **THE LEYO GROUP** Chicago, Illinois creative people JAYCE SCHMIDT client WILMINGTON CHILDREN'S MUSEUM

creative firm **BUTTITTA DESIGN** Healdsburg, California creative people PATTI BUTTITTA, JEFF REYNOLDS client

client GREEN MUSIC CENTER

GSM Association * Plenary 49

creative Intri FINISHED ART, INC. Atlanta, Georgia creative people MARY JANE HASEK, LINDA STUART client CINGULAR WIRELESS

PARADOWSKI GRAPHIC DESIGN

client WORLD AGRICULTURAL FORUM

St. Louis, Missouri creative people SHAWN CORNELL

NORDYKE DESIGN West Hartford, Connecticut creative people JOHN NORDYKE client PROJECT HORIZON—COMMUNITY

TATE CAPITAL PARTNERS

creative firm LARSEN DESIGN + INTERACTIVE

Minneapolis, Minnesota creative people JO DAVISON, BILL PFLIPSEN client TATE CAPITAL PARTNERS

creative firm **PORTFOLIO CENTER** Atlanta, Georgia creative people PIPER MOORE client DOMAIN HOME FURNISHINGS

> creative firm **KIRCHER, INC.** Washington, D.C. creative people BRUCE E. MORGAN client HIRE RETURN, LLC

creative firm **BRAD NORR DESIGN** Minneapolis, Minnesota creative people BRAD D. NORR client MINNESOTA HISTORICAL SOCIETY PRESS

client

creative firm LOGOS IDENTITY BY DESIGN LIMITED Toronto, Canada creative people RENA WELDON, FRANCA DINARDO, BRIAN SMITH

ALPHA STAR TELEVISION NETWORK

creative firm ART270, INC. Jenkintown, Pennsylvania creative people SUE STROHM client DOYLESTOWN SPORTS MEDICINE CENTER

creative firm **ZD STUDIOS, INC.** Madison, Wisconsin creative people MARK SCHMITZ, TINA REMY client GREEN BAY PACKERS

creative firm **POOL DESIGN GROUP** Englewood, Colorado creative people JEANNA POOL client PRUFROCK'S COFFEE

NEIGHBORHOOD SCHOOL

> creative firm **EVENSON DESIGN GROUP** Culver City, California creative people KEN LOH, STAN EVENSON client WESTCHESTER NEIGHBORHOOD SCHOOL

creative firm **PLANIT** Baltimore, Maryland creative people JAN KLEMSTINE, MOLLY STEVENSON client NUTRITION 21

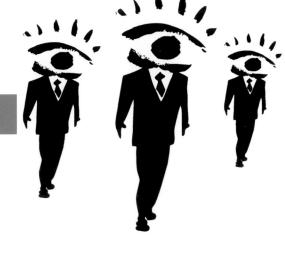

creative firm **FUSZION COLLABORATIVE** Alexandria, Virginia creative people JOHN FOSTER client ART DIRECTORS CLUB OF METROPOLITAN WASHINGTON

REALSHOW

creative firm **PORTFOLIO CENTER** Atlanta, Georgia creative people AMANDA MACCAULEY client MEXICO CITY

creative firm COMPUTER ASSOCIATES INTERNATIONAL, INC. Islandia, New York creative people LOREN MOSS MEYER, PAUL YOUNG client COMPUTER ASSOCIATES

PANNAWAY

MONDERER DESIGN Cambridge, Massachusetts creative people JASON C.K. MILLER client PANNAWAY

creative firm HARDBALL SPORTS Jacksonville, Florida creative people ANDY GOSENDI client GOODRICH & ASSOCIATES

goodrich & associates

creative firm CLARK CREATIVE GROUP San Francisco, California creative people ANNE MARIE CLARK, THURLOW WASHAM client ESOTERA GROUP, INC.

creative firm VIVIDESIGN GROUP Elizabethtown, Kentucky creative people VIVIDESIGN GROUP client ARMORCOAT, LLC.

creative firm **LEXNIEWICZ ASSOCIATES** Toledo, Ohio creative people *AMY LESNIEWICZ*, TERRENCE LESNIEWICZ client PREVIEW HOME INSPECTION

creative firm MCMILLIAN DESIGN Brooklyn, New York creative people WILLIAM MCMILLIAN client ENTERPRISE LOGIC

creative firm HAMAGAMI/CARROLL Santa Monica, California creative people KRIS TIBOR client AMGEN

T R I U M P H B U I L D E R S

creative firm **BOELTS/STRATFORD ASSOCIATES** Tucson, Arizonia creative people BRETT WEBER, JACKSON BOELTS, KERRY STRATFORD client BOURN/KARIL CONSTRUCTION

creative firm

ADDISON WHITNEY Charlotte, North Carolina

BRINKER INTERNATIONAL

creative people KIMBERLEE DAVIS, LISA JOHNSTON, DAVID HOUK client Impinj

creative firm GAGE DESIGN Seattle, Washington creative people CHRIS ROBERTS client IMPINJ, INC.

OF CONSTRUCTORS

KEYWORD DESIGN Highland, Indiana creative people JUDITH MAYER client THE AMERICAN GROUP OF CONSTRUCTORS, INC.

135

CHRISDAVISINTERNATIONAL

creative firm MARYL SIMPSON DESIGN Tollica Lake, California creative people MARYL SIMPSON client CHRIS DAVIS

CAL-PACIFIC CONCRETE, INC.

creative firm **NEVER BORING DESIGN** Modesto, California creative people CHERYL CERNIGOJ client CAL—PACIFIC CONCRETE, INC.

creative firm **TOOLBOX STUDIOS, INC.** San Antonio, Texas creative people PAUL SOUPISET, RYAN FOERSTER client HEALING PLACE MUSIC

creative firm **THE WECKER GROUP** Monterey, California creative people ROBERT WECKER, HARRY BRIGGS client PRODUCE PARADISE

BERKELEY DESIGN LLC

St. Louis, Missouri reative people

creative people LARRY TORNO

PARK PROVENCE/CHARLES DEUTSCH

creative firm **MFDI** Selinsgrove, Pennsylvania creative people MARK FERTIG client THE ECCENTRIC GARDENER PLANT COMPANY

creative firm **DULA IMAGE GROUP** South Coast Metro, California creative people MICHAEL DULA client LONNIE DUKA PHOTOGRAPHY

Native Forest

reative imm FUNK/LEVIS & ASSOCIATES Eugene, Oregon reative people DAVID FUNK lient NATIVE FOREST COUNCIL

creative firm **PLATFORM CREATIVE GROUP** Seattle, Washington creative people ROBERT DIETZ client AHBL

Joie de Charlotte

creative firm **AUE DESIGN STUDIO** Aurora, Ohio creative people JENNIFER AUE client JOIE DE CHARLOTTE

creative firm **PORTFOLIO CENTER** Atlanta, Georgia creative people MARSHAL WOLFE client BUNDLES BABY CLOTHES

creative firm LESNIEWICZ ASSOCIATES Toledo, Ohio creative people AMY LESNIEWICZ client ALLIANCE VENTURE MORTGAGE

Alliance Venture Mortgage

creative firm SEWICKLEY GRAPHICS & DESIGN, INC. Sewickley, Pennsylvania creative people MICHAEL SEIDL client ST. STEPHEN'S

creative firm KARL KROMER DESIGN San Jose, California creative people KARL KROMER client ENROUTE COURIER SERVICES

Julie Scholz

Certified Clinical Hypnotherapist

creative firm JIVA CREATIVE Alameda, California creative people JAMES WAGSTAFF client JULIE SCHOLZ, CCHT

> FORENSIC Laboratory Technologies

creative'firm PORTFOLIO CENTER Atlanta, Georgia creative people CARMEN BROWN client FORENSIC LABS

PERFORMANCE

creative firm **EVENSON DESIGN GROUP** Culver City, California creative people MARK SOJKA, STAN EVENSON client PEIK PERFORMANCE

creative firm **MILESTONE DESIGN, INC.** San Diego, California creative people DIANE GIANFAGNA—MEILS client MICHAEL TOLLAS

creative firm **DESIGN COUP** Decatur, Georgia creative people MICHAEL HIGGINS, PATRICK FOSTER client STORK PIZZA

first coast wine experience

creative firm HARDBALL SPORTS Jacksonville, Florida creative people ANDY GOSENDI client WORLD GOLF FOUNDATION

ZD STUDIOS, INC. Madison, Wisconsin creative people MARK SCHMITZ, TINA REMY client GREEN BAY PACKERS creative firm **MFDI** Selinsgrove, Pennsylvania creative people MARK FERTIG client BRIDGEHAMPTON MOTORING

creative firm **PHOENIX CREATIVE GROUP** Herndon, Virginia creative people KATHY BYERS client LAFARGE NORTH AMERICAN, CORP. COMMUNICATIONS

Creative from Magaal AnonKey New York, New York Creative people POSWITHAR RODRIGUES CREATING CRE

Appropriate Temporaries

creative firm THE LEYO GROUP, INC. Chicago, Illinois creative people MIKE KELLY, JASON TURNER, BILL LEYO client APPROPRIATE TEMPORARIES, INC. creative firm **THE WECKER GROUP** Monterey, California creative people *ROBERT WECKER*, *MATT GNIBUS* client *FIRST CLASS FLYER*

creative firm INGEAR Buffalo Grove, Illinois creative people MATT HASSLER client TARGET

creative firm **KIKU OBATA + COMPANY** St. Louis, Missouri creative people ELEANOR SAFE client A PLACE TO GROW

creative firm **GLITSCHKA STUDIOS** Salem, Oregon creative people VON R. GLITSCHKA client MALLARD CREEK GOLF COURSE creative firm MICHAEL NIBLETT DESIGN Fort Worth, Texas creative people MICHAEL NIBLETT

client UNWINED WINE STORE

CollegeLabels.com

creative firm **MFDI** Selinsgrove, Pennsylvania creative people MARK FERTIG, KEVIN PITTS client LABELS-R-US

creative firm JEFF FISHER LOGOMOTIVES Portland, Oregon creative people JEFF FISHER client AIDS RESPONSE—SEACOAST

creative firm ART270, INC. Jenkintown, Pennsylvania creative people JOHN OPET client DRAKE TAVERN

creative firm BRAD NORR DESIGN Minneapolis, Minnesota creative people BRAD D. NORR BUSINESS INCENTIVES

vo fin

GALLERY C

creative firm **EVENSON DESIGN GROUP** Culver City, California creative people MARK SOJKA, STAN EVENSON

creative firm
PARADOWSKI GRAPHIC DESIGN St. Louis, Missouri creative people STEVE COX client THE VISIBILITY COMPANY

creative firm **PORTFOLIO CENTER** Atlanta, Georgia creative people DENISE SCHIFER client TOULOUSE

creative firm GRAFIQA Oneonta, New York creative people CHRISTOPHER QUEREAU client BETTER BEGINNINGS LEARNING CENTER

BELL MEMORIALS & GRANITE WORKS

DESIGNFIVE Fresno, California

creative people RON NIKKEL client BELL MEMORIALS & GRANITE WORK

creative firm MARCIA HERRMANN DESIGN Modesto, California creative people MARCIA HERRMANN client HILLTOP RANCH INC.

creative firm BRUCE YELASKA DESIGN San Francisco, California creative people BRUCE YELASKA client COPPERFASTEN

NATIVE LANDSCAPES

creative firm **THE LEYO GROUP, INC.** Chicago, Illinois creative people JAYCE SCHMIDT client

NATIVE LANDSCAPES

creative firm WHISTLE Atlanta, Georgia creative people RORY CARLTON client BEAR BODIES FITNESS STUDIO

creative firm SCHNIDER & YOSHINA LTD. New York, New York creative people LESLEY KUNIKIS client SWEET RHYTHM

ascentives

corporate speciality solutions

creative firm

creative firm

BARBARA BROWN MARKETING & DESIGN Ventura, California creative people BARBARA BROWN, JON A. LESLIE, CAROLE BROOKS client FITWEST, INC. RULE29 Elgin, Illinois creative people JUSTIN AHRENS, JIM BOBORCI, JON MCGRATH client ASCENTIVES

> THE GALLERY AT FULTON STREET

creative firm **KOLANO DESIGN** Pittsburgh, Pennsylvania creative people CATE SIDES client THOR EQUITIES

Retirement Consultants, Ltd.

creative firm GCG ADVERTISING Fort Worth, Texas creative people PAULA LECK client RETIREMENT CONSULTANTS, LTD.

BLACKSTOCK

creative firm HAMBLY & WOOLEY INC. Toronto, Canada creative people JAYSON ZALESKI, KATINA CONSTANTINOU client BLACKSTOCK LEATHER

creative firm **DESIGN NUT** Washington, D.C.

BRENT M. ALMOND

TIMOTHY PAUL CARPETS & TEXTILES

ZD STUDIOS, INC. Madison, Wisconsin creative people MARK SCHMITZ, TINA REMY client GREEN BAY PACKERS

creative firm FIXGO ADVERTISING SDN BHD Selangor, Malaysia creative people FGA CREATIVE TEAM client PEREGRINE TECHNOLOGY SDN BHD

creative firm HERIP ASSOCIATES Peninsula, Ohio creative people WALTER M. HERIP, JOHN R. MENTER client CUYAHOGA VALLEY NATIONAL PARK

Interlocking Media

creative firm KIRCHER, INC. Washington, D.C. creative people BRUCE E. MORGAN client INTERLOCKING MEDIA

Can O y

PORTFOLIO CENTER Atlanta, Georgia creative people MARSHALL WOLFE client CANOPY RESTAURANT

creative firm ART270, INC.

Jenkintown, Pennsylvania creative people SEAN FLANAGAN, NICOLE GANZ client LEXICOMM creative firm **TOOLBOX STUDIOS, INC.** San Antonio, Texas creative peole PAUL SOUPISET client CLARKE AMERICAN

glebeandmail.com

creative firm CONCRETE DESIGN COMMUNICATIONS INC. Toronto, Canada creative people JOHN PYLYPCZAK client GLOBE AND MAIL

Olives & Lemons

CATERING

creative firm CROWLEY WEBB AND ASSOCIATES Buffalo, New York creative people DAVID BUCK client OLIVES & LEMONS CATERING

creative firm (ARGUS) Reykjavik, Iceland creative people FRIDA HOLMFRIDUR VALDIMARSOOTTIR client A GARDENING COMPANY

creative firm **CAPT FLYNN ADVERTISING** Abilene, Texas creative people TOM RIGSBY, ISAAC MUNOZ client TELEPHONY FOR INFORMATION SERVICES

LEADING**BRANDS**[™]

creative firm **DESBROW & ASSOCIATES** Pittsburgh, Pennsylvania creative people BRIAN LEE CAMPBELL client VOCOLLECT

RIVER VALLEY RIDERS

.

creative firm **CAPSULE** Minneapolis, Minnesota creative people ANCHALEE CHAMBUNDABONGSE client RIVER VALLEY RIDERS KARACTERS DESIGN GROUP Vancouver, Canada creative people MARIA KENNEDY, NANCY WU client LEADING BRANDS

creative tirm KARACTERS DESIGN GROUP Vancouver, Canada creative people MATTHEW CLARK client SPIKE BRAND

PHOENIX DESIGN WORKS New York, New York creative people JAMES M. SKILES, ROD OLLERENSHAW, CRAIG MILLER, RICHARD TSAI client

MLBP INTERNATIONAL

creative firm

creative firm **PORTFOLIO CENTER** Atlanta, Georgia creative people DAVID ZORNE client COLEMAN OUTDOOR ESSENTIALS

YARDBIRDS

FREE RANGE CHICKENS

PORTFOLIO CENTER Atlanta, Georgia creative people DENISE SCHISER client YARDBIRDS ORGANIC CHICKEN

creative firm

THE WECKER GROUP Monterey, California creative people ROBERT WECKER client SAGE METERING, INC.

creative firm

creative firm **OUT OF THE BOX** Fairfield, Connecticut creative people RICK SCHNEIDER client ANASYS

anasys

creative firm FINISHED ART, INC. Atlanta, Georgia creative people DOUG CARTER, DONNA JOHNSTON client THE COCA-COLA COMPANY

creative firm KARACTERS DESIGN GROUP Vancouver, Canada creative people MARIA KENNEDY, MATTHEW CLAHK client QUICK

creative firm LESNIEWICZ ASSOCIATES Toledo, Ohio creative people LES ADAMS client SCHMAKEL DENTISTRY

creative firm MATT TRAVAILLE GRAPHIC DESIGN Ocheyedan, Iowa creative people MATT TRAVAILLE client JDS STABLES

creative firm
PRACTICAL COMMUNICATIONS, INC. Palatine, Illinois creative people BRIAN DANAHER client UTILITY SAFETY CONFERENCE & EXPO

Raising Expectations And Discovering our Youth

creative firm IM-AJ COMMUNICATIONS & DESIGN, INC. West Kingston, Rhode Island creative people JAMI OUELLETTE, TYLER HALL, MARK BEVINGTON client PROVIDENCE SCHOOL DEPARTMENT & THE RI CHILDREN'S CRUSADE

creati GLITSCHKA STUDIOS Salem, Oregon creative people VON R. GLITSCHKA client WEBDOCTOR

STAHL PARTNERS INC. Indianapolis, Indiana creative people DAVID STAHL, BRIAN GRAY client YOUNG AUDIENCES OF INDIANA

creative firm MICHAEL ORR + ASSOCIATES, INC. Corning, New York creative people MICHAEL R. ORR, THOMAS FREELAND client ROBINSON KNIFE COMPANY

BARBARA BROWN MARKETING & DESIGN Ventura, California creative people BARBARA BROWN, JON A. LESLIE client RONALD REAGAN PRESIDENTIAL LIBRARY FOUNDATION

crea

creative firm **ZD STUDIOS, INC.** Madison, Wisconsin creative people MARK SCHMITZ, TINA REMY client GREEN BAY PACKERS

creative firm FUTUREBRAND creative people MICHAEL THIBODEAU, KEVIN SZELL, ADAM STRINGER client McGRAW-HILL

The **McGraw·Hill** Companies

creative firm GCG ADVERTISING Fort Worth, Texas creative people BRIAN WILBURN client STRATA CORE

creative firm **TOOLBOX STUDIOS, INC.** San Antonio, Texas creative people STAN MCELRATH, RAQUEL SAVAGE client HOME FIELD SERVICES INC.

creative firm LEINICKE DESIGN Manchester, Missouri creative people BOB GAUEN, TONYA HUGHES client OPTITEK, INC.

KARACTERS DESIGN GROUP Vancouver, Canada creative people JEFF HARRISON client DESTINA creative firm **PHOENIX DESIGN WORKS** New York, New York creative people JAMES M. SKILES, ROD OLLERENSHAW client COCA-COLA COMPANIES

MaxMining&Resources

creative firm **THE IMAGINATION COMPANY** Bethel, Vermont creative people MICHAEL CRONIN client MAX MINING AND RESOURCES

Creative Imm DULA IMAGE GROUP South Coast Metro, California creative people MICHAEL DULA client MUNIFINANCIAL

NORTHWESTERN NASAL + SINUS

creative firm LISKA + ASSOCIATES, INC. Chicago, Illinois creative people HANS KREBS client NORTHWESTERN NASAL + SINUS

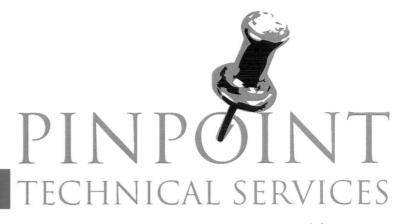

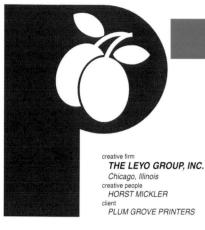

creative firm MCMILLIAN DESIGN Brooklyn, New York creative people WILLIAM MCMILLIAN client PINPOINT TECH SERVICES

TOP DESIGN STUDIO Toluia, California creative people REBEKAH BEATON, PELEG TOP

client RENDEZVOUS ENTERTAINMENT

FINELINE

creative firm **NESNADNY + SCHWARTZ** *Cleveland, Ohio* creative people *TERESA SNOW* client *FINE LINE LITHO*

creative firm **PHOENIX DESIGN WORKS** New York, New York creative people JAMES M. SKILES client NASCAR

creative firm PHOENIX DESIGN WORKS New York, New York creative people JAMES M. SKILES, ROD OLLERENSHAW, CRAIG MILLER, RICHARD TSAI client INDIANAPOLIS 500

LANTANA

creative firm **ID8 STUDIO/RTKL** Dallas, Texas creative people DAMON ROBINSON

client PUBLIC PROPERTY GROUP

Dream House for medically fragile children

A home. A family. A future.

creative firm WHISTLE Atlanta, Georgia creative people RORY CARLTON client THE DREAMHOUSE FOR MEDICALLY FRAGILE CHILDREN

EPS Settlements Group

creative firm **X DESIGN COMPANY** Denver, Colorado creative people ALEX VALDERRAMA, ANDY SHERMAN client

Westboroug

OFFICE

EPS SETTLEMENTS GROUP

creative firm
DOERR ASSOCIATES

Winchester, Massachusettes creative people JOAN WILKING, LINDA BLACKSMITH client ARCHON GROUP

PARK

THE JEWISH ME & HOSPITAL SYSTEM FECARE

creative firm **BAILEY DESIGN GROUP** Plymouth Meeting, Pennsylvania creative people CHRISTIAN WILLIAMSON, WENDY SLAVISH.

MANHATTAN • BRONX • SARAH NEUMAN CENTER/WESTCHESTER • LIFECARE SERVICES

STEVE PERRY, DAVE FIEDLER client

Itent THE JEWISH HOME & HOSPITAL OF NEW YORK

creative firm AQUEA DESIGN Las Vegas, Nevada creative people ALEX FRAZIER, RAYMOND PEREZ WALTERS GOLF

WALT DISNEY COMPANIES

creative firm KOLANO DESIGN Pittsburgh, Pennsylvania creative people TIM CARRERA, ADRIENNE CIUPRINSKAS client PHARMACHEM LABORATORIES, INC.

creative firm **PHOENIX DESIGN WORKS** New York, New York creative people JAMES M. SKILES, ROD OLLERENSHAW, CRAIG MILLER, RICHARD TSAI Client

SAINT JOSEPH'S UNIVERSITY

POOL DESIGN GROUP Englewood, Colorado creative people JEANNA POOL

client PHIL'S NATURAL FOOD GROCERY

creative firm **OUSLEY CREATIVE** Santa Ana, California creative people MIKE OUSLEY client OUTDOORS CLUB

creative firm **MFDI** Selinsgrove, Pennsylvania creative people MARK FERTIG, RICHARD HILLIARD client BIRDPLAY

creative firm GCG ADVERTISING Fort Worth, Texas creative people BILL BUCK client PINNACLE ENVIRONMENTAL

EDITORIAL DESIGN

How to get yourself out of the dumps and onto a positive path

000

By Kobert McGarvey and Babs S. Harrison Illustrations by Lisa Manning

No sales rep manages to the submer of the sale of the

Next!

Next! How do you stomach rejection after rejection and stay upbeat? Mark Victor Hansen, co-creator of Chicken Soup for the Soul (Heath Communications, 1993), swears by the N-E-XT formula. As he points out, "Everybody gets rejected. Count on it. And you have to know how to deal with it." A prime prospect will say. "No thanks," key customers will sliht their business elsewhere and, well, those things happen. At that point, if you don't have a plan for meeting rejection head-on, you'll lose important mo-mentum and begin to failer. To avoid that. "Use this formula: N-E-XT," Hansen explains. "If a prospect says no, go to the next one. Next is the most important word I know. Whenever something doesn't work for me. I just tell myself, Next" It works." Remember what N-E-XT can do. It helped transform Hansen into a multimillion-aire. Perhaps it will work for you.

Make a Journal

MGRE a JOUTNAI According to preaker and author Jim Reilly. "I keep a journal which I refer to as my idea book 1 throw in motivating stories dipped from newspapers, such as stories on Tiger Woods. Read these and you are reminded how other people struggled and persevered." Reilly also advises keenging in the book a list of everything you are really proud of, from accomplishments to things your kids have done, and reviewing it when you're down. The next time you feel you cannot do anything worthwhile. flip your book open and – right there in front of you – you'll see that not only have others done amazing things, so, too, have you.

SELLING POWER NOVEMBER/DECEMBER 2001 69

creative firm SELLING POWER Fredericksburg, Virginia

creative people MICHAEL AUBRECHT, LISA MANNING client

SELLING POWER MAGAZINE

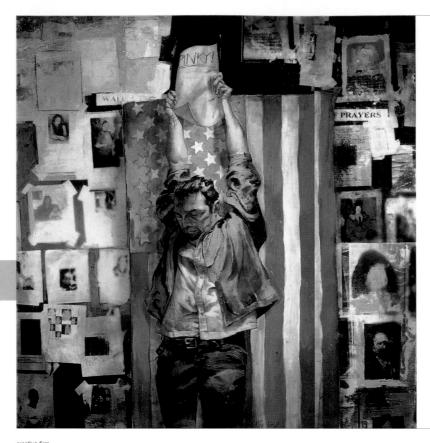

a last call from the burning tower 25 sent abel on a desperate quest

tiction By Walter Mosley



creative firm SELLING POWER Fredericksburg, Virginia creative people TARVER HARRIS clie SELLING POWER MAGAZINE

PLAYBOY ENTERPRISES INTERNATIONAL, INC. Chicago, Illinois creative people TOM STAEBLER, KENT WILLIAMS, KERIG POPE client PLAYBOY MAGAZINE

GERMAN LAWYER

Making A Mark

Even with the German economy in a slump. American law

afford to stay away.

firms, foreign firms, and their own compatriots. Three U.K. leaders—Freshfields, Clifford Chance, and Linklaters—went after the market in the late 1990s and established them-selves through mergers with top domestic firms. Those global gi-wats certainly command atten-By Tom Blass

G OF A e by New an & Ster-emed like a move. Based f with four practice ap-comparison dent Gulliv-former conter The short more laser Disabeldor with a short matrix of the short here with the distribution is compared by the short here with the short here with the distribution is compared by the short here with the short here with the distribution is compared by the short here with the short here with

t all ti

and have to of

Hootz Hirsch. Germany's economy may be an the doldrums, but it remains a magnet for U.S. firms. Pioneers like Shearman now have plenty euros a year. But mon from de

132 THE AMERICAN LAWYER

creative firm THE AMERICAN LAWYER New York, New York creative people DARLENE SIMIDIAN, WILLIAM RIESER client THE AMERICAN LAWYER

firms cannot

guan Cola

main relat ners

relaxed the rule barred foreign practicing. The set up Fr APRIL 2002 133

creative firm THE AMERICAN LAWYER New York, New York creative people JOAN FERRELL, NICHOLAS WILTON client THE AMERICAN LAWYER

A probe led by Skadden's Bob Bennett levels withering criticism at the U.S. track federation for its handling of athlete drug charges. By Susan Beck

THE SUMMER OF 1999 AN AMERICAN TRACK AND FIELD ATHLETE TESTED POSITIVE a barned atenuid during a competition. A write sample through the presence of anadysine, which disk muscle anas, A USA Track & Field hearing panel roled that the allotte way gaily of doping and panel a supersisting then, you mostle before the star of large year summer Oppropriate to hydrory. A RT appeal and panel or tertimed the decision. The allotte, whose same has never been publicly in-disc, competen in hydrory and the decision. The allotte, whose same has never been publicly in-the document of hydrory and the decision of the during and the during of the other terms. The Way hatter during addition are started by an and possibly needed in the Openpics?

USATS appeals panel overtime of the decision. The athlete, whose same has never been publicly re-vealed, composed in Syshes. We have a set of the set of

102 THE AMERICAN LAWYER

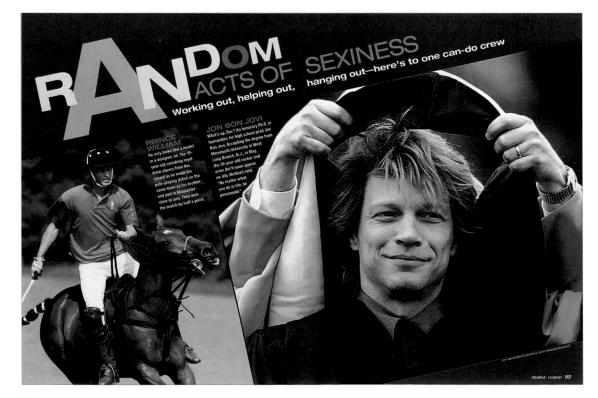

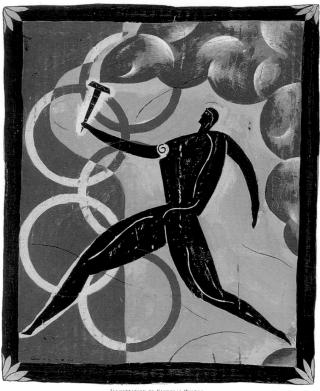

ILLUSTRATION BY NICHOLAS WILTON

reative firm PEOPLE SPECIAL ISSUES New York, New York creative people GREGORY MONFRIES, JANICE HOGAN client PEOPLE MAGAZINE

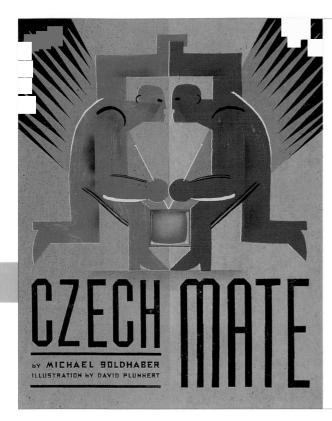

creative firm THE AMERICAN LAWYER New York, New York creative people JOAN FERRELL, DAVID PLUNKERT THE AMERICAN LAWYER

After Ronald Lauder lost his bet on a Prague television station, he filed a \$500 million claim against the Ezech Republic—and won A case study in how investor protection treaties and international arbitration panels have radically changed the financial world.

1

using sectors, the site action through the mis west involves. need that he had been cheated, Lander to sin compensation. His company ran p ad in *The New Fork Times* with high-streading, CZGL COVERNMENT WOOS UNVERTORS.... BUT THEX ANISES THEM. In his company filed three arbitration nee against Zelezzy and two against the equality. Lander method all three he made the host one count.

intraction panels have radically changed the financial world.
Intro world appella will cut

thesk for allow half a billion dollary pin inter That's in allow nodes.

MARCH 2002 83

THE AMERICAN LAWYER New York, New York creative people JOAN FERRELL, .IUD GUITTFAU client THE AMERICAN LAWYER

creative firm

92 THE AMERICAN LAWYER

How to manage the different personality types on your team to improve productivity and boost sales

creative firm SELLING POWER Fredericksburg, Virginia creative people COLLEEN MCCUDDEN, TIM ROBINSON client SELLING POWER MAGAZINE

JARY/FEBRUARY 2002 SELLING POWER

74 1

Is everyone crazy or does it just seem that way? Well, both. But sales managers don't have to follow the team over the edge.

creative firm THOMSON MEDICAL ECONOMICS Montvale, New Jersev

reative people BARRY BLACKMAN, DONNA MORRIS,

ROGER DOWD clie

MEDICAL ECONOMICS FOR OBGYNS

Medical Economics the money drain!



11

creative firm NASSAR DESIGN Brookline, Massachussettes creative people NELIDA NASSAR, MARGARITA ENCONIENDA client THE AMERICAN LAWYER

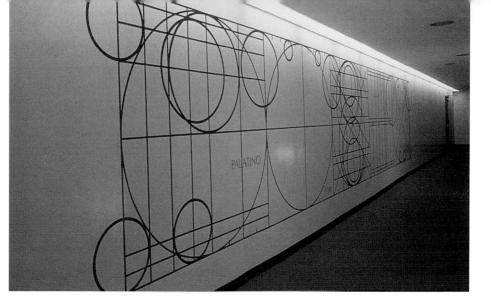

ENVIRONMENTAL GRAPHICS

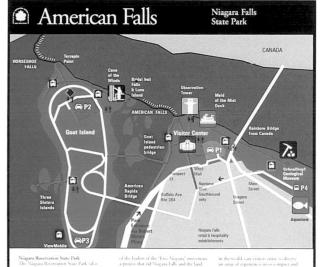

M

creative KRAHAM & SMITH Chatham, New York creative people RICH KRAHAM NYS DEP'T PARKS & RECREATION

creative firm Traverse City, Michigan creative people JEFF CORBIN, ROBERT BRENGMAN, HEATH GNEPPER FERRIS STATE UNIVERSITY

creative firm **ID8 STUDIO/RTKL** Los Angeles, California creative people PAUL F. JACOB III, KATHERINE J. SPRAGUE, KEVIN HORN, DAVE SCHMITZ client IRVINE COMPANY

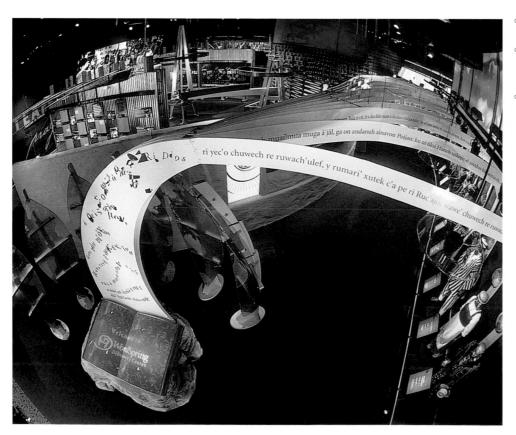

creative firm
LORENC + YOO DESIGN

Roswell, Georgia creative people JAN LORENC, CHUNG YOO, DAVID PARK, MARK MALAER, SAKCHAI RANGSIYAKORN, SUSIE NORRIS, KEN BOYD, STEVE MCCALL, GARY FLESHER

WYCLIFFE

creative firm HORNALL ANDERSON DESIGN WORKS, INC. Seattle, Washington creative people JACK ANDERSON, LISA CERVENY, SONJA MAX, JAMES TEE, ANDREW SMITH, MICHAEL BRUGMAN client JAMBA JUICE

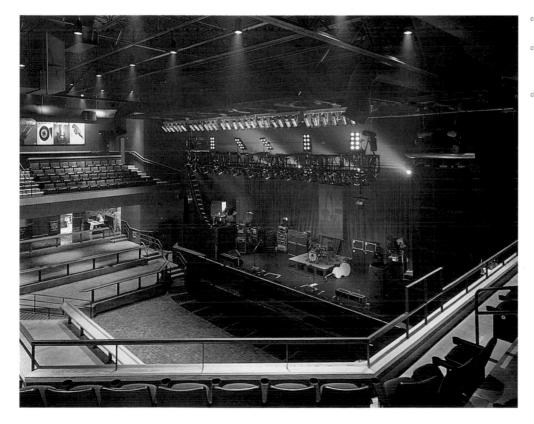

creative firm *KIKU OBATA + COMPANY St. Louis, Missouri*

St. Louis, Missouri creative people KIKU OBATA, KEVIN FLYNN,AIA, DENNIS HYLAND, AIA, LAURA MCCANNA, RICH NELSON, TOM KOWALSKI, JEF EBERS, JON MILLER client

client TI IE FAGEANT

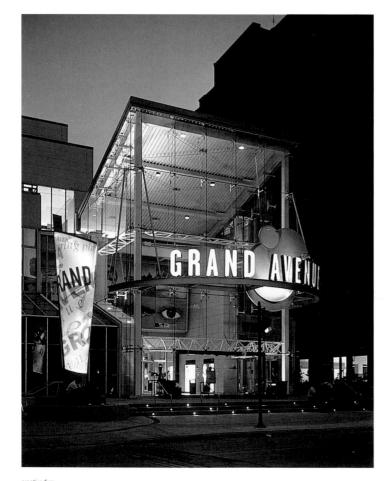

creative firm **KIKU OBATA + COMPANY** St. Louis, Missouri creative people KIKU OBATA, TODD MAYBERRY, RICH NELSON, TROY GUZMAN, AMBER ELLI, DENISE FUEHNE, CAROLE JEROME client PALISADES REALTY

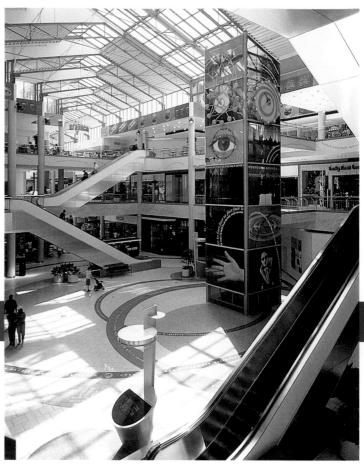

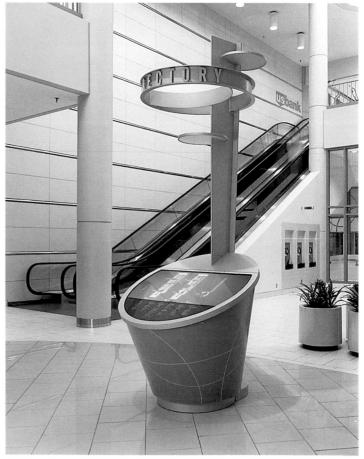

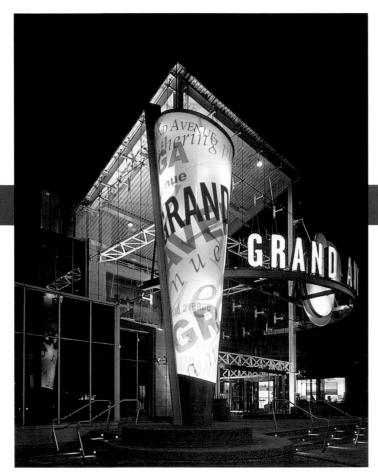

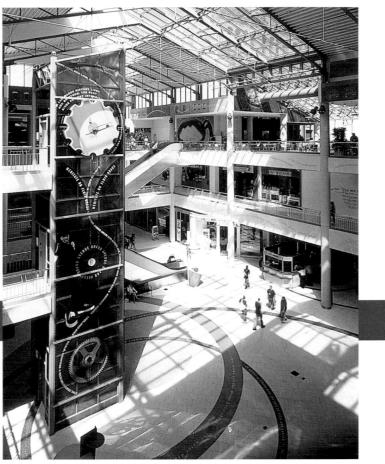

creative firm LIPPINCOTT & MARGULIES New York, New York creative people CONSTANCE BIRDSALL client CONOCO "BREAKPLACE"

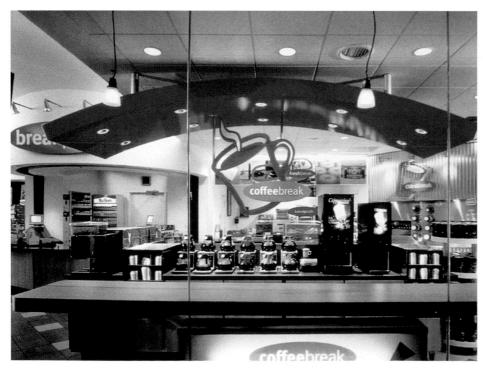

creative fir KIKU OBATA + COMPANY St. Louis, Missouri Creative people KIKU OBATA, RUSSELL BUCHANAN JR., JOHN SCHEFFEL, ANSELMO TESTA, AIA, KAY PANGRAZE, UZ SULLIVAN, JEANNA STOLL,

HEATHER TESTA, AIA, AL SACUI

PALACE OF AUBURN HILLS

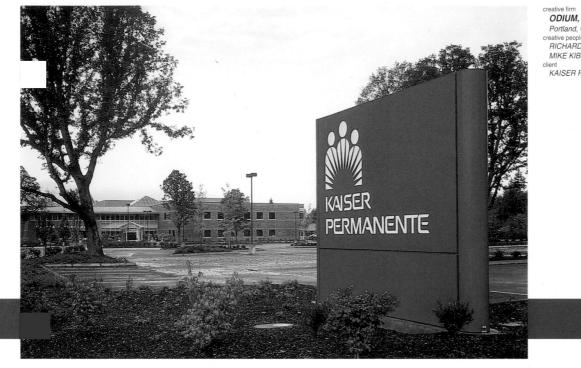

creative firm **DIUM, INC.** Portland, Oregon creative people RICHARD A. GOTTFRIED, MIKE KIBBEE client KAISER PERMANENTE NORTHWEST

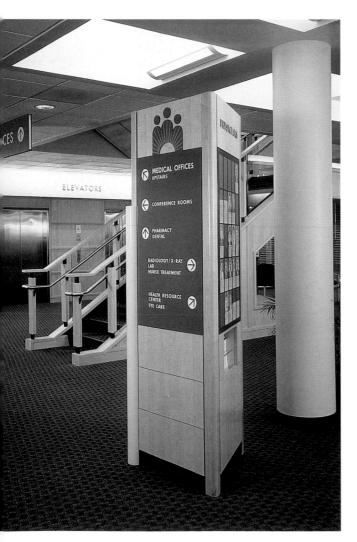

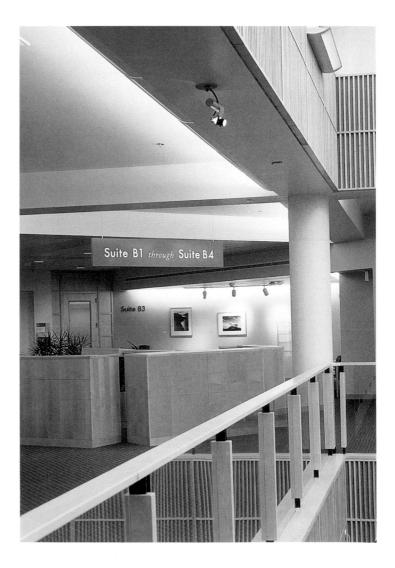

creative firm **DDIUM, INC.** Portland, Oregon creative people RICHARD A. GOTTFRIED, MIKE KIBBEE client S & G PROPERTIES, NW LLC

creative firm IMS Chicago, Illinois creative people JAMIE ANDERSON client NAVY PIER

SIGNAGE

creative firm **DENNIS S. JUETT & ASSOCIATES INC.** Pasadena, California creative people DENNIS S. JUETT client HUNTINGTON MEMORIAL HOSPITAL

creative firm IMS Chicago, Illinois creative people JAMIE ANDERSON client FIFIELD DEVELOPMENT COMPANY

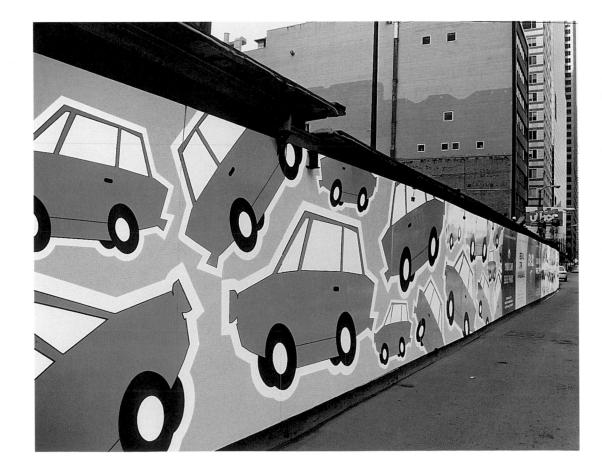

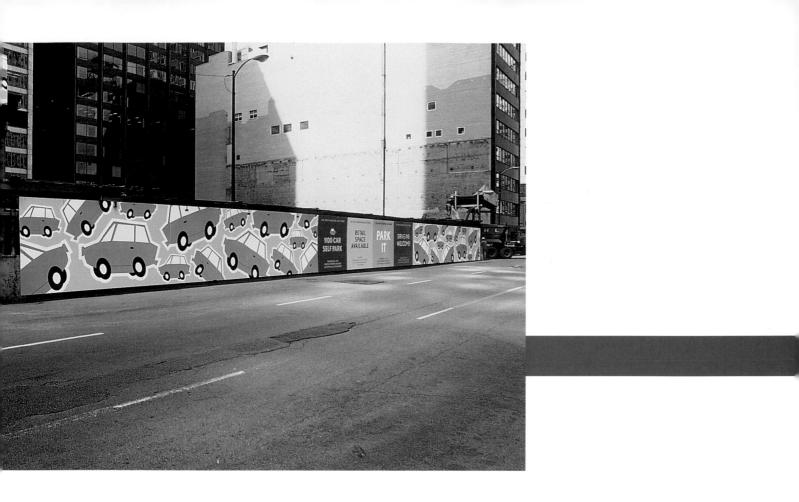

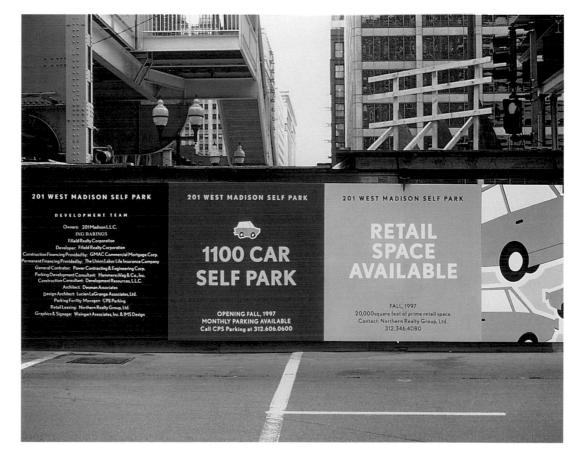

creative firm **TWO TWELVE ASSOCIATES** New York, New York creative people ANDY SIMONS, CESAR SANCHEZ client CHICAGO PARK DISTRICT

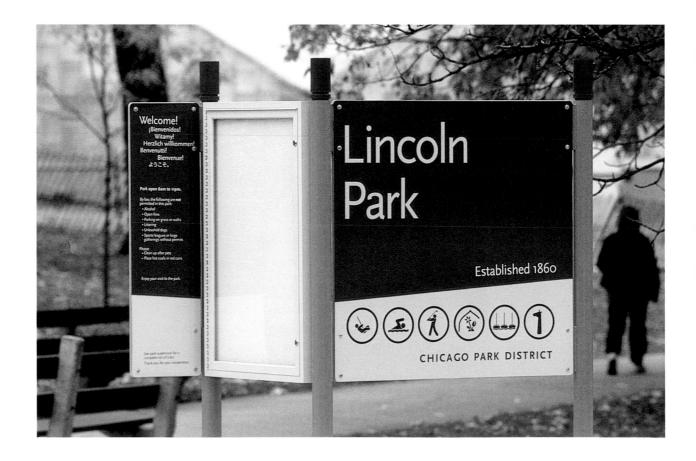

creative firm **BULLET COMMUNICATIONS, INC.** Joliet, Illinois creative people TIM SCOTT client HEY! HOT DOG RESTAURANT

> creative firm **CORBIN DESIGN** Traverse City, Michigan creative people ROBERT BRENGMAN client OAKLAND UNIVERSITY

creative firm **ADDISON DESIGN CONSULTANTS PTE LTD** Singapore, China client CHINA REBAR CO., LTD.

creative firm **ESI DESIGN** New York, New York creative people EDWIN SCHLOSSBERG, JOE MAYER, STACEY LISHERON, MARTHA GARVEY, MATTHEW MOORE, GIDEON D' ARCANGELO, ANGELA GREENE, JOHN ZAIA, MARK CORRAL, DEAN MARKOSIAN, NAOMI MIRSKY, RON MCBAIN client

client REUTERS NORTH AMERICA AND INSTINET CORP

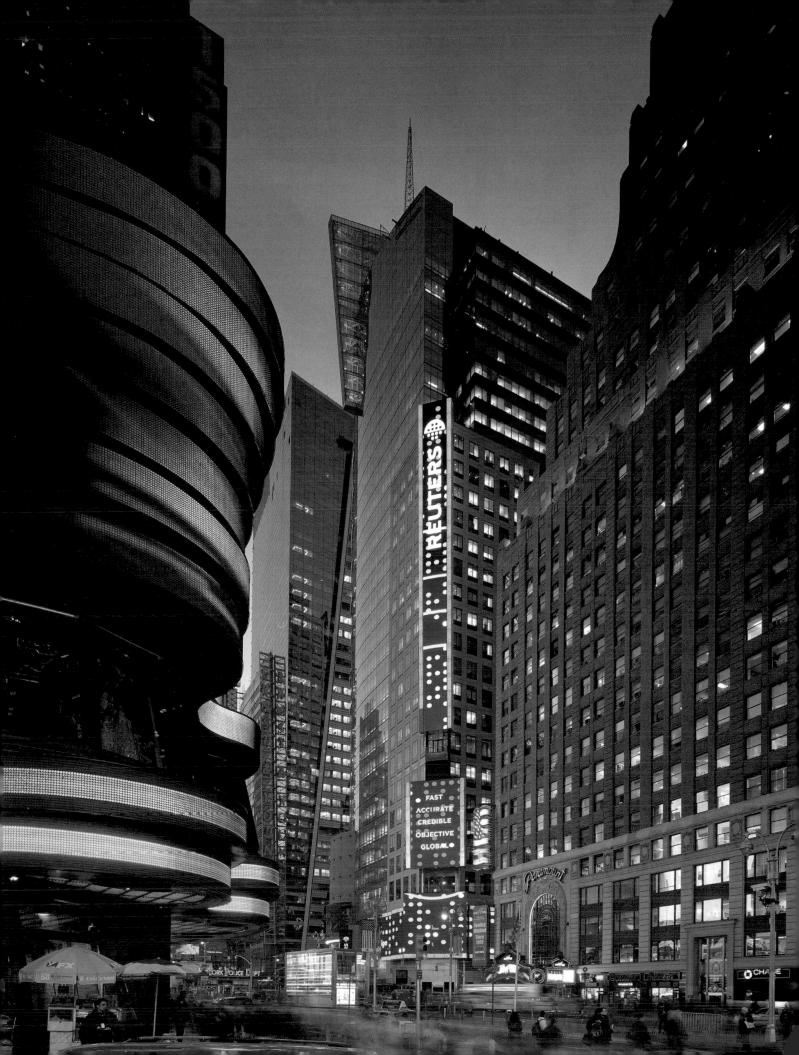

Information

creative firm **CORBIN DESIGN** Traverse City, Michigan creative people ROBERT BRENGMAN, JIM HARPER client

client CLARIAN HEALTH INDIANAPOLIS, IN creative firm **NOBLE ERICKSON INC.** Denver, Colorado creative people STEVEN ERICKSON, ROBIN H. RIDLEY, NOAH DEMPEWOLF

client ENGLE HOMES/THE JAMES COMPANY

creative firm **SMITH DESIGN ASSOCIATES** Charleston, Indiana creative people CHERYL SMITH client CITY OF JEFFERSONVILLE, INDIANA

creative firm LORENC + YOO DESIGN Roswell, Georgia creative people JAN LORENC, CHUNG YOO, DAVID PARK, MARK MALAER, SAKCHAI RANGSIYAKORN, SUSIE NORRIS, KEN BOYD, STEVE MCCALL client SONY ERICSSON

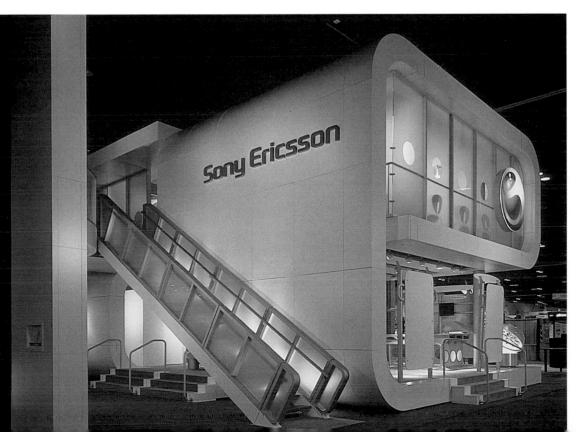

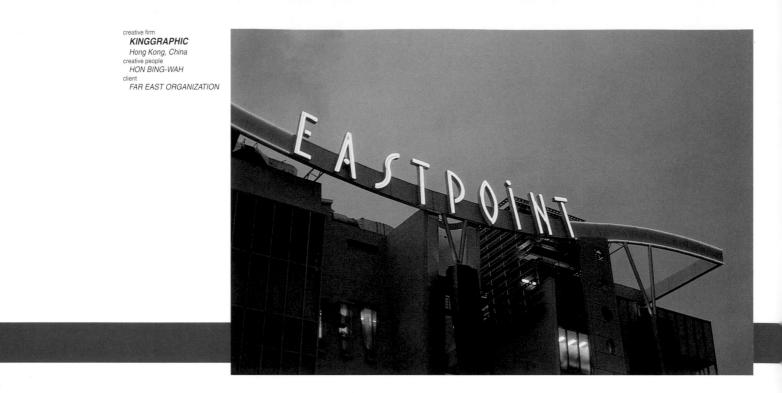

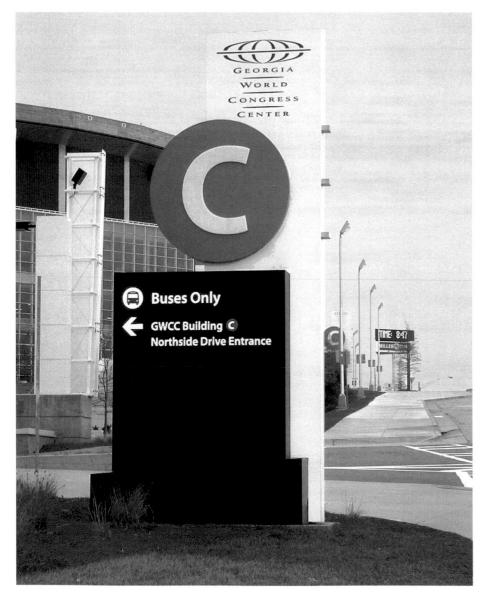

creative firm JONES WORLEY DESIGN INC. Atlanta, Georgia creative people NELSON HAGOOD, BARRY WORLEY client GEORGIA WORLD CONGRESS CENTER

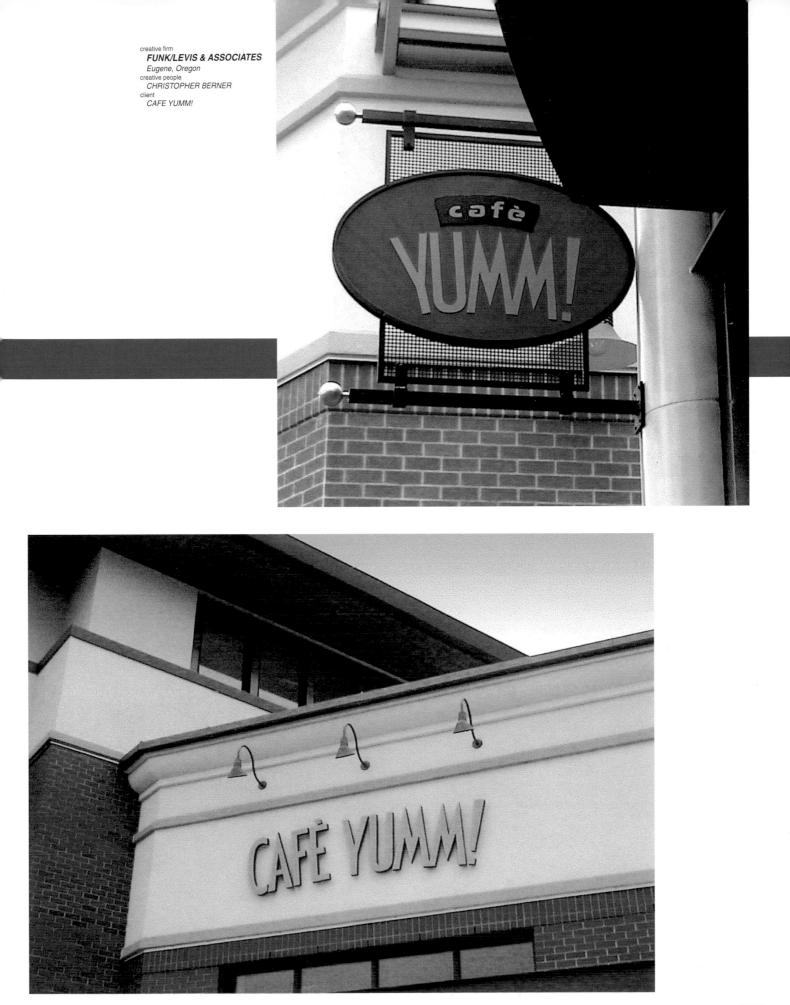

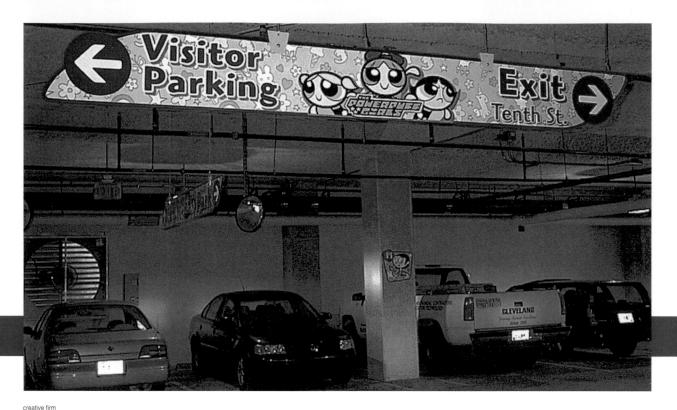

JONES WORLEY DESIGN INC. Atlanta, Georgia creative people BARRY MATION, BARRY WORLEY client TURNER PROPERTIES

creative firm **YUGUCHI & KROGSTAD, INC.** Los Angeles, California creative people CLIFFORD YUGUCHI, KOJI TAKEI client WELLS FARGO BANK

creative firm WALSH & ASSOCIATES, INC. Seattle, Washington creative people MIRIAM LISCO client FRAN'S CHOCOLATES LTD.

creative firm FUNK & ASSOCIATES Eugene, Oregon creative people JOAN GILBERT MADSEN client ECOSORT

creative firm KINGGRAPHIC Hong Kong, China creative people HON BING-WAH client FAR EAST ORGANIZATION

creative firm LIPSON-ALPORT-GLASS & ASSOCIATES Northbrook, Illinois creative people KEITH SHUPE client ALLEGIANCE

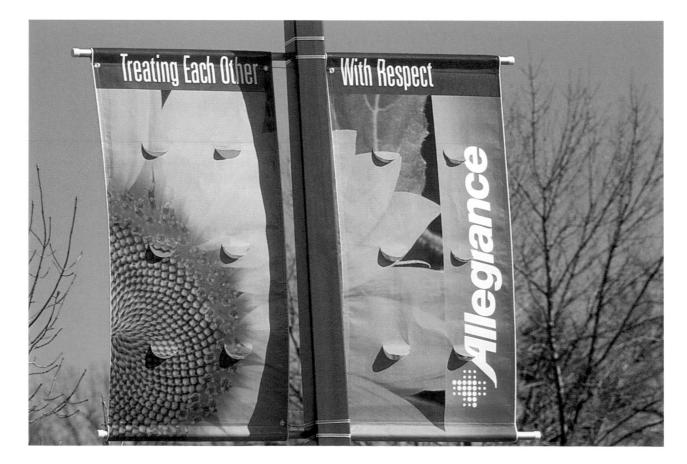

client MEMPHIS SHELBY COUNTY

creative firm ADDISON SEEFELD AND BRE New York, New York creative people KRAIG KESSEL, MOE SUELIMAN, JONATHAN CRESON, DAVID TAKEUCHI client DOMINO'S PIZZA

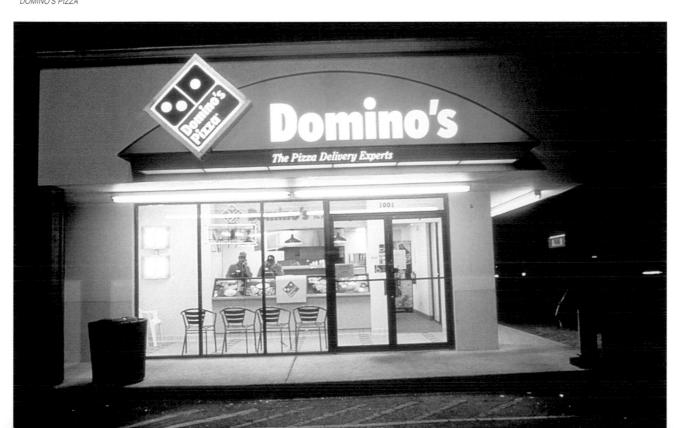

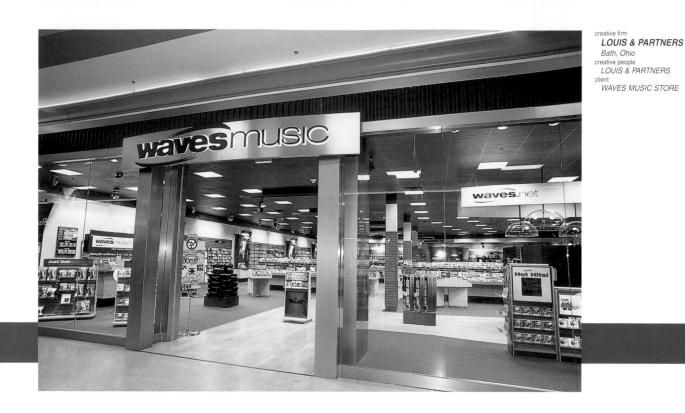

creative firm WALSH DESIGN Seattle, Washington creative people LIN GARRETSON client SEATTLE CHILDREN'S HOME

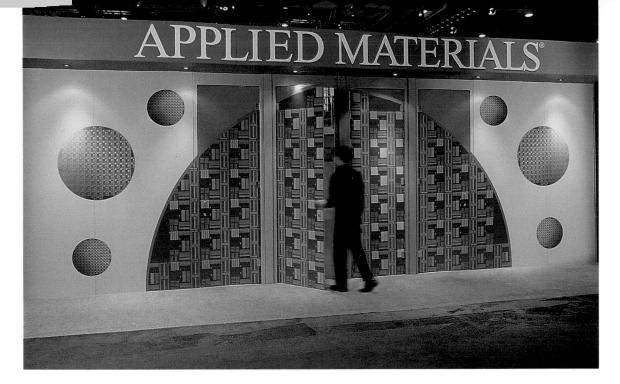

EXHIBITS & TRADE SHOWS

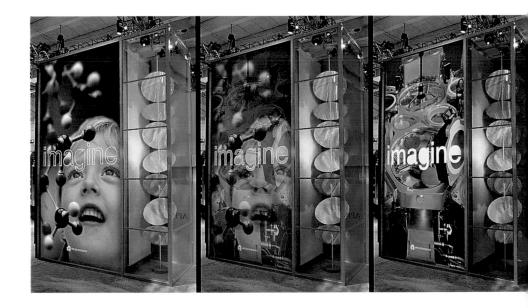

creative firm GEE + CHUNG DESIGN San Francisco, California creative people EARL GEE, FANI CHUNG client APPLIED MATERIALS

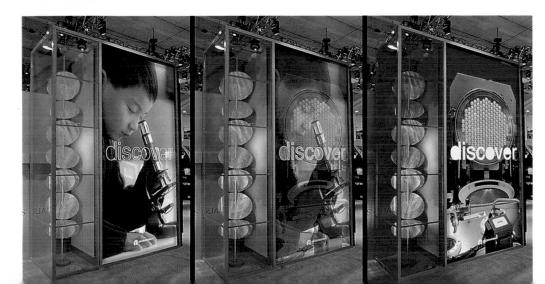

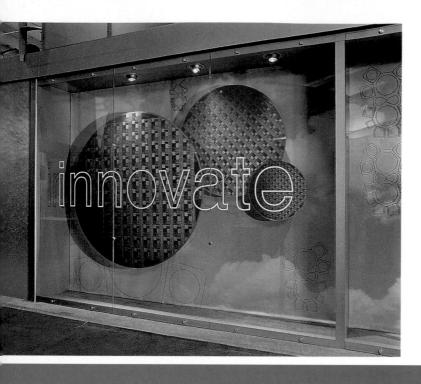

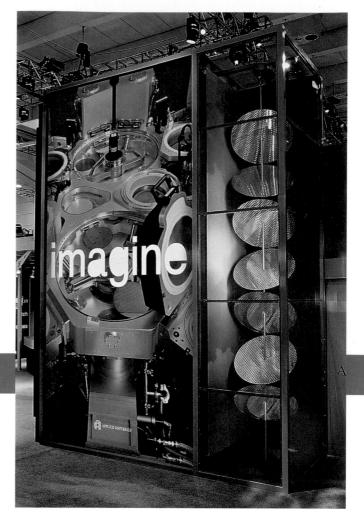

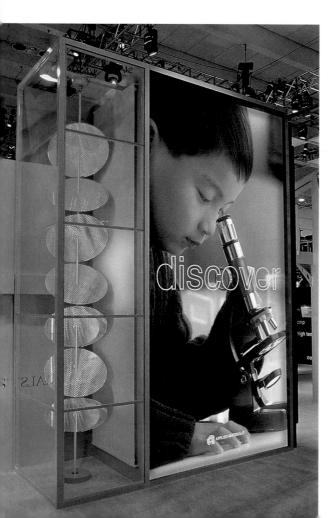

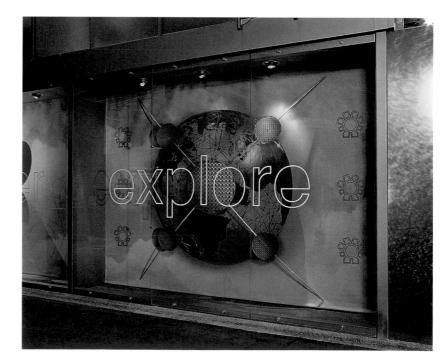

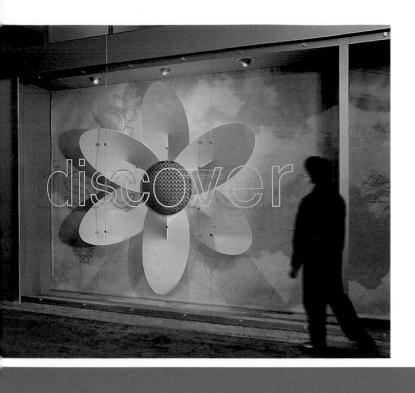

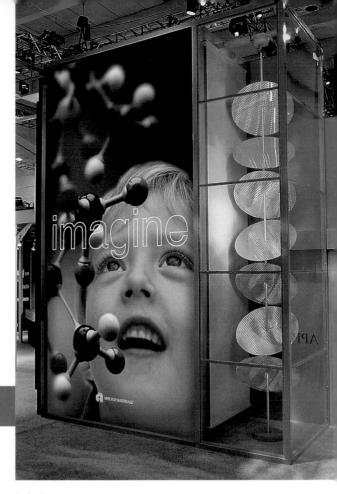

(continued) creative firm GEE + CHUNG DESIGN San Francisco, California client APPLIED MATERIALS

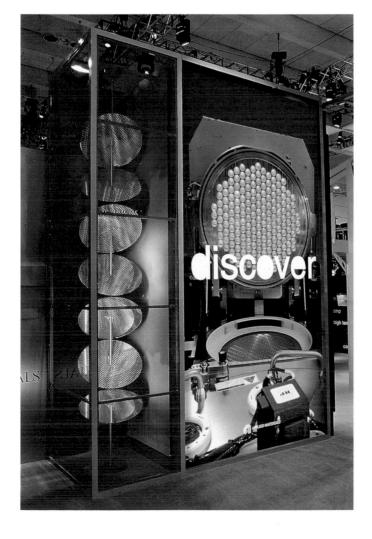

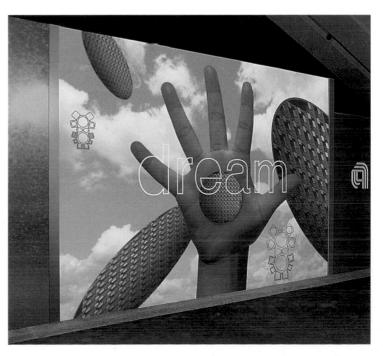

Orne Power of a Multimedia PC Freed From The Desktop.

AP.

) att

creative firm **PROFILE DESIGN** San Francisco, California creative people KENICHI NISHIWAKI, ANTHONY LUK, BRIAN JACOBSON client SONY ELECTRONICS

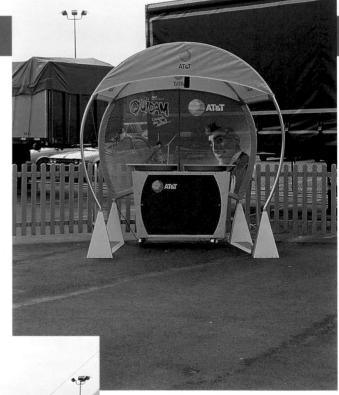

creative firm **BLUMLEIN ASSOCIATES, INC.** Greenvale, New York creative people WILLIAM ARBIZU, SURIN KIM client AT&T/ACURA/CIRQUE DUSOLEIL

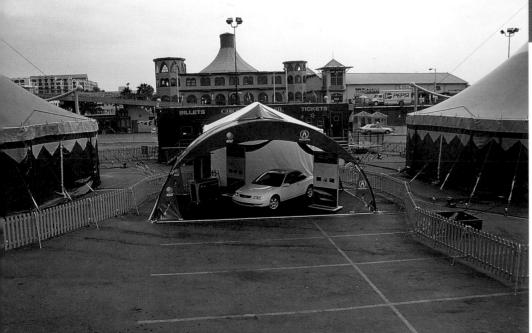

creative firm **RED CANOE** Deer Lodge, Tennessee Creative people DEB KOCH, CAROLINE KAVANAGH, JAN COLLIER, GARY BASEMAN client JAN COLLIER REPRESENTS

USTRATION 1

Deer Lodge, Tennessee creative people DEB KOCH, CAROLINE KAVANAGH, JAN COLLIER, RICHARD BORGE client JAN COLLIER REPRESENTS

creative firm **RED CANOE** Deer Lodge, Tennessee creative people DEB KOCH, CAROLINE KAVANAGH, JAN COLLIER, NICHOLAS WILTON client JAN COLLIER REPRESENTS

> creative firm **RED CANOE** Deer Lodge, Tennessee creative people DEB KOCH, CAROLINE KAVANAGH, JAN COLLIER, GERALD BUSTAMANTE client JAN COLLIER REPRESENTS

creative firm **RED CANOE** Deer Lodge, Tennessee Creative people DEB KOCH, CAROLINE KAVANAGH, JAN COLLIER, MARTI SOMERS client JAN COLLIER REPRESENTS

creative firm RED CANOE

Deer Lodge, Tennessee

Creative people DEB KOCH, CAROLINE KAVANAGH, JAN COLLIER, PETER SYLVADA client JAN COLLIER REPRESENTS

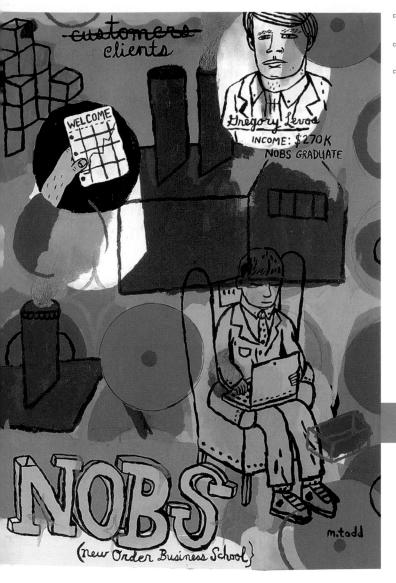

creative firm **RED CANOE** Deer Lodge, Tennessee creative people DEB KOCH, CAROLINE KAVANAGH, JAN COLLIER, MARK TODD client JAN COLLIER REPRESENTS

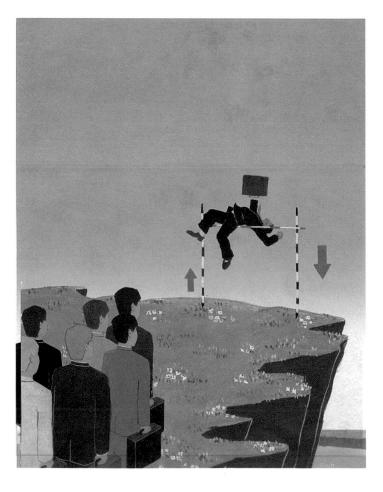

creative firm **RED CANOE** Deer Lodge, Tennessee creative people DEB KOCH, CAROLINE KAVANAGH, JAN COLLIER, ELLIOTT GOLDEN client JAN COLLIER REPRESENTS creative firm **RED CANOE** Deer Lodge, Tennessee creative people DEB KOCH, CAROLINE KAVANAGH, JAN COLLIER, DAVID LESH client JAN COLLIER REPRESENTS

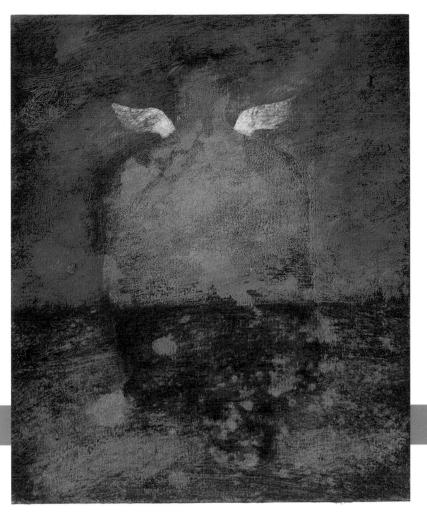

creative firm **RED CANOE** Deer Lodge, Tennessee creative people DEB KOCH, CAROLINE KAVANAGH, JAN COLLIER, RICHARD BORGE client JAN COLLIER REPRESENTS

207

creative firm **RED CANOE** Deer Lodge, Tennessee creative people DEB KOCH, CAROLINE KAVANAGH, JAN COLLIER, JENNIE OPPENHEIMER client JAN COLLIER REPRESENTS

creative firm **RED CANOE** Deer Lodge, Tennessee creative people DEB KOCH, CAROLINE KAVANAGH, JAN COLLIER, RAE ECKLUND client JAN COLLIER REPRESENTS

creative firm **RED CANOE** Deer Lodge, Tennessee creative people DEB KOCH, CAROLINE KAVANAGH, JAN COLLIER, GREG MABLY client JAN COLLIER REPRESENTS

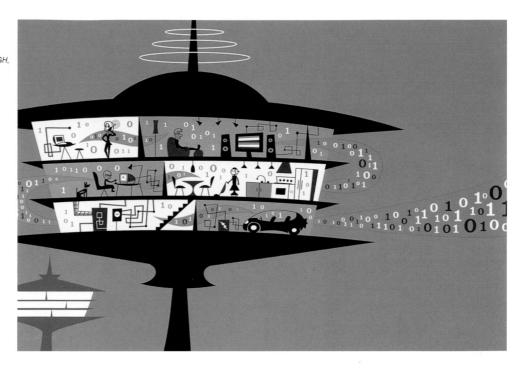

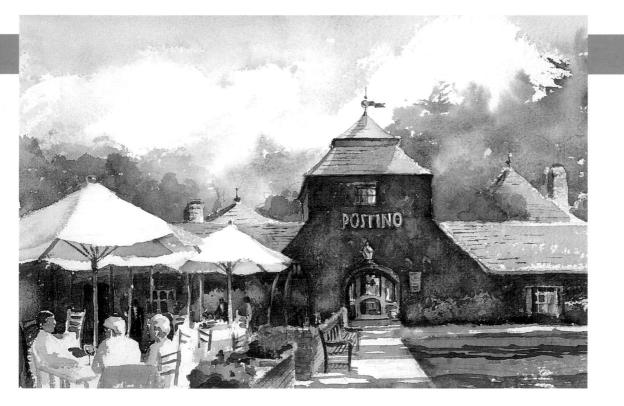

creative firm **RED CANOE** Deer Lodge, Tennessee creative people DEB KOCH, CAROLINE KAVANAGH, JAN COLLIER, RAE ECKLUND client JAN COLLIER REPRESENTS

creative firm **RED CANOE** Deer Lodge, Tennessee creative people DEB KOCH, CAROLINE KAVANAGH, JAN COLLIER, PETER SYLVADA client JAN COLLIER REPRESENTS creative firm **RED CANOE** Deer Lodge, Tennessee creative people DEB KOCH, CAROLINE KAVANAGH, JAN COLLIER, DAVID MILGRIM client JAN COLLIER REPRESENTS

creative firm **RED CANOE** Deer Lodge, Tennessee creative people DEB KOCH, CAROLINE KAVANAGH, JAN COLLIER, TRAVIS FOSTER client JAN COLLIER REPRESENTS

creative firm **RED CANOE** Deer Lodge, Tennescoo creative people DEB KOCH, CAROLINE KAVANAGH, JAN COLLIER, GARY BASEMAN client JAN COLLIER REPRESENTS creative firm **RED CANOE** Deer Lodge, Tennessee creative people DEB KOCH, CAROLINE KAVANAGH, JAN COLLIER, TYSON FULLER client JAN COLLIER REPRESENTS

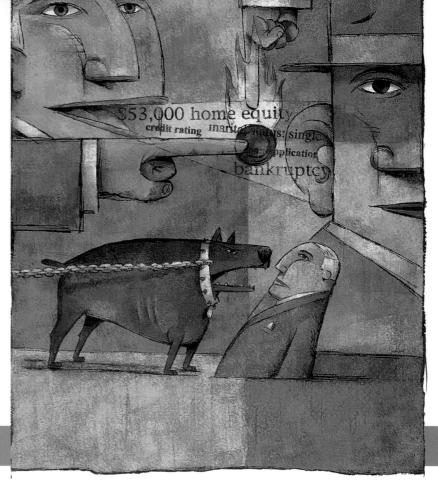

creative firm **RED CANOE** Deer Lodge, Tennessee creative people DEB KOCH, CAROLINE KAVANAGH, JAN COLLIER, PETER SYLVADA client JAN COLLIER REPRESENTS creative firm **RED CANOE** Deer Lodge, Tennessee creative people DEB KOCH, CAROLINE KAVANAGH, JAN COLLIER, JOE FLEMING client JAN COLLIER REPRESENTS

creative firm **RED CANOE** Deer Lodge, Tennessee creative people DEB KOCH, CAROLINE KAVANAGH, JAN COLLIER, TRAVIS FOSTER client JAN COLLIER REPRESENTS

creative firm **RED CANOE** Deer Lodge, Tennessee creative people DEB KOCH, CAROLINE KAVANAGH, JAN COLLIER, RICHARD BORGE client JAN COLLIER REPRESENTS

creative firm **RED CANOE** Deer Lodge, Tennessee creative people DEB KOCH, CAROLINE KAVANAGH, JAN COLLIER, GARY BASEMAN client JAN COLLIER REPRESENTS

creative firm **RED CANOE** Deer Lodge, Tennessee creative people DEB KOCH, CAROLINE KAVANAGH, JAN COLLIER, NICHOLAS WILTON client JAN COLLIER REPRESENTS

creative firm **RED CANOE** Deer Lodge, Tennessee creative people DEB KOCH, CAROLINE KAVANAGH, JAN COLLIER, MARTI SOMERS client JAN COLLIER REPRESENTS

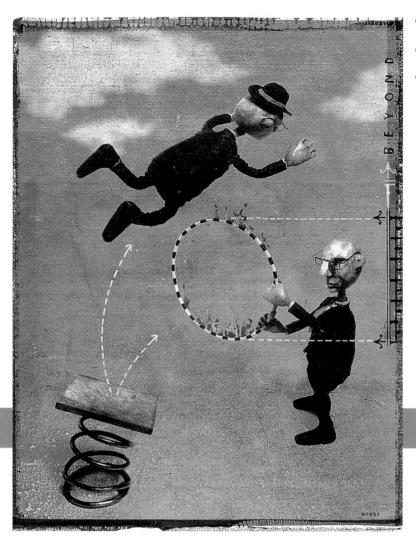

creative firm **RED CANOE** Deer Lodge, Tennessee creative people DEB KOCH, CAROLINE KAVANAGH, JAN COLLIER, RICH BORGE client JAN COLLIER REPRESENTS

creative firm **RED CANOE** Deer Lodge, Tennessee creative people DEB KOCH, CAROLINE KAVANAGH, JAN COLLIER, NICHOLAS WILTON client JAN COLLIER REPRESENTS

creative firm RED CANOE

Deer Lodge, Tennessee creative people DEB KOCH, CAROLINE KAVANAGH, JAN COLLIER, RICH BORGE

client JAN COLLIER REPRESENTS

creative firm **RED CANOE** Deer Lodge, Tennessee creative people DEB KOCH, CAROLINE KAVANAGH, JAN COLLIER, CHRISTIAN NORTHEAST client

client JAN COLLIER REPRESENTS

creative firm **P2 COMMUNICATIONS SVCS.** Falls Church, Virginia creative people BRYN FARRAR client CSC

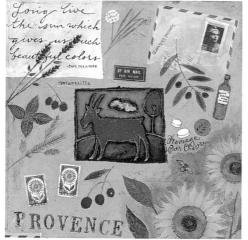

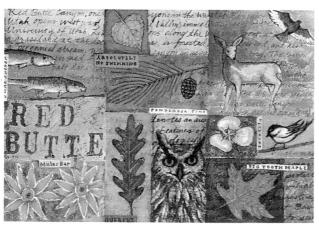

creative firm **PED CANOE** Deer Lodge, Tennessee creative people DEB KOCH, CAROLINE KAVANAGH, JAN COLLIER, MARTI SOMERS client JAN COLLIER REPRESENTS

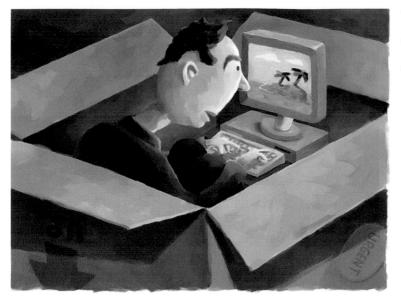

creative firm **RED CANOE** Deer Lodge, Tennessee creative people DEB KOCH, CAROLINE KAVANAGH, JAN COLLIER, MARTI SOMERS client client JAN COLLIER REPRESENTS

creative firm **RED CANOE** Deer Lodge, Tennessee creative people DEB KOCH, CAROLINE KAVANAGH, JAN COLLIER, TRAVIS FOSTER client JAN COLLIER REPRESENTS

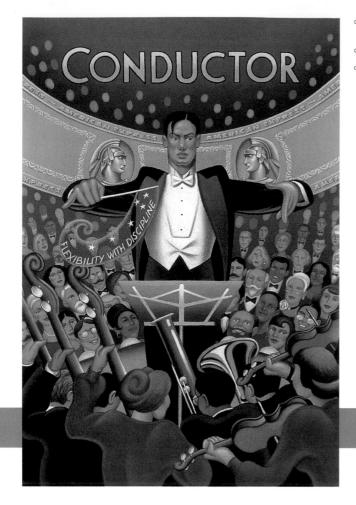

creative firm **P2 COMMUNICATIONS SVCS.** Falls Church, Virginia creative people BRYN FARRAR client client CSC

creative firm **RED CANOE**

Deer Lodge, Tennessee creative people DEB KOCH, CAROLINE KAVANAGH, JAN COLLIER, TRAVIS FOSTER client JAN COLLIER REPRESENTS

creative firm **P2 COMMUNICATIONS SVCS.** Falls Church, Virginia creative people BRYN FARRAR client CSC

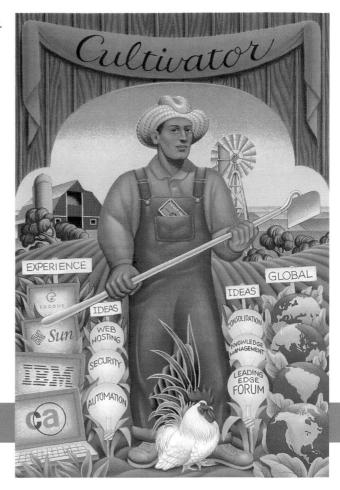

creative firm **RED CANOE** Deer Lodge, Tennessee creative people DEB KOCH, CAROLINE KAVANAGH, JAN COLLIER, DAVID MILGRIM client JAN COLLIER REPRESENTS

LABELS & TAGS

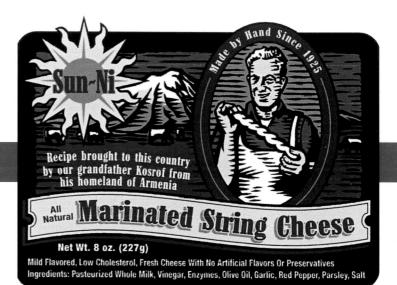

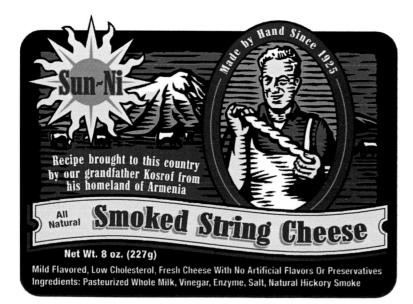

creative firm **DEAN DESIGN/MARKETING GROUP, INC.** Lancaster, Pennsylvania creative people JEFF PHILLIPS client SUN-NI CHEESE

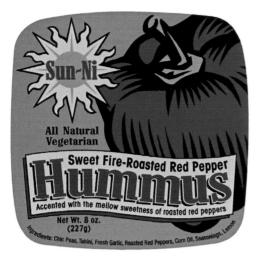

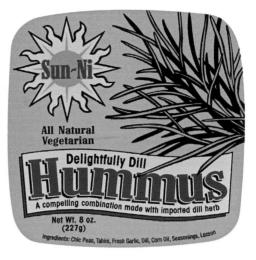

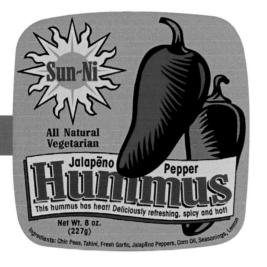

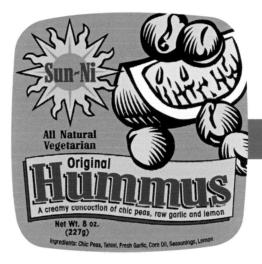

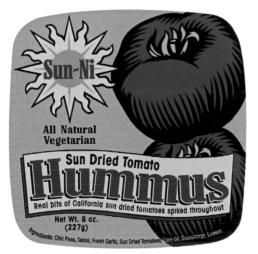

creative firm DEAN DESIGN/ MARKETING GROUP, INC. Lancaster, Pennsylvania creative people JEFF PHILLIPS client SUN-NI CHEESE

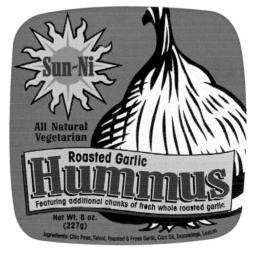

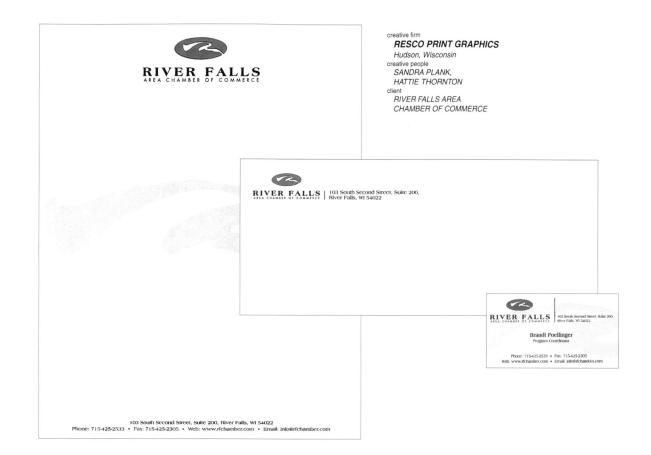

LETTERHEAD SETS

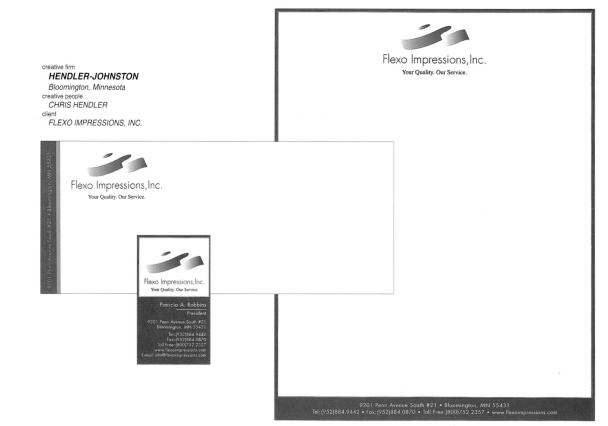

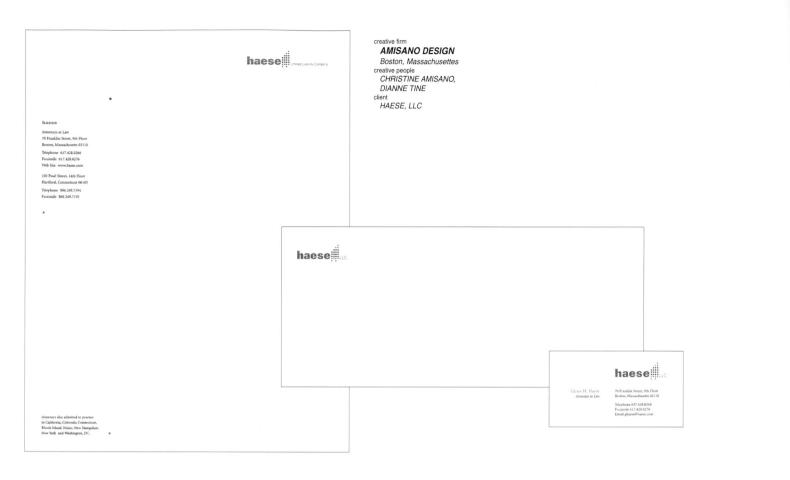

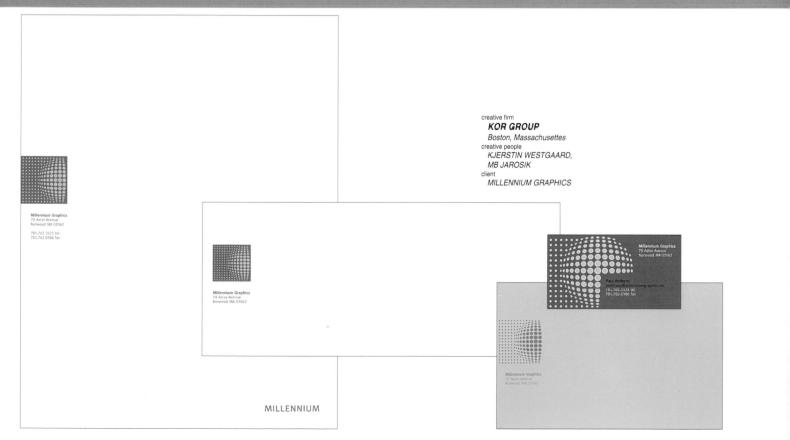

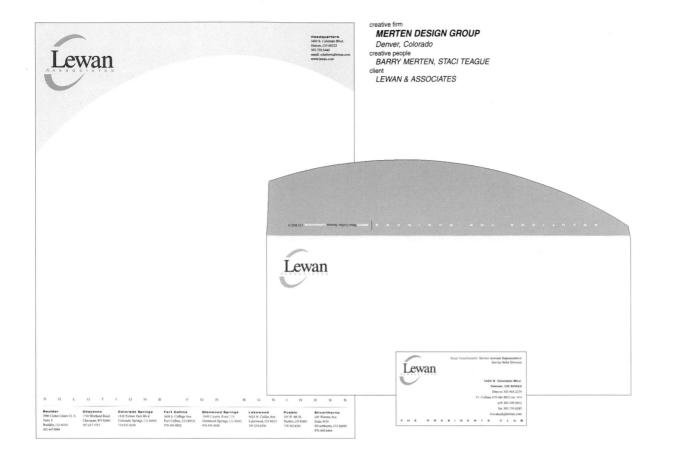

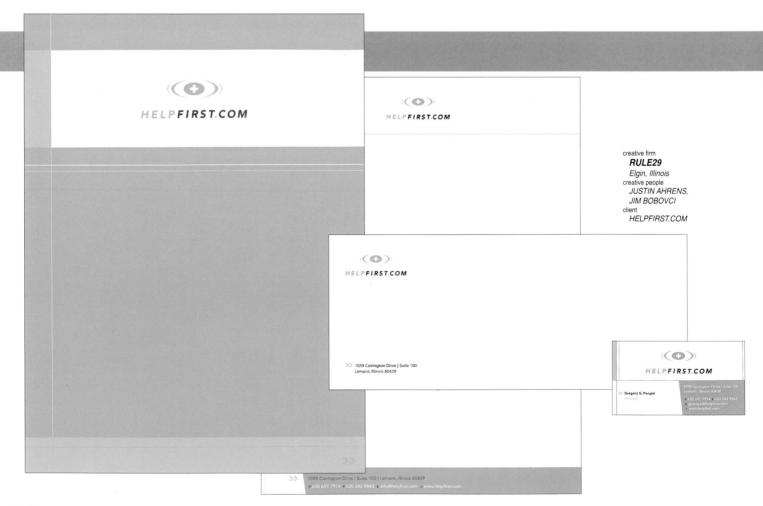

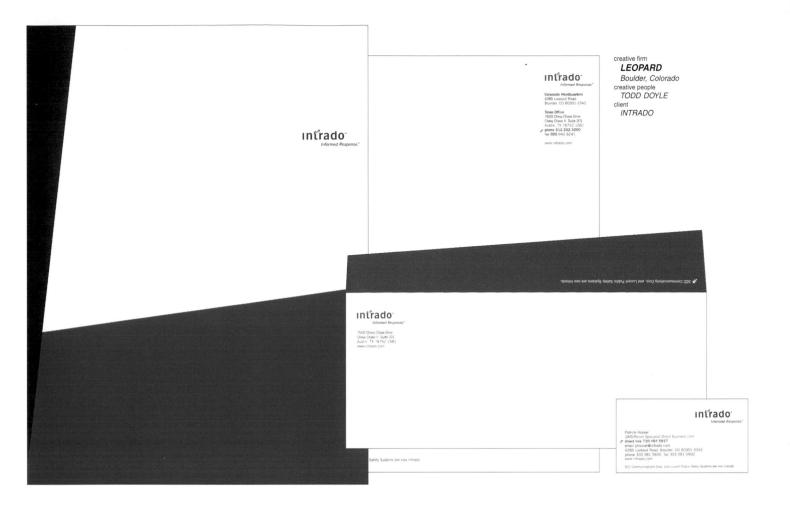

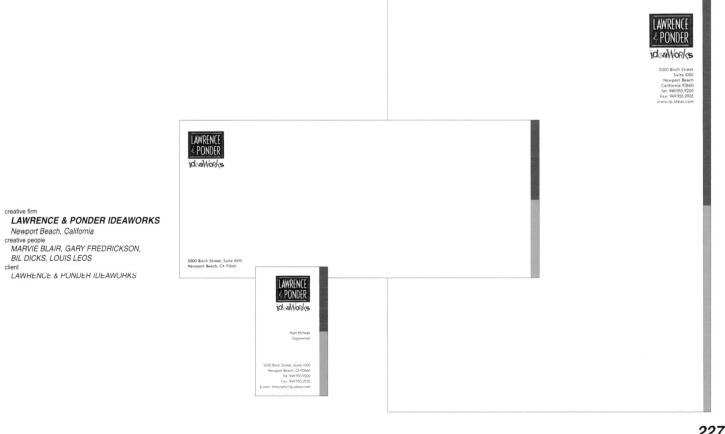

creative firm WELCH DESIGN GROUP, Madison, Wisconsin creative people NANCY WELCH, LISA HEITKE client WELCH DESIGN GROUP, INC.	Welch Design Group, Inc.
Weich Design Group, Inc. 553 yr Mons 52, Modoron Wri 53703 Weich Design Group, Inc. 403-208-1068 Mediowerth-design Group, Inc. 403-208-1068 Mediowerth-design Group, Inc. 403-208-1068 Mediowerth-design Group, Inc. 403-208-1068 Mediowerth-design Group, Inc. 403-208-1068 Mediowerth-design Group, Inc. 403-208-1068 Mediowerth-design Group, Inc.	
	636 W. Washington Ave., Madison, WI 53703 Voice 608 258,1988 Fax 608,258,1977 info@welchidesigrigroup.com www.welchidesigrigroup.com

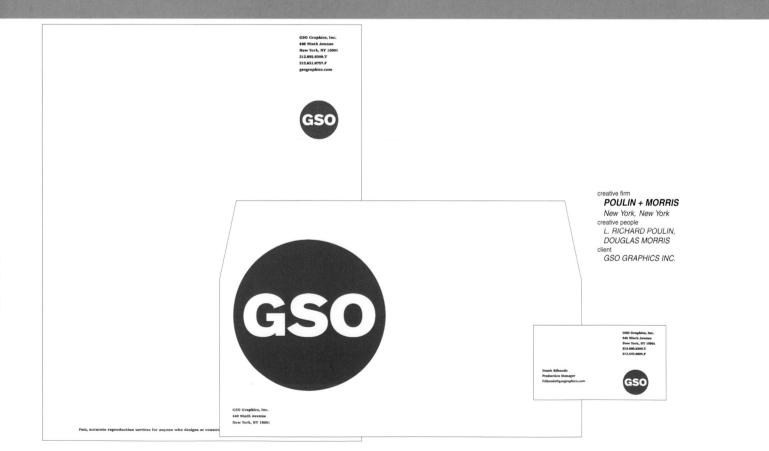

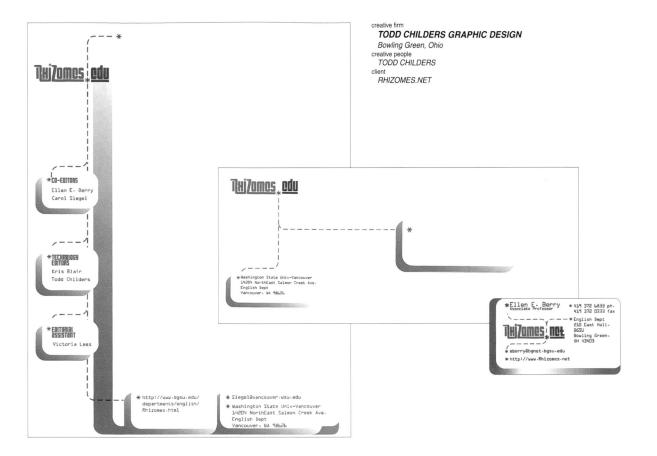

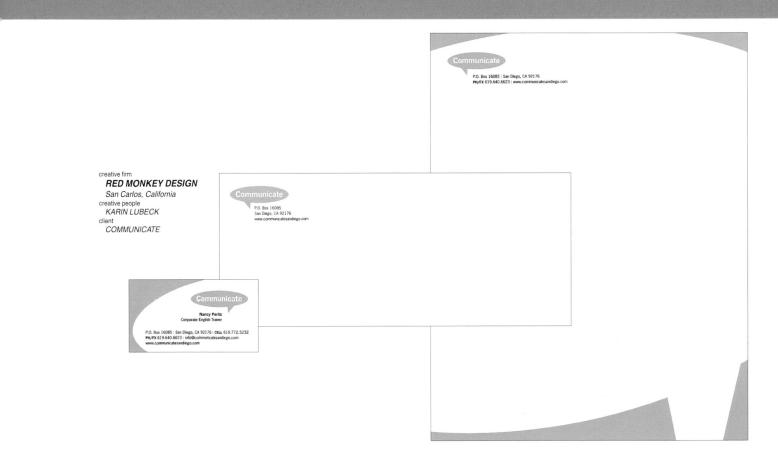

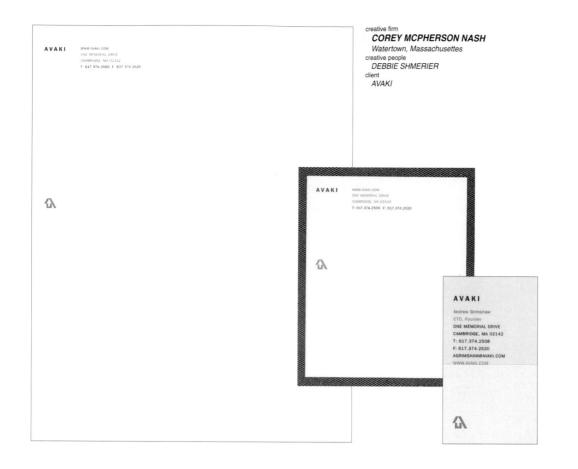

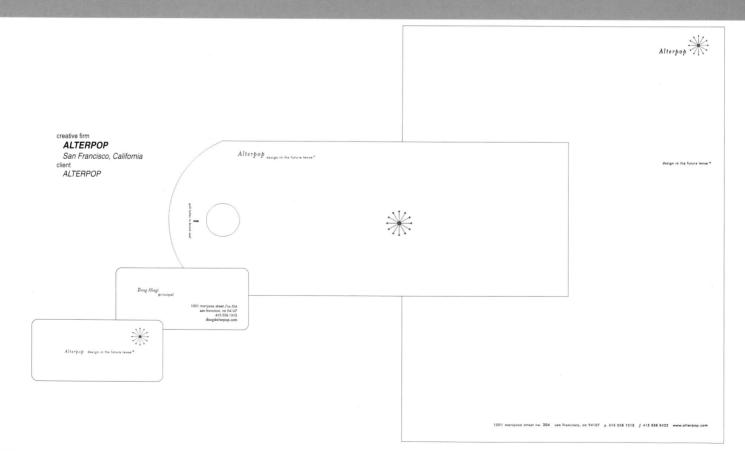

Board of Directors Board O. Directors Board A. Bieterman Toroit A. Bieterman Heat I. Andrade Toroit A. Andrade Toroit A. Andrade Toroit A. Andrade Toroit A. Andrade Toroit A. Andrade Toroit A. Andrade William Bater Heat Burnes matrix Turoit Toroit George Conference Status Conference Co	34th Street Partnership		creative firm SKOORKA DESIGN New York, New York creative people <i>SUSAN SKOORKA</i> client 34TH STREET PARTNERSHIP
No.51 for Resp. Constants and Resp. Constants and Resp. Constants and Resp. Constants and Resp. Constants Resp. Res		334 34th Street Partnership Soli Fith Aerone Soli Fith Aerone	
Graa Health, so Anderen Wron (c. William) / Rod Notari / Rotari Robert Nuto Robert Nuto Robert Nuto Robert Nuto Robert Nuto La Officia C. Vrama Field Auro (J. viewe Deboon Wrets Auron Gray New Astan Tarton Constanting Astrono Kannet Const Astrono Kannet Const A	cei: 500 MM Auerue + Sante 1120 • New York, NY 10 Ing: 212 West 35th 51.+ 3rd Floor • New York, NY 10	110 • 161 212 719 3434 (au 212 718 3499 001 • 161 212 967 3433 (au 212 279 4970	

CONVENAS		G		
630 Johnson Avenue				
Bohemia, NY 11716				
631-218-1400 m 631-218-8448 m				
0.31-216-8448 IAX				
A 44 A VOLTABLINGTON				
				creative firm
	0			CROWLEY WEBB AND ASSOCIATE
	C			Buffalo, New York creative people
	CONVENAS			ANN CASADY
	CONVENAS			client
				CONVENAS SOLUTIONS
	630 Johnson Avenue			
	Bohemia, NY 11716			
			Amy Niles Gonzalez	
			630 Jahnson Avenue Bohemia, NY 11716	
			631-218-1400 m. 631-218-8448 rax	ONVENAS
			617-308-9254 cts. agonzalez@convenas.net	

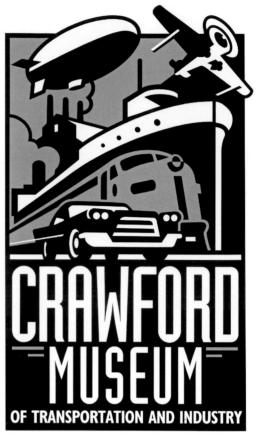

	creative firm TILKA DESIGN
the Teach Street, Soite 300 RAYAN	TILKA DESIGN
Ensured Latitud BL_OTODARY	Minneapolis, Minnesota creative people SARAH STEIL client RYAN COMPANY

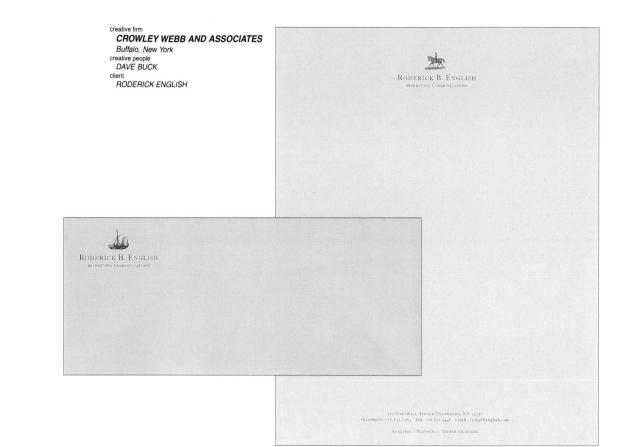

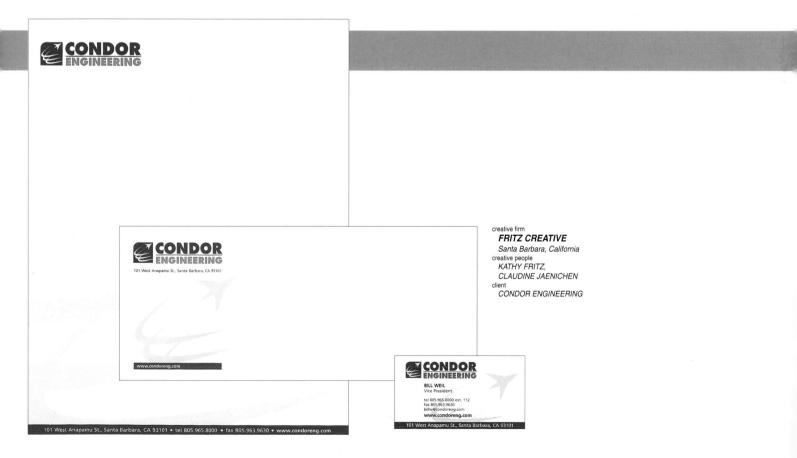

creative firm **DEKA DESIGN INC.** New York, New York creative people DMITRY KRASNY client SUMMERTECH INC. S SummerTech SUMMERTECH PO BOX 70281 WWW.YOK. NO. 10023 SummerTech www.summertech.ne P.O. 9 New Free: 866.814.TECH Phone: 212.579.8500 Fax: 212.579.8573 Steven Daniel Fink owner steven@summertech.net www.summertech.ne Free: 866.814.TECH Phone: 212.579.8500 Fax: 212.579.8573 www.summertech.net P.O. Box 230281 New York NY 10023

EXECUTIVE SEARCH		PHINNEY BISCHOFF DESIGN HOUSE Seattle, Washington creative people LORIE RANSON, LESLIE PHINNEY client ESI	
	Executive Search Intern 375 NV Gleann Boulevar 155aquar, wa 98027		
			UNNE WARD BUCKTA EXECUTIVE SEARCH CONTINUE STANDA EXECUTIVE SEARCH SUIT CIOI BISAQUAL WA 98027 WWW LEI-STANCH COM

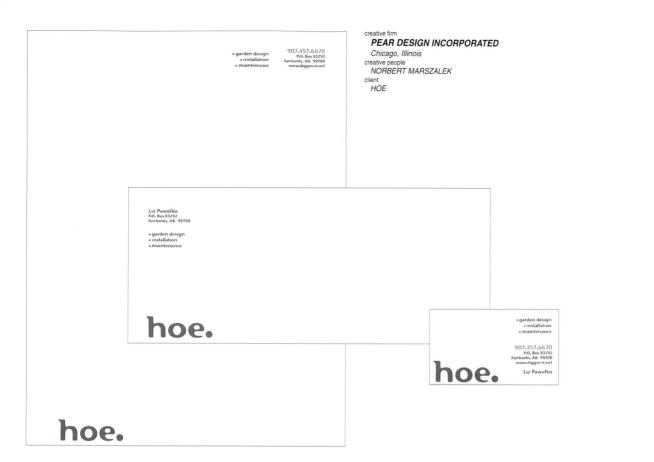

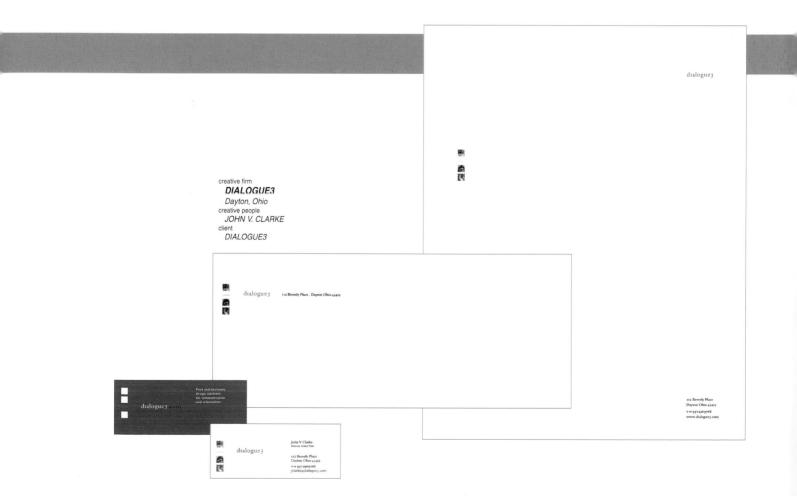

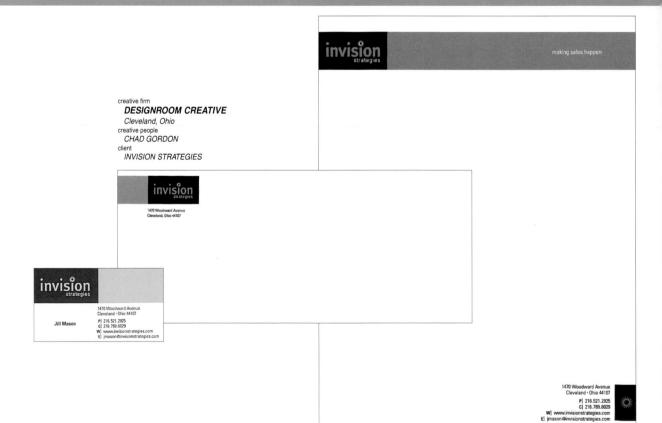

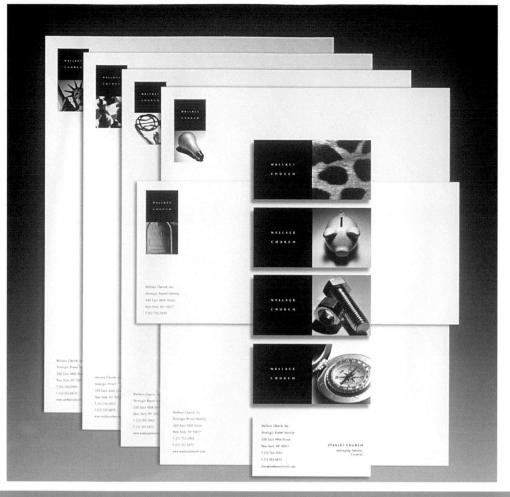

creative firm WALLACE CHURCH, INC. New York, New York creative people STAN CHURCH, NIN GLAISTER, LAWRENCE HAGGERTY client WALLACE CHURCH, INC.

creative firm LAURA COE DESIGN ASSOC. San Diego, California creative people THOMASS RICHMAN client PRINTING INDUSTRIES ASSOCIATION OF SAN DIEGO PRINTING PRINTING COOD PRINTING PRINTING

creative firm LAURA COE DESIGN ASSOC. San Diego, California creative people RYOICHI YOTSUMOTO client ACTIVE MOTIF

reative time **PACE DATE DA**

PLISE DEVELOPMENT & CONSTRUCTION

compete in the new economy Wirestone

Re presents

creative firm PHINNEY BISCHOFF DESIGN HOUSE Seattle, Washington creative people DEAN HART, LESLIE PHINNEY client LOCATE NETWORKS	3250 Cardine Pret 000 Kotkind, WA 19023 000 Preme: 423 122 4600 1 Fax: 475 322 4600 1
STO Carifie Point Entidene, WA 58023	
LECENTE 3200 Curilles Pour N.T. W. O. S.K.S. Excluded, MA B023 Paner 453 222 4280 France 453 222 4280 Frank A. Nexuel Concret/ restand@Listatehenswitk.com France 453 222 4280	

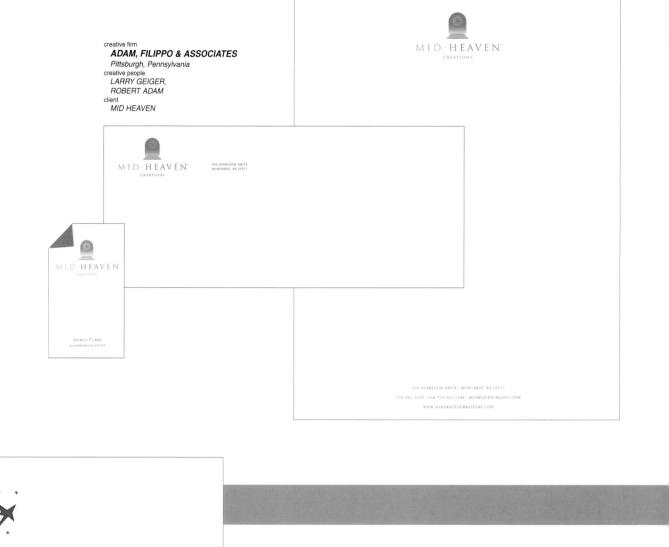

creative firm ORIGINAL IMPRESSIONS Miami, Florida creative people MARIO ACUNA, MARY RUIZ client MAKU ART USA CORP.

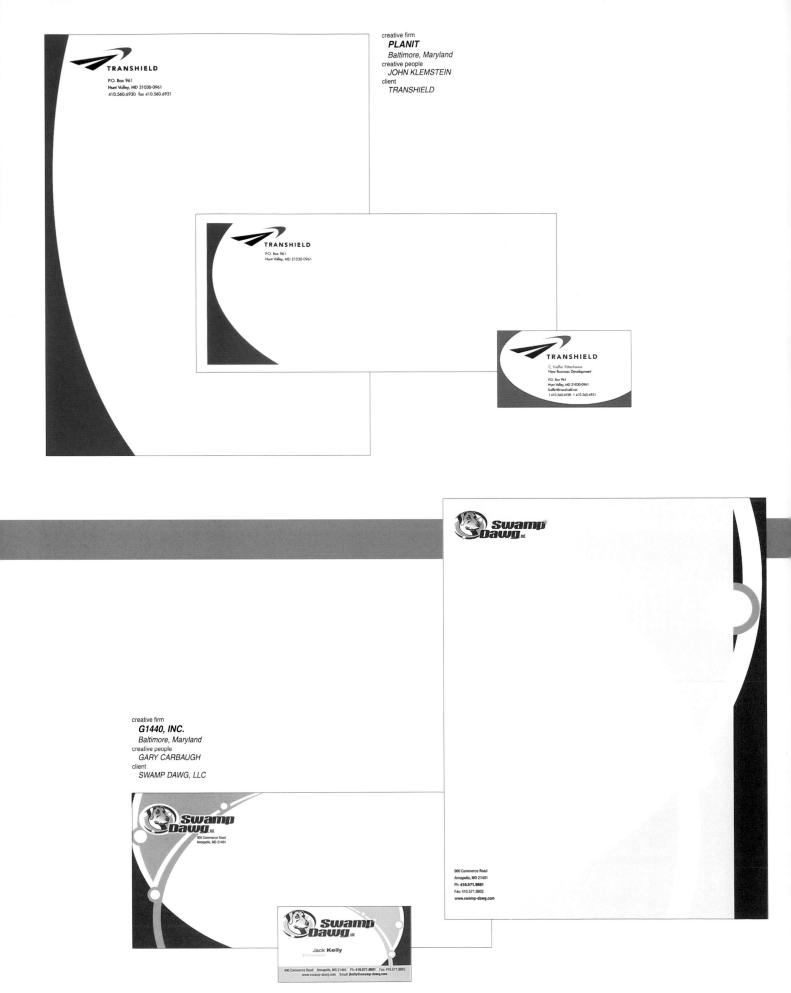

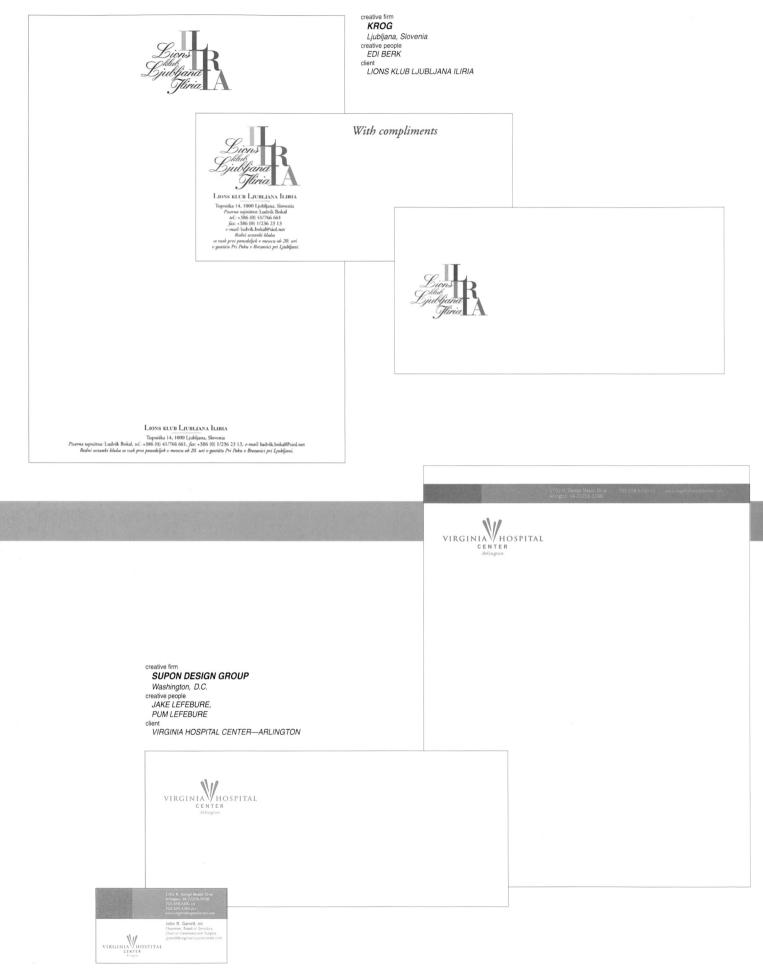

MENUS

creative firm **DESIGN SOLUTIONS** Napa, California creative people DEBORAH MITCHELL, RICHARD MITCHELL client TREFETHEN VINEYARDS creative firm CREATIVE DYNAMICS, INC. Las Vegas, Nevada creative people MICHELLE GEORGILAS, EDDIE ROBERTS client MOUNTAIN HAMS

creative firm **GLITSCHKA STUDIOS** Salem, Oregon creative people VON R. GLITSCHKA client SASSY ONION GRILL

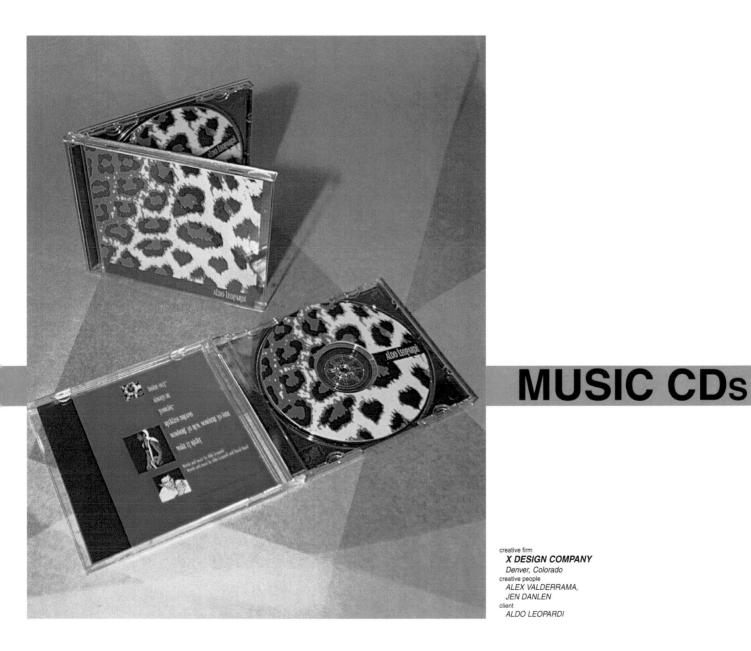

creative firm HAMAGAMI/CARROLL Santa Monica, California creative people KRIS TIBOR client 20TH CENTURY FOX

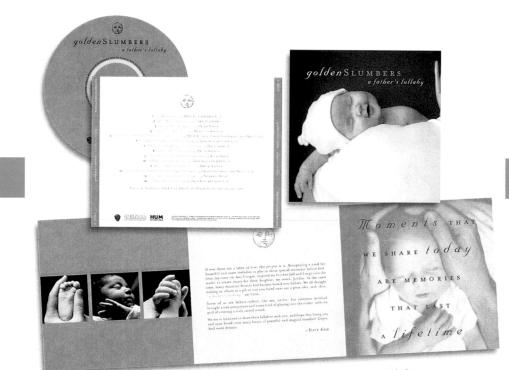

creative firm **TOP DESIGN STUDIO** Toluca Lake, California creative people REBEKAH BEATON, PELEG TOP client WARNER BROTHERS RECORDS RENDEZVOUS ENTERTAINMENT

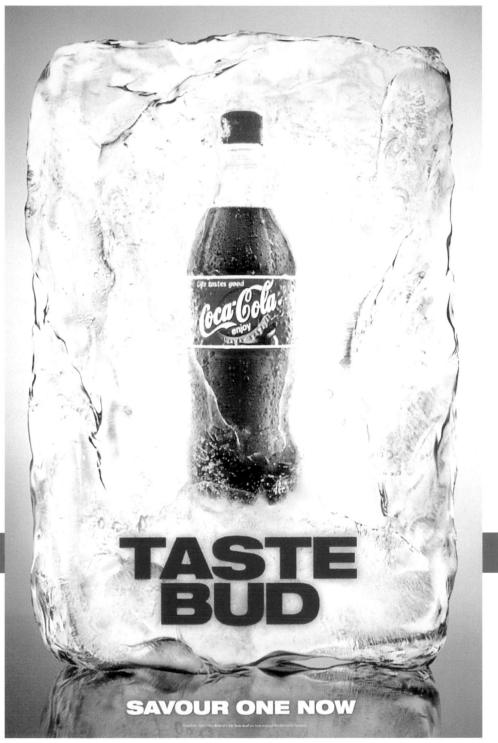

OUTDOOR

creative firm MCCANN-ERICKSON SYDNEY Sydney, Australia creative people PATRICK BARON, JULIAN SCHREIBER client COCA-COLA

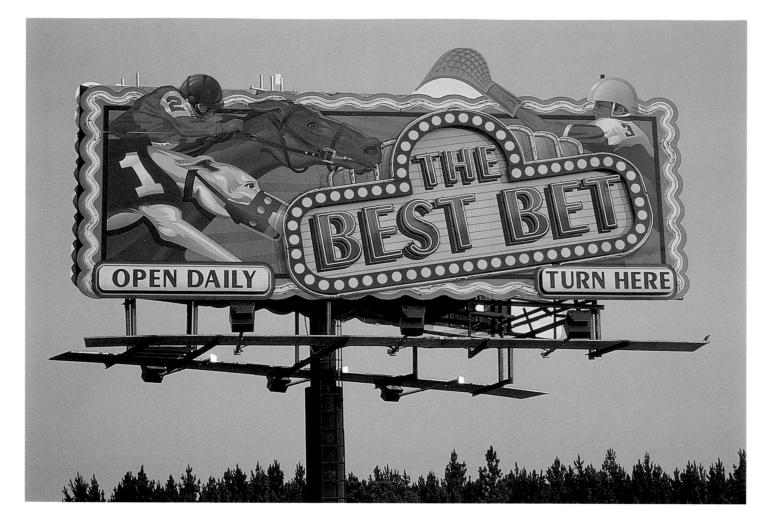

creative firm GOLD & ASSOCIATES Ponte Vedra Beach, Florida creative people KEITH GOLD, JOSEPH VAVRA client THE KENNEL CLUBS/ ST. JOHNS GREYHOUND PARK

creative firm **GOLD & ASSOCIATES** Ponte Vedra Beach, Florida creative people KEITH GOLD, JOSEPH VAVRA client THE KENNEL CLUBS

Windham Mountain Exit 21

PERFORMANCE GRAPHICS PERFORMANICE OF LAKE NORMAN INC. Cornelius, North Carolina creative people MITZI MAYHEW, ALEC MCALISTER client LIMEAIDE REFRESHING DELIVERY

creative firm COLGATE-PALMOLIVE PROMOTION DESIGN STUDIO New York, New York creative people LISA SILVERIO, RANDI RODIN client COLGATE-PALMOLIVE

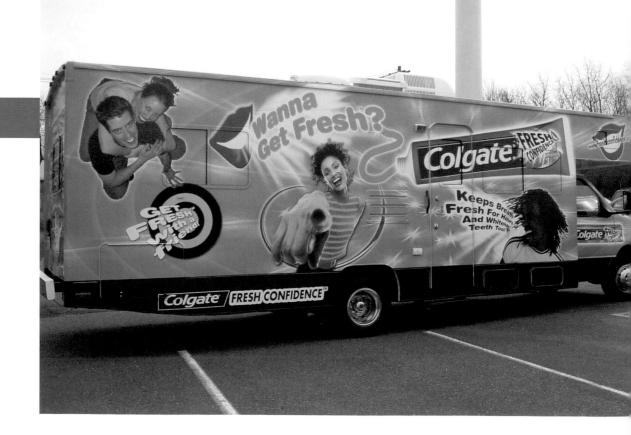

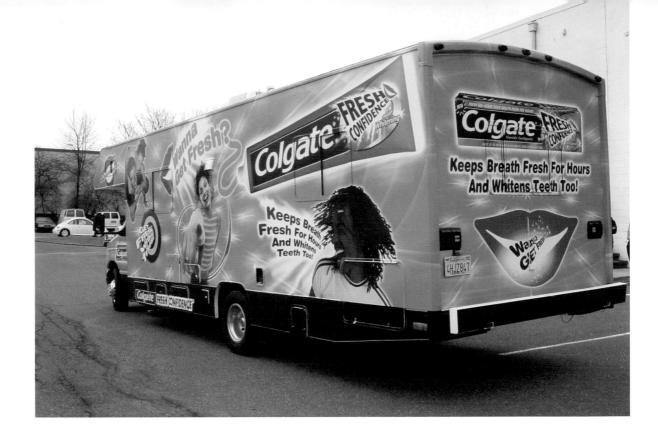

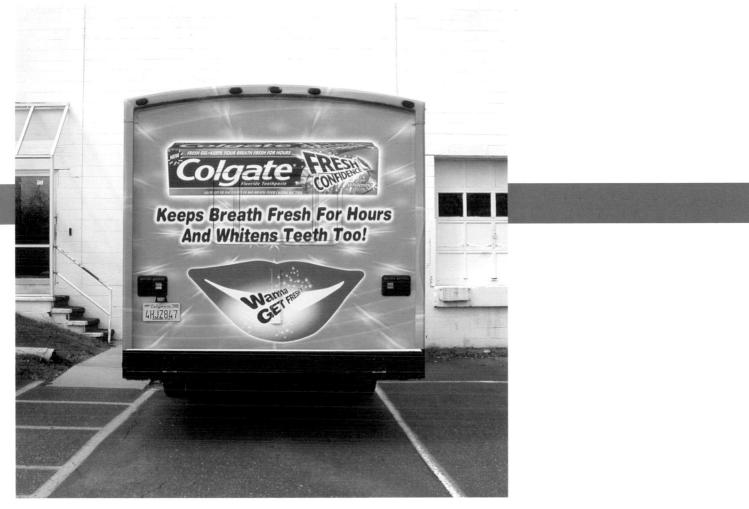

creative firm **WKSP ADVERTISING** Ramat Gan, Israel creative people DANIEL GOLDIN, ORLY FRUM client SONOL translation CAN'T GET UP THE HILL? THERE'S DIESEL.....AND THERE'S GOLDIESEL THE ENGINE PROTECTOR. ONLY AT SONOL

IKSP

שומר הראש של המנוע. רק ב- **סונול**

creative firm WKSP ADVERTISING Ramat Gan, Israel creative people DANIEL GOLDIN, ORLY FRUM client SONOL translation FILTERS BLOCKED? THERE'S DIESEL....AND THERE'S GOLDIESEL THE ENGINE PROTECTOR. ONLY AT SONOL

לא סוחב בעלייה?

creative IIIm WKSP ADVERTISING Ramat Gan, Israel creative people DANIEL GOLDIN, ORLY FRUM client SONOL translation ENGINE TROUBLE? THERE'S DIESEL.....AND THERE'S GOLDIESEL THE ENGINE PROTECTOR. ONLY AT SONOL

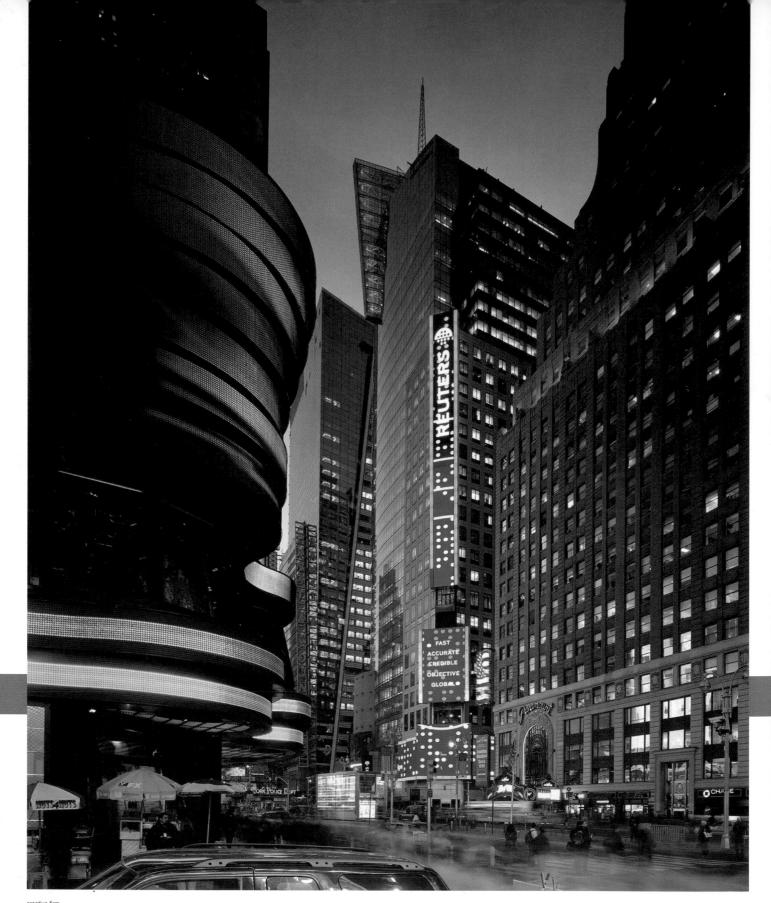

creative firm **ESI DESIGN** New York, New York

creative people

Teative people EDWIN SCHLOSSBERG, JOE MAYER, STACEY LISHERON, MARTHA GARVEY, MATTHEW MOORE, GIDEON D'ARCANGELO, ANGELA GREENE, JOHN ZAIA, MARK CORRAL, DEAN MARKOSIAN, NAOMI MIRSKY, RON McBAIN

client REUTERS AND INSTINET

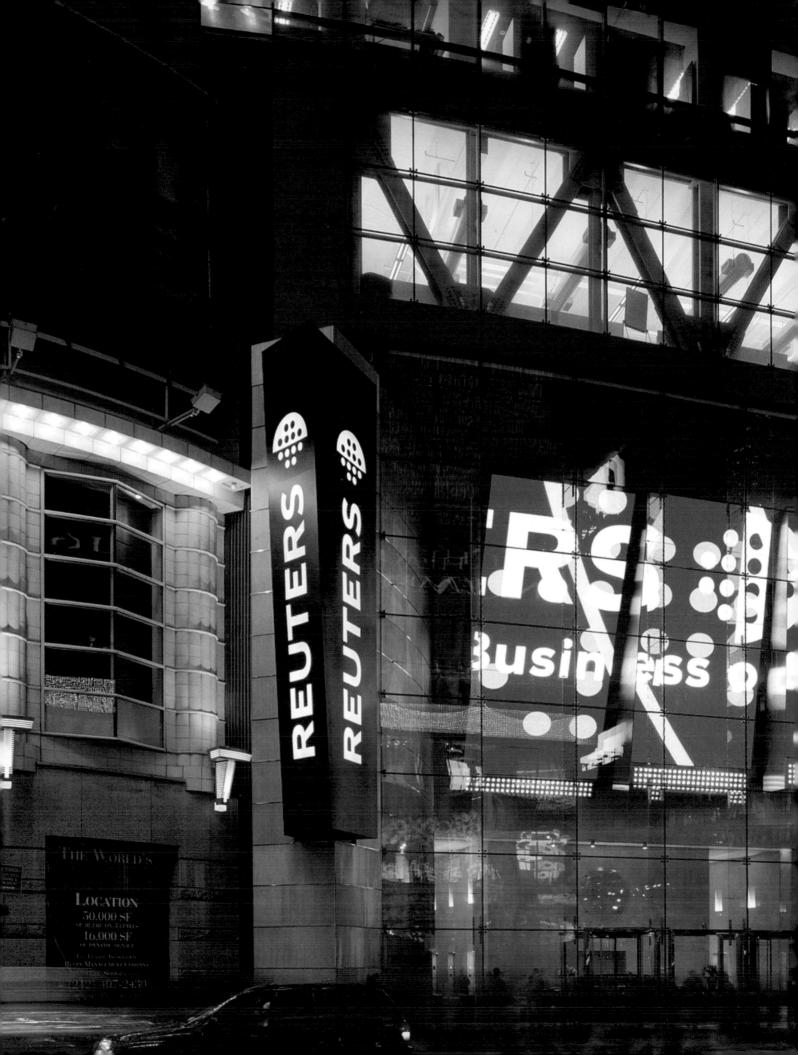

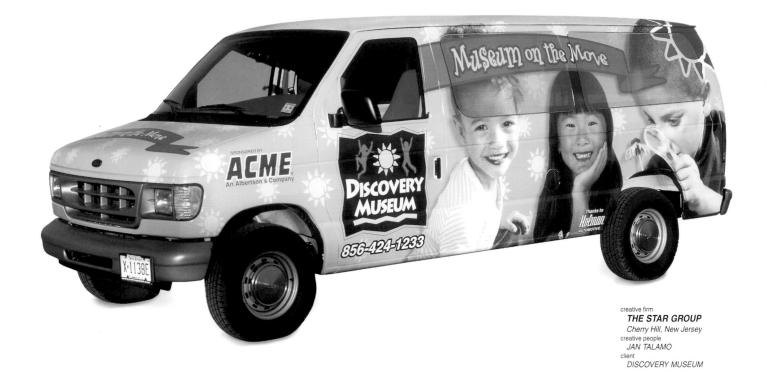

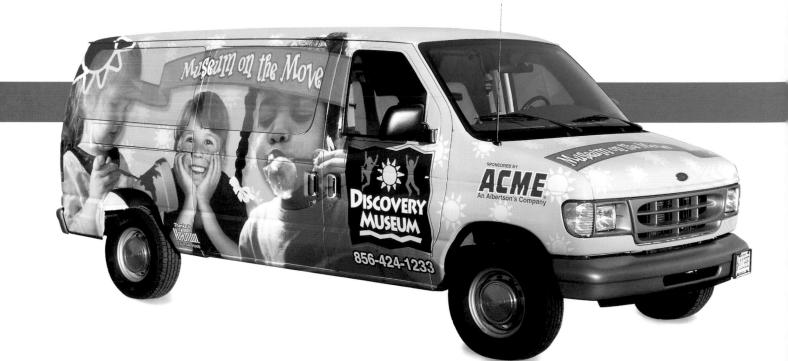

creative firm **COMPASS DESIGN** Minneapolis, Minnesota orrative pooplo MITCH LINDGREN, BILL COLLINS, TOM ARTHUR MATT MCKEE client BETTY CROCKER

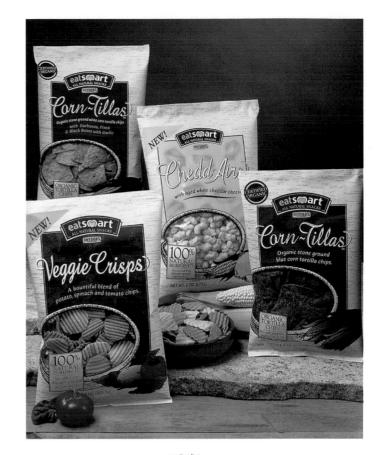

creative firm ALBERT BOGNER DESIGN COMMUNICATIONS Lancaster, Pennsylvania creative people KELLY ALBERT, KERRY BURKHART client SNYDER'S OF HANOVER

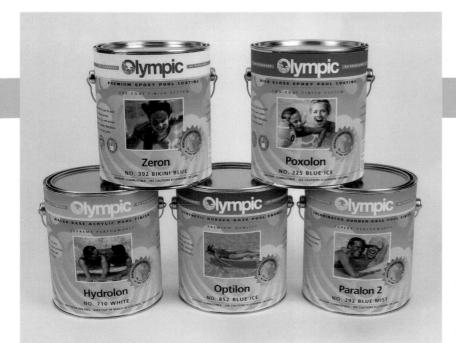

PACKAGING

creative firm SMITH DESIGN ASSOCIATES Charlestown, Indiana creative people CHERYL SMITH client KELLEY TECHNICAL COATINGS

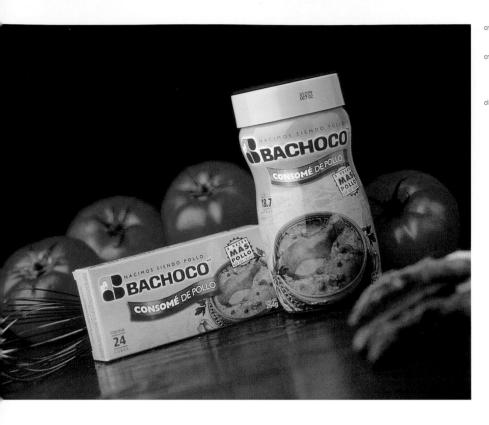

creative firm **TD2, S.C.** Mexico City, Mexico creative people RAFAEL TREVINO MONTEAGUDO, RAFAEL RODRIGO CORDOVA ORTIZ, BRENDA CAMACHO SAENZ, EDGAR MEDINA GRACIANO client BACHOCO

creative firm **SZYLINSKI ASSOCIATES INC.** New York, New York creative people ED SZYLINSKI client BAYER CONSUMER CARE DIVISION

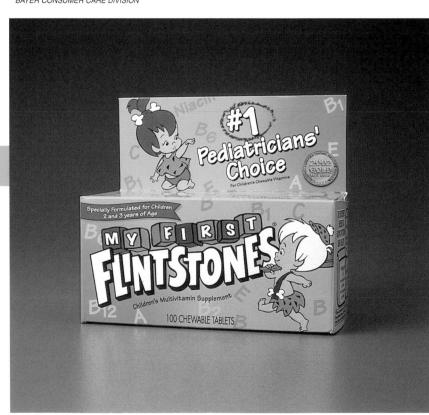

creative firm **TOM FOWLER, INC.** Norwalk, Connecticut creative people THOMAS G. FOWLER, MARY ELLEN BUTKUS, BRIEN O'REILLY client HONEYWELL CONSUMER PRODUCTS GROUP

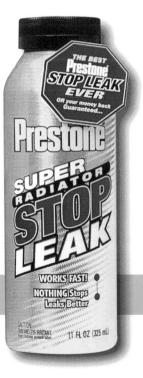

creative firm **THE WEBER GROUP, INC.** Racine, Wisconsin creative people ANTHONY WEBER, SCOTT SCHREIBER, NICK BINETTI, SHAD SMITH client S.C. JOHNSON & SON, INC.

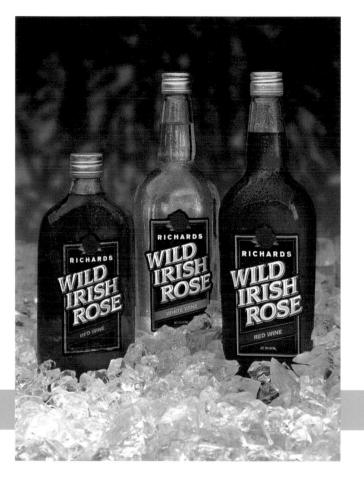

creative firm MCELVENEY & PALOZZI DESIGN GROUP, INC. Rochester, New York creative people NICK WOYCIESJES creative firm **THE IMAGINATION COMPANY** Bethel, Vermont creative people KRISTEN SMITH, SHANE YOUNG, MICHAEL CRONIN client ROCK OF AGES

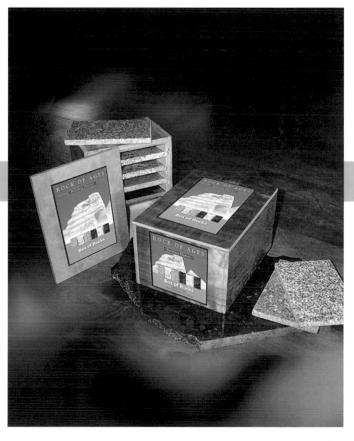

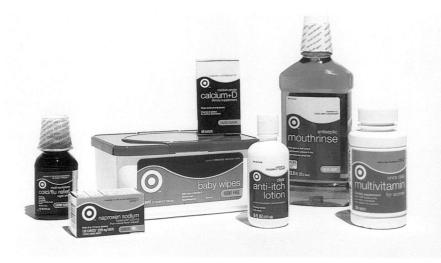

creative firm **DESIGN GUYS** Minneapolis, Minnesota creative people STEVE SIKORA, KATIE KIRK, WENDY BONNSTETTER client TARGET STORES

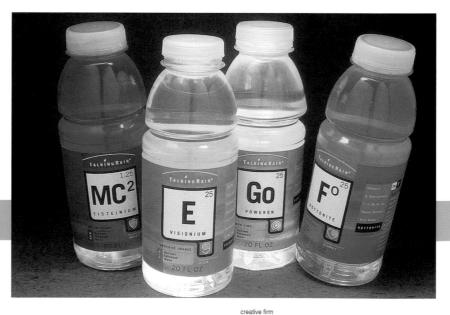

HORNALL ANDERSON DESIGN WORKS, INC. Seattle, Washington creative people JACK ANDERSON, JANA NISHI, MARY CHIN HUTCHISON, BELINDA BOWLING client TALKING RAIN

creative firm FORWARD BRANDING & IDENTITY Webster, New York client WEGMANS FOOD MARKETS

Wegmans

Hot & Tangyl

12 FL OZ • 355mL

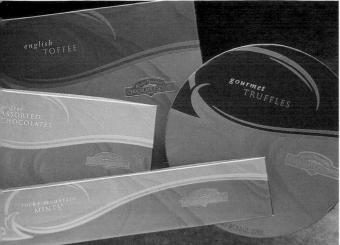

creative firm

DESIGN WORKS, INC. Seattle, Washington creative people JACK ANDERSON, LARRY ANDERSON, GRETCHEN COOK, JAY HILBURN, KAYE FARMER, ANDREW WICKLUND

client ROCKY MOUNTAIN CHOCOLATE FACTORY

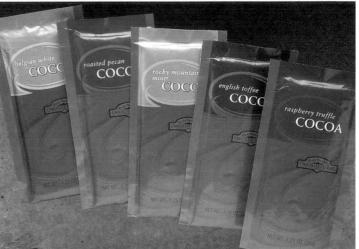

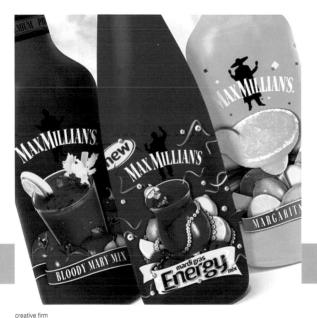

ZUNDA DESIGN GROUP South Norwalk, Connecticut creative people CHARLES ZUNDA, PATRICK SULLIVAN client MAXMILLIAN'S MIXERS

creative firm THOMPSON DESIGN GROUP San Francisco, California creative people DENNIS THOMPSON, PATRICK FRASER client NESTLÉ PURINA PETCARE COMPANY

DARK CHOCOLATI

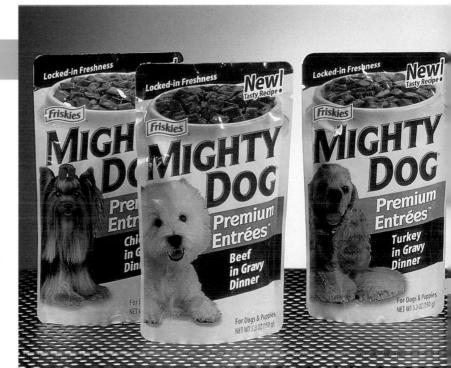

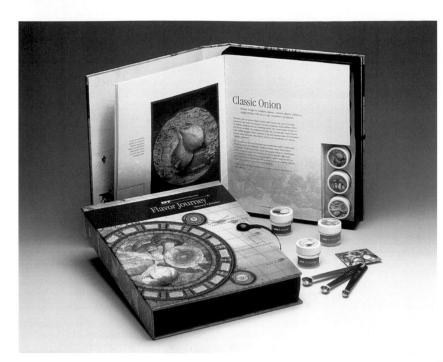

creative firm **AJF MARKETING** Piscataway, New Jersey creative people JUSTIN BRINDISI client IFF INTERNATIONAL FLAVORS & FRAGRANCES

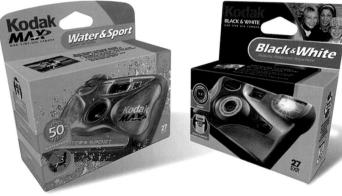

creative firm **FORWARD BRANDING & IDENTITY** Webster, New York client EASTMAN KODAK COMPANY

creative firm **TOM FOWLER, INC.** Norwalk, Connecticut creative people MARY ELLEN BUTKUS, THOMAS G. FOWLER, BRIEN O'REILLY client HONEYWELL CONSUMER PRODUCTS

280

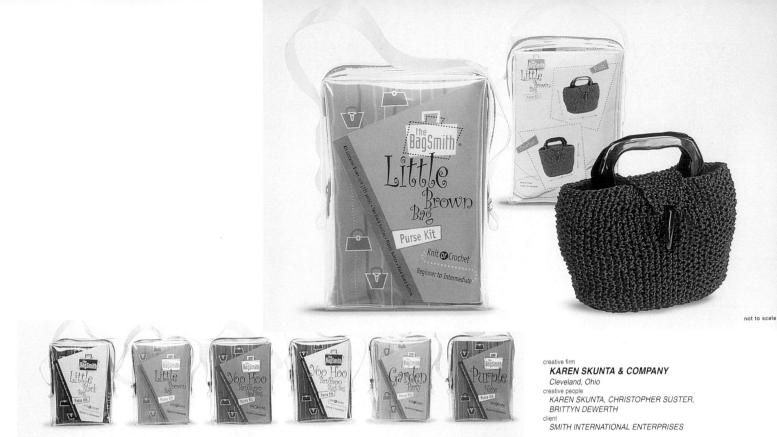

creative firm THE LEYO GROUP, INC. Chicago, Illinois creative people JAYCE SCHMIDT, HORST MICKLER, ROBY AZUBEL, FERNANDA FINGUER, GERARDO LASPIUR, BILL LEYO

BELLA NICO, INC.

с

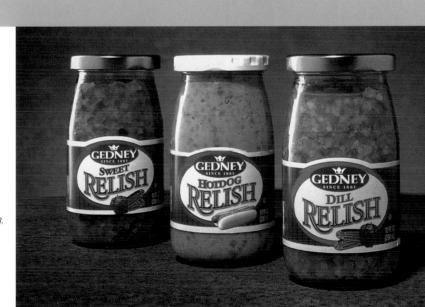

creative firm Minneapolis, Minnesota creative people MITCH LINDGREN, TOM ARTHUR, BILL COLLINS, RICH MCGOWEN client GEDNEY

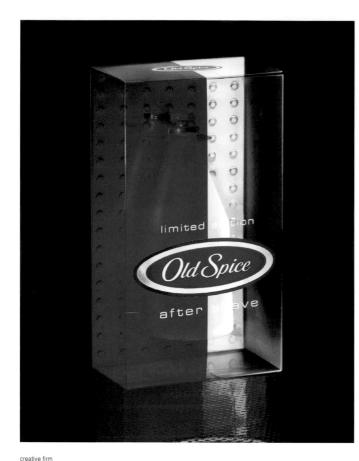

creative firm CASSATA & ASSOCIATES Schaumburg, Illinois creative people JAMES WOLFE client WM. WRIGLEY JR. CO.

INTERBRAND HULEFELD Cincinnati, Ohio creative people DENNIS DILL, BART LAUBE, JEAN CAMPBELL Client PROCTER & GAMBLE

POLAROLO IMMAGINE E COMUNICAZIONE Torino, Italy creative people FELICE POLAROLO, CRISTINA GARELLO client MEDESTEA

creative firm

282

creative firm BALL ADVERTISING & DESIGN, INC. Statesville, North Carolina creative people LANE BALL, SHELLEY BALL client OLDHAM

creative firm HORNALL ANDERSON DESIGN WORKS, INC. Seattle, Washington creative people JACK ANDERSON, JOHN ANICKER, ANDREW SMITH, ANDREW WICKLUND, MARY HERMES, JOHN ANDERLE elient

client ONEWORLD CHALLENGE

creative firm **DESIGN GUYS** Minneapolis, Minnesota creative people STEVEN SIKORA, ANNE PETERSON client TARGET STORES

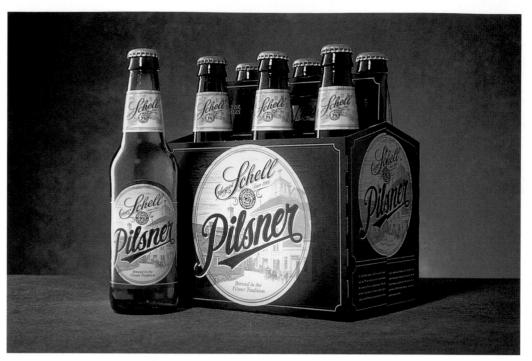

creative firm **COMPASS DESIGN** Minneapolis, Minnesota

creative people MITCH LINDGREN, TOM ARTHUR, BILL COLLINS, RICH MCGOWEN client AUGUST SCHELL BREWING CO.

creative firm MARCIA HERRMANN DESIGN Modesto, California creative people MARCIA HERRMANN client MARSHALL McCORMICK WINERY

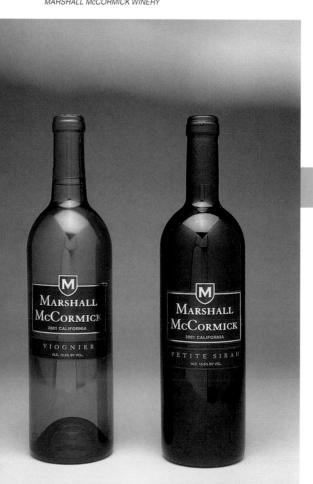

creative firm **BAILEY DESIGN GROUP** Plymouth Meeting, Pennsylvania creative people CHRISTIAN WILLIAMSON, STEVE PERRY, WENDY SLAVISH client WILLIAM GRANT AND SONS

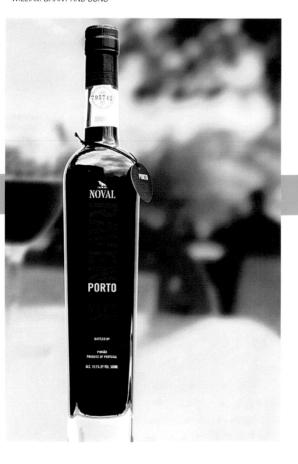

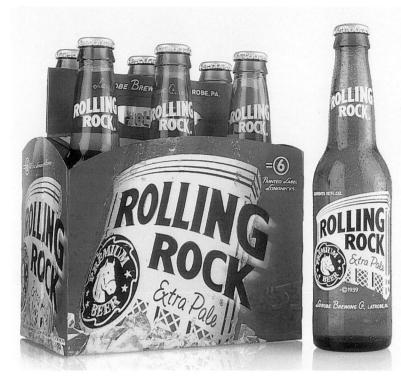

creative firm HMS DESIGN, INC. S.Norwalk, Connecticut creative people JOSH LAIRD client LABATT USA, INC.

creative firm MARCIA HERRMANN DESIGN Modesto, California creative people MARCIA HERRMANN client WEND TYLER WINERY

HORNALL ANDERSON DESIGN WORKS, INC. Seattle, Washington

JACK ANDERSON, LARRY ANDERSON, JACK ANDERSON, LARRY ANDERSON, JAY HILBURN, KAYE FARMER, HENRY YIU, MARY CHINN HUTCHISON, SONJA MAX, DOROTHEE SOECHTING

client KAZI BEVERAGE COMPANY

creative firm

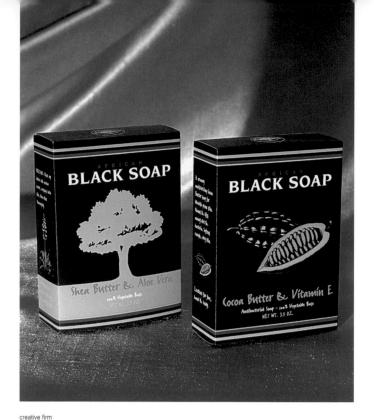

creative firm WALLACE CHURCH, INC. New York, New York creative people STAN CHURCH, JOHN BRUNO client AHOLD

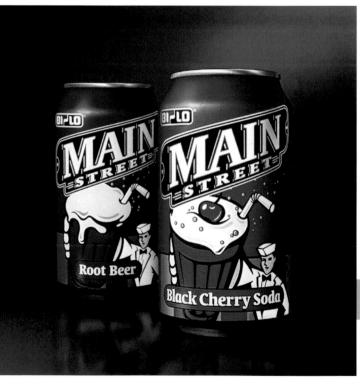

creative firm HMS DESIGN, INC. S.Norwalk, Connecticut creative people INGA EKGAUS client DPSU, INC.

20 FL 0Z (125 FT) 592 mL

creative firm **COMPASS DESIGN** Minneapolis, Minnesota creative people MITCH LINDGREN client AUGUST SCHELL BREWING CO.

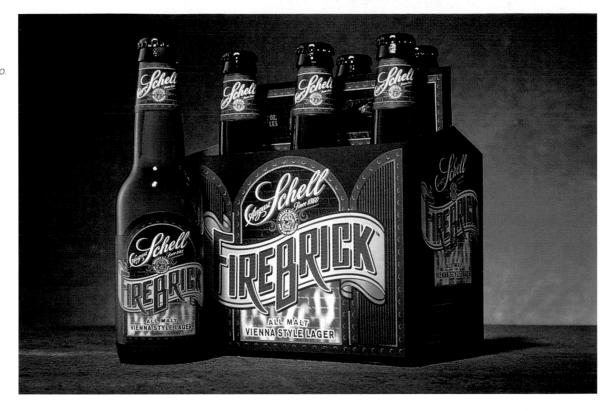

creative firm **BAILEY DESIGN GROUP** Plymouth Meeting, Pennsylvania creative people JERRY COVCORAN, WENDY SLAVISH, STEVE PERRY client WILLIAM GRANT AND SONS creative firm MCELVENEY & PALOZZI DESIGN GROUP Rochester, New York creative people NICK WOYCIESJES client HERON HILL WINERY

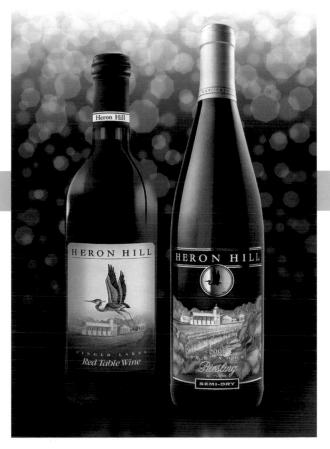

creative firm KARACTERS DESIGN GROUP Vancouver, Canada creative people MARIA KENNEDY, MATTHEW CLARK Client CLEARLY CANADIAN BEVERAGE CORP.

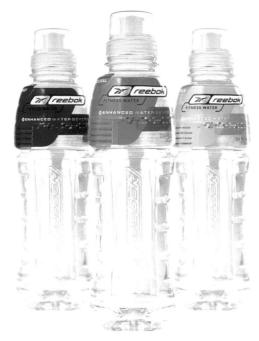

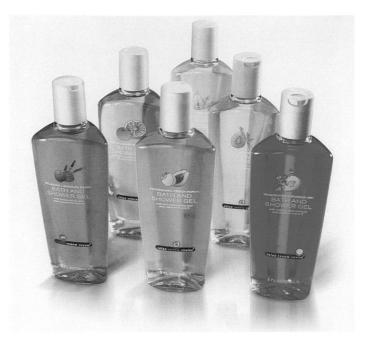

creative firm WALLACE CHURCH, INC. New York, New York creative people STAN CHURCH, DAVID MINKLEY client AHOLD

creative firm POLAROLO IMMAGINE E COMUNICAZIONE Torino, Italy creative people FELICE POLAROLO, SONIA AMBROGGI, STEFANIA RICCHIERI client MIRATO—ITALY

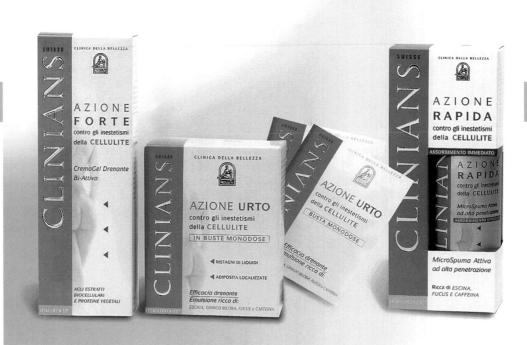

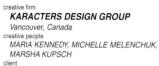

C*ME COSMETICS

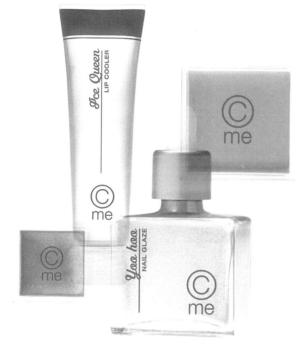

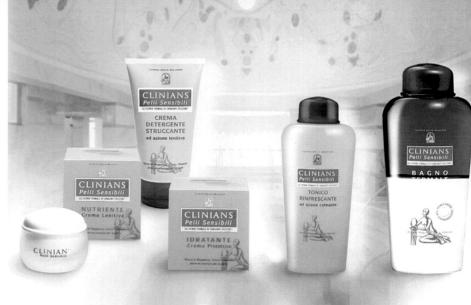

creative firm POLAROLO IMMAGINE E COMUNICAZIONE Torino, Italy creative people FELICE POLAROLO, SONIA AMBROGGI, STEFANIA RICCHIERI client MIRATO—ITALY

creative firm RGB DESIGN

Rio De Janeiro, Brazil creative people MARIA LUIZA GONCALVES VEIGA BRITO client DE MILLUS IND E COM. S.A.

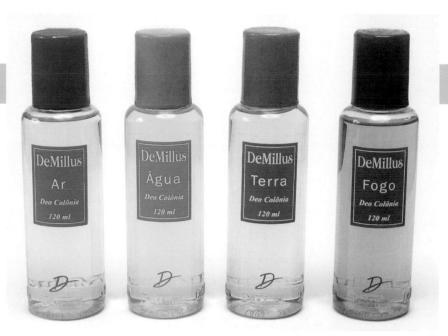

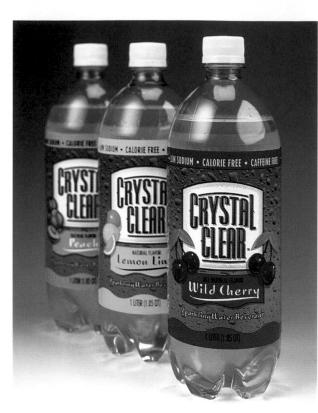

creative firm FORWARD BRANDING & IDENTITY Webster, New York client EASTMAN KODAK COMPANY

creative firm **INTERBRAND HULEFELD** Cincinnati, Ohio creative people BART LAUBE, CHRISTIAN NEIDHARD client KROGER

creative firm COMPUTER ASSOCIATES INTERNATIONAL, INC. Islandia, New York creative people LOREN MOSS MEYER, DOMINIQUE MALATERRE client COMPUTER ASSOCIATES creative firm **AJF MARKETING** Piscataway, New Jersey creative people PAUL BORKOWSKI client IFF-INTERNATIONAL FLAVORS & FRAGRANCES

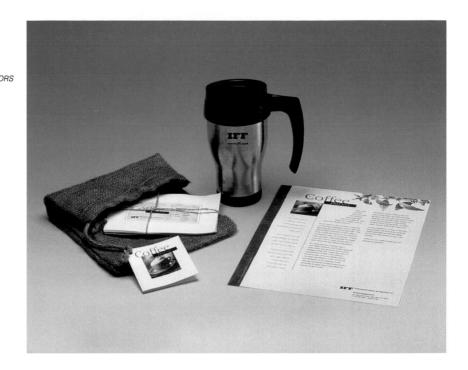

creative firm INGEAR Buffalo Grove, Illinois creative people MATT HASSLER client SAM'S

creative firm **AJF MARKETING** Piscataway. New Jersey creative people JUSTIN BRINDISI client IFF-INTERNATIONAL FLAVORS & FRAGRANCES

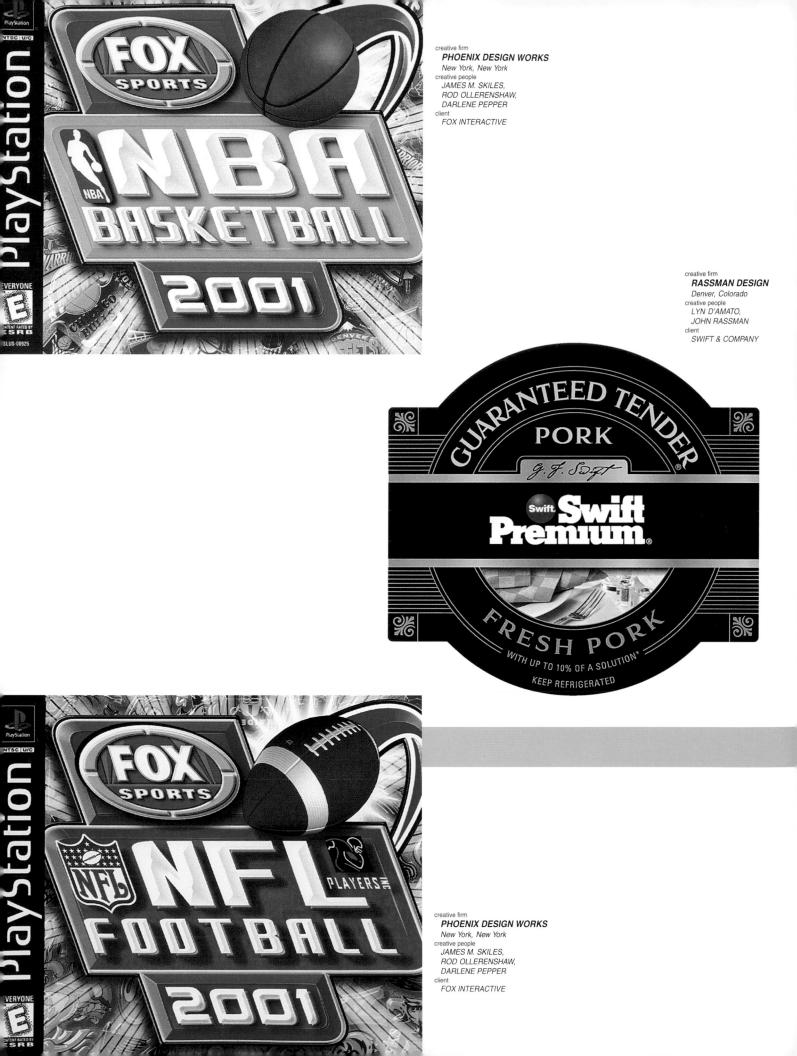

JOHN RASSMAN client SWIFT & COMPANY SS B 26 NC NC 0 Swift. h NON X CHOICE BEEF SDA 3ER KEEP REFP CERTIFIED

creative firm

RASSMAN DESIGN Denver, Colorado creative people LYN D'AMATO,

> creative firm PHOENIX DESIGN WORKS New York, New York creative people JAMES M. SKILES, ROD OLLERENSHAW, DARLENE PEPPER client FOX INTERACTIVE

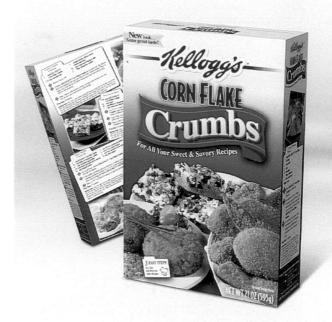

creative firm CASSATA + ASSOCIATES Schaumburg, Illinois creative people LESLEY WEXLER client KELLOGGS/KEEBLER

creative firm FORWARD BRANDING & IDENTITY Webster, New York client SORRENTO

creative firm LIPSON ALPORT GLASS & ASSOC. Northbrok, Illinois creative people MACK KRUKONIS, WALTER PERLOWSKI client UNILEVER BEST FOODS

creative firm **RASSMAN DESIGN** Denver, Colorado creative people LYN D'AMATO, JOHN RASSMAN client SWIFT & COMPANY

creative firm **COMPASS DESIGN** Minneapolis, Minnesota creative people MITCH LINDGREN, TOM ARTHUR, RICH MCGOWEN client KEMPS

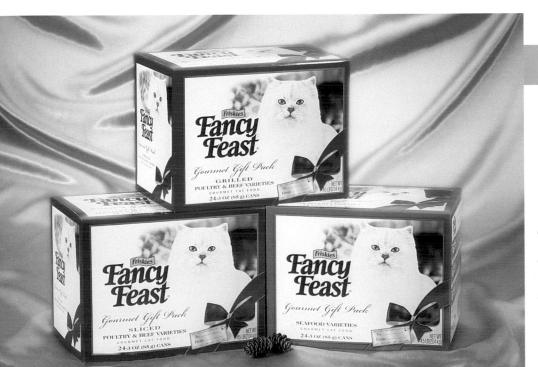

creative firm **THOMPSON DESIGN GROUP** San Francisco, California creative people DENNIS THOMPSON, FELICIA UTOMO, ELIZABETH BERTA client NESTLE PURINA PETCARE COMPANY

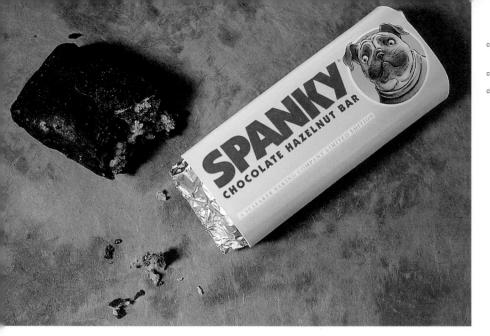

creative firm **SABINGRAFIK, INC.** Carlsbad, California creative people TRACY SABIN client SEAFARER BAKING COMPANY

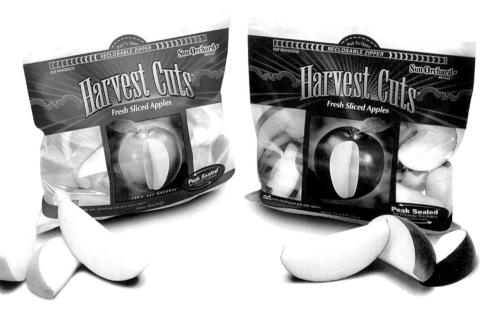

creative firm MCELVENEY & PALOZZI DESIGN GROUP Rochester, New York creative people JON WESTFALL, MIKE JOHNSON client SUN ORCHARD BRAND

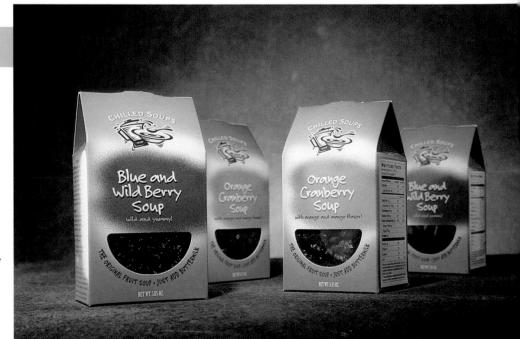

creative firm **COMPASS DESIGN** Minneapolis, Minnesota creative people

creative people MITCH LINDGREN, TOM ARTHUR BILL COLLINS, RICH MCGOWEN client NORTH AIRE MARKET

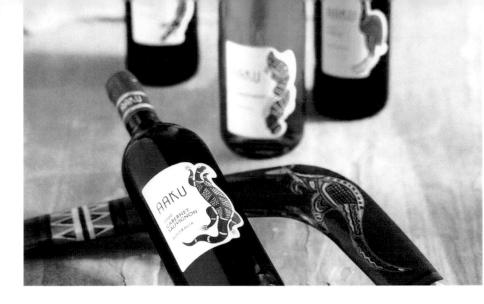

creative firm BE.DESIGN San Rafael, California creative people ERIC READ, CORALIE RUSSO, LISA BRUSSELL, CORINNE BRIMM client COST PLUS WORLD MARKET

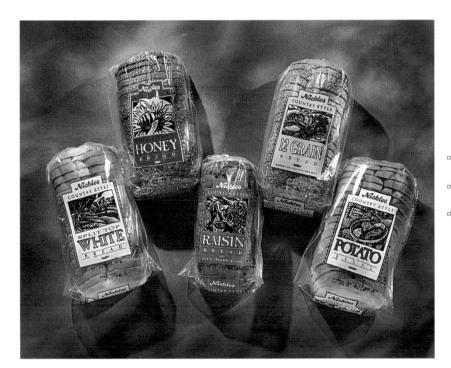

creative firm INNIS MAGGIORE GROUP Canton, Ohio creative people JEFF MONTER, CHERYL MOLNAR, ERIC KITTELBERGER client NICKLES BAKERY

creative firm BRADY COMMUNICATIONS Pittsburgh, Pennsylvania creative people JIM BOLANDER, JIM LILLY, PAUL SEMONIK client OLYMPIC

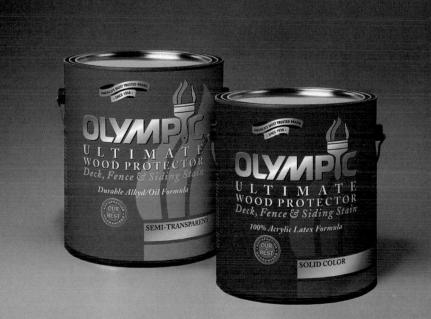

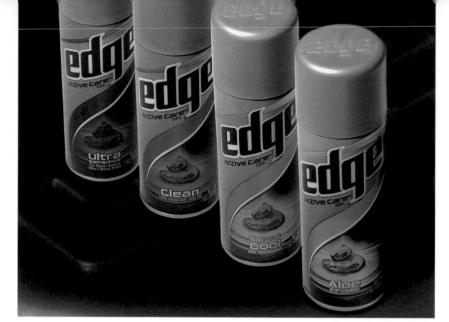

creative firm THE WEBER GROUP, INC. Racine, Wisconsin creative people ANTHONY WEBER, SCOTT SCHREIBER client S.C. JOHNSON & SON, INC.

creative firm EVENSON DESIGN GROUP Culver City, California creative people KERA SCOTT, STAN EVENSON client ROCAMOJO

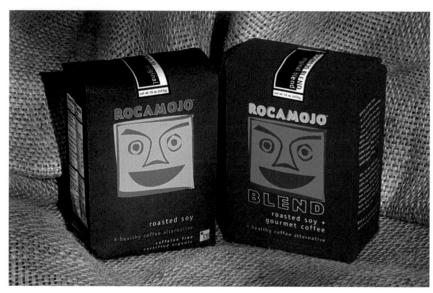

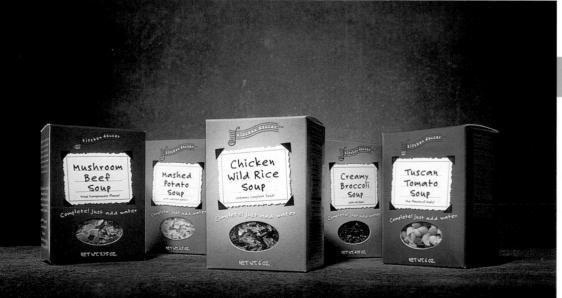

creative firm

Minneapolis, Minnesota creative people MITCH LINDGREN, BILL COLLINS, TOM ARTHUR, RICH MCGOWEN client NORTH AIRE MARKET

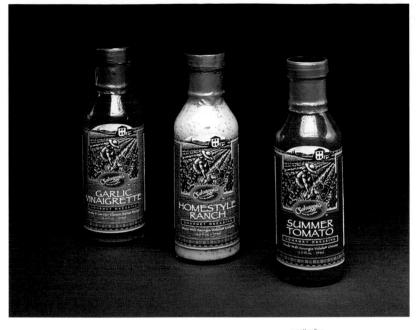

creative firm GOLDFOREST Miami, Florida creative people MICHAEL GOLD, LAUREN GOLD, CAROLYN RODI, RAY GARCIA client NINO SALVAGGIO INTERNATIONAL MARKETPLACE

creative firm MAINFRAME MEDIA & DESIGN LLC Chester, New Jersey creative pooplo LUCINDA WEI client BLACK SOAP

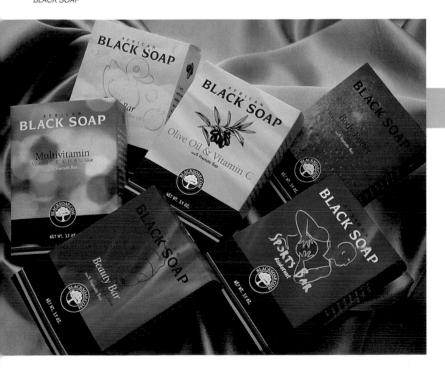

creative firm TOM FOWLER, INC. Norwalk, Connecticut creative people MARY ELLEN BUTKUS, THOMAS G. FOWLER, BRIEN O'REILLY client HONEYWELL CONSUMER PRODUCTS

creative firm INTERBRAND HULEFELD Cincinnati, Ohio creative people CHRISTIAN NEIDHARD, JEAN CAMPBELL client PROCTER & GAMBLE

> creative firm LEVERAGE MAR COM GROUP Newtown, Connecticut creative people RICH BRZOZOWSKI client FAIRFIELD PROCESSING

GOLDFOREST Miami, Florida creative people MiCHAEL GOLD, LAUREN GOLD, CAROLYN RODI, RAY GARCIA client NINO SALVAGGIO INTERNATIONAL MARKETPLACE

creative firm

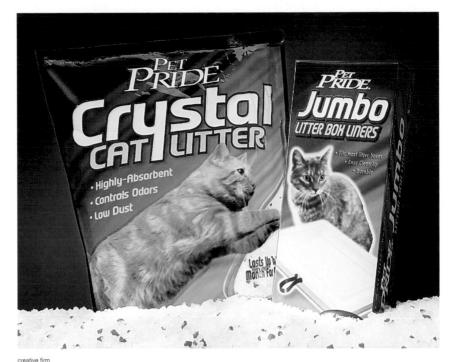

creative firm INTERBRAND HULEFELD Cincinnati, Ohio creative people BART LAUBE client KROGER

creative firm FUTUREBRAND creative people PETER CHIEFFO, JOE VIOLANTE client NESTLE

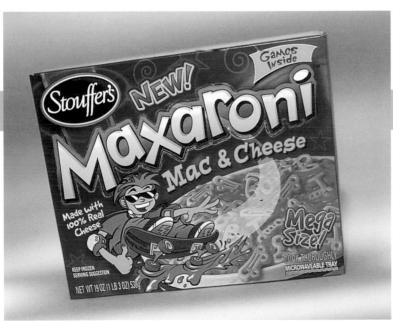

creative firm **PAPRIKA** Montreal, Canada creative people LOUIS GAGNON, LOUISE MAROIS, FRANCOIS LECLERC client BARONET

DESIGN CENTER / HIGH POINT, NC / 04.18-25.02 BARONET D523

POSTERS

CELEBRATE MATIKA WITH THOSE YOU LOVE:

YOUR TV, YOUR CDs, YOUR GUACAMOLE.

MATIKA.

MATIKAFUSIONS.COM

MATIKA IS A TIME FILLED WITH MYSTERY.

KIND OF LIKE YOUR DORM ROOM CLOSET, ONLY DIFFERENT.

Tea & Juice Fusion

MATIKAFUSIONS.COM

creative firm J. WALTER THOMPSON New York, New York creative people MIKE CAMPBELL, JON KREVOLIN, MICKEY PAXTON, AVI HALPER, STEVE KRAUSS client MATIKA

MATIKA' IS MORE THAN A DRINK, IT'S A FEELING. UNLESS YOU SPILL IT ON THE COUCH, THEN IT'S JUST A DRINK.

Tes & Juic

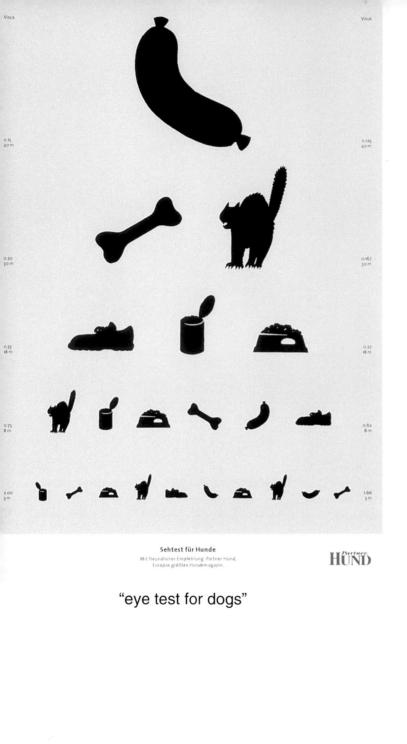

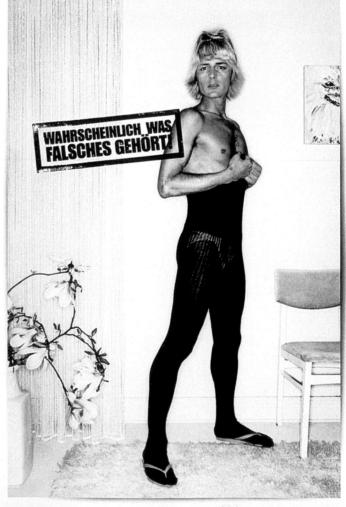

deine frequenz | 1431 AM

creative firm HEYE & PARTNER Munich, Germany creative people ALEXANDER EMIL MÕLLER client MONA DAVIS MUSIC

MEGARADIO

Я

DANIEL & GED FUCHS FOTOAUSSTELLUNG IM KUNSTHAUS HAMBURG KLOSTERWALL 15 VOM 23.04. BIS 18.08.2002 ÖFFNUNGSZEITEN DI-SO 11-18 UHR

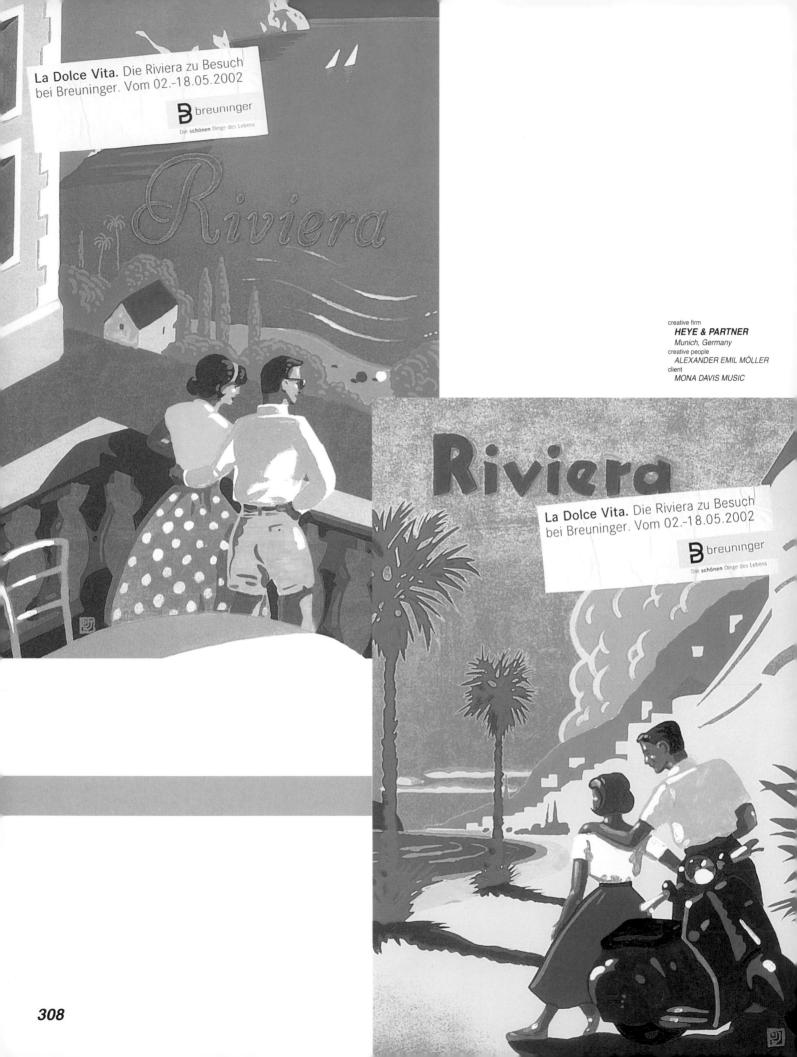

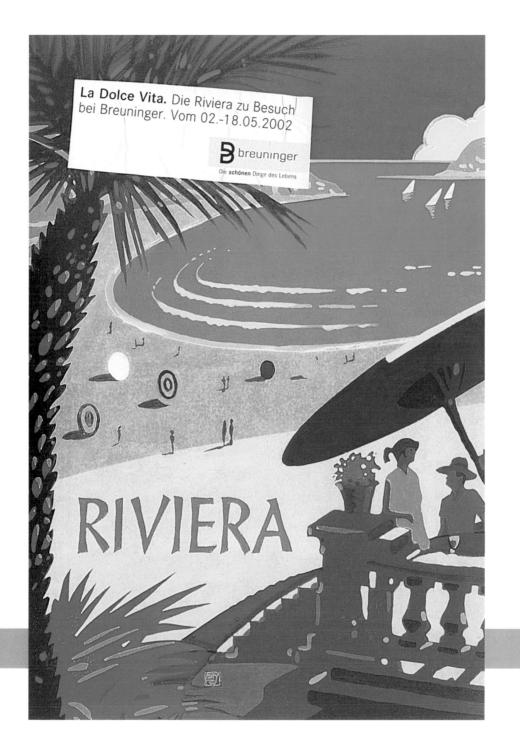

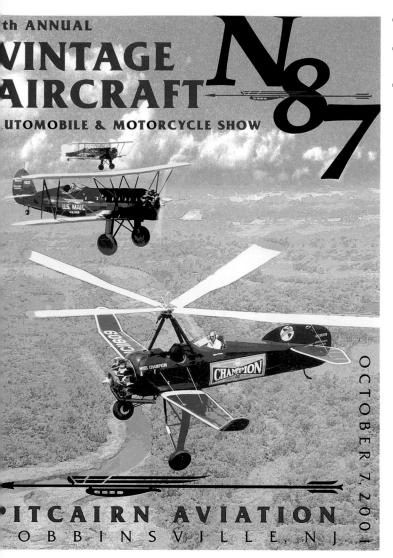

creative firm **ROBERT TALARCZYK DESIGN** Fair Haven, New Jersey creative people

creative people ROBERT TALARCZYK, ALAN COPEN, JIM KOEPNICK, HOWARD LEVY, CHROMEWERKS, TOPRAN

client PITCARIN AVIATION

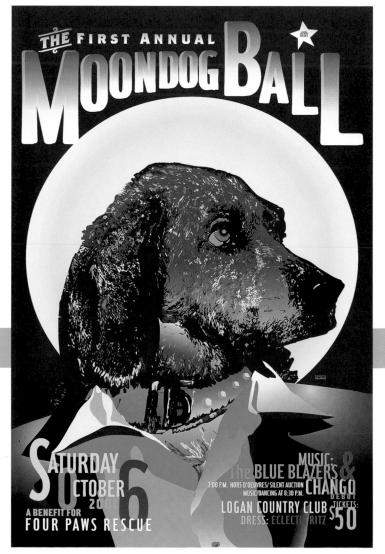

creative firm SLANTING RAIN GRAPHIC DESIGN Logan, Utah creative people R.P. BISSLAND client FOUR PAWS DOG RESCUE ON SUPERBOWL WEEKEND

GROWLER⁶⁴ Juid 0Z.

WHY FILL YOUR HEAD WITH ANYTHING ELSE?

MAKE ROOM FOR YOUR FAVORITE BEER

\$12-TAKE A GROWLER HOME. (\$3-COME FOR A REFILL.

Offer good Super Bowl weekend only (Friday-Sunday). Ask your server for details and other specials.

> creative firm **MIRES** San Diego, California

creative people JENNIFER CADAM, SCOTT MIRES, JODY HEWGILL, GARY KELLEY client ARENA STAGE

creative firm GRAFIK Alexandria, Virginia creative people JOHNNY VITOROVICH, JUDY KIRPICH client DuCLAW BREWERY

ofmiceandmen

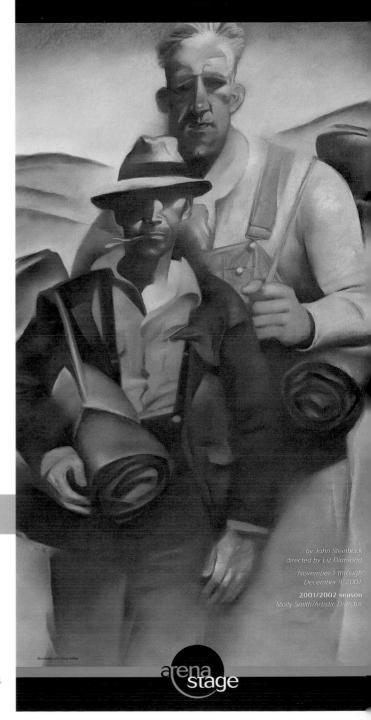

polkcounty

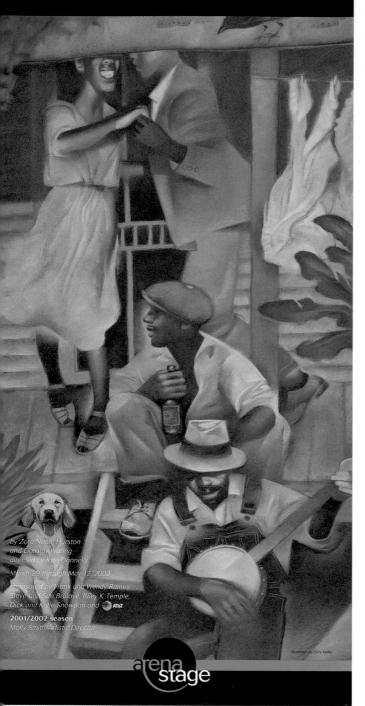

creative firm MIRES San Diego, California creative people JENNIFER CADAM, SCOTT MIRES, JODY HEWGILL, GARY KELLEY client ARENA STAGE

FIGHT THE POWER

GIARDIA TRACK AND DRINKING CLUB LENGTH: 420,000, 000,000 PARTS PER BILLION

OCTOBER :

LOAIRQUALITYAGAN, UT.

creative firm SLANTING RAIN GRAPHIC DESIGN Logan, Utah creative people R.P. BISSLAND, KEVIN KOBE

client GIARDIA TRACK & DRINKING CLUB

Figure correcting supplements available at **PAL STORE**

creative firm **TBWA-ANTHEM (INDIA)** New Delhi, India creative people ARINAB CHATTERJEE, KAPIL DHAWAN, ABHINAV PRATIMAN, ROHIT DEVGUN client PAL SUPER STORE

agamemnonandhisdaughters

adapted by Kenneth Cavander directed by Molly Smith August 31 through October 7, 2001 sponsored by Joan and David Maxwell 2001/2002 season Molly Smith/Artistic Director

> erena stage

creative firm MIRES San Diego, California creative people JENNIFER CADAM, SCOTT MIRES, JODY HEWGILL, GARY KELLEY client ARENA STAGE

creative firm **CAMPBELL EWALD ADVERTISING** Warren, Michigan creative people BILL LUDWIG, JIM MILLIS, NANCY WELLINGER client UNITED WAY

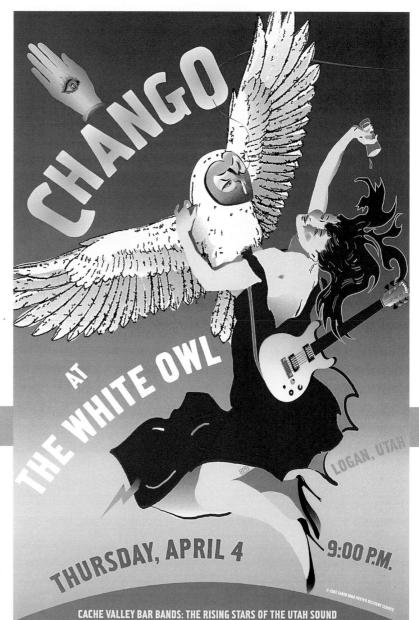

creative firm SLANTING RAIN GRAPHIC DESIGN Logan, Utah creative people R.P. BISSLAND client

CHANGO THE BAND

A STORY ABOUT LEAVING HOME AND COMING OF AGE.

THE PULITZER PRIZE AND NEW YORK CRITICS' WINNER BY KETTI FRINGS FROM THE NOVEL BY THOMAS WOLFE Directed by Susan Sargeant January 17 through February 3

ANGE

HOME

creative firm **CAMPBELL-EWALD ADVERTISING** Warren, Michigan creative people BILL LUDWIG, JIM MILLIS, NANCY WELLINGER client UNITED WAY

Give more to the United Way. It brightens the hopes of tens of thousands of area families. It'll give you a sunnier disposition, too For more info. visit Socrates. To pledee. call 1-800-462-5188.

WANT TO SEE YOURSELF IN A BETTER LIGHT?

More. Get Mor 800-462-5188

creative firm **FREDERICK/VANPELT** Garland, Texas creative people CHIP VANPELT, J. FREDERICK client GARLAND CIVIC THEATRE

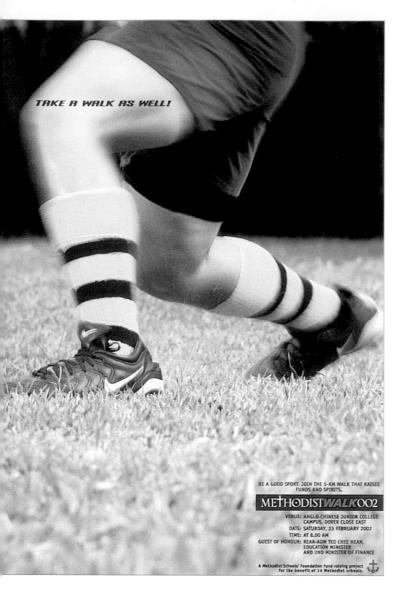

creative firm **ZENDER FANG ASSOCIATES** Singapore creative people DOLLAH JAAFAR, HATTY/HAN CHEWS STUDIO, ESA SIDIN, SOPHIA TAN client

METHODIST'S SCHOOL FOUNDATION

There's no such thing as natural beauty. It takes some effort to look like this.

> I would rather have thirty minutes of wonderful than a lifetime of nothing special.

My personal tragedy will not interfere with my ability to do good hair.

The only thing that separates us from the animals is our ability to accessorize.

If you can't say anything nice, come sit by me. Come To Garland Civic Theatre's 8th Annual Fundraiser And Hear Southern Belles Tell It Like It Is.

By Robert Harling Directed by Much Carr February 14 - March 3 Garland Performing Ans Center For nekets, eall 972 205 2790 or at the box office

creative firm FREDERICK/VANPELT Garland, Texas creative people CHIP VANPELT, J. FREDERICK client GARLAND CIVIC THEATRE

316

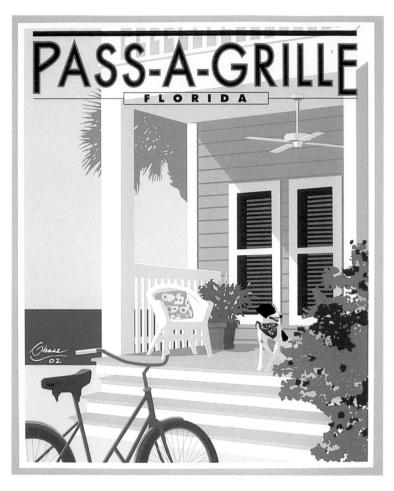

creative firm CHASE CREATIVE Galena, Illinois creative people GEORGE CHASE client PASS-A-GRILLE WOMEN'S CLUB

MIRES DESIGN San Diego, California creative people JOSE SERRANO, JEFF SAMARIPA, TRACY SABIN client HOT ROD HELL

creative firm

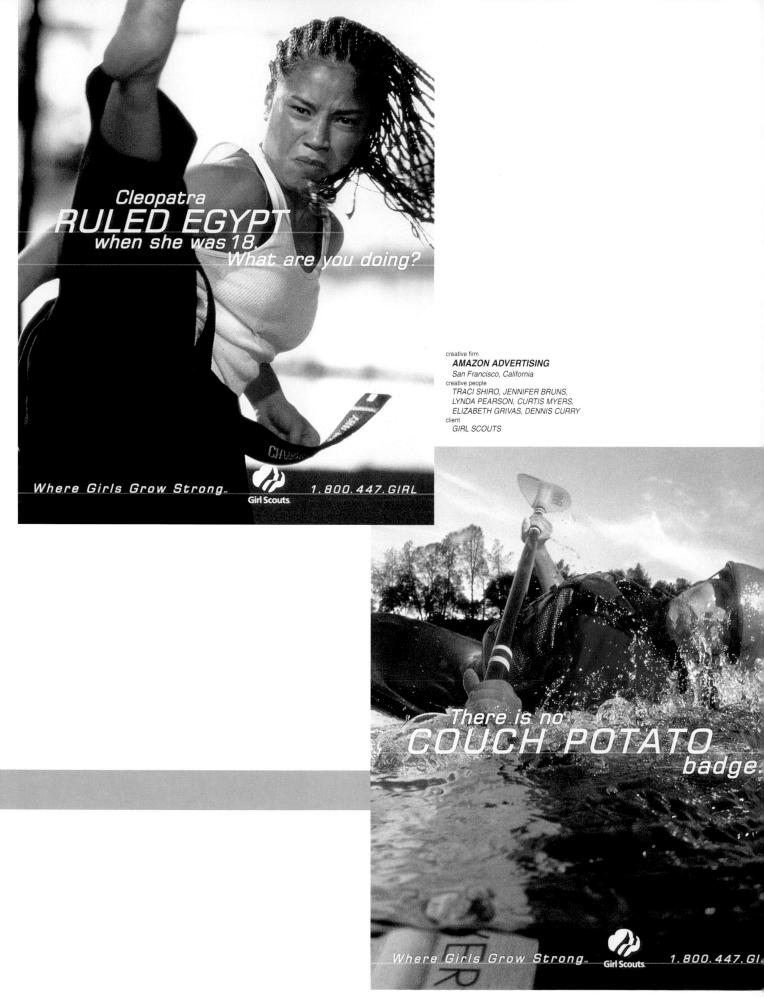

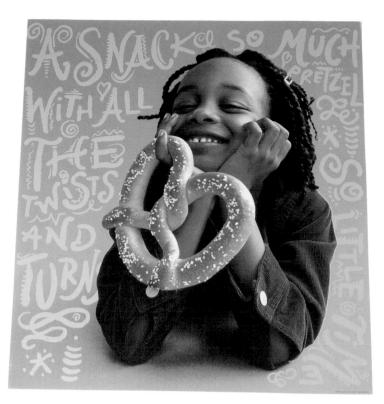

creative firm **GRAPHICULTURE** Minneapolis, Minnesota creative people SHARON MCKENDRY, CHERYL WATSON client TARGET

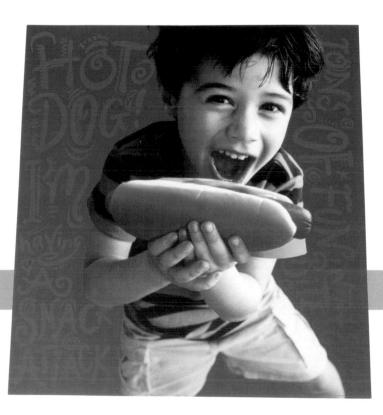

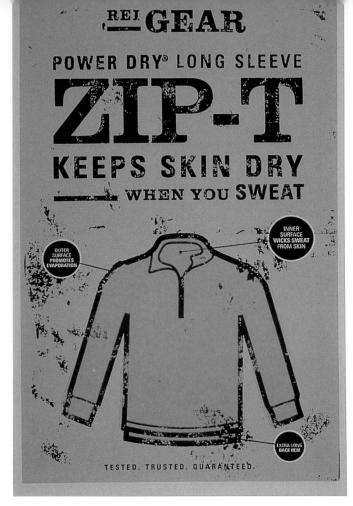

creative firm
LEMLEY DESIGN COMPANY Seattle, Washington

creative people DAVID LEMLEY, YURI SHVETS, MATTHEW LOYD, TOBI BROWN,

client RECREATIONAL EQUIPMENT, INC.

JENNY HILL

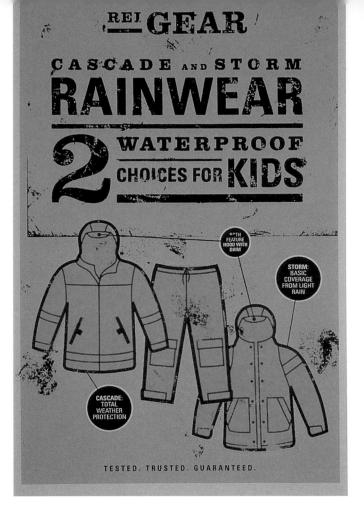

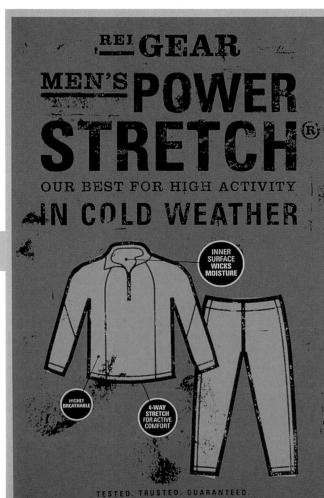

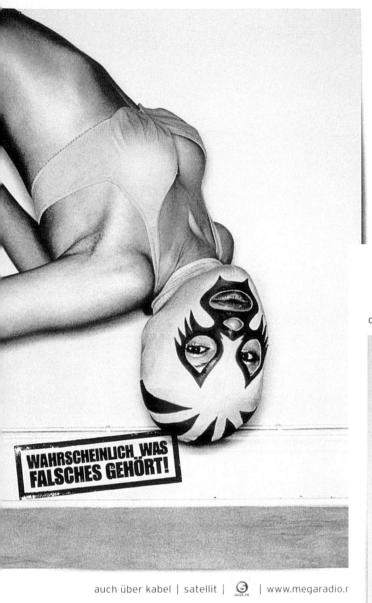

creative firm **GBK, HEYE** Munich, Germany creative people ALEXANDER BARTEL, MARTIN KIESSLING, CHRISTINE BADER, PAUL WAGNER, HEINZ HELLE, BILLY & HELLS client MEGARADIO

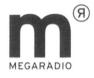

deine frequenz | 1431 AM

auch über kabel | satellit | 🥥 | www.megaradio.net

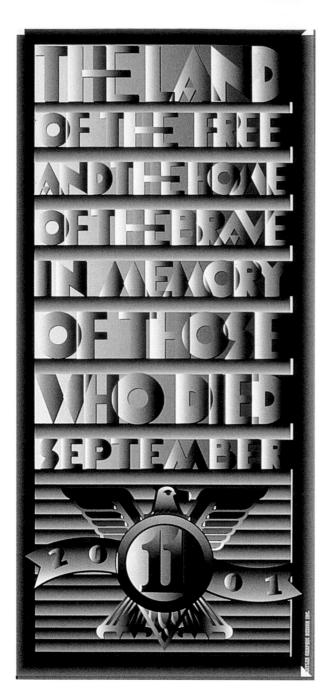

creative firm SAVLES GRAPHIC DESIGN Des Moines, Iowa creative people JOHN SAYLES, SOM INTHALANGSY client ART FIGHTS BACK

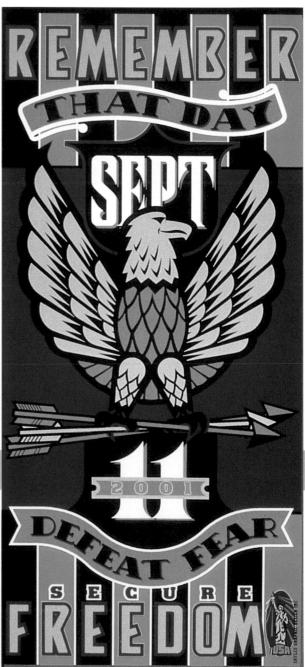

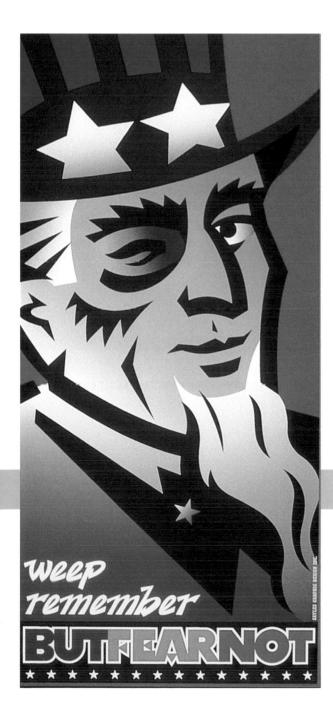

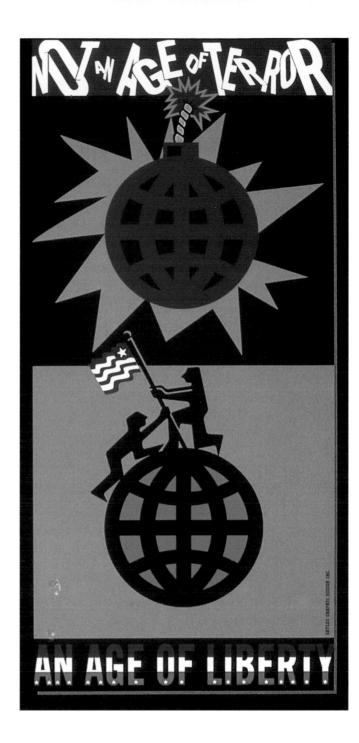

UNDER ATTACK 🖁 SEPT•11•2001

creative firm **SAVLES GRAPHIC DESIGN** Des Moines, Iowa creative people JOHN SAYLES, SOM INTHALANGSY client ART FIGHTS BACK

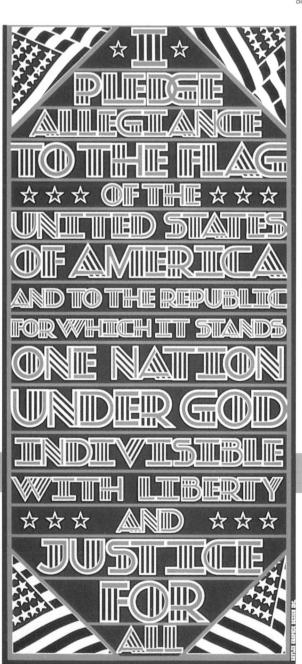

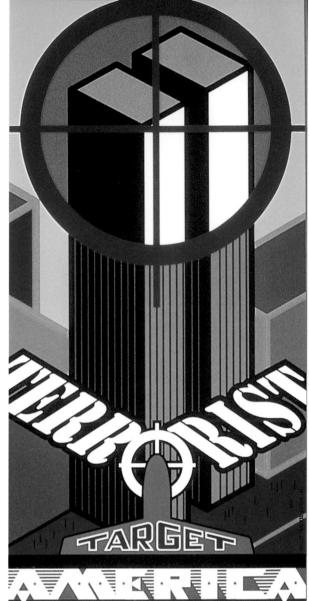

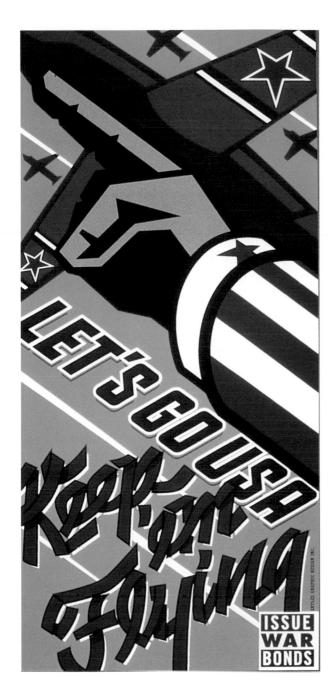

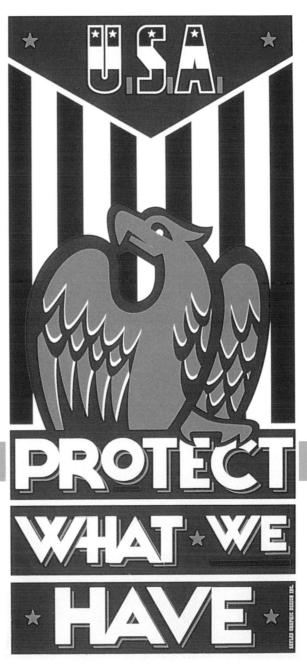

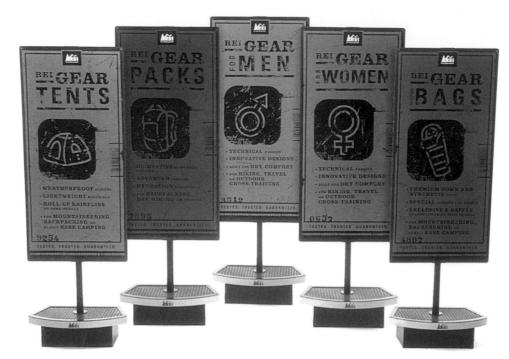

creative firm LEMLEY DESIGN COMPANY

Ceatile, Washington creative people DAVID LEMLEY, YURI SHVETS, MATTHEW LOYD, JENNIFER HILL, TOBI BROWN

client REI

cent of each dollar ance, rehabilitatior ake you feel good. 1-800-462-5188 ectly to people in need of med ion and moral support. That or cal assis ght to n

creative firm CAMPBELL EWALD ADVERTISING Warren, Michigan creative people BILL LUDWIG, NANCY WELLINGER, JIM MILLIS client UNITED WAY

VILNIUS ART ACADEY Lithuania creative people AUSRA LISAUSKIENE

MINDAUGO KARŪNAVIMUI–750

EUROPE angenc form/europe 2020 angenc form/e

> creative firm **LIZA RAMALHO** client PAN EUROPEAN POSTER DESIGN COMPETITION AND EXHIBITION

creative firm **MBDISENTO Y COMUNICACION VISUAL** Madrid, Spain creative people OSCAR MARINÉ, JOHN GIORNO client SWATCH

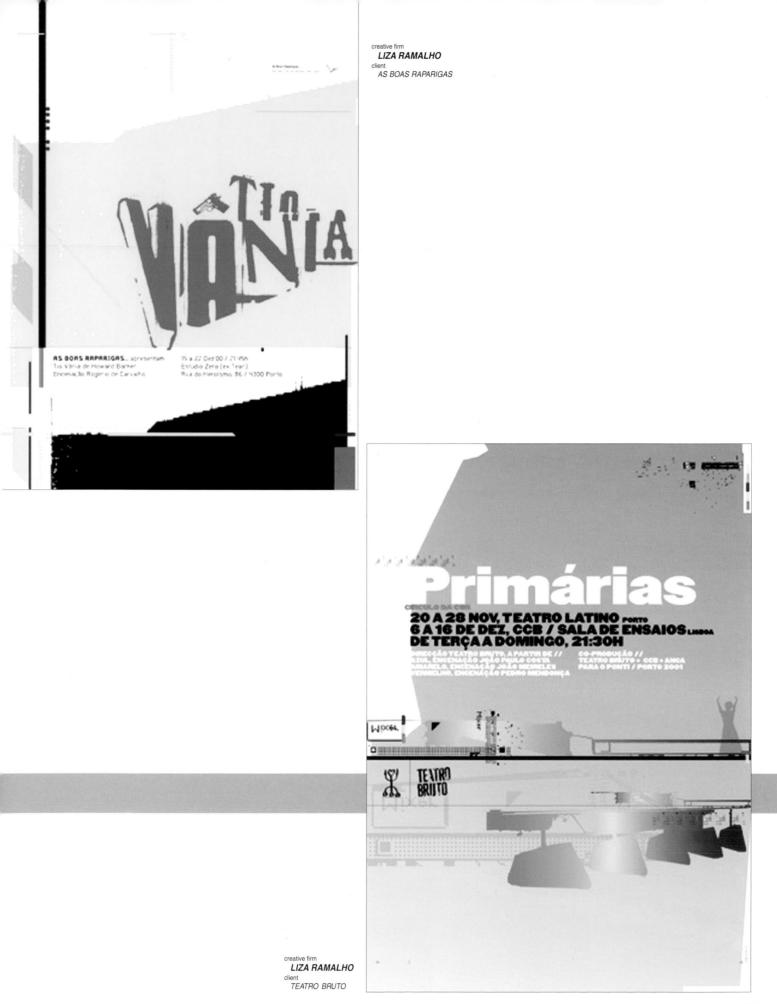

הבושם החדש לבית מבית סיף פנטסטיק

WKSP ADVERTISING Ramat Gan, Israel creative people ALON ZAID, ORLY FRUM, ORI LIVNY client UNILEVER

creative firm

הבושם החדש לבית

נוזל לניקוי כללי

הכושם החדש לכית סיף פנטסטיק

נוזל לניקוי כללי מנקה, מבריק ומבשם

Const Andrew Co

FANTASTIK

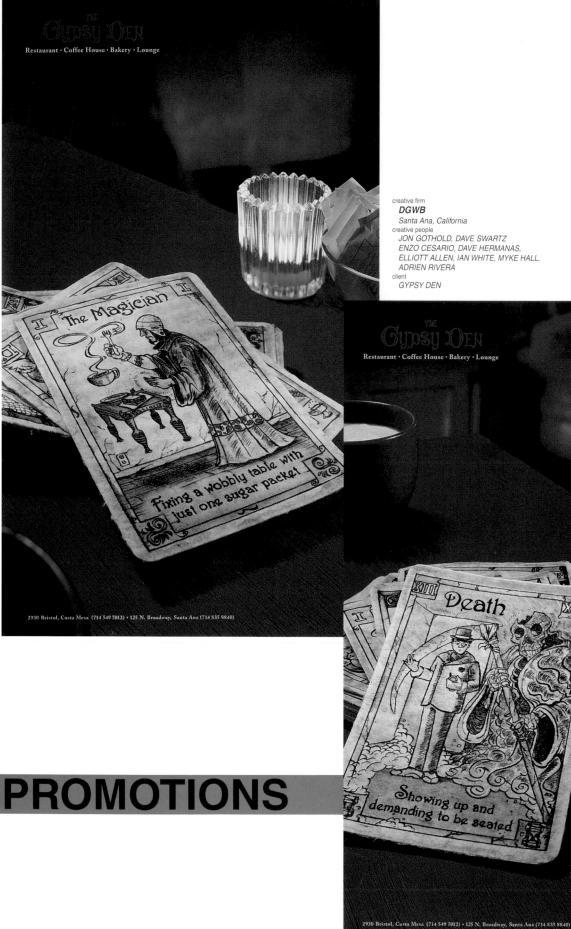

JON GOTHOLD, DAVE SWARTZ ENZO CESARIO, DAVE HERMANAS, ELLIOTT ALLEN, IAN WHITE, MYKE HALL, ADRIEN RIVERA

2000

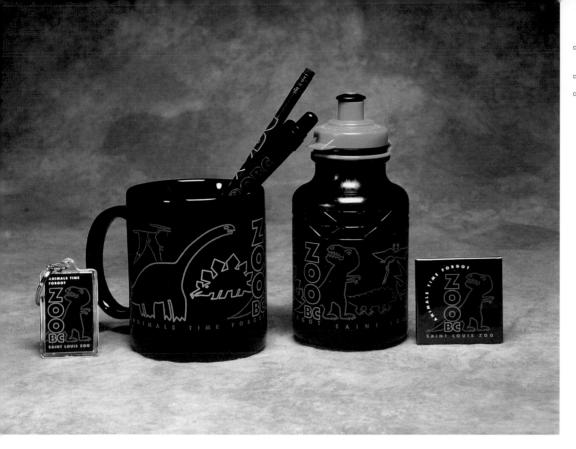

creative firm **CUBE ADVERTISING & DESIGN** St. Louis, Missouri creative people DAVID CHIOW client client SAINT LOUIS ZOO

creative firm BURROWS Shenfield, Essex

Creative people GARY CARLESS, BOB ASHWOOD, CAROL INF RICF, ROYDON HEARNE client FORD MOTOR COMPANY

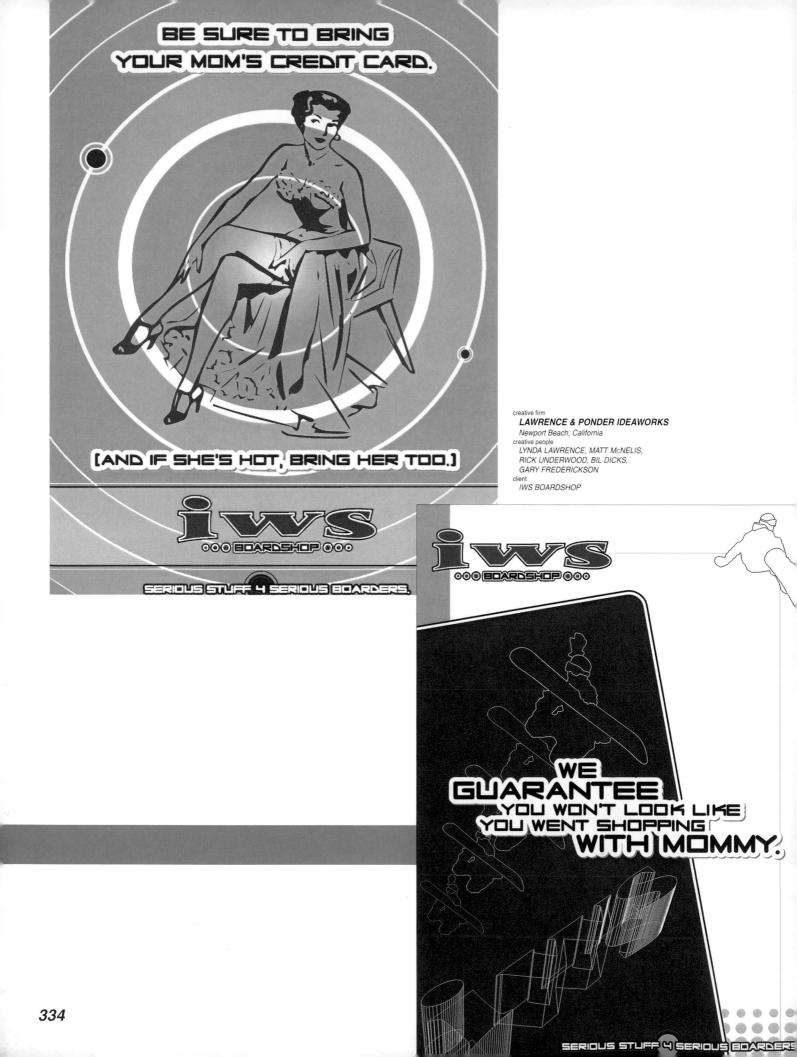

creative firm **LYNN SCHULTE DESIGN** Minneapolis, Minnesota creative people LYNN SCHULTE client NATURAL RESOURCE GROUP

creative firm DAVID CARTER DESIGN ASSOC. Dallas, Texas creative people EMILY HUCK, DONNA ALDRIDGE, ASHLEY BARRON MATTOCKS client WATERCOLOR INN

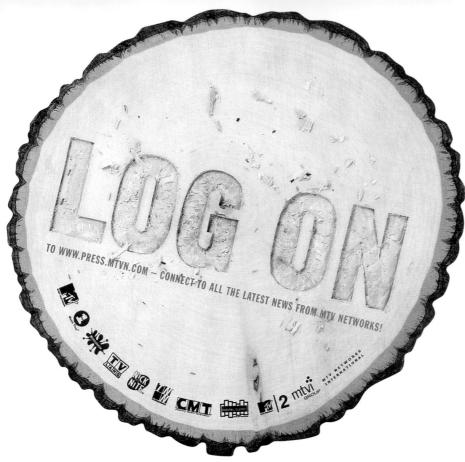

creative firm MTV NETWORKS CREATIVE SERVICES

New York, New York creative people JOHN FARRAR, KEN SAJI, CHERYL FAMILY client MTV NETWORKS

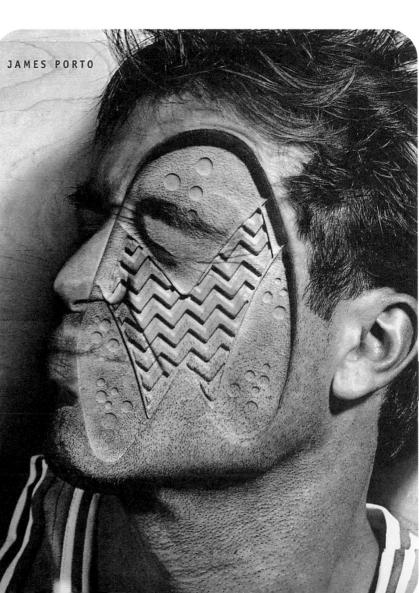

creative firm HUTTER DESIGN New York, New York Cettive people LEA ANN HUTTER, JULIE GANG, JIM HUIBREGTSE, JOHN MANNO, JAMES PORTO, MICHAEL LUPPINO, DAVID WEISS, MERVYN FRANKLYN client M REPRESENTS

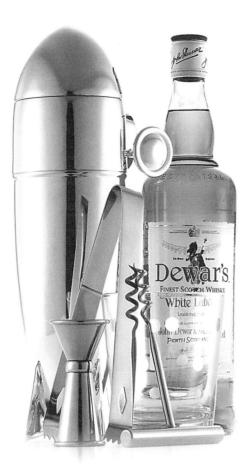

DAVID WEISS

(continued) creative firm HUTTER DESIGN New York, New York client M REPRESENTS

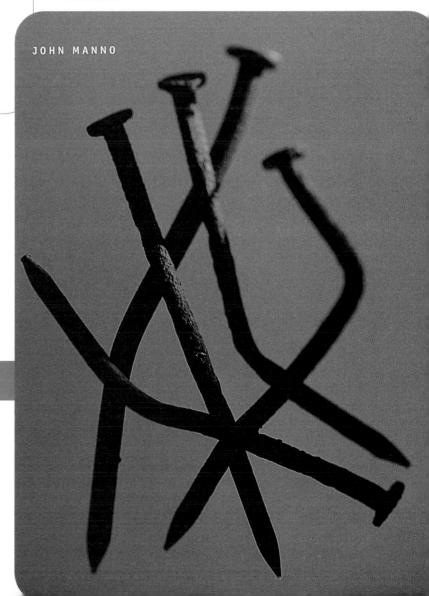

creative firm ATOMZ INTERACTIVE Singapore creative people PATRICK LEE, VIVI CHANG client MCI WORLDCOM PTE LTD

When the heat is on Stay cool with Power XL.

0

power XL

Expose your risk to temperature

creative firm GOODWICK/LIAZON LEVERAGE MARCOM GROUP Newtown, Connecticut DAVID GOODWICK, HEATHER PATRICK, MIKE PARTENIO

client TRIPLE POINT TECHNOLOGY

creative firm **DAVID CARTER DESIGN ASSOC.** Dallas, Toxas creative people RACHEL GRAHAM client RENAISSANCE HOLLYWOOD HOTEL

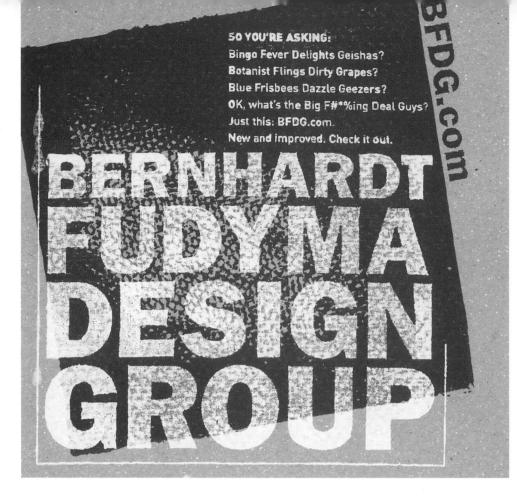

creative firm BERNHARDT FUDYMA DESIGN GROUP New York, New York creative people KRISTIN REUTTER, IGNACIO RODRIGUEZ, DOUG HALL, ANGELA VALIE client BERNHARDT FUDYMA DESIGN GROUP

Sniff. Scratch. Beg, if you must.

(continued) creative firm CHAMPCOHEN DESIGN Del Mar, California client ABBOTT ANIMAL HEALTH

Crown Club Work like a dog. Relax like a royal.

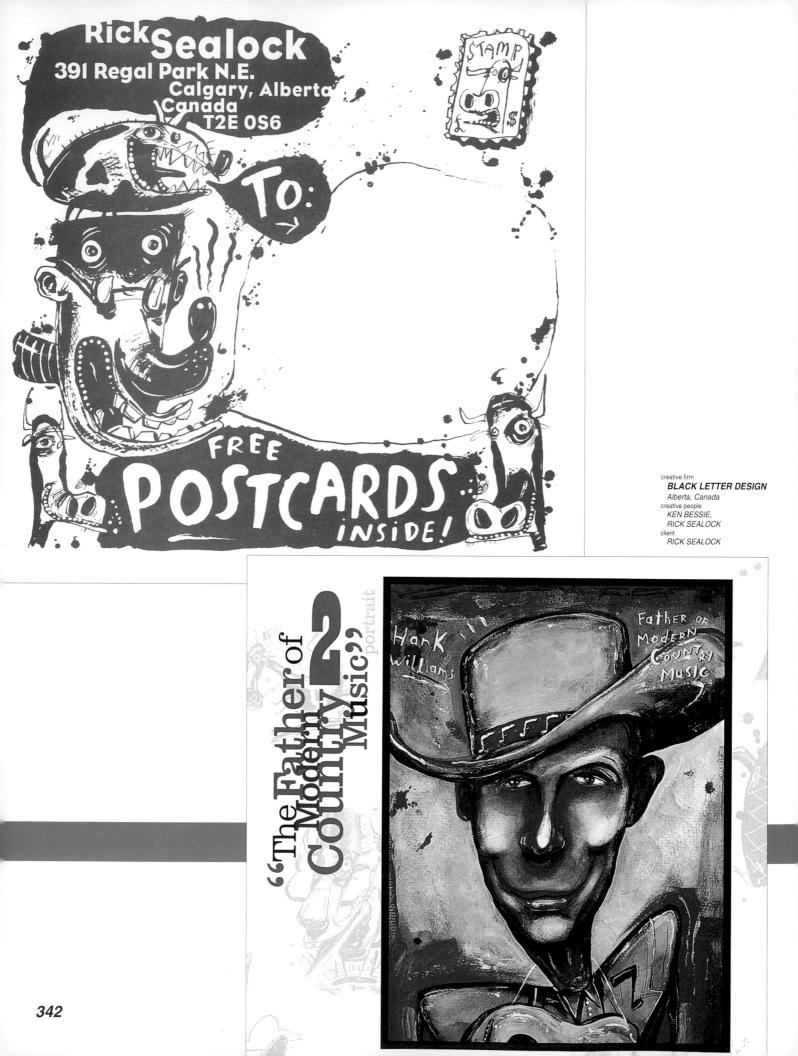

(continued) creative firm **BLACK LETTER DESIGN** Alberta, Canada client RICK SEALOCK

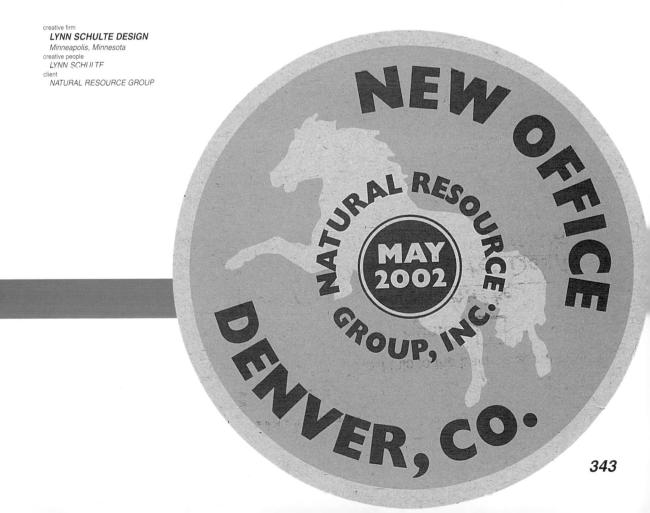

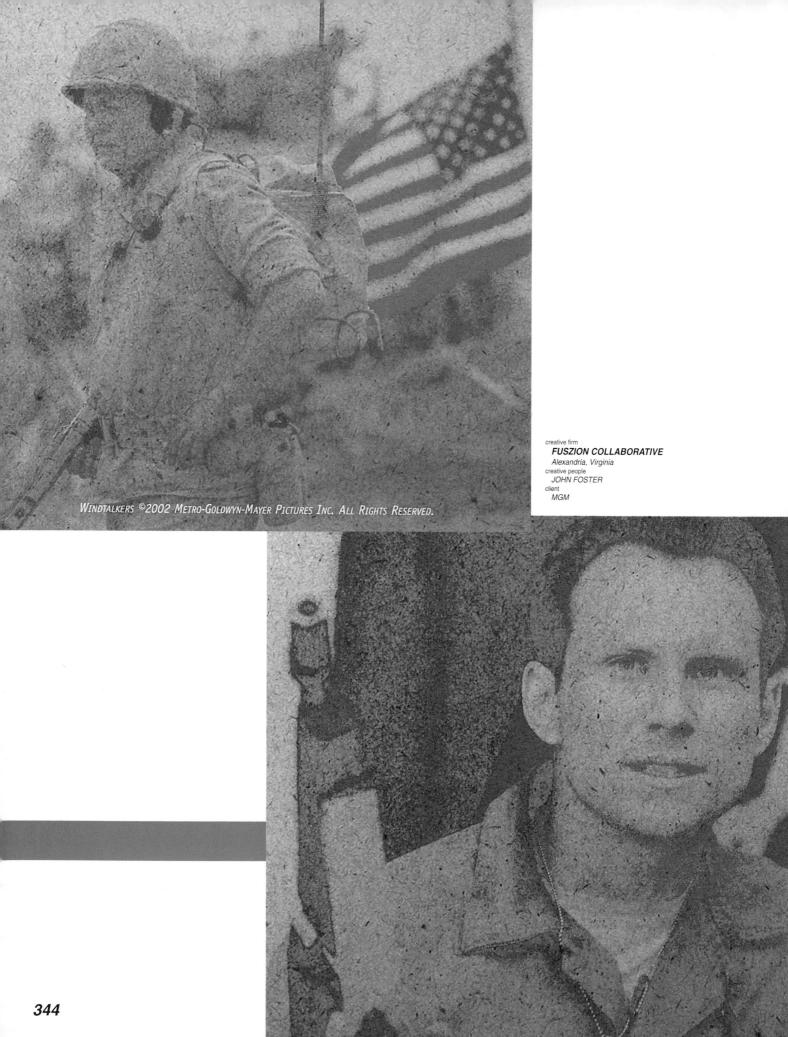

Minimize Downtime.

We're here for you. Kodak Service & Support

FORWARD BRANDING & IDENTITY Webster, New York client EASTMAN KODAK COMPANY

Minimize Risk.

We're here for you. Kodak Service & Support

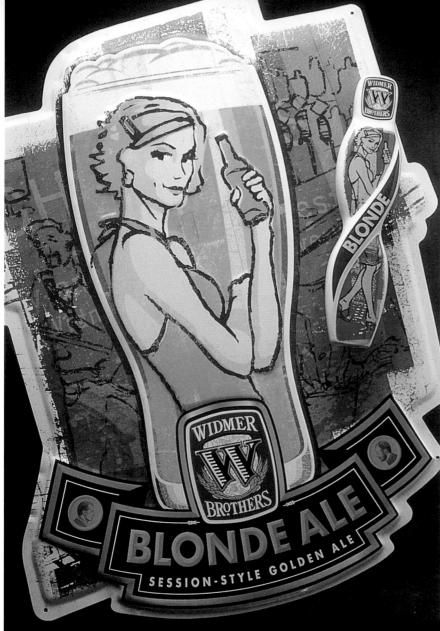

ALE

BLONDE

HORNALL ANDERSON DESIGN WORKS, INC. Seattle, Washington creative people LARRY ANDERSON, JACK ANDERSON, JAY HILBURN, BRUCE STIGLER, HENRY YIU, KAYE FARMER, DOROTHEE SOECHTING

client WIDMER BROTHERS

creative firm

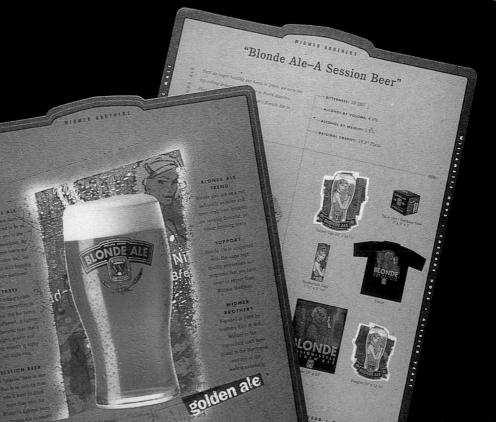

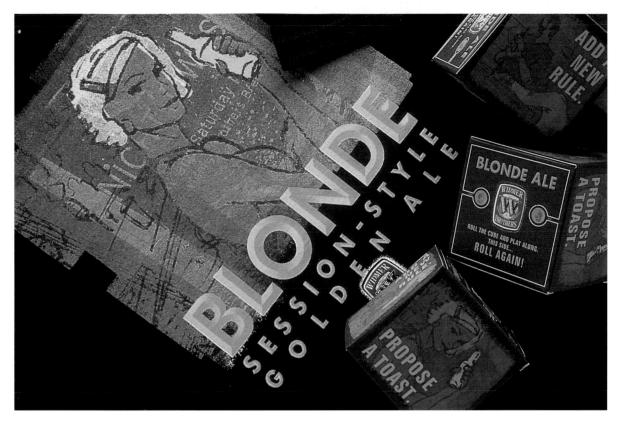

(continued) creative firm HORNALL ANDERSON DESIGN WORKS, INC. Seattle, Washington client WIDMER BROTHERS

> creative firm **AMP** Costa Mesa, California creative people LUIS CAMANO, CARLOS MUSQUEZ, LUCAS RISE client COCA-COLA

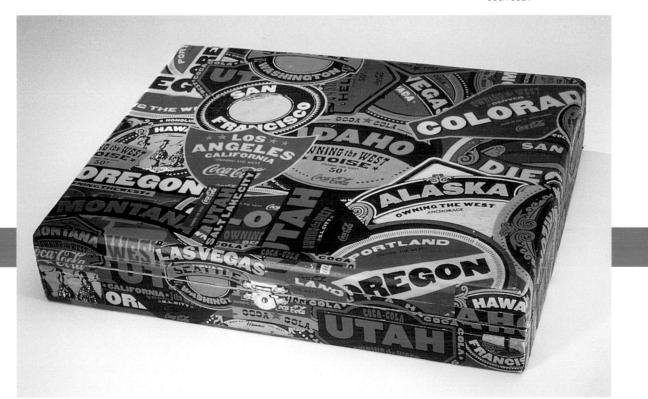

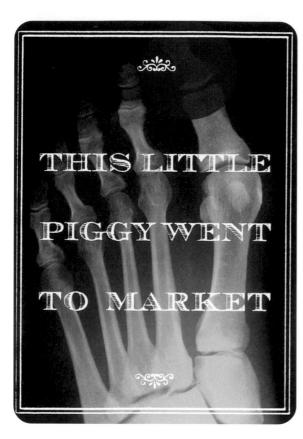

creative firm **METHODOLOGIE** Seattle, Washington creative people GABE GOLDMAN, MIAH NGUYEN, SANNA MONTENEGRO, CLAUDIA MEYER-NEWMAN, PAUL NASENBERRY Client Q PASS

(continued) creative firm **METHODOLOGIE** Seattle, Washington client Q PASS

creative firm PUBLICIS DIALOG San Francisco, California creative people LOTUS CHILD, CHRISTOPHER ST. JOHN client HEWLETT-PACKARD

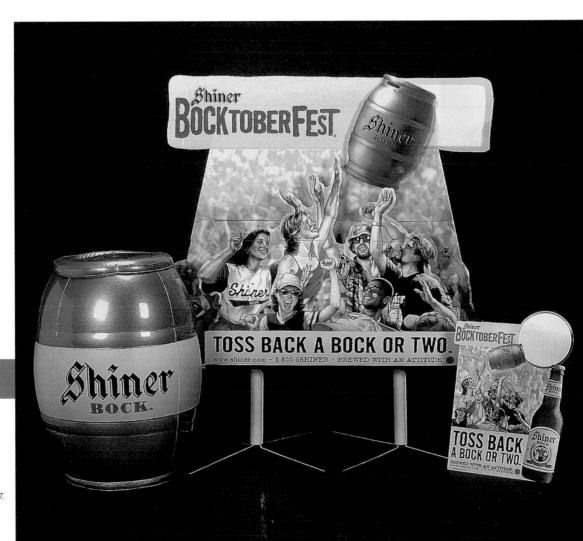

PROTECT

60 IT .

POWER

STREAMLINE

creative firm TOOLBOX STUDIOS, INC. San Antonio, Texas creative people BRUCE EAGLE, PAUL SOUPISET, ROB SIMONS client THE GAMBRINUS COMPANY

SAYLES GRAPHIC DESIGN Des Moines, Iowa creative people JOHN SAYLES, SOM INTHALANGSY client BRIX RESTAURANT

creative firm **FUTUREBRAND** New York, New York creative people JOE VIOLANTE, PETER CHIEFFO client LAF ENTERPRISES

creative firm **PUBLICIS DIALOG** San Francisco, California creative people LOTUS CHILD, TORIA EMERY client HEWLETT-PACKARD

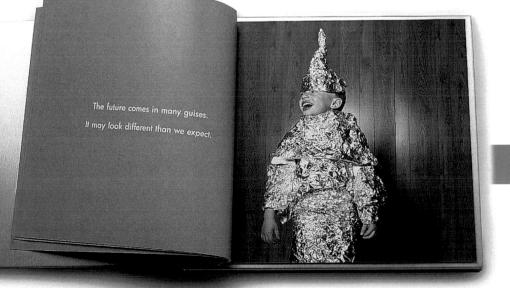

HUTTER DESIGN New York, New York creative people LEA ANN HUTTER, JOHN MANNO client JOHN MANNO PHOTOGRAPHY

creative firm **GRAFIK** Alexandria, Virginia creative people JOHNNY VITIVARICH, JUDY KIRPICH, RON HARMAN client GRAFIK

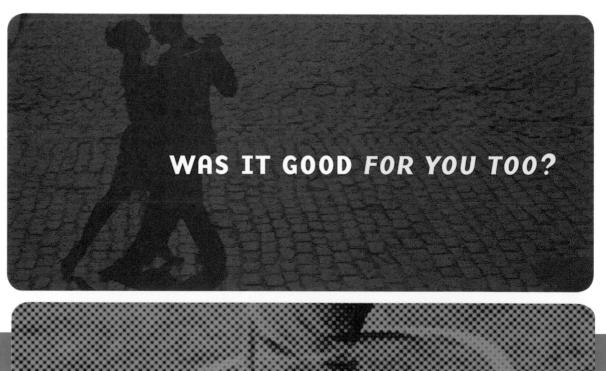

THAT WAS FUN!

_periphere

thien vous invite au lancement de la première collection periphere_ canapés et tables d'appoint_ luxe au goût du jour_ meubles haut de gamme pour ceux et celles à l'affut de moyens d'exprimer avec passion et modernité leur desir d'individualisme et de sophistication_ le lundi 19 novembre 2001_ de 17h 30 a 19h_ musée d'art contemporain de montreal_ 185, rue sainte-catherine ouest_ rsyp 514.733.0899 ou rsyp@periphere.com_

Ч

PAPRIKA Montreal, Canada creative people LOUIS GAGNON, FRANÇOIS LECLERC, RICHARD BERNARDIN client PERIPHERE

SELF PROMOTIONS

creative firm **GRAFIK** Alexandria, Virginia creative people JUDY KIRPICH, JOHNNY VITOROVICH, RODOLFO CASTRO client **GRAFIK**

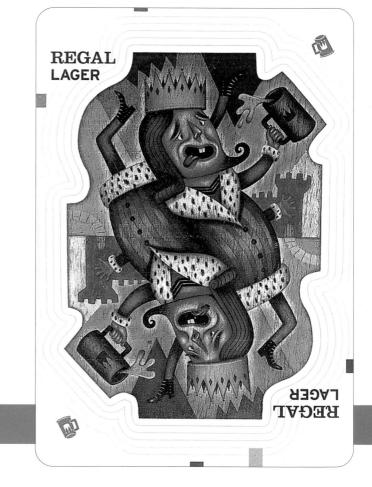

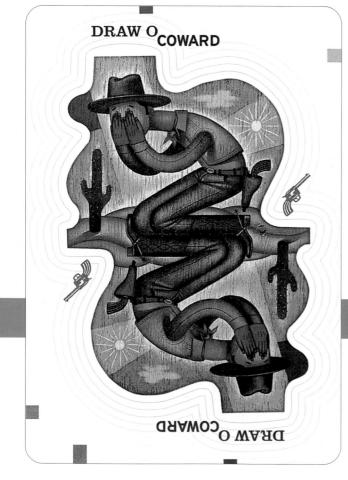

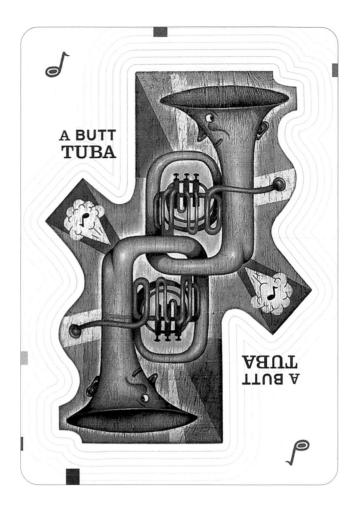

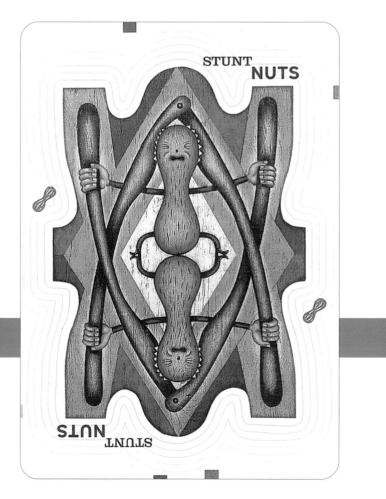

creative firm **THE WYANT SIMBOLI GROUP, INC.** Norwalk, Connecticut creative people JULIA WYANT, JENNIFER DUARTE, JASON JOHNSON, JENNIE CHEN, TOD BRYANT client THE WYANT SIMBOLI GROUP, INC.

creative firm

creative firm JENSEN DESIGN ASSOC. INC. Long Beach, California creative people DAVID JENSEN, VIRGINIA TEAGER, CHARLES HARNISH, JOEL PENOS, STEPHANIE WIDDHAM, JEROME CALLEJA, ALYSSA IGAWA, KRISTEN BROWN, SHIM SANTOS, KRISTEN BROWN, SHIM SANTOS, KRIST ANGSLIVARD, PATTY JENSEN, ANNO TAONO, ELMER JIMENEZ client client JENSEN DESIGN ASSOC. INC.

creative firm LPG DESIGN Wichita, Kansas creative people RICK GIMLIN client LPG DESIGN

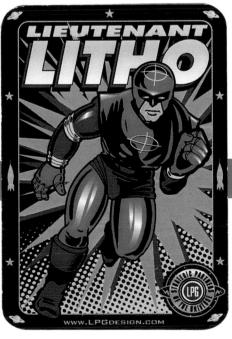

creative firm INTERROBANG DESIGN COLLABORATIVE Richmond, Vermont creative people MARK D. SYLVESTER, LISA TAFT SYLVESTER client

client INTERROBANG DESIGN COLLABORATIVE

creative firm DESIGN5 Fresno, California creative people RON NIKKEL client TODD & BETSY PIGOTT

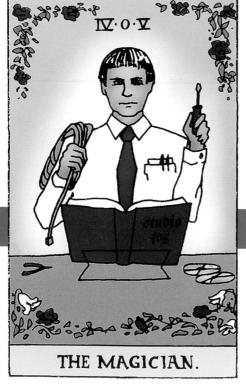

creative firm STUDIO 405 Takoma Park, Maryland creative people JODI BLOOM, KRISTEN ARGENIO STUDIO 405

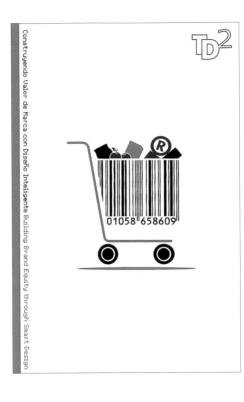

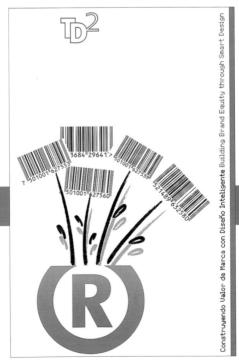

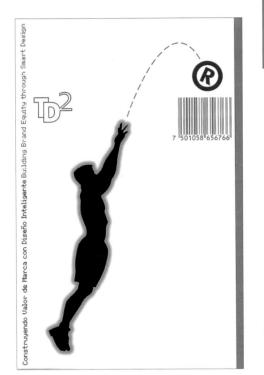

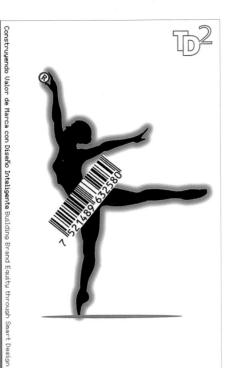

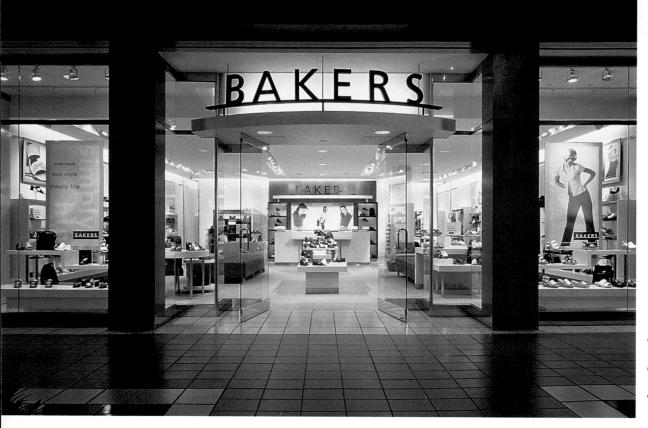

creative firm FRCH DESIGN WORLDWIDE New York, New York creative people DERICK HUDSPITH, ANDY BERGMAN client EDISON BROTHERS (BAKERS)

creative firm **AMBROSI AND ASSOC.** Chicago, Illinois creative people JOHN GARRISON client SEARS ROEBUCK & CO.

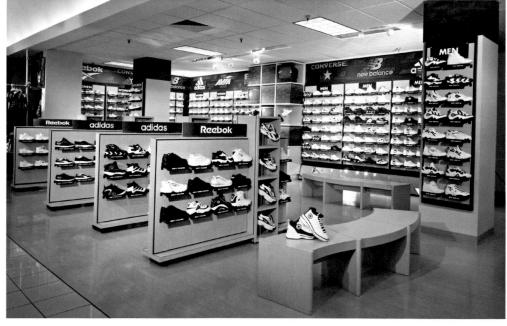

RETAIL GRAPHICS

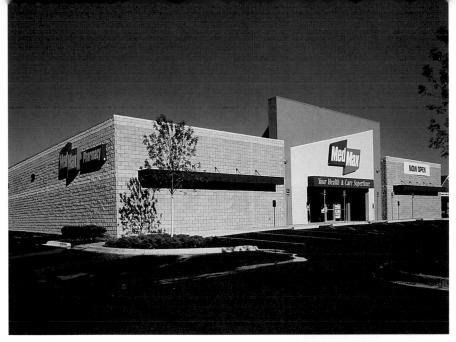

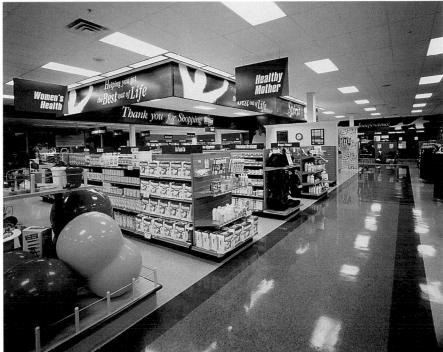

creative firm JON GREENBERG & ASSOCIATES Southfield, Michigan creative people TONY CAMILLETTI, BRIAN EASTMAN client MEDMAX

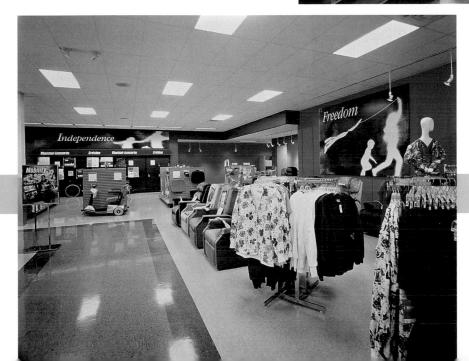

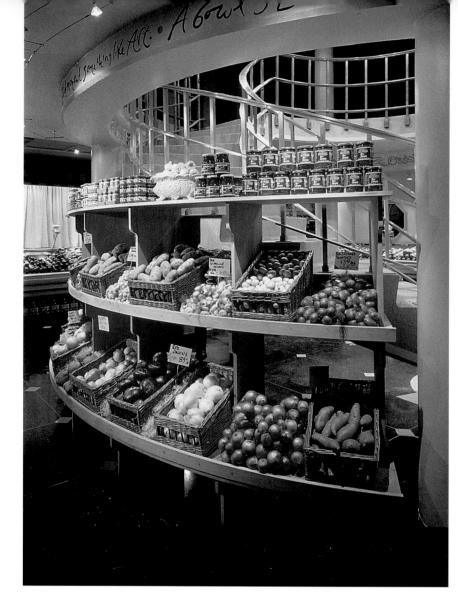

creative firm **KIKU OBATA + COMPANY** St. Louis, Missouri creative people KIKU OBATA, PAM BLISS, KEVIN FLYNN, AIA, THERESA HENREKIN, LISA BOLLMANN, ALISSA ANDRES, SANDY KAISER client STRAUB'S

> creative firm WALKERGROUP/CNI New York, New York creative people CHRISTINA WALKER, ROSS CARN client AT&T WIRELESS SERVICES

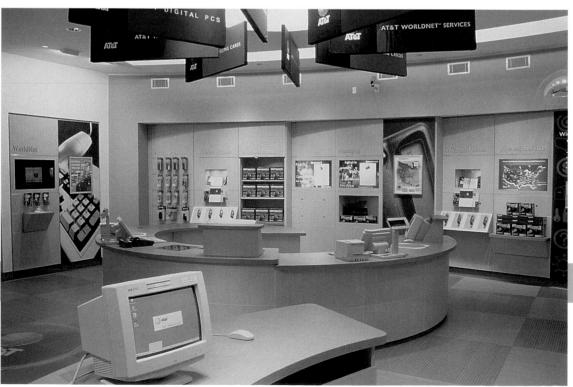

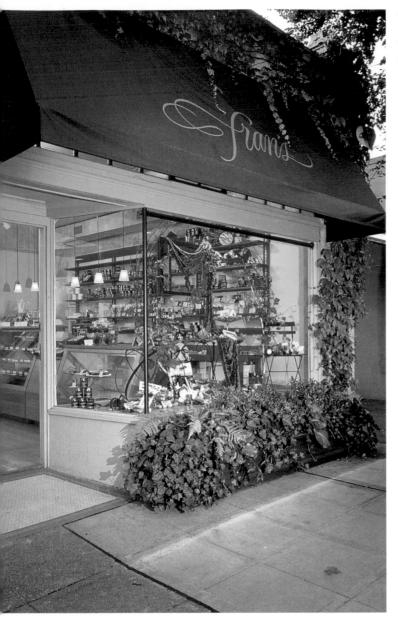

creative firm WALSH & ASSOCIATES, INC. Seattle, Washington creative people MIRIAM LISCO client FRAN'S CHOCOLATES LTD.

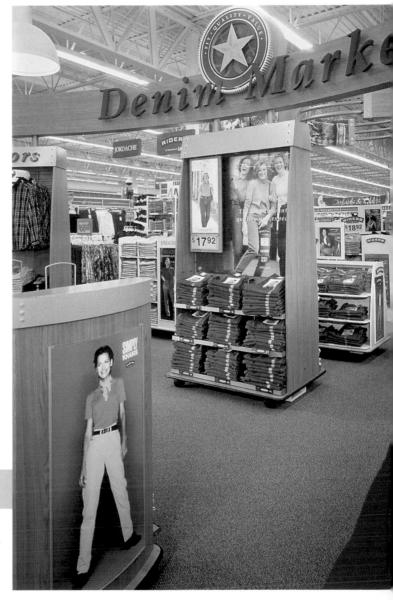

creative firm **CHUTE GERDEMAN, INC.** Columbus, Ohio creative people ADAM LIMBACH client WRANGLER

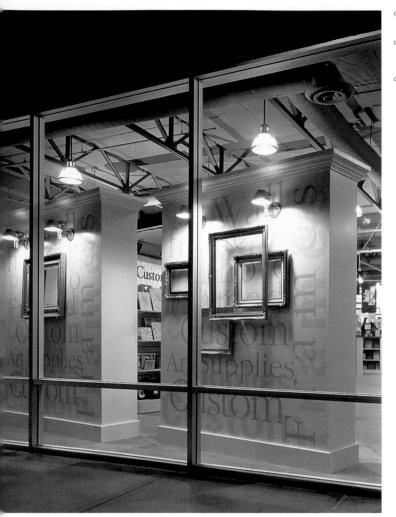

creative firm **KIKU OBATA + COMPANY** St. Louis, Missouri creative people KIKU OBATA, KEVIN FLYNN, AIA, DAVID HERCULES, JOE FLORESCA, JEFF RIFKIN, LAURA McCANNA client AARON BROTHERS ART & FRAMING

creative firm **RTKL ASSOCIATES INC.** Dallas, Texas creative people TOM BRINK client HINES

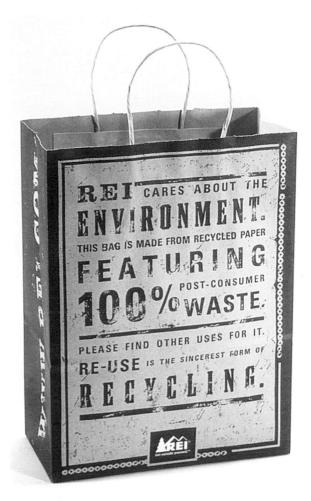

creative firm LEMLEY DESIGN COMPANY Seattle, Washington creative people DAVID LEMLEY, YURI SHVETS, MATTHEW LOYD, JENNIFER HILL, TOBI BROWN client REI

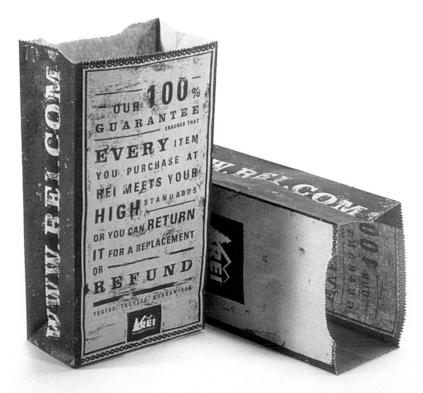

SHOPPING BAGS

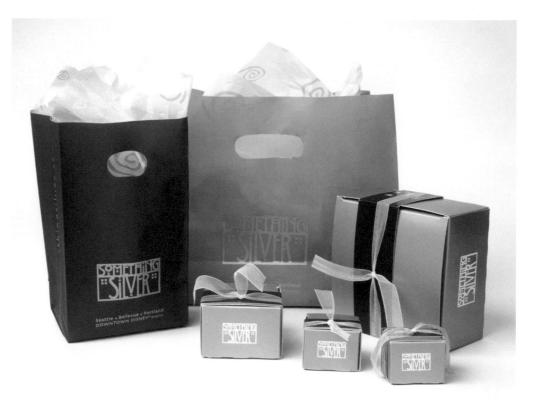

creative firm **MONSTER DESIGN** Redmond, Washington creative people THERESA VERANTH client SOMETHING SILVER

creative firm **HORNALL ANDERSON DESIGN WORKS, INC.** Seattle, Washington creative people JACK ANDERSON, JULIE LOCK JANA WILSON ESSER client

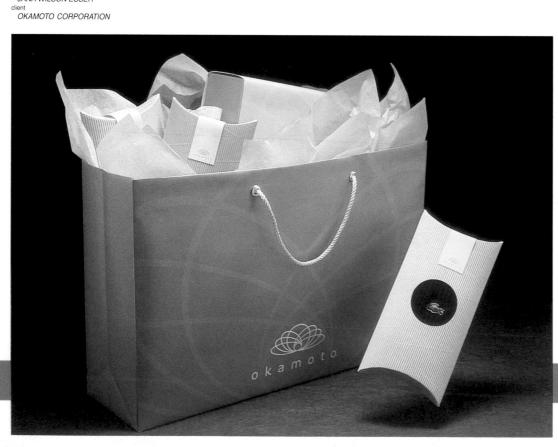

creative firm HORNALL ANDERSON DESIGN WORKS, INC. Seattle, Washington

Seattle, Washington creative people JACK ANDERSON, MARK POPICH, ANDREW WICKLUND, ELMER DELA CRUZ, GRETCHEN COOK, JOHN ANDERLE, SONJA MAX, ANDREW SMITH

client SEATTLE SUPERSONICS

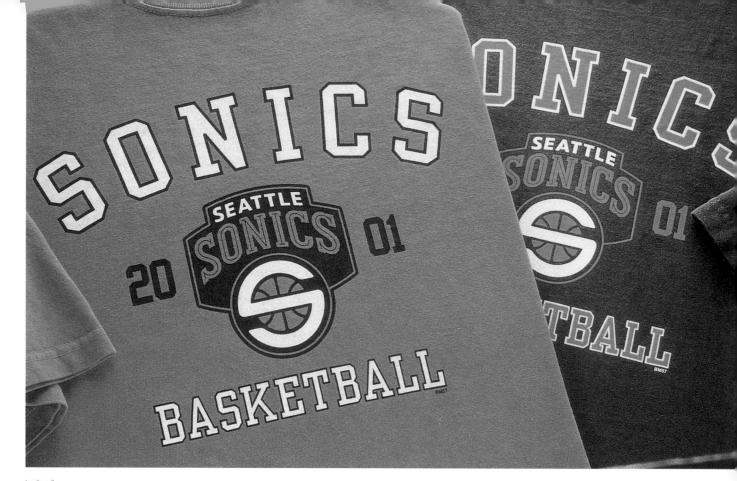

(continued) creative firm HORNALL ANDERSON DESIGN WORKS, INC. Seattle, Washington client SEATTLE SUPERSONICS

creative firm **TOM FOWLER, INC.** Norwalk, Connecticut creative people THOMAS G. FOWLER, MARY ELLEN BUTKUS, DRIEN O'REILLY

client HONEYWELL CONSUMER PRODUCTS GROUP

creative firm **CUBE ADVERTISING & DESIGN** St. Louis, Missouri creative people DAVID CHIOW client SAINT LOUIS ZOO

creative firm **PINKHAUS** Miami, Florida

creative people RAFAEL ROSA, NATHALIE BRESZTYENSZKY, JILL GREENBERG, PLUMB DESIGN client BACARDI USA, INC.

WEB PAGES

did-take decisive actions to help ensure the continued competitiveness of our organization. We lowered our structural costs and resized the company to operate more effectively and efficiently. We shed businesses and product lines that no longer fit our strategic objectives. We closed plants and consolidated facilities and functions. And we reduced the size of our workforce in order to compete at lower levels of economic activity. We expect these restructuring actions to deliver \$100 million of savings in 2002. Additional restructuring actions undertaken in early 2002 in the Truck, Fluid Power and Industrial & Commercial Controls segments are expected to yield an additional \$30 million of savings, for a total of \$130 million of savings during the year. In 2001, we also acquired new businesses to help us reach or exceed our target of growing earnings per share by 10 percent through the cycle. All of this would have been impossible to accomplish without the

> creative firm NESNADNY + SCHWARTZ Cleveland, Ohio creative people CINDY LOWREY, JOHN-PAUL WALTON clien

THE EATON CORPORATION

Introduction Financial Highlights Letter to Shareholders Focal Points
Our Business Model Organizing for Success The Power of One Eaton Bold New Solution: Growth Opportunities 2001 Financial Review Leadership

ho We Are & Support Busines Home > Investor Relations > Document Center > Annual Report > Annual Report 2001 Accelerate

Growth Opportunities

E:T.N

High-performance products come out of Eaton facilities every day-products that contribute to our customers' success. And as they succeed, so do we. Our Aerospace business won nearly \$2 billion in future commercial and military contracts during the year with fluid power system awards on Lockheed Martin's Joint Strike Fighter, the U.S. Army's new RAH-66 Comanche helicopter, Gulfstream's new GIV aircraft, and the world's largest lighter-than-air cargo airship from CargoLifter AG. In addition, Airbus selected Eaton to provide the hydraulic power generation system for the world's largest commercial atriliner, the A380. We also secured a contract with General Electric to develop the gas turbine engine lubrication system to power the Army's M2 main battle tank and Crusader armored vehicle. New supercharger contracts with Mercedes-Benz and our \$500 million multi-year variable valve actuation technology contract with General Motors reinforce our Automotive segment's strategic focus on improving safety, performance, fuel economy and the environment. Our Truck segment accelerated its global reach with the \$250 million DalmlerChrysler AG

ne | Help | Contact Us |

client ORRICK HERRINGTON + SUTCLIFFE

BURKEY BELSER, JILL SASSER, JASON HENDRICKS, ROBYN McKENZIE, LISA HENDERLING, DANIELLE CANTOR

GREENFIELD/BELSER LTD. Washington, D.C. creative people BURKEY BELSER, JILL SASSER,

creative firm

above and beyond	2001 FINANCIAL HIGHLIGHTS Uision, Ualues, Objectives What you should expect Letter to Shareholders	* 2001 FINANCIAL REVIEW SHAREHOLDER INFORMATION 2001 DOWNLOADS INVESTOR RELATIONS
1 Financial Review		
n Year Summaries 🔶	* TEN YEAR SUMMARY-FINANCIAL HIGHLIGHTS	TEN YEAR SUMMARY-GAAP CONSOLIDATED Operating results
n Year Summary—Financial H	ighlights	
en Year Summaries	ighlights Intents)	

Insurance Companies Selected Financial Information and Operating Statistics-Statutory Basis					
Policyholders' surplus ¹	\$2,647.7	\$ 2,177.0	\$ 2,258.9	\$2.029.9	\$ 1,722.9
Ratios:					
Net premiums written to policyholders' surplus	2.7	2.8	2.7	2.6	2.7
Loss and loss adjustment expense reserves to					
policyholders' surplus	1.2	1.3	1.0	1.0	1.1
Loss and loss adjustment expense	73.6	83.2	75.0	68.5	71.1
Underwriting expense	21.1	21.0	22.1	22.4	20.7
Statutory combined ratio	94.7	104.2	97.1	90.9	91.8
Selected Consolidated Financial Information-GAAP Basis					
Total revenues	\$7,488.2	\$ 6,771.0	\$6,124.2	\$5,292.4	\$4,608.2
Total assets	11,122.4	10,051.6	9,704,7	8,463.1	7,559.6
Todal should ald and a suidu?	2.050.7	0.000.0	0,750.0	0,100.1	7,000.0

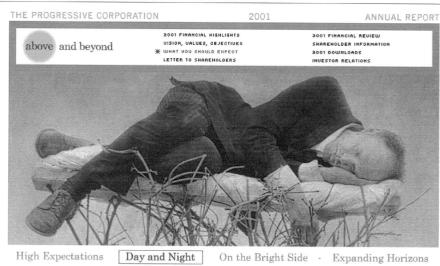

creative firm **NESNADNY + SCHWARTZ** *Cleveland, Ohio* creative people *CINDY LOWREY,*

THE PROGRESSIVE CORPORATION

2001

JOHN-PAUL WALTON

No.

Answers | Recommended Links

You're a Progressive customer.

ANNUAL REPORT

It's 1 a.m. You're going out of town in the morning and you want to pay your bill before you go. [more]

Do you remember when you first started using the Internet?

Progressive does. In 1995, the Company stepped into the future with the launch of progressive.com [more]

THE PROGRESSIVE CORPORATION

above and beyond

2001 FINANCIAL HIGHLIGHTS Uision, Ualues, objectives What you should expect Letter to shareholders

2001 FINANCIAL REUIEW Shareholder Information 2001 Downloads Investor Relations

and beyond

Since the Progressive insurance organization began business in 1937, we have been innovators--growing into new markets and pioneering new ways to meet consumers' needs. In 1956, Progressive Casualty Insurance Company was founded to be among the first specialty underwriters of nonstandard auto insurance. Today, The Progressive Corporation provides all drivers throughout the United States with competitive rates and 24-hour, in-person and online services, through its 73 subsidiaries and two affiliates. Our commitment to creating a Virtually Perfect customer experience led us to

Our commitment to creating a Virtually Perfect customer experience led us to choose service as the theme for this year's annual report. Progressive combines online access to policy information with 247 personalized assistance for buying, policyholder service and claims. For examples of Progressive's commitment to service, please visit <u>personal progressive.com</u>. Artist Robert ParkeHarrison was commissioned to respond visually to service.

Aust robert Parkerfainson was commissioned to respond visually to service. Parkel-farrison is the inventor, painter, set designer, producer and model of his photographic situations. Parkel-Harrison's work will become part of Progressive's growing collection of contemporary art. For a brief history of Progressive's art collection, stop by <u>art.progressive.com</u>.

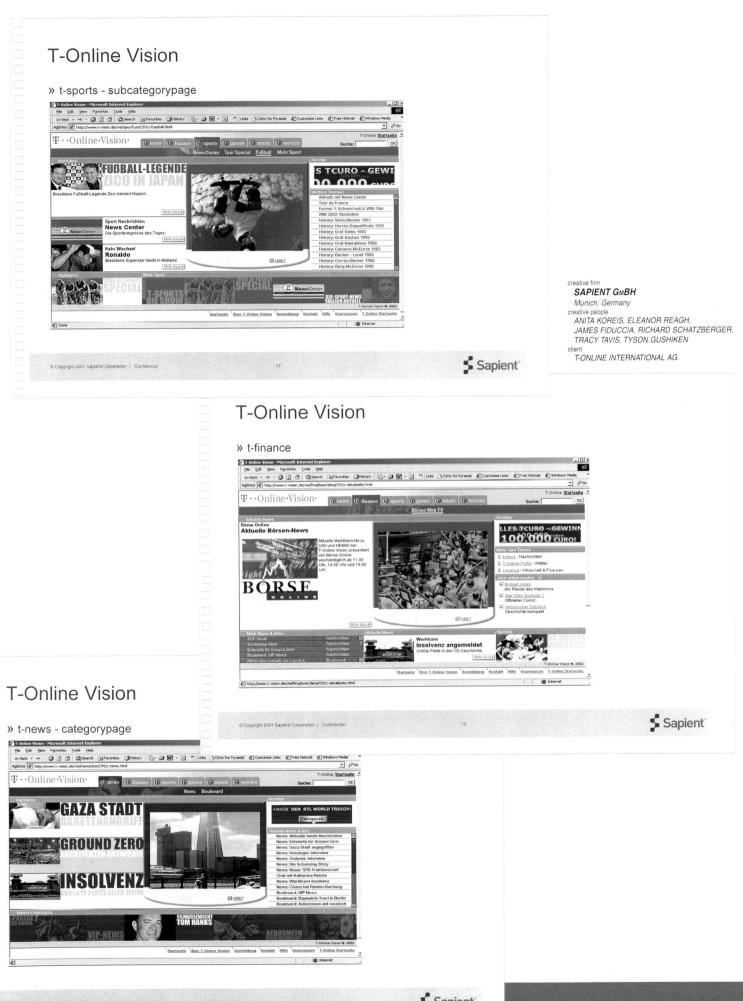

P Convinit 2001 Sabient Corporation | Confidential

Sapient

SYMBOLS

(ARGUS) 150 20TH CENTURY FOX 264 34TH STREET PARTNERSHIP 231

Α

A GARDENING COMPANY 150 A PLACE TO GROW 142 AARON BROTHERS ART & FRAMING 370 ABBOTT ANIMAL HEALT 340, 341 ACADIA CONSULTING GROUP 141 ACE HARDWARE CORPORATION 80 ACTERNA 24 ACTIVE MOTIF 242 ADAM, FILIPPO & ASSOCIATES 255 ADDISON DESIGN CONSULTANTS PTE LTD 184, 185 ADDISON SEEFELD AND BRE 197 ADDISON WHITNEY 135 ADVANTAGE LTD, 73 AHBL 138 AHOLD 286, 288 AIDS RESPONSE-SEACOAST 143 AIGA LAS VEGAS CHAPTER 22 AJF MARKETING 280, 291 AKA DESIGN, INC. 96, 100, 105, 106, 110, 114 ALBERT BOGNER DESIGN COMMUNICATIONS 69, 275 ALDO LEOPARDI 252, 263 ALEX MELLI DESIGN 247 ALL MEDIA PROJECTS LIMITED (AMPLE) 8 ALLEGIANCE 196 ALLIANCE VENTURE MORTGAGE 138 ALPHA STAR TELEVISION NETWORK 130 ALTERPOP 230 AMASINO DESIGN 58 AMAZON ADVERTISING 318 AMBROSI AND ASSOC. 366 AMD 83 AMERICA MOVIL 30 AMERICAN HARDWARE MANUFACTURERS ASSN: 5 AMERICAN INSTITUTE OF ARCHITECTURE 80 AMERICAN URILOGICAL ASSOCIATION 119 AMGEN 134 AMISANO DESIGN 225 AMP 347 AMY C. CECIL, O.D. 246 ANASYS 152 ANHEUSER BUSCH EMPLOYEES **CREDIT UNION 25** APPLIED MATERIALS 60, 199, 201 APPROPRIATE TEMPORARIES, INC. 142 AQUEA DESIGN 161 ARCHON GROUP 160 ARENA STAGE 311, 312, 313 ARMORCOAT, LLC. 133 ART DIRECTORS CLUB OF METROPOLITAN WASHINGTON 132 ART FIGHTS BACK 322, 324 ART270, INC. 131, 144, 149 ARTENERGY 240 AS BOAS RAPARIGAS 44, 329 ASCENTIVES 147

ASIA SATELLITE TELECOMMUNI-CATIONS HOLDINGS LIMIT 26 ASTRAL MEDIA 23 AT&T WIRELESS SERVICES 368 AT&T/ACURA/CIRQUE DUSOLEIL

202 AT HOME AMERICA 124 ATOMZ INTERACTIVE 338 ATWOOD MOBILE PRODUCTS 127 AUE DESIGN STUDIO 138 AUGUST SCHELL BREWING CO 284, 287 AUTOGERMA-AUDI DIVISION 19, 20 AVAKI 230 AVERY AFTERBURNER 14

в

BACARDI USA, INC. 376 BACHOCO 276 BADGER TECHNOLOGY 252 BAILEY DESIGN GROUP 161, 284, 287 BAKER DESIGNED COMMUNICA-TIONS 52 BALL ADVERTISING & DESIGN, INC. 283 BAMENDA SERVICES 244 **BARBARA BROWN MARKETING &** DESIGN 125, 147, 156 BARONET 302 **BAUER NIKE HOCKEY 123** BAYER CONSUMER CARE DIVISION 276 **BAYKEEPER 257** BBK STUDIO 244 **BE.DESIGN 297** BEAR BODIES FITNESS STUDIO 146 BELANGER RHEAULT COMMUNI-CATIONS DESIGN LTD 23 **BELL MEMORIALS & GRANITE** WORK 145 BELLA NICO, INC. 281 BERKELEY DESIGN LLC 94, 137 BERNHARDT FUDYMA DESIGN GROUP 340 **BERNI MARKETING & DESIGN** 104, 107, 111, 112, 113, 115 **BETH SINGER DESIGN 91** BETTER BEGINNINGS LEARNING CENTER 145 BETTY CROCKER 275 BIJAN ADVERTISING 21 **BIJAN FRAGRANCES 21 BIRDPLAY 162** BISCOTTI & CO., INC. 115 BLACK LETTER DESIGN 342, 343 BLACK SOAP 286, 299 BLACKSTOCK LEATHER 148 BLUMLEIN ASSOCIATES, INC. 202 B'NAL B'RITH YOUTH ORGANIZA-TION 91 BOELTS/STRATFORD ASSOCIATES 135 BON-TON OPTICALS 8, 11 BOURN/KARIL CONSTRUCTION 135 BP TRINIDAD AND TOBAGO LLC (BPTT) 8 BRAD NORR DESIGN 130, 144 **BRADY COMMUNICATIONS 297** BRAND, LTD, 245 BRAND MANAGEMENT 7 BRIDGE CREATIVE 82

BRIDGEHAMPTON MOTORING 141

BUNDLES BABY CLOTHES 138 BURROWS 333 **BUSINESS INCENTIVES** 144 BUTTITTA DESIGN 128 С C*ME COSMETICS 289 CAFE YUMM! 191 CAHAN & ASSOCIATES 232, 241, 257 CAL-PACIFIC CONCRETE, INC. 136 CAMPBELL-EWALD ADVERTISING 314, 315, 326 CANOPY RESTAURANT 149 CAPSULE 99, 151 CAPT FLYNN ADVERTISING 150 CARE 86 CASA DA MÚSICA 32 CASA DA MÚSICA/PORTO 2001 34, 46 CASSATA & ASSOCIATES 282, 294 CASSIOPEIA 42 CHAMPCOHEN DESIGN 340, 341 CHANDLER EHRLICH 19 CHANGO THE BAND 314 CHASE CREATIVE 317 CHEN DESIGN ASSOCIATES 61 CHERRY CREEK SHOPPING CENTER 12 CHICAGO PARK DISTRICT 182 CHILDREN'S ACADEMY OF THEATRE ARTS 75 CHINA REBAR CO., LTD. 184, 185 CHOURA-FORBES ARCHITEC-**TURE & DESIGN 65** CHRIS DAVIS 136 CHURCH HEALTH CENTER 19 CHUTE GERDEMAN, INC. 369 CINGULAR WIRELESS 129 CITY OF JEFFERSONVILLE, INDIANA 189 CLARIAN HEALTH INDIANAPOLIS, IN 188 CLARION 248 CLARK CREATIVE GROUP 133 CLARKE AMERICAN 150 CLEARLY CANADIAN BEVERAGE CORP. 288 CLUBE PORTUGUES DE ARTES E **IDEIAS 38** CNA TRUST 128 COCA-COLA 265, 347 COCA-COLA COMPANIES 158 COLEMAN OUTDOOR ESSENTIALS 152 COLGATE-PALMOLIVE 268 COLGATE-PALMOLIVE PROMO-TION DESIGN STUDIO 268 COLT STAFFING 247 COMMUNICATE 229 COMMUNITY FOUNDATION FOR MONTEREY COUNTY 125 COMPANY DNA 122 COMPASS DESIGN 275, 281, 284, 287, 295, 296, 298 COMPUTER ASSOCIATES 132, 290 COMPUTER ASSOCIATES INTERNATIONAL, INC. 132, 290

INDEX

BRINKER INTERNATIONAL 13

BRUCE YELASKA DESIGN 146

BULLET COMMUNICATIONS, INC.

BRIX RESTAURANT 352

BTC MOBILITY 73

183

BUCK & PULLEYN 18

CONCRETE DESIGN COMMUNICA-TIONS INC. 122, 150 CONDOR ENGINEERING 235 CONFLUX DESIGN 127 CONOCO "BREAKPLACE" 174 CONVENAS SOLUTIONS 231 COPERNICUS FINE JEWELRY 106 COPPERFASTEN 146 COBBIN 169 CORBIN DESIGN 183, 188 COBBINS ELECTRIC 257 COREY MCPHERSON NASH 230 CORNELL FORGE COMPANY 253 CORNERSTONE CHURCH 122 COST PLUS WORLD MARKET 297 CP2 DISTRIBUTION, LLC 61 CRAWFORD MUSEUM OF TRANSPORTATION AND INDUSTRY 234 CREATIVE DYNAMICS, INC. 262 CROWLEY WEBB AND ASSOCI-ATES 150, 231, 235 CSC 218, 220, 221 CUBE ADVERTISING & DESIGN 116. 333. 375 CULLINANE 63 CUYAHOGA VALLEY NATIONAL PARK 126, 149

D

DAVID CARTER DESIGN ASSOC. 335, 339 DAVIDOFF ASSOCIATES 29 DE MILLUS IND E COM. S.A. 289 DEAN DESIGN/MARKETING GROUP, INC. 222, 223 DECATHLON 22 DEKA DESIGN INC. 236 DELO DAILY NEWSPAPER 57 DELRIVERO MESSIANU DDB 13 DEMICHO 127 DENISON LANDSCAPING 84 DENNIS S. JUETT & ASSOCIATES INC. 179 DESBROW 86, 119 DESBROW & ASSOCIATES 151 **DESIGN COUP 140 DESIGN FORUM 119** DESIGN GUYS 278, 283 **DESIGN NUT 148** DESIGN RESOURCE CENTER 61, 80 DESIGN SOLUTIONS 71, 261 DESIGN5 364 DESIGNEIVE 145 DESIGNROOM CREATIVE 238, 258 DESTINA 157 DEVER DESIGNS 28, 85 DGWB 5, 10, 14, 332 DIALOGUE3 237 DICKINSON BRANDS 111 DIESTE HARMEL & PARTNERS 7 DIGITAL PRINTING CENTER 121 **DISCOVERY MUSEUM 274** DISNEYLAND CREATIVE PRINT SERVICES 7 DOERR ASSOCIATES 77, 160 DOMAIN HOME FURNISHINGS 130 DOMINO'S PIZZA 197 DOMTAR 51 DON BLAUWEISS ADVERTISING & DESIGN 65 DOYLESTOWN SPORTS MEDICINE CENTER 131 DPSU, INC. 286 DRAKE TAVERN 144

DRUCKWERKSTATT 254 DUCLAW BREWERY 311 DULA IMAGE GROUP 137, 158, 246 DUNN AND RICE DESIGN, INC. 119 DYER, ELLIS & JOSEPH 90, 93

Е

EASTMAN KODAK COMPANY 280, 290.345 ECOSORT 193 EDISON BROTHERS (BAKERS) 366 FLLE 16 ELLEN BRUSS DESIGN 12 EMERSON, WAJDOWICZ STUDIOS 51 EMPHASIS SEVEN COMMUNICA-TIONS, INC. 253 ENGLE HOMES/THE JAMES COMPANY 188 ENROUTE COURIER SERVICES 139 ENTERPRISE LOGIC 134 ENVENTURE GLOBAL TECHNOL-**OGY 15** EPS SETTLEMENTS GROUP 160 EQUITY BANK 239 ESI DESIGN 186, 236, 272 ESOTERA GROUP INC. 133 EVENSON DESIGN GROUP 125, 131, 140, 144, 298 EXXON MOBIL 21

F

F&P-RISO GALLO 18 FAIRFIELD PROCESSING 300 FAR EAST ORGANIZATION 190, 194 FAUST ASSOCIATES CHICAGO 66 FERRIS STATE UNIVERSITY 169 FIFIELD DEVELOPMENT COMPANY 180, 181 FINE ARTS MUSEUM 232 FINE LINE LITHO 159 FINISHED ART, INC. 129, 153 FIRESTARTER 120 FIRST CLASS FLYER 142 FIRST HEALTH OF THE CAROLINAS 21 FITWEST, INC. 147 FIXGO ADVERTISING (M) SDN BHD 120, 148 FLEXO IMPRESSIONS, INC. 224 FLORIDA HOSPITAL 20 FOR SOMEONE SPECIAL 120 FORD MOTOR COMPANY 333 FORENSIC LABS 139 FORSYTH SCHOOL/PHOEBE RUESS 94 FORWARD BRANDING & IDENTITY 62, 278, 280, 290, 294, 345 FOUR PAWS DOG RESCUE 310 FOX INTERACTIVE 292 293 FRAN'S CHOCOLATES LTD. 193. 369 FRCH DESIGN WORLDWIDE 366 FREDERICK/VANPELT 315, 316 FRIDA HOLMFRIDUR VALDIMARSDOTTIR 120 FRITZ CREATIVE 235 FRX SOFTWARE CORPORATION 75 FRY HAMMOND BARR 20 FUNDY CABLE 123 FUNK & ASSOCIATES 193

FUNK/LEVIS & ASSOCIATES 137, 191

FUSION DESIGNWORKS 243 FUSZION COLLABORATIVE 132, 344 FUTURA DDB D.O.O. 57 FUTUREBRAND 31, 83, 86, 92, 118, 156, 251, 301, 352

G

G1440, INC. 256 GAGE DESIGN 135 GALLERY C 144 GALLO OF SONOMA 70 GARLAND CIVIC THEATRE 315, 316 GAUGER + SANTY 5 GBK, HEYE 16, 321 GCG ADVERTISING 147, 157, 162 GEDNEY 281 GEE + CHUNG DESIGN 60, 199, 201 GENERAL ELECTRIC 31 **GENERAL MOTORS 92** GENE'S RISTORANTE 134 **GEOGRAPHICS 88** GEORGIA WORLD CONGRESS CENTER 190 GIARDIA TRACK & DRINKING CLUB 312 GIDEON CARDOZO 158 **GIRL SCOUTS 318** GIVO, LJUBLJANA 72 GLITSCHKA STUDIOS 143, 154, 262 GLOBE AND MAIL 150 GMC ENVOY 84 GOLD & ASSOCIATES 266 GOLDCOAST SPECIALTY FOODS 254 GOLDFOREST 299, 300 GOLDMAN SACHS 63 **GOODLIFE FITNESS CLUBS 14 GOODRICH & ASSOCIATES 133** GOODWICK/LIAZON LEVERAGE MARCOM GROUP 339 GOUTHIER DESIGN 74, 233 GRAFIK 24, 311, 354, 356, 357 GRAFIQA 145 GRAPHIC PERSPECTIVES 75. 82 **GRAPHICAT LIMITED 26** GRAPHICULTURE 319 GREEN BAY PACKERS 131, 141, 148, 158 GREEN MUSIC CENTER 128 GREENFIELD/BELSER LTD 76, 81, 90, 93, 95, 378, 379

90, 93, 95, 378, 379 GSO GRAPHICS INC. 51, 228 GUTIERREZ DESIGN ASSOCIATES 259 GYPSY DEN 332

н

H.J. HEINZ CO. OF CANADA 9 H3R, INC. 240 HAESE, LLC 225 HAMAGAMI/CARROLL 134, 264 HAMBLY & WOOLEY INC. 122, 148 HANSEN DESIGN COMPANY 85 HARDBALL SPORTS 133, 140 HASBRO, INC. 119 HEALING PLACE MUSIC 136 HEIMBURGER 6, 22 HELPFIRST.COM 226 HENDLER-JOHNSTON 224, 239 HERIP ASSOCIATES 126, 149 HERON HILL WINERY 287 HEWLETT-PACKARD 351, 353 HEY! HOT DOG RESTAURANT 183 HEYE & PARTNER 306, 308

HILLTOP RANCH INC. 145 HINES 370 HIRE RETURN, LLC 130 HMS DESIGN, INC. 285, 286 HO BEE INVESTMENTS LIMITED 27 HOE 237 HOLLY DICKENS DESIGN 126, 156 HOME FIELD SERVICES INC. 157 HONEYWELL CONSUMER PRODUCTS GROUP 276, 280, 299, 375 HORNALL ANDERSON DESIGN WORKS, INC. 171, 233, 278, 279, 285, 283, 346, 347, 372, 373, 374 HOT ROD HELL 317 HRABROSLAV PERGER 258 HUBERT CONSTRUCTION 245 HUNTINGTON MEMORIAL HOSPITAL 179 HUTTER DESIGN 336, 337, 354 Ĩ. IAFIS 125 ICC TOOLS 123

ID8 STUDIO/RTKL 80, 160, 170 **IDEA SCIENCES 82** IFF INTERNATIONAL FLAVORS & FRAGRANCES 280, 291 **IHI TRAVEL INSURANCE 6** IM-AJ COMMUNICATIONS & DESIGN, INC. 154 IMPINJ, INC. 135 IMS 178, 180, 181 IMS SYSTEMS 127 INDIANAPOLIS 500 160 INGEAR 142, 291 INNIS MAGGIORE GROUP 297 INSIGHT DESIGN COMMUNICA-TIONS 109 INTERBRAND HULEFELD 282, 290, 300.301 INTERLOCKING MEDIA 149 INTERNATIONAL ASSOCIATION OF AMUSEMENT PARKS AND 15 INTERROBANG DESIGN COLLABORATIVE 364 INTRADO 227 INVISION STRATEGIES 238 IRIDIUM, A DESIGN AGENCY 121 IRVINE COMPANY 170 IWS BOARDSHOP 334

J

J. WALTER THOMPSON 14, 305 JAMBA JUICE 171 JAN COLLIER REPRESENTS 203, 204, 205, 206, 207, 208, 209, 210, 211, 212, 213, 214, 215, 216, 217, 218, 219, 220, 221, 248 JDS STABLES 153 JEFF FISHER LOGOMOTIVES 143 JENSEN DESIGN ASSOC. INC. 360 JILL TANENBAUM GRAPHIC DESIGN & ADVERTISING 89 JIVA CREATIVE 139, 249, 250 JOHN MANNO PHOTOGRAPHY 354 JOHNS HOPKINS UNIVERSITY/PTE 89 JOHNSTON ENTERPRISES 240 JOIE DE CHARLOTTE 138 JON GREENBERG & ASSOCIATES 367 JONES DESIGN GROUP 88, 253 JONES WORLEY DESIGN INC. 190, 192 JOURNEYMAN PRESS 58 JULIANE HALIOWELL 249

JULIE SCHOLZ, CCHT 139

κ KAISER PERMANENTE NORTHWEST 176 KARACTERS DESIGN GROUP 120, 121, 151, 153, 157, 288, 289 KAREN SKUNTA & COMPANY 281 KARL KROMER DESIGN 120, 139 KAZI BEVERAGE COMPANY 285 **KEEN BRANDING 127** KELLEY TECHNICAL COATINGS 275 KELLOGG CANADA 10 **KELLOGGS/KEEBLER 294 KEMPS 295 KEYWORD DESIGN 135** KIKU OBATA + COMPANY 25. 124. 142, 171, 172, 175, 368, 370 KINGGRAPHIC 190, 194 KINGSBOROUGH COMMUNITY COLLEGE 124 KIRCHER, INC. 15, 125, 130, 149 KNYGU NAUJIENOS 48 KODAK 18 KOEN SUIDGEEST 121 KOLANO DESIGN 147, 161 KOR GROUP 225 KRAHAM & SMITH 169 KROG 72, 258, 260 KROGER 290, 301 KULTURSELSKABET STILLING 13

L

LABATT USA, INC. 285 LABELS-R-US 143 LADLE OF LOVE 156 LADY LINDA 107 LAF ENTERPRISES 352 LAFARGE NORTH AMERICAN, CORP. COMMUNICATIONS 141 LARSEN DESIGN + INTERACTIVE 129 LAURA COE DESIGN ASSOC. 241. 242 LAWRENCE & PONDER IDEAWORKS 9, 227, 334 LEADING BRANDS 151 LEINICKE DESIGN 157 LEKAS MILLER DESIGN 78 LEMLEY DESIGN COMPANY 320, 326.371 LEO BURNETT COMPANY LTD. 8. 9, 10, 14 LEOPARD 227 LESLIE TANE DESIGN 244 LESNIEWICZ ASSOCIATES 134. 138, 153 LEVERAGE MAR COM GROUP 300 LEVICK STRATEGIC COMMUNICA-TIONS 95 LEVINE & ASSOCIATES 62, 77, 87, 119 LEWAN & ASSOCIATES 226 LEXICOMM 149 LIBRARY OF CONGRESS 85 LIMEAIDE REFRESHING DELIVERY 267 LIONS KLUB LJUBLJANA ILIRIA 260 LIPPINCOTT & MARGULIES 174 LIPSON•ALPORT•GLASS & ASSOCIATES 196, 294 LISKA + ASSOCIATES, INC. 124, 158 LIZÁ RAMALHO 32, 34, 36, 38, 41, 42, 44, 46, 328, 329 LOCATE NETWORKS 250 LOGOS IDENTITY BY DESIGN LIMITED 123, 130

LONNIE DUKA PHOTOGRAPHY 137 LORENC + YOO DESIGN 170, 189. 197 LOUIS & PARTNERS 198 LOUISIANA STATE UNIVERSITY 119 LPG DESIGN 363 LUND FOOD HOLDINGS 99 LYNN SCHULTE DESIGN 335, 343 M REPRESENTS 336, 337 M3AD.COM 22 MAGICAL MONKEY 124, 141 MAINFRAME MEDIA & DESIGN LLC 286, 299 MAKU ART USA CORP. 255 MALIBU 14 MALLARD CREEK GOLF COURSE

143 MARCH OF DIMES 86 MARCIA HERRMANN DESIGN 70. 124, 145, 284, 285 MARITZ 124 MARKETING CONCEPTS 250 MARSHALL MCCORMICK WINERY 284 MARYL SIMPSON DESIGN 136 MATIKA 305 MATT TRAVAILLE GRAPHIC DESIGN 153 MAVERICKS GYM 125 MAX MINING AND RESOURCES 158 MAXMILLIAN'S MIXERS 279 MCCANN-ERICKSON 17, 21 MCCANN-ERICKSON SYDNEY 15, 265 MCCLAIN FINLON ADVERTISING 7 MCELVENEY & PALOZZI DESIGN GROUP 252, 277, 287, 296 MCGRAW-HILL 156 MCI WORLDCOM PTE LTD 338 MCMILLIAN DESIGN 134, 159 MEDESTEA 282 MEDICAL ECONOMICS FOR OBGYNS 168 MEDMAX 367 MEGARADIO 321 MEMPHIS SHELBY COUNTY 197 MERTEN DESIGN GROUP 226 METHODIST'S SCHOOL FOUNDATION 316 METHODOLOGIE 348, 350 MEXICO CITY 132 MFDI 137, 141, 143, 162 MGM 344 MICHAEL NIBLETT DESIGN 143 MICHAEL ORR + ASSOCIATES, INC. 155 MICHAEL TOLLAS 140 MICROSOFT 118 MID HEAVEN 255 MILESTONE DESIGN, INC. 140 MILLENNIUM GRAPHICS 225 MINNESOTA HISTORICAL SOCIETY PRESS 130

MINUSCIAL PRESS 130 MIRATO—ITALY 288, 289 MIRES 311, 312, 313 MIRES DESIGN 317 MLBP 123 MLBP INTERNATIONAL 122, 152 MN DESIGN GROUP 56 MONA DAVIS MUSIC 306, 308 MONDERER DESIGN 133 MONSTER DESIGN 372 MOUNTAIN HAMS 262 MTV NETWORKS 19, 336 MTV NETWORKS CREATIVE SERVICES 19, 336 MUELLER & WISTER, INC. 64 MUNIFINANCIAL 158 MUTUAL UFO NETWORK & MUSEUM 7

NASCAR 121, 159 NASSAR DESIGN 169, 249 NATIONAL CENTER ON EDUCATION AND THE ECONOMY 87 NATIONAL FISH AND WILDLIFE FOUNDATION 28 NATIONAL INSTITUTE ON AGING 77 NATIVE FOREST COUNCIL 137 NATIVE LANDSCAPES 146 NATURAL RESOURCE GROUP 335 343 NAVY PIER 178 NESNADNY + SCHWARTZ 159, 234, 377, 380 NESTLE 15, 301 NESTLÉ PURINA PETCARE COMPANY 279, 295 **NEVER BORING DESIGN 136** NICK WOYCIESJES 277 NICKLES BAKERY 297 NINO SALVAGGIO INTERNATIONAL MARKETPLACE 299, 300 NOBLE ERICKSON INC. 188 NOLIN BRANDING & DESIGN INC. 123 NORDYKE DESIGN 129 NORTH AIRE MARKET 296, 298 NORTHERN KANE COUNTY CHAMBER OF COMMERCE 122 NORTHWESTERN NASAL + SINUS 158 NOVELLO FESTIVAL OF READING 11.13 NUTRITION 21 132 NYS DEP'T PARKS & RECREATION 169

)

OAKLAND UNIVERSITY ROCHESTER, MICHIGAN 183 ODIUM, INC. 176, 178 OKAMOTO CORPORATION 372 OLDHAM 283 OLIVES & LEMONS CATERING 150 OLYMPIC 297 OMB DISENTO Y COMUNICACION VISUAL 328, 330 ONEWORLD CHALLENGE 233, 283 OPTITEK, INC. 157 **ORIGINAL IMPRESSIONS 255 ORRICK HERRINGTON +** SUTCLIFFE 378, 379 OUSLEY CREATIVE 128 OUSLEY CREATIVE 162 OUT OF THE BOX 79, 152 OUTDOORS CLUB 162 OVERTURE.COM 125

P P&G 126

P2 COMMUNICATIONS SVCS. 218, 220, 221 PAL SUPER STORE 313 PALACE OF AUBURN HILLS 175 PALIS GENERAL CONTRACTING 120 PALISADES REALTY 172 PALM ISLAND DEVELOPERS 251

PAN EUROPEAN POSTER DESIGN COMPETITION AND EXHIB 328 PANNAWAY 133 PAPRIKA 302, 355 PARADOWSKI GRAPHIC DESIGN 129,144 PARAGRAPH DESIGN 251 PARAGRAPHS DESIGN 251 PARIS BAGUETTE 119 PARK PROVENCE/CHARLES DEUTSCH 137 PASS-A-GRILLE WOMEN'S CLUB 317 PAT TAYLOR INC. 120 PEAR DESIGN INCORPORATED 237 PEIK PERFORMANCE 140 PEOPLE MAGAZINE 166 PEOPLE SPECIAL ISSUES 166 PEREGRINE TECHNOLOGY SDN BHD 148 PERFORMANCE GRAPHICS OF LAKE NORMAN INC. 267 PERIPHERE 355 PERLMAN COMPANY 134 PET EXPRESS 258 PETE SMITH DESIGN 123 PHARMACHEM LABORATORIES, INC. 161 PHIL'S NATURAL FOOD GROCERY 162 PHINNEY BISCHOFF DESIGN HOUSE 236, 250 PHOENIX CREATIVE GROUP 127. 141 PHOENIX DESIGN WORKS 119, 121, 122, 123, 152, 158, 159, 160, 161, 162, 292, 293 PICK UP STIX 9 PILLSBURY WINTHROP LLP 81 PINKHAUS 376 **PINNACLE ENVIRONMENTAL 162** PINPOINT TECH SERVICES 159 PIPER RUDNICK LLP 76 **PITCARIN AVIATION 310** PLANIT 132, 256 PLANNED PARENTHOOD 9 PLATFORM CREATIVE GROUP 138 PLAYBOY ENTERPRISES INTERNA-TIONAL, INC 164, 166 PLAYBOY MAGAZINE 164, 166 PLISE DEVELOPMENT & CON-STRUCTION 245 PLUM GROVE PRINTERS 159 PLURIMUS 122 POLAROLO IMMAGINE E COMUNICAZIONE 282, 288, 289 POLSHEK PARTNERSHIP 259 POLSHEK PARTNERSHIP ARCHITECTS 232 POOL DESIGN GROUP 131, 162 PORTAL PLAYER 241 PORTFOLIO CENTER 122, 130, 132, 138, 139, 145, 149, 152 POULIN + MORRIS 51, 228, 232, 259 PRACTICAL COMMUNICATIONS. INC. 154 PREMIER COMMUNICATIONS GROUP 84 PREVIEW HOME INSPECTION 134 PRINTING INDUSTRIES ASSOCIATION OF SAN DIEGO 241 PROCTER & GAMBLE 282, 300 PRODUCE PARADISE 136

PROFILE DESIGN 202 PROJECT HORIZON-COMMUNITY 129

PROTOCOL OFFICE, PROV. OF BC 123 **PROVIDENCE SCHOOL** DEPARTMENT & THE RI CHILDBEN'S 154 PRUFROCK'S COFFEE 131 PUBLIC PROPERTY GROUP 160 PUBLICIS DIALOG 351, 353

Q

Q PASS 348, 350 QUICK 153

R

RAM MANAGEMENT CO., INC. 82 RASSMAN DESIGN 292, 293, 295 RECREATION STATION 105 RECREATIONAL EQUIPMENT, INC. 320 RECRUITEX 121 RED CANOE 203, 204, 205, 206, 207, 208, 209, 210, 211, 212, 213, 214, 215, 216, 217, 218, 219, 220, 221 **RED CANOE 248 RED MONKEY DESIGN 229** BEI 326, 371 RENAISSANCE HOLLYWOOD HOTEL 339 RENDEZVOUS ENTERTAINMENT 159 REPUBLIC OF SINGAPORE AIR FORCE 54 **RESCO PRINT GRAPHICS 224.** 242, 243 RETIREMENT CONSULTANTS, LTD. 147 **REUTERS AND INSTINET 272** REUTERS NORTH AMERICA AND **INSTINET CORP 186 RGB DESIGN 289** RHIZOMES.NET 229 RICK SEALOCK 342, 343 **RIVARD STONE 242** RIVER FALLS AREA CHAMBER OF COMMERCE 224 **RIVER VALLEY RIDERS 151** ROBERT TALARCZYK DESIGN 310 ROBINSON KNIFE COMPANY 155 ROCAMOJO 298 ROCK OF AGES 277 ROCKY MOUNTAIN CHOCOLATE FACTORY 279 ROCKY MOUNTAIN FOODS 124 **RODERICK ENGLISH 235** RONALD REAGAN PRESIDENTIAL LIBRARY FOUNDATION 156 ROSENBERGER DESIGN 247 ROTTMAN CREATIVE GROUP, LLC 68,84 RTKL ASSOCIATES INC. 370 RULE29 147, 226 RYAN COMPANY 234 s S & G PROPERTIES, NW LLC 178 S.C. JOHNSON & SON, INC. 277. 298

SABINGRAFIK, INC. 296 SAGE METERING, INC. 152 SAGEWORTH 69 SAINT JOSEPH'S UNIVERSITY 162 SAINT LOUIS ZOO 116, 333, 375 SAM'S 291 SAPIENT GMBH 381 SASSY ONION GRILL 262 SAVAGE DESIGN GROUP 15 SAYLES GRAPHIC DESIGN 322, 324, 352 SCANAD 13, 18, 22

SCHNIDER & YOSHINA LTD. 127. 146 SCHWENER DESIGN GROUP 246 SCRAPS & MUMBLES CREATIVE FUN CO., LLC 102 SEAFARER BAKING COMPANY 296 SEARS ROEBUCK & CO. 366 SEATTLE CHILDREN'S HOME 198 SEATTLE SUPERSONICS 373, 374 SELLING POWER 163, 164, 168 SELLING POWER MAGAZINE 163, 164, 168 SEWICKLEY GRAPHICS & DESIGN. INC. 139 SHEETZ 112 SIGNI DESIGN 30 SIMTREX CORP. 126 SKITS OUTREACH SERVICES, INC. 243 SKOORKA DESIGN 231 SLANTING RAIN GRAPHIC DESIGN 310, 312, 314 SMITH DESIGN ASSOCIATES 189. 275 SMITH INTERNATIONAL ENTERPRISES 281 SNYDER'S OF HANOVER 275 SOMETHING SILVER 372 SONOL 270, 271 SONY ELECTRONICS 202 SONY ERICSSON 189 SOBBENTO 294 SPARK DESIGN 257 SPARKMAN + ASSOCIATES, INC. 245 SPIKE BRAND 151 SPLASH CITY FAMILY WATERPARK 100 **SBBI 127** ST. STEPHEN'S 139 STAHL PARTNERS INC. 154 STEINHORN CONSULTING 78 STERRETT DYMOND STEWART **ADVERTISING 21** STORK PIZZA 140 STRATA CORE 157 STRAUB'S 368 STRIEGEL & ASSOCIATES 240 STUDIO 3600 5 STUDIO 405 364 SUKTION PRODUCTION 247 SUMMERTECH INC. 236 SUN ORCHARD BRAND 296 SUN-NI CHEESE 222, 223 SUPON DESIGN GROUP 260 SWAMP DAWG, LLC 256 SWATCH 328, 330 SWEET RHYTHM 146 SWIFT & COMPANY 292, 293, 295 SZYLINSKI ASSOCIATES INC. 276 т

SCHMAKEL DENTISTRY 153

T-ONLINE INTERNATIONAL AG 381 TALKING RAIN 278 TARGET STORES 142, 278, 283, 319 TATE CAPITAL PARTNERS 129 TBWA-ANTHEM (INDIA) 8, 11, 313 TD2, S.C. 276, 365 TEATRO BRUTO 36, 41, 329 TELEPHONY FOR INFORMATION SERVICES 150 **TEQUIZA** 7 THE AMERICAN GROUP OF CONSTRUCTORS, INC. 135 THE AMERICAN LAWYER 165, 167, 169

THE ANCHOR CLUB 74, 233

U

THE KENNEL CLUBS/ST. JOHNS **GREYHOUND PARK 266** THE LEYO GROUP, INC. 102, 121, 128, 142, 146, 159, 281 THE MATTEL COMPANIES 85 THE NFL AND UNITED WAY 68 THE PAGEANT 171 THE PEPSI BOTTLING GROUP INC. 29 THE PROGRESSIVE CORPORA-TION 380 THE SERVICE GROUP 62 THE SLOAN GROUP 11 THE SPICE MERCHANT AND TEA **ROOM 128** THE STAR GROUP 274 THE TOURISM BUREAU SOUTHWESTERN ILLINOIS 96 THE UNGAR GROUP 5 THE VISIBILITY COMPANY 144 THE WEBER GROUP, INC. 277, 298 THE WECKER GROUP 125, 136, 142, 152 THE WYANT SIMBOLI GROUP, INC 358 THINK SNOW 238 THOMPSON DESIGN GROUP 279, 295 THOMSON MEDICAL ECONOMICS 168 THOR EQUITIES 147 **TILKA DESIGN 234** TIMEX 11 TIMOTHY PAUL CARPETS & **TEXTILES 148** TODD & BETSY PIGOTT 364 TODD CHILDERS GRAPHIC DESIGN 229 TOM FOWLER, INC. 67,158, 276, 280, 299, 375 TOMPERTDESIGN 254 TOOLBOX STUDIOS, INC. 121, 136, 150, 155, 157, 351 TOP DESIGN STUDIO 159, 264 TOSHIBA COPIERS 5 **TOULOUSE 145** TRANSHIELD 256 TRAPEZE COMMUNICATIONS 123 TREFETHEN VINEYARDS 71, 261 TRINITY BAPTIST CHURCH 155 TRIPLE POINT TECHNOLOGY 339 TRISILCO MOTOR GROUP 120 TUBNER PROPERTIES 192 TWO TWELVE ASSOCIATES 182

THE COCA-COLA COMPANY 153

THE DREAMHOUSE FOR MEDI-

THE EATON CORPORATION 377

THE GAMBRINUS COMPANY 351

THE ICELANDIC ASSOCIATION

OF INTERNAL MEDICINE 120

THE IMAGINATION COMPANY 158.

THE JEWISH HOME & HOSPITAL

OF NEW YORK 161

THE KENNEL CLUBS 266

THE ECCENTRIC GARDENER

PLANT COMPANY 137

THE FOTOS GROUP 253

THE GYPSY DEN 10

238, 277

CALLY FRAGILE CHILDREN 160

THE COLLEGE OF NEW

ROCHELLE 17

THE DAILY PERC 110

U.S. SMOKELESS TOBACCO 104 U.S.S.T. 113 UKULELE DESIGN CONSULTANTS PTE LTD 27, 54 UNILEVER BEST FOODS 294

UNITED WAY 314, 315, 326 UNIVERSITY OF ILLINOIS AT URBANA/CHAMPAIGN 66 UNWINED WINE STORE 143 UTILITY SAFETY CONFERENCE & EXPO 154

v

VERBA SRL 18, 19, 20 VILNIUS ART ACADEMY 48, 50, 327 VIRGINIA HOSPITAL CENTER-ARLINGTON 260 VIVIDESIGN GROUP 133 VMA 254 VMI MEDICAL SYSTEMS 121 VOCOLLECT 119, 151 VOLKSWAGEN 13

w

WALKERGROUP/CNI 368 WALLACE CHURCH, INC. 239, 286, 288 WALSH & ASSOCIATES, INC. 193. 369 WALSH DESIGN 198 WALT DISNEY COMPANIES 161 WALTERS GOLF 161 WARNER BROTHERS RECORDS RENDEZVOUS ENTERTAIN-MENT 264 WATERCOLOR INN 335 WAVES MUSIC STORE 198 WEBDOCTOR 154 WEGMANS FOOD MARKETS 278 WELCH DESIGN GROUP, INC. 228 WELLS FARGO BANK 192 WEND TYLER WINERY 285 WESTCHESTER NEIGHBORHOOD SCHOOL 131 WESTED 61 WHISTLE 126, 146, 160 WIDMER BROTHERS 346, 347 WILLIAM GRANT AND SONS 284, 287 WILMINGTON CHILDREN'S MUSEUM 128 WIRE STONE 246 WISE LIVING 77 WKSP ADVERTISING 270, 271 WM. WRIGLEY JR. CO. 282 WOODBINE ENTERTAINMENT GROUP 8 WORLD AGRICULTURAL FORUM 129 WORLD GOLF FOUNDATION 140 WORLD THEATRE 248 WRANGLER 369 WRAY WARD LASETER ADVERTISING 11, 13 WYCLIFFE 170

X DESIGN COMPANY 75, 126, 160, 252, 263

YARDBIRDS ORGANIC CHICKEN 152

YOUNG AUDIENCES OF INDIANA 154

YUGUCHI & KROGSTAD, INC. 192

7

ZD STUDIOS, INC. 131, 141, 148, 156

ZENDER FANG ASSOCIATES 316 ZGRAPHICS, LTD, 122, 128 ZUNDA DESIGN GROUP 279